W9-CEE-800

BATMAN
THE WAR YEARS
1939–1945

BAT MAN

THE WAR YEARS
1939 – 1945

By Roy Thomas

CHARTWELL
BOOKS

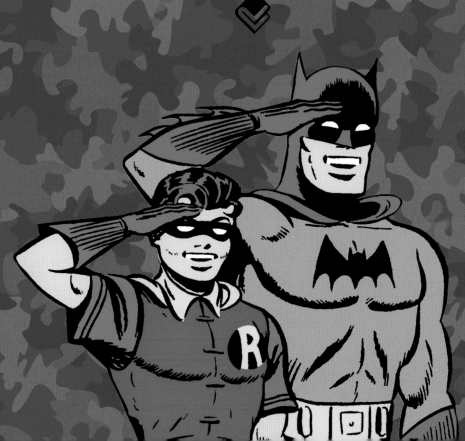

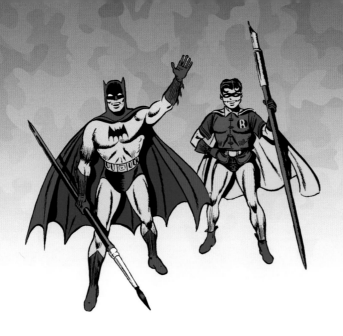

EDITORS
Michelle Faulkner
Frank Oppel

EDITORIAL ASSISTANT
Jason Chappell

DESIGNER
Maria P. Cabardo

COVER DESIGNER
Rachael Cronin

This edition published in 2015 by Chartwell Books , an imprint of Book Sales, a division of Quarto Publishing Group USA Inc.
142 West 36th Street, 4th Floor, New York, New York 10018 USA

This edition published with permission of and by arrangement with DC Entertainment
2900 W. Alameda Ave. #9010, Burbank, CA 91505 USA
A Warner Bros. Entertainment Company.

© 2015 by DC Comics.
All Rights Reserved.

No part of this publication may be reproduced, stored in a retrieval system, or transmitted, in any form or by any means, electronic, mechanical,
photocopying, recording, or otherwise, without prior written permission from the publisher. All rights reserved.

ISBN-13: 978-0-7858-3283-6 Printed in China 2 4 6 8 10 9 7 5 3 1 www.quartous.com

All identification of writers and artists made in this book utilized information provided by the Online Grand Comics Database.

Compiled by Roy Thomas

This book is dedicated to my mother,
Mrs. Leona Thomas,
who bought me my first comic books
at age four
and at first read to me about two characters
whose names I thought must be
"Badman and Robber"–
after all, they wore masks,
so they must be *crooks,* right?

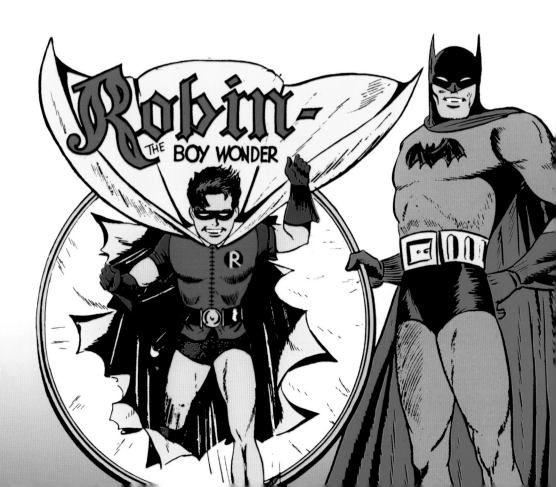

BATMAN: THE WAR YEARS 6
By Roy Thomas

PART 1: FROM PERFIDY TO PEARL HARBOR 9

THE CASE OF THE CHEMICAL SYNDICATE 11
From DETECTIVE #27 issued May 1939

THE BATMAN WARS AGAINST THE DIRIGIBLE OF DOOM 18
From DETECTIVE #33 issued November 1939

THE SPIES 31
From DETECTIVE #37 issued March 1940

DETECTIVE #38 Cover 44
Issued April 1940

BATMAN #1 Cover 45
Issued Spring 1940

THE STRANGE CASE OF THE DIABOLICAL PUPPET MASTER 46
From BATMAN #3 issued Fall 1940

THE CASE OF THE LAUGHING DEATH 60
From DETECTIVE #45 issued November 1940

THE BRAIN BURGLAR 73
From DETECTIVE #55 issued September 1941

THE STRANGE CASE OF PROFESSOR RADIUM 86
From BATMAN #8 issued December 1941-January 1942

BATMAN #10 Cover 99
Issued April – May 1942

PART 2: THE HOME FRONT WAR 100

WORLD'S FINEST COMICS #5 Cover 102
Issued Spring 1942

DETECTIVE #64 Cover 103
Issued June 1942

DETECTIVE #65 Cover 104
Issued July 1942

WORLD'S FINEST COMICS #6 Cover 105
Issued Summer 1942

BATMAN #12 Cover 106
Issued August – September 1942

WORLD'S FINEST COMICS #7 Cover 107
Issued Fall 1942

THE HARLEQUIN'S HOAX 108
From DETECTIVE #69 issued November 1942

BATMAN #13 Cover 121
Issued October – November 1942

SWASTIKA OVER THE WHITE HOUSE 122
From BATMAN #14 issued December 1942 – January 1943

PART 3: GUARDING THE HOME FRONT 135

THE BOY WHO WANTED TO BE ROBIN 137
From BATMAN #15 issued February – March 1943

THE TWO FUTURES 151
From BATMAN #15 issued February – March 1943

THE SCARECROW RETURNS 164
From DETECTIVE #73 issued March 1943

CRIME OF THE MONTH 178
From WORLD'S FINEST COMICS #9 issued Spring 1943

BATMAN #17 Cover 192
Issued June – July 1943

MAN WITH THE CAMERA EYES 193
From WORLD'S FINEST COMICS #10 issued Summer 1943

WORLD'S FINEST COMICS #11 Cover 205
Issued Fall 1943

PART 4: CLOSING THE RING 206

BATMAN #18 Cover 208
Issued August – September 1943

THE CRIME CLINIC 209
From DETECTIVE #77 issued July 1943

THE BOND WAGON 221
From DETECTIVE #78 issued August 1943

ATLANTIS GOES TO WAR 234
From BATMAN #19 issued October – November 1943

BLITZKRIEG BANDITS 247
From BATMAN #21 issued February – March 1943

THE CURSE OF ISIS 259
From WORLD'S FINEST COMICS #13 issued Spring 1944

THE YEAR 3000 271
From BATMAN #26 issued December 1944 – January 1945

PART 5: VICTORY 284

BATMAN GOES TO WASHINGTON 286
From BATMAN #28 issued April – May 1945

DETECTIVE #101 Cover 298
Issued July 1945

BATMAN #30 COVER 299
Issued August – September 1945

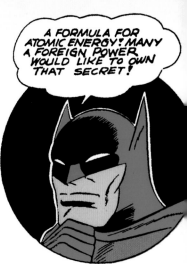

Introduction

BY ROY THOMAS

BATMAN.

Today, Batman is probably the most famous and respected hero in the DC Comics pantheon. Until at least the mid-1960s, however—and perhaps until at least the 1980s—he definitely came in second at DC, behind a certain Man of Steel.

And, when you consider how many super-heroes DC published in the 1940s—from the famous Wonder Woman, Flash, and Green Lantern down to relative obscurities like Tarantula and TNT (with Dan the Dyna-Mite)—that was no mean accomplishment.

Of course, besides being faster than a speeding bullet, Superman had a head start. He burst upon the comic book scene in spring of 1938, Batman nearly a year later, the product of Bob Kane. DC editor Vin Sullivan, the same man who'd overseen the four-color debut of Superman, liked what Kane turned in, and Batman (well, "The Bat-Man") became the cover feature of the 27th issue of DC's flagship title, *Detective Comics.*

Not that Batman was a pure-bred concept with no antecedents beyond the general idea of a hero wearing an acrobat-style costume. But hey, everything has antecedents. Even *The Iliad* drew on a background of earlier songs and stories about the Trojan War.

The idea of a man without special powers assuming a secret identity and a costume and going out to do good went back at least to Zorro, a masked avenger who lived and fought in the long-ago days when the Spanish ruled California. He first appeared in pulp-magazine stories written by one Johnston McCulley twenty years earlier, in 1919. Zorro— which means "The Fox" in Spanish—was an instant

hit, so much so that by the very next year silent screen star Douglas Fairbanks portrayed him in a hit movie titled *The Mark of Zorro.* More movies and movie serials and comic books and TV series would follow over the decades.

In one very real sense, Zorro himself had been preceded by the protagonist of Emma Orczy's 1905 British stage play *The Scarlet Pimpernel,* in which an English lord rescued endangered Parisian noblemen during the French Revolution's Reign of Terror. A film version had been made in 1934 and had proved quite popular. But the Scarlet Pimpernel—real name, Sir Percy Blakeney—didn't wear a costume or mask; he simply left a calling card with the emblem of a red flower at the scene of his endeavors. Like the alter ego of Zorro, though, Sir Percy was upper-class, all the way . . . not a lowly newspaper reporter raised by farmers as Clark Kent was.

In addition, since 1936, a masked and costumed hero had existed even in the more staid world of newspaper comics strips: *The Phantom,* who had another name, though he'd pretty much given it up to fight evil in the jungles of Southeast Asia. Even earlier, in *The Shadow,* a pulp magazine launched in 1931, a playboy named Lamont Cranston became one of the civilian identities of yet another masked hero, this one performing his derring-do at night or at least in darkness. And in 1936 *The Green Hornet* made his debut on radio; he was a newspaper tycoon who donned a mask and overcoat to combat crime, armed with a gas-gun.

So much for the mask and costume and even the patrician origins. Unlike Superman, Batman also

had an alternate life as one of the idle rich . . . a playboy . . . Bruce Wayne. The idea with Batman, clearly, was to look and act a *bit* like Superman—but not *too* much—and to perform heroic acts. At least theoretically, a normal human being without alien origins or super-powers could aspire to emulate Batman, assuming he'd spent hours of every day of his young life in a gym, with evenings devoted to becoming the greatest detective since Sherlock Holmes. However, to the presumably superstitious criminals that he wanted to frighten by assuming the look of a creature of the night, it must have seemed that this "Bat-Man" was indeed possessed of supernatural powers. For, if bullets didn't bounce off him, they also rarely if ever seemed to *touch* him; and his athletic powers—including the force behind that gloved fist—made mincemeat of everyone in the underworld that he encountered.

Another thing that Superman and Batman had in common besides secret identities and costumes: each of them was a huge bona fide hit, right out of the starting gate. By spring of 1940, Batman, too, had his own eponymous comic book, originally published quarterly, though it would quickly jump to bimonthly.

By then, though, Batman had acquired something that Superman didn't have and didn't need: a *partner*. In *Detective Comics #38* (April 1940), Batman befriends a youngster, a child of acrobats who've been murdered, just as Bruce Wayne's own parents once were. It's a small world after all. Batman trains Robin in both a gym and the library, until he's basically a junior version of himself,

although in a much brighter costume . . . a robin running around with a bat.

Presumably, Robin was brought into the series so that kids could identify with him, the "Boy Wonder" running around with Batman. In point of fact, however, the kids identified not with Robin, but with Batman. Who wanted to be the boy in short pants and a short yellow cape running around with Batman? They wanted to be *Batman!* Still, when all was said and done, at least Batman, unlike Superman, had someone he could talk to—a confidant who knew of his double life, and indeed was living one himself! And that's got to count for something. Superman mostly had to talk to *himself* if the reader was going to know what was going on in his Kryptonian mind.

What's more, if Batman set the pace for a whole generation of so-called "super-heroes" who didn't have true super-powers—and he surely *did*—so did Robin mightily influence comic book stories that came after his debut. Soon, many a masked hero had a kid sidekick. Captain America had Bucky—the Human Torch had Toro—the Shield had Dusty—and Air Male had Stampy (I kid you not!). Oh, and Cat-Man had Kitten, who was a pre-pubescent *girl*. But none of those ever held a candle to Robin, who, beginning several years later, would even have his own solo-star series for half a decade.

Batman and Robin's original venue, *Detective Comics,* was the second comic book launched by publisher Major Malcolm Wheeler-Nicholson (after *New Fun,* which evolved into *More Fun Comics*). From its

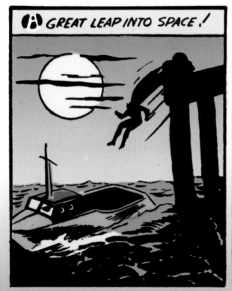

inception, it had been the first regularly-published comic to be devoted to a single subject matter—namely, detectives and crime-fighting. Before Batman flitted onto the scene, Detective had even featured a different masked hero, The Crimson Avenger, who was in some ways a precursor of Batman, though he never really made much of a splash and only ever appeared on two covers. After printing-press owner Harry Donenfeld took over Wheeler-Nicholson's company and became the publisher of *Detective Comics,* the company was known as Detective Comics, Inc. Soon the covers of *More Fun, Detective, Action Comics,* et al., sported a symbol which consisted of a circle around the letters "DC."

Batman's backstory is one of the best-known in the universe of fiction. The poor little rich boy orphaned in a late-night robbery. The lad training for years so that one day he could avenge his parents' deaths. The bat that flies through the window at a crucial moment, inspiring Bruce Wayne with a name and a motif. All of these are wonderful elements in a timeless tale.

By early 1940, Batman and Robin were up and running in no less than *two* hit comic books. Although Bob Kane had earlier had an artist assistant named Sheldon Moldoff, "Shelly" soon left to pursue his own destiny as the artist of other

features for DC, especially Hawkman. So Kane hired a teenager he happened to meet—Jerry Robinson—to help him churn out what looked like a nice long run of Batman stories.

They didn't know the half of it.

For, as the Second World War loomed ever larger on the horizon, Batman was about to become big business, comic-book style.

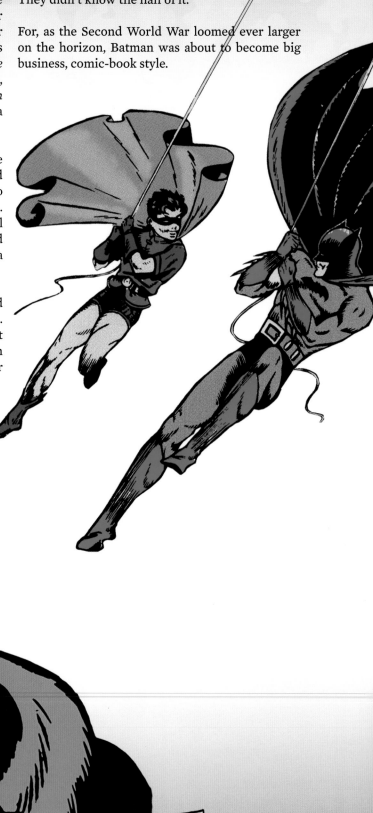

Part One

At the end of 1938, around the time that Batman was being created, things on the world stage were going from bad to worse.

FROM PERFIDY TO PEARL HARBOR

Adolf Hitler, *Der Führer*, came to power in Germany in 1933, determined to get revenge for the harsh terms forced on the Fatherland at the end of the Great War of 1914–18. He and his Nazi minions gained control of the nation's armed forces and proceeded to rebuild the military in defiance of the terms of the war-ending Treaty of Versailles. In 1938 his Third Reich annexed neighboring Austria, which had been Hitler's birthplace. Soon afterward, he stared down the leaders of Britain and France and took over the German-speaking parts of Czechoslovakia. By March of 1939 he grabbed the remainder of that nation. Reasoning that his next target would probably be Poland, on Germany's eastern border, France and Britain declared that, if Hitler invaded that country, they would go to war with Germany.

By contrast, Benito Mussolini, leader of Italy since the 1920s, was perceived as a less serious threat. Still, his Fascist soldiers and airmen invaded Ethiopia in 1935, and in the latter half of the 1930s his orbit grew ever closer to that of the German dictator. Together, they would constitute a formidable threat.

Meanwhile, on the other side of the world, the Japanese, now ruled by the military, launched a full-scale attack on China in 1937, hoping to subdue that far-larger country and, after it, much of Asia and the western Pacific. The United States and Britain, both naval powers in the Pacific and Atlantic Oceans, were determined to defend their colonies and allies in the region from hostile takeover. However, by and large they were more focused on the threat of Nazi Germany.

Yet all the while, those three totalitarian nations drew slowly closer together. Germany and Italy formed an "Axis" by treaty in 1936. And in August of 1939, Hitler shocked the world by signing a pact with the Soviet Union; that freed him to attack Poland without fearing an assault from the east. Only days later, German troops invaded Poland. Hitler quickly found himself at war with the British Empire and France. The United States remained neutral, though most of its population was unsympathetic to the Third Reich; Americans felt they had gotten involved in Europe's quarrels a quarter-of-a-century earlier, and a majority were determined to never do so again.

Meanwhile, the four-color world of Batman developed amid its own version of "splendid isolation," with little more than an occasional nod to developments abroad.

For example, in *Detective Comics* #33 (Nov. 1939), half a year after Batman's debut, the story that recounts his origin (in two pages) pits him against a decidedly Napoleonic villain. If there are overtones of Hitler, Mussolini, or Japan's General Hideki Tojo in the comic book bad-guy, they're purely symbolic.

Still, by 1939 and 1940, some of the movie studios were using spies and sabotage in their films—perhaps partly out of conviction, but surely partly with an eye to box office receipts—and DC's comics edge in the same direction. In *Detective* #37 (March 1940), which went into production around the time of Germany's blitz of Poland, Batman battles foreign agents. They aren't identified as working for any of

the Axis powers (a group that by now also includes Japan, which signed a treaty with Germany and Italy in September of 1939); yet somehow, it's hard to believe that the youngsters of America (and Canada, a part of the British Commonwealth) imagined those spies were working for England, France, or Luxembourg.

By the issue of *Detective* cover-dated April 1940, as we've seen, Batman is joined by Robin. With that teaming, the feel of the Batman stories changes radically. They become much less dark, as the Dynamic Duo trade wisecracks while tackling criminals. Even as the world gets grimmer and grimmer, the Batman series gets lighter in tone . . . perhaps in a conscious attempt to lighten everybody's spirits in those troubled times.

War increasingly forms the background of stories: the Puppeteer steals an early atomic formula (well before the fabled Manhattan Project is begun), but only to try to profit from its sale . . . the Joker, Batman's quintessential foe, steals a statue scheduled to be auctioned off to help the "war-stricken" . . . fifth columnists (i.e., spies and enemy agents) sabotage bomber and steel production in

the U.S. . . . and Professor Radium uses radioactivity to commit his crimes, although what that might have to do with the wars raging in Europe and China won't be apparent for a few years.

Oh, and just in case you're asking yourself why, if America was neutral in the developing conflict, it was building bomber aircraft . . .

Even as the nation tried to stick its collective head in the sand, many of its people—and even more so, its President, Franklin D. Roosevelt—believed that the U.S.A. wouldn't be able to stay on the sidelines forever. Or even, after the Fall of France left Britain. alone, that it *should*.

Then, on the Sunday morning of December 7, 1941, carrier-based aircraft of the Empire of Japan attacked U.S. forces at their base at Pearl Harbor, Hawaii — with attacks on the U.S.-controlled Philippines and British-controlled Singapore quickly following. A couple of days later, Hitler and Mussolini declared war on America, honoring their treaty with Japan.

Now two separate wars, in two separate hemispheres, had become one gigantic Second World War—and the United States was in it for the long haul.

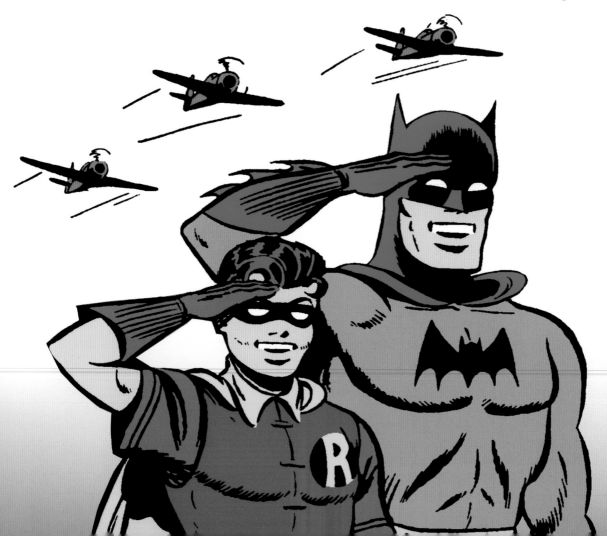

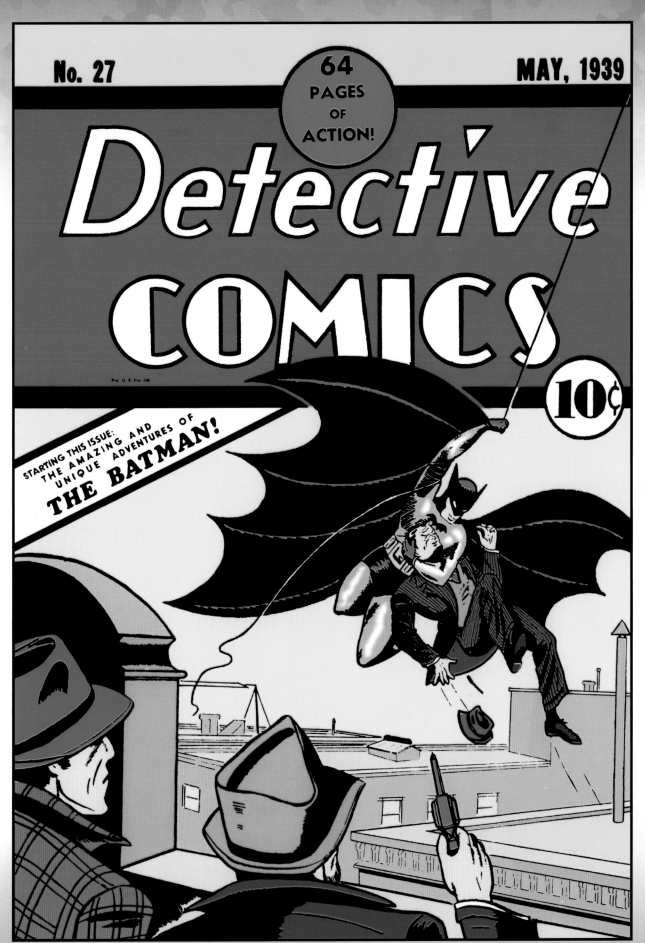

Detective Comics #27 (May 1939) - cover art: Bob Kane

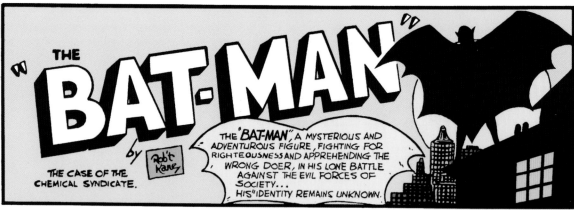

"THE BAT-MAN"

THE CASE OF THE CHEMICAL SYNDICATE.

by Rob't Kane

THE "BAT-MAN", A MYSTERIOUS AND ADVENTUROUS FIGURE, FIGHTING FOR RIGHTEOUSNESS AND APPREHENDING THE WRONG DOER, IN HIS LONE BATTLE AGAINST THE EVIL FORCES OF SOCIETY... HIS "IDENTITY REMAINS UNKNOWN.

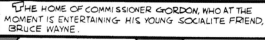

THE HOME OF COMMISSIONER GORDON, WHO AT THE MOMENT IS ENTERTAINING HIS YOUNG SOCIALITE FRIEND, BRUCE WAYNE.

WELL COMMISSIONER, ANYTHING EXCITING HAPPENING THESE DAYS?

-NO-O- EXCEPT THIS FELLOW THEY CALL THE "BAT-MAN" PUZZLES ME!

RING!

HELLO...WHAT'S THAT? LAMBERT, THE CHEMICAL KING... STABBED TO DEATH? HIS SON'S FINGER PRINTS ON THE KNIFE?...I'LL BE RIGHT OVER!

- TALK ABOUT SOMETHING EXCITING... OLD LAMBERT HAS BEEN MURDERED AT HIS MANSION... I'M GOING THERE NOW, LIKE TO COME ALONG?

OH WELL, NOTHING ELSE TO DO, MIGHT AS WELL

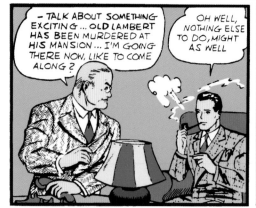

THE COMMISSIONER AND BRUCE WAYNE, SPEED TOWARD THE LAMBERT RESIDENCE...

HELLO SERGEANT, EVERYTHING UNDER CONTROL?

YES SIR, WE'VE GOT YOUNG LAMBERT IN THE BACK ROOM!

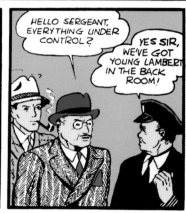

...AND AFTER A THOROUGH EXAMINATION OF THE SCENE OF THE CRIME, THE ROOM BECOMES BUSY WITH THE USUAL POLICE ROUTINE...

WELL I'M FINISHED IN HERE, LET ME TALK TO YOUNG LAMBERT

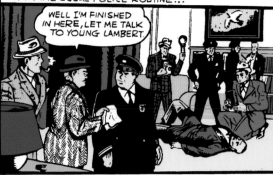

HELLO LAMBERT, THEY SAY YOU KILLED YOUR FATHER!

I DIDN'T DO IT! COMMISSIONER, BELIEVE ME, I DIDN'T DO IT!!!

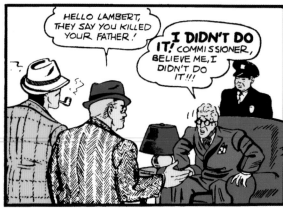

Detective Comics #27 (May 1939) - script: Bill Finger - art: Bob Kane

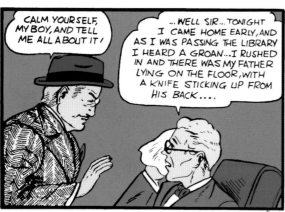

CALM YOURSELF, MY BOY, AND TELL ME ALL ABOUT IT!

...WELL SIR... TONIGHT I CAME HOME EARLY, AND AS I WAS PASSING THE LIBRARY I HEARD A GROAN... I RUSHED IN AND THERE WAS MY FATHER LYING ON THE FLOOR, WITH A KNIFE STICKING UP FROM HIS BACK....

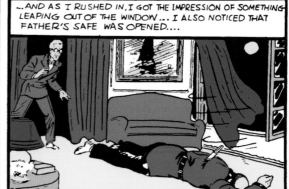

...AND AS I RUSHED IN, I GOT THE IMPRESSION OF SOMETHING LEAPING OUT OF THE WINDOW... I ALSO NOTICED THAT FATHER'S SAFE WAS OPENED....

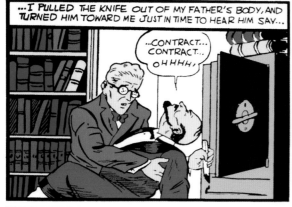

...I PULLED THE KNIFE OUT OF MY FATHER'S BODY, AND TURNED HIM TOWARD ME JUST IN TIME TO HEAR HIM SAY...

...CONTRACT... CONTRACT... OHHHH,

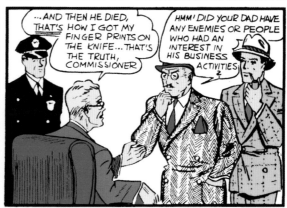

...AND THEN HE DIED, THAT'S HOW I GOT MY FINGER PRINTS ON THE KNIFE... THAT'S THE TRUTH, COMMISSIONER

HMM! DID YOUR DAD HAVE ANY ENEMIES OR PEOPLE WHO HAD AN INTEREST IN HIS BUSINESS ACTIVITIES?

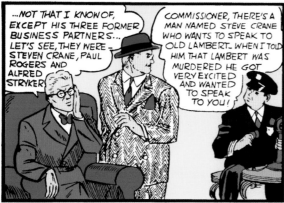

...NOT THAT I KNOW OF, EXCEPT HIS THREE FORMER BUSINESS PARTNERS... LET'S SEE, THEY WERE—STEVEN CRANE, PAUL ROGERS AND ALFRED STRYKER!

COMMISSIONER, THERE'S A MAN NAMED STEVE CRANE WHO WANTS TO SPEAK TO OLD LAMBERT... WHEN I TOLD HIM THAT LAMBERT WAS MURDERED HE GOT VERY EXCITED AND WANTED TO SPEAK TO YOU!

THIS IS COMMISSIONER GORDON, WHAT'S THE TROUBLE?

...YESTERDAY, MR. LAMBERT CALLED AND TOLD ME HE RECEIVED AN ANONYMOUS THREAT ON HIS LIFE... TODAY I RECEIVED THE SAME ...THAT'S WHY I CALLED UP... AND I'M AFRAID I'LL BE NEXT... WHAT SHALL I DO?

WAIT... AND DO NOT LEAVE ANYBODY IN—WE'LL BE OVER SOON AS WE CAN— WHAT'S THAT, BRUCE?

HO HUM! I'LL LEAVE YOU HERE TO FINISH YOUR WORK... I'M GOING HOME.

CLICK!

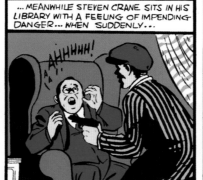

...MEANWHILE STEVEN CRANE SITS IN HIS LIBRARY WITH A FEELING OF IMPENDING DANGER... WHEN SUDDENLY...

AHHHHH!

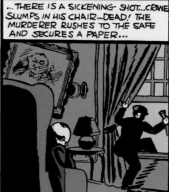

...THERE IS A SICKENING SHOT... CRANE SLUMPS IN HIS CHAIR... DEAD! THE MURDERER RUSHES TO THE SAFE AND SECURES A PAPER...

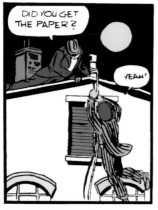

DID YOU GET THE PAPER?

YEAH!

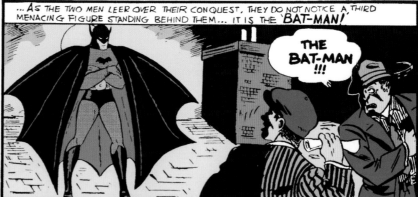

... AS THE TWO MEN LEER OVER THEIR CONQUEST, THEY DO NOT NOTICE A THIRD MENACING FIGURE STANDING BEHIND THEM ... IT IS THE 'BAT-MAN!'

THE BAT-MAN !!!

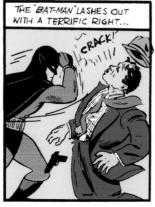

THE "BAT-MAN" LASHES OUT WITH A TERRIFIC RIGHT...

CRACK!

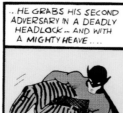

.. HE GRABS HIS SECOND ADVERSARY IN A DEADLY HEADLOCK ... AND WITH A MIGHTY HEAVE

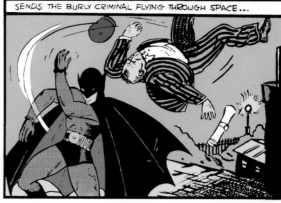

SENDS THE BURLY CRIMINAL FLYING THROUGH SPACE...

THE "BAT-MAN" SWIFTLY PICKS UP THE PAPER THAT THE MURDERER STOLE FROM STEVEN CRANE'S SAFE...

... MEANWHILE THE COMMISSIONER DRAWS UP IN HIS CAR...

IT'S THE BAT-MAN! GET HIM!

MR. CRANE HAS BEEN MURDERED, SIR - IT'S HORRIBLE

THAT'S TWO DEAD PARTNERS OUT OF THE FOUR THAT HAVE RECEIVED THREATENING NOTES THE OTHER TWO MUST HAVE RECEIVED THEM TOO .. LET'S GO TO ROGERS NEXT !

THE "BAT-MAN" READS THE PAPER HE SNATCHED FROM THE KILLERS AND A GRIM SMILE COMES TO HIS LIPS

HE SPEEDS HIS CAR FOWARD TO AN UNKNOWN DESTINATION

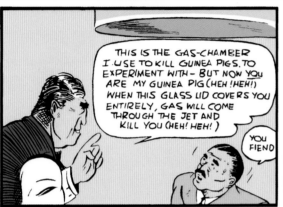

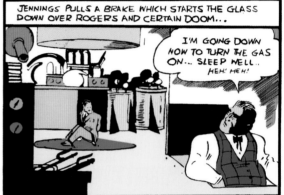

15

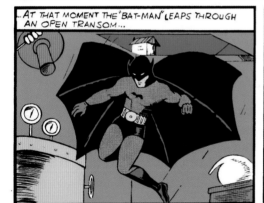

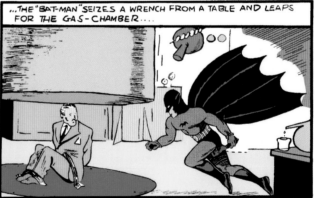

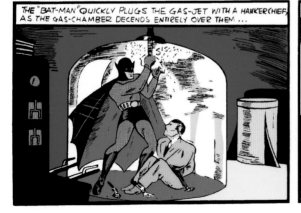

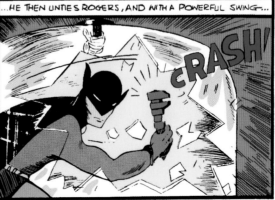

JENNINGS RETURNS AND IS STARTLED BY THE BAT-MAN... HE REACHES FOR HIS GUN...

WHAT TH'...?

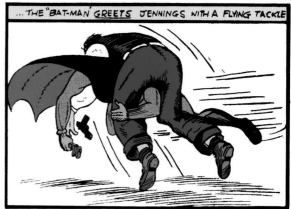

...THE "BAT-MAN" GREETS JENNINGS WITH A FLYING TACKLE

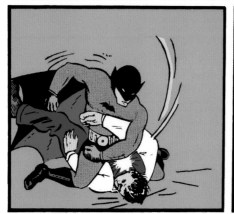

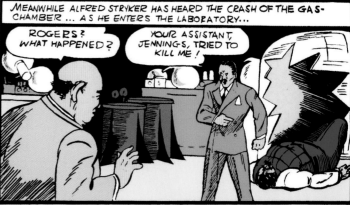

MEANWHILE ALFRED STRYKER HAS HEARD THE CRASH OF THE GAS-CHAMBER ... AS HE ENTERS THE LABORATORY...

ROGERS? WHAT HAPPENED?

YOUR ASSISTANT, JENNINGS, TRIED TO KILL ME!

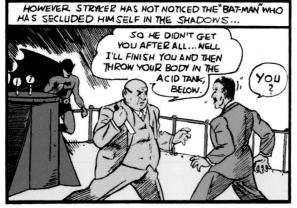

HOWEVER STRYKER HAS NOT NOTICED THE "BAT-MAN" WHO HAS SECLUDED HIMSELF IN THE SHADOWS...

SO HE DIDN'T GET YOU AFTER ALL... WELL I'LL FINISH YOU AND THEN THROW YOUR BODY IN THE ACID TANK, BELOW.

YOU?

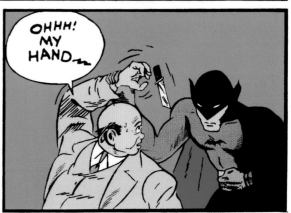

OHHH! MY HAND...

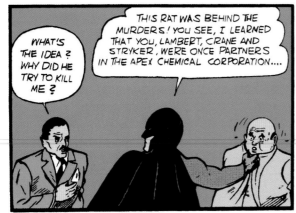

WHAT'S THE IDEA? WHY DID HE TRY TO KILL ME?

THIS RAT WAS BEHIND THE MURDERS! YOU SEE, I LEARNED THAT YOU, LAMBERT, CRANE AND STRYKER, WERE ONCE PARTNERS IN THE APEX CHEMICAL CORPORATION....

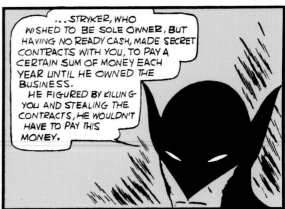

...STRYKER, WHO WISHED TO BE SOLE OWNER, BUT HAVING NO READY CASH, MADE SECRET CONTRACTS WITH YOU, TO PAY A CERTAIN SUM OF MONEY EACH YEAR UNTIL HE OWNED THE BUSINESS.
HE FIGURED BY KILLING YOU AND STEALING THE CONTRACTS, HE WOULDN'T HAVE TO PAY THIS MONEY.

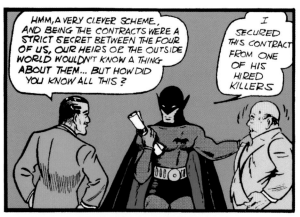

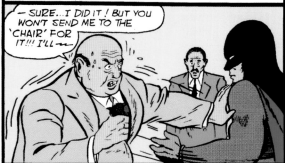

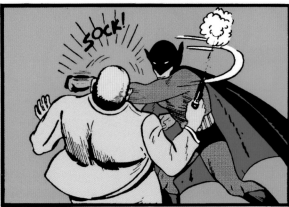

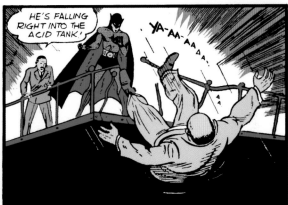

17

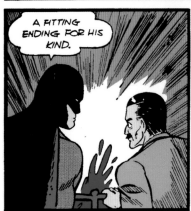

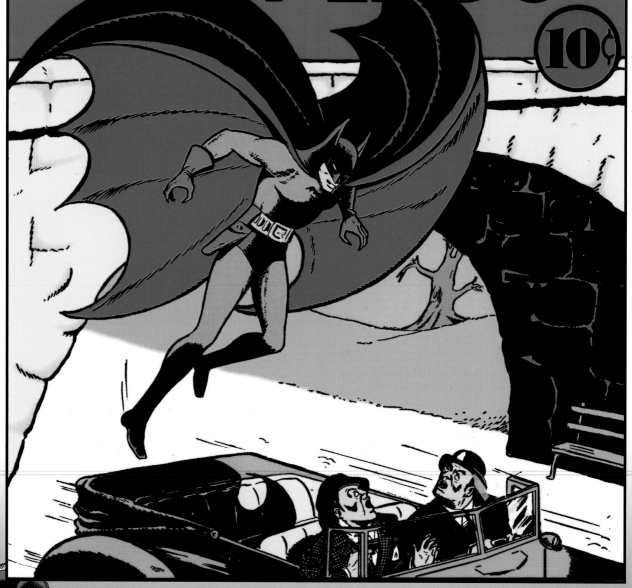

No. 33

In this issue:
ANOTHER THRILLING
ADVENTURE
OF
THE BATMAN

NOVEMBER, 1939

Detective
COMICS

REG. U. S. PAT OFF

10¢

Detective Comics #33 (Nov. 1939) - cover art: Bob Kane

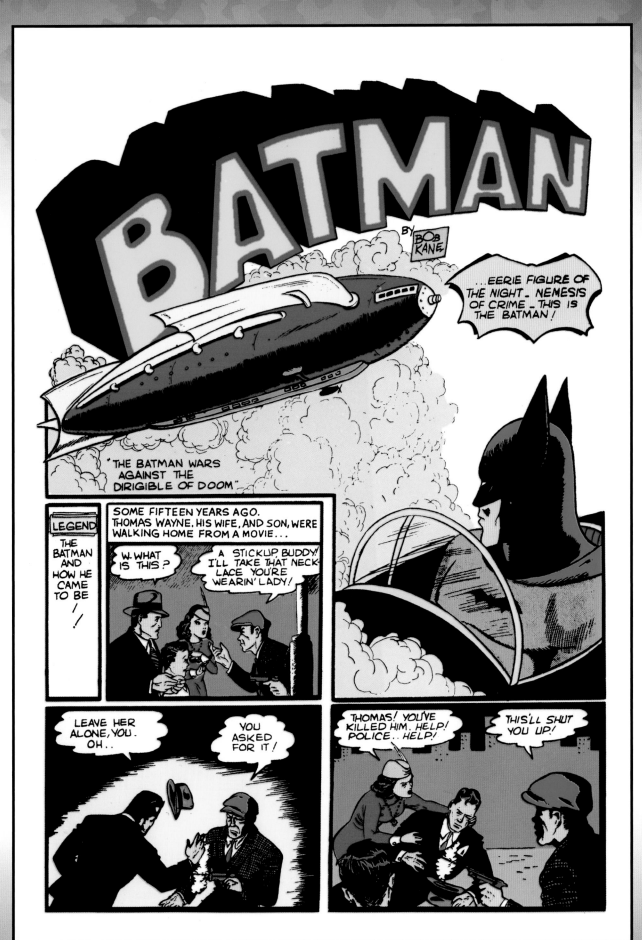

Detective Comics #33 (Nov. 1939) - script: Bill Finger (pp. 1–2), Gardner Fox
(pp. 3–12) - art: Bob Kane (with Sheldon Moldoff, backgrounds)

THE BOY'S EYES ARE WIDE WITH TERROR AND SHOCK AS THE HORRIBLE SCENE IS SPREAD BEFORE HIM.

FATHER.. MOTHER!

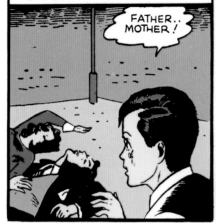

...DEAD! THEY'RE D..DEAD.

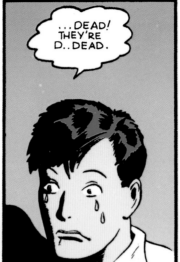

DAYS LATER, A CURIOUS AND STRANGE SCENE TAKES PLACE.

AND I SWEAR BY THE SPIRITS OF MY PARENTS TO AVENGE THEIR DEATHS BY SPENDING THE REST OF MY LIFE WARRING ON ALL CRIMINALS.

AS THE YEARS PASS, BRUCE WAYNE PREPARES HIMSELF FOR HIS CAREER. HE BECOMES A MASTER SCIENTIST.

TRAINS HIS BODY TO PHYSICAL PERFECTION UNTIL HE IS ABLE TO PERFORM AMAZING ATHLETIC FEATS.

DAD'S ESTATE LEFT ME WEALTHY. I AM READY.. BUT FIRST I MUST HAVE A DISGUISE.

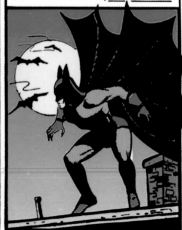

CRIMINALS ARE A SUPERSTITIOUS COWARDLY LOT. SO MY DISGUISE MUST BE ABLE TO STRIKE TERROR INTO THEIR HEARTS. I MUST BE A CREATURE OF THE NIGHT, BLACK, TERRIBLE.. A. A...

-AS IF IN ANSWER, A HUGE BAT FLIES IN THE OPEN WINDOW!

A BAT! THAT'S IT! IT'S AN OMEN. I SHALL BECOME A BAT!

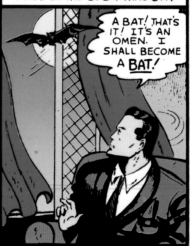

AND THUS IS BORN THIS WEIRD FIGURE OF THE DARK.. THIS AVENGER OF EVIL, 'THE BATMAN'

NIGHTFALL. BRUCE WAYNE WALKS THE CROWDED STREETS OF DOWNTOWN MANHATTAN.

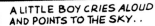

A LITTLE BOY CRIES ALOUD AND POINTS TO THE SKY..

LOOK, MOM! A DIRIGIBLE.

STRANGE-LOOKING SHIP. HMM.. MORE LIKE A ROCKET SHIP.

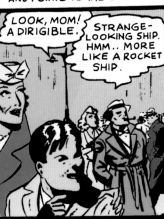

SUDDENLY RED BEAMS OF LIGHT SHOOT FROM THE SHIP.

RED LIGHTS! WHAT IS IT? HELP! I'M GOING BLIND!

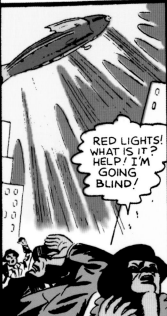

AS THE RAYS STRIKE, THE BUILDINGS EXPLODE. HURLING THEIR WRECKAGE UPON THE CROWDED STREETS BELOW.

HELP!

HELP! THE END OF THE WORLD! HELP!

HELP!

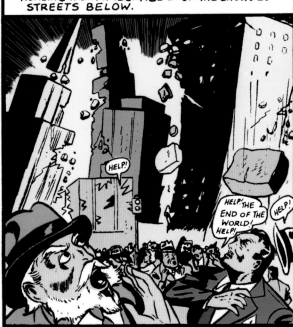

HELP!

HELP! MAMMA, SAVE ME! HELP!!

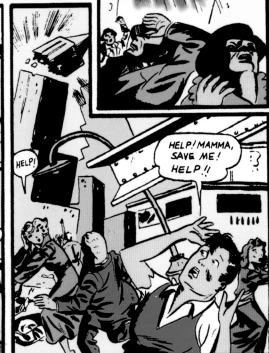

21

SUDDENLY FROM THE CRAFT..

WE COME TO RULE THE WORLD. DO NOT RESIST US. OR THE RAYS STRIKE AGAIN.. WE, THE SCARLET HORDE! — WARN YOU..

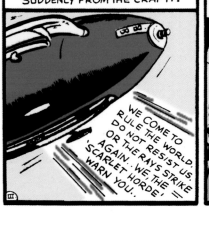

THE DIRIGIBLE GONE. RESCUE WORK BEGINS. BRUCE WAYNE HELPS.

EASY, OLD MAN.

THE HOME OF BRUCE WAYNE.

-AND THE RESCUE WORK IS STILL GOING ON. THOUSANDS ARE DEAD.. ETC.. ETC..

BRUCE PRESSES A PANEL AND PART OF THE WALL SLIDES AWAY.

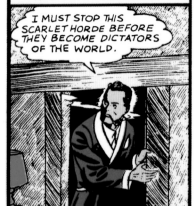
I MUST STOP THIS SCARLET HORDE BEFORE THEY BECOME DICTATORS OF THE WORLD.

REVEALING A SECRET LABORATORY..

THOSE RED BEAMS FROM THE DIRIGIBLE. HM. MY FILE MIGHT HELP ME..

BRUCE COMES ACROSS A NEWSPAPER CLIPPING.

PROF CARL KRUGER RELEASED FROM INSANE ASYLUM. SUFFERED FROM NAPOLEON COMPLEX. NOW WORKING ON NEW TYPE DEATH-RAY..

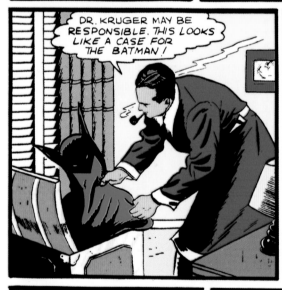
DR. KRUGER MAY BE RESPONSIBLE. THIS LOOKS LIKE A CASE FOR THE BATMAN!

THE BAT-MAN PRE-PARES TO VISIT DR. KRUGER

AND NOW MY SILK ROPE AND I'M READY.

THE BATMAN'S HIGH-POWERED CAR SPEEDS TOWARD THE HOME OF DR. CARL KRUGER.

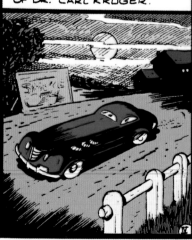

THE CAR WILL BE SAFE HERE. WHERE NO ONE CAN SEE IT.

A WEIRD FIGURE RACES THROUGH THE NIGHT.

A LIGHT! I'LL TRY THAT ROOM!

THINKS HE'S NAPOLEON. HMMM..

. INSIDE THE LIGHTED ROOM!

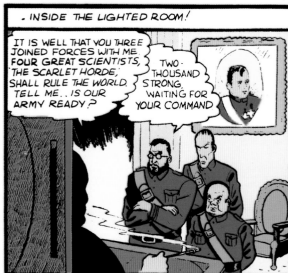

IT IS WELL THAT YOU THREE JOINED FORCES WITH ME. FOUR GREAT SCIENTISTS, THE SCARLET HORDE, SHALL RULE THE WORLD. TELL ME.. IS OUR ARMY READY?

TWO-THOUSAND STRONG, WAITING FOR YOUR COMMAND

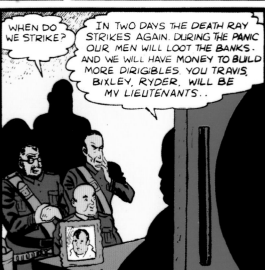

WHEN DO WE STRIKE?

IN TWO DAYS THE DEATH RAY STRIKES AGAIN. DURING THE PANIC OUR MEN WILL LOOT THE BANKS. AND WE WILL HAVE MONEY TO BUILD MORE DIRIGIBLES. YOU TRAVIS, BIXLEY, RYDER, WILL BE MY LIEUTENANTS..

23

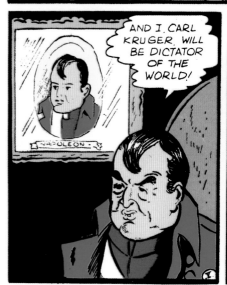

AND I, CARL KRUGER, WILL BE DICTATOR OF THE WORLD!

NAPOLEON

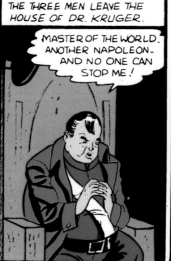

THE THREE MEN LEAVE THE HOUSE OF DR. KRUGER.

MASTER OF THE WORLD. ANOTHER NAPOLEON- AND NO ONE CAN STOP ME!

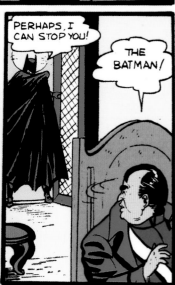

PERHAPS, I CAN STOP YOU!

THE BATMAN!

THE BATMAN HURLS HIS BATERANG AT KRUGER...

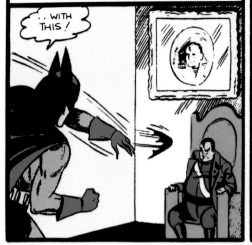

..WITH THIS!

..WHICH STOPS IN MID-AIR.

FOOL! DO YOU THINK I'D LEAVE MYSELF NO PROTECTION FROM MY ENEMIES! THERE IS A SHEET OF THICK GLASS BETWEEN US.

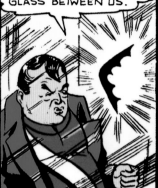

SUDDENLY THE PAINTING OF NAPOLEON MOVES ASIDE...

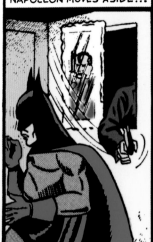

HE IS SECURELY BOUND.

MEDDLER! YOU MUST DIE! IN FIVE MINUTES AN INCANDESCERY BOMB WILL GO OFF, SETTING THE HOUSE AFIRE. WHEN YOUR CHARRED BODY IS FOUND, THEY WILL THINK ME DEAD. LEAVING ME TO DO AS I PLEASE HA·HA··

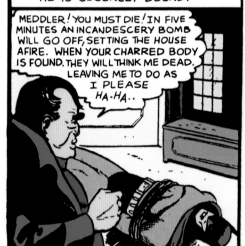

AS KRUGER LEAVES. THE BATMAN ROLLS OVER AND DRAWS FORTH A STEEL BLADE FROM HIS BOOT.

AND HE IS SOON FREE.

GOT TO GET OUT BEFORE THAT BOMB GOES OFF.

AS HE REACHES THE GROUND. A TERRIFIC BLAST BLOWS UP THE HOUSE!

BOOM

THE BATMAN MIRACULOUSLY ESCAPES DEATH..

WHEW! THAT WAS CLOSE. NOW HOME TO REST AND THINK.

THE FOLLOWING NIGHT... THE HOME OF RYDER. ONE OF KRUGER'S LIEUTENANTS.

WHAT IS IT? WHO?

THE BATMAN.

YES.. AND VERY MUCH ALIVE. TELL THAT TO KRUGER. I SHALL BE BACK FOR YOU LATER. GOOD NIGHT.. AND PLEASANT DREAMS.

H.HE'S GONE. BUT HE SAID HE'D BE BACK FOR ME! I'VE GOT TO GET AWAY FROM HERE.

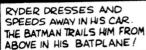

RYDER DRESSES AND SPEEDS AWAY IN HIS CAR. THE BATMAN TRAILS HIM FROM ABOVE IN HIS BATPLANE!

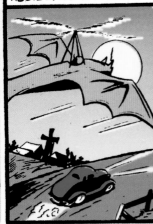

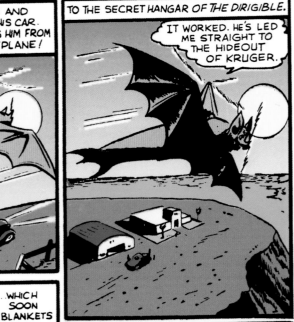

TO THE SECRET HANGAR OF THE DIRIGIBLE.

IT WORKED. HE'S LED ME STRAIGHT TO THE HIDEOUT OF KRUGER.

25

THE BATMAN BREAKS A GLASS VIAL. A THICK, BLACK, SMOKE POURS FORTH..

THIS WILL PREVENT THE GUARDS FROM SEEING THE PLANE

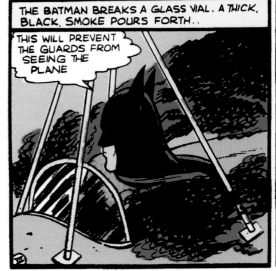

..WHICH SOON BLANKETS THE WHOLE PLANE!

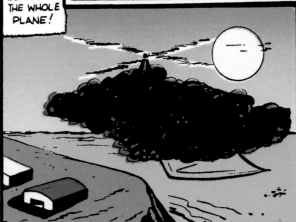

LIKE A GREAT BLACK CLOUD THE BAT-PLANE FLOATS OVER THE HANGAR.

A BLACK CLOUD..

YEAH. LOOKS LIKE RAIN.

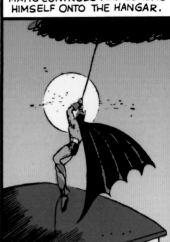

THE BATMAN FIXES HIS AUTO-MATIC CONTROLS AND LOWERS HIMSELF ONTO THE HANGAR.

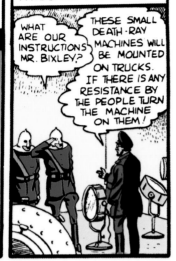

A ROOM INSIDE THE HANGAR.

WHAT ARE OUR INSTRUCTIONS MR. BIXLEY?

THESE SMALL DEATH-RAY MACHINES WILL BE MOUNTED ON TRUCKS. IF THERE IS ANY RESISTANCE BY THE PEOPLE TURN THE MACHINE ON THEM!

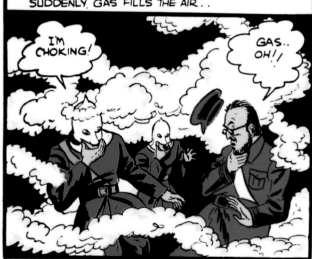

SUDDENLY GAS FILLS THE AIR..

I'M CHOKING!

GAS.. OH!!

THAT GAS VIAL DID THE TRICK.

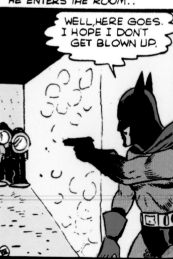

HE ENTERS THE ROOM..

WELL, HERE GOES. I HOPE I DON'T GET BLOWN UP.

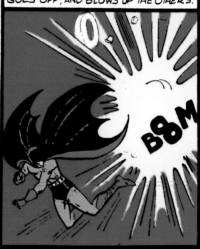

THERE IS A BLAST AS A MACHINE GOES OFF, AND BLOWS UP THE OTHERS.

BOOM

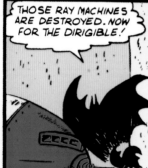

THOSE RAY MACHINES ARE DESTROYED. NOW FOR THE DIRIGIBLE!

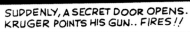

THE BATMAN PICKS UP AN AXE . .

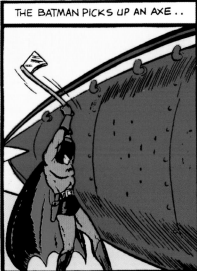

SUDDENLY, A SECRET DOOR OPENS. KRUGER POINTS HIS GUN . . FIRES !!

YOU ARE TOO LATE MY FRIEND_ TOO LATE !

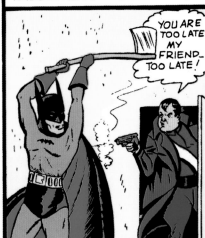

THE BATMAN IS HIT_

HE IS FINISHED ! . . ANOTHER CONQUEST FOR NAPOLEON ! HA-HA-HA !!

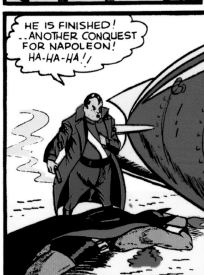

I WILL DESTROY HIS BODY WITH A DEATH- RAY MACHINE. GUARD! WATCH THIS BODY. I AM GOING TO GET THE ONE THAT IS LEFT !

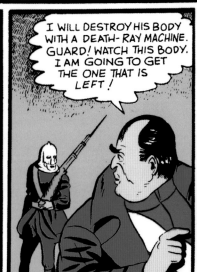

KRUGER SOON RETURNS!

IT IS IRONICAL THAT HIS BODY SHALL BE DISPOSED OF WITH THE VERY MACHINE HE TRIED TO DESTROY!

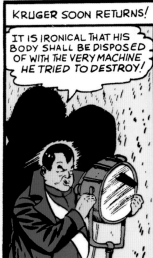

27

THE DEATH RAY STRIKES THE BATMAN-

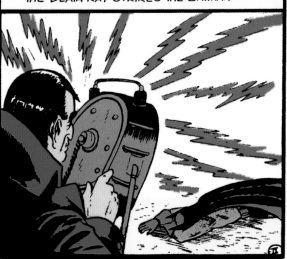

THERE IS A BLAST. AND WHERE ONCE HAD BEEN THE BODY OF THE BATMAN_ A HEAP OF ASHES.

MY FUSION OF OZONE GAS AND THE GAMMA RAY HAS AT LAST ELIMINATED THE ONE MAN WHO STOOD IN MY PATH.

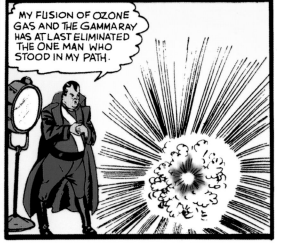

SOME TIME LATER. A FIGURE CLIMBS THE ROPE TO THE BATPLANE.

IT IS BRUCE WAYNE, THE BATMAN!

LATER. THE WAYNE MANSION.

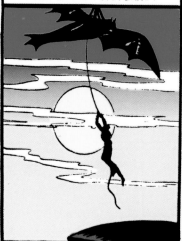

IT WAS A GOOD THING MY BULLET-PROOF VEST STOPPED THOSE BULLETS..JUST A FEW FLESH WOUNDS. LOST SOME BLOOD THOUGH!

..WHEN I OVERPOWERED THAT GUARD AND CHANGED INTO HIS CLOTHING, MY RESCUE WAS COMPLETE...AND NOW TO WORK!

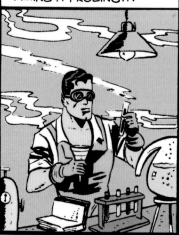
THROUGH THE NIGHT HE WORKS IN HIS SECRET LABORATORY.. MIXING .. PROBING...

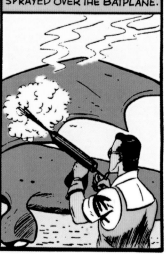
A MYSTERIOUS CHEMICAL IS SPRAYED OVER THE BATPLANE.

THE NEXT DAY_

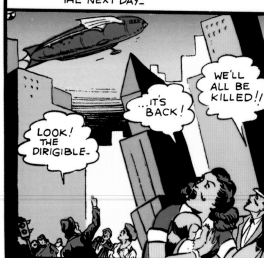
LOOK! THE DIRIGIBLE_

..IT'S BACK!

WE'LL ALL BE KILLED!!

WHEN SUDDENLY..THE BATPLANE APPEARS.

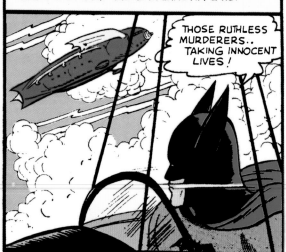
THOSE RUTHLESS MURDERERS.. TAKING INNOCENT LIVES!

THE BATMAN PLUNGES HIS SHIP FOR THE DIRIGIBLE, WHOSE DEATH-RAYS STRIKE THE PLANE.

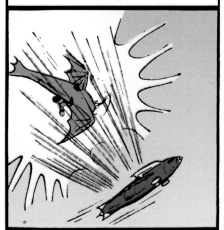

BUT IT IS UNSCATHED. THE CHEMICAL SPRAY HAS COUNTER-ACTED THE DEATH RAY.

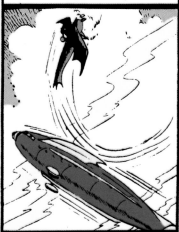

A CATAPULT-PLANE IS RELEASED FROM THE AIRSHIP.

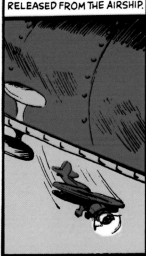

SUDDENLY THE BATMAN DIVES..

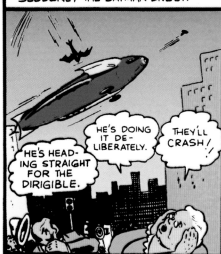

HE'S HEADING STRAIGHT FOR THE DIRIGIBLE.

HE'S DOING IT DE-LIBERATELY.

THEY'LL CRASH!

A TERRIFIC BLAST AND THE DIRIGIBLE AND BAT-PLANE ARE BLOWN TO SMITHEREENS.

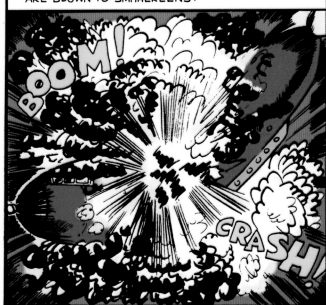

BOOM!

CRASH!

29

- BUT THE BATMAN IS SAFE IN A PARACHUTE.

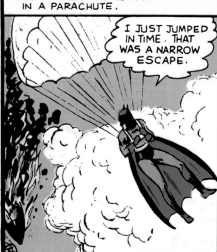

I JUST JUMPED IN TIME. THAT WAS A NARROW ESCAPE.

IN THE CATAPULT-PLANE .. KRUGER!

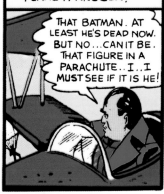

THAT BATMAN. AT LEAST HE'S DEAD NOW. BUT NO...CAN IT BE. THAT FIGURE IN A PARACHUTE.. I..I MUST SEE IF IT IS HE!

THE BATMAN!!

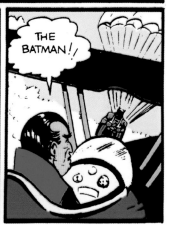

AS THE PLANE GOES PAST.. THE BATMAN FLINGS HIS SILKEN CORD.

WHICH CATCHES UPON A WHEEL! HE UNBUCKLES HIS CHUTE, AND HANGS IN SPACE.

HE GAINS THE WING WHERE..

THIS TIME I'LL MAKE SURE YOU DIE!!

KRUGER'S SHOT GOES WILD. THE BATMAN HOLDS HIS BREATH AND FLINGS A GAS PELLET!

AH-AGH. I'M CHOKING!

AS KRUGER SLUMPS UNCONSCIOUS _THE PLANE PLUNGES DOWNWARD TOWARD THE BAY!

THE BATMAN DIVES AS THE PLANE HITS THE WATER, TAKING KRUGER WITH IT..

A FEW HOURS LATER _ THE HOME OF BRUCE WAYNE.

.. AND THE BODY OF KRUGER WAS RECOVERED FROM THE WATER. BUT THAT OF THE BATMAN HAS NOT YET BEEN FOUND. LATEST DISPATCHES REPORT THE CAPTURE OF THE ENTIRE SCARLET ARMY..

THE END

THE

BATMAN

APPEARS ONLY IN "DETECTIVE COMICS"

DON'T MISS AN ISSUE OF THIS THRILLING NEW CHARACTER IN HIS AMAZING ADVENTURES!!

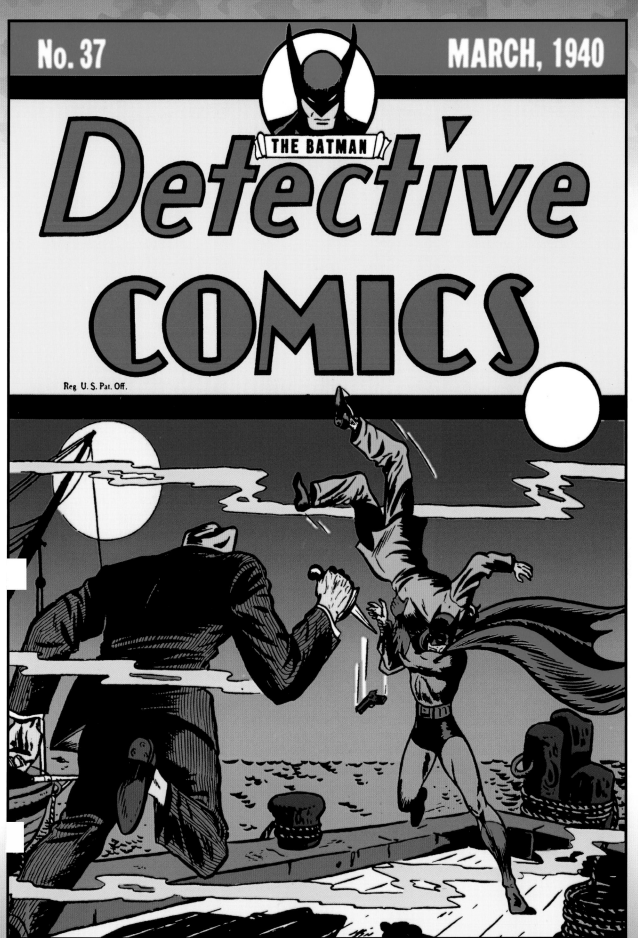

Detective Comics #37 (March 1940) - cover art: Bob Kane

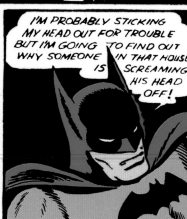

Detective Comics #37 (March 1940) - script: Bill Finger - art: Bob Kane (with Jerry Robinson, backgrounds)

OPENING THE DOOR, HE CAUTIOUSLY STEPS INSIDE...

VOICES FROM A LIGHTED ROOM DRAW HIS ATTENTION

SHALL I GIVE IT TO HIM AGAIN?

NO! NO! DON'T! PLEASE DON'T!

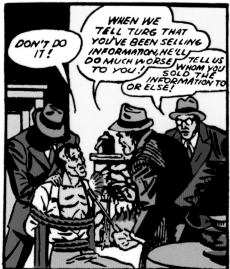

DON'T DO IT!

WHEN WE TELL TURG THAT YOU'VE BEEN SELLING INFORMATION, HE'LL DO MUCH WORSE TO YOU!

TELL US WHOM YOU SOLD THE INFORMATION TO OR ELSE!

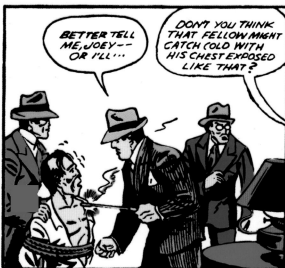

BETTER TELL ME, JOEY-- OR I'LL···

DON'T YOU THINK THAT FELLOW MIGHT CATCH COLD WITH HIS CHEST EXPOSED LIKE THAT?

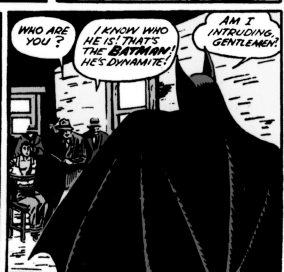

WHO ARE YOU?

I KNOW WHO HE IS! THAT'S THE BATMAN! HE'S DYNAMITE!

AM I INTRUDING, GENTLEMEN!

33

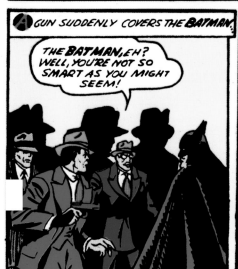

A GUN SUDDENLY COVERS THE BATMAN.

THE BATMAN, EH? WELL, YOU'RE NOT SO SMART AS YOU MIGHT SEEM!

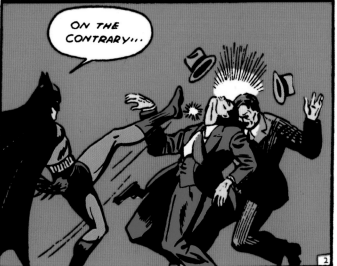

ON THE CONTRARY···

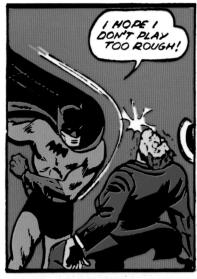

I HOPE I DON'T PLAY TOO ROUGH!

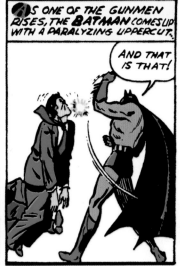

AS ONE OF THE GUNMEN RISES, THE **BATMAN** COMES UP WITH A PARALYZING UPPERCUT.

AND THAT IS THAT!

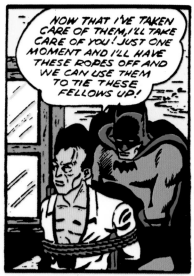

NOW THAT I'VE TAKEN CARE OF THEM, I'LL TAKE CARE OF YOU! JUST ONE MOMENT AND I'LL HAVE THESE ROPES OFF AND WE CAN USE THEM TO TIE THESE FELLOWS UP!

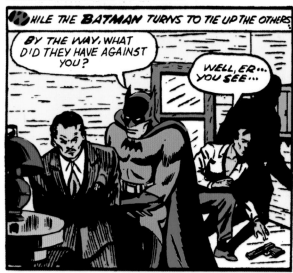

WHILE THE **BATMAN** TURNS TO TIE UP THE OTHERS

BY THE WAY, WHAT DID THEY HAVE AGAINST YOU?

WELL, ER... YOU SEE...

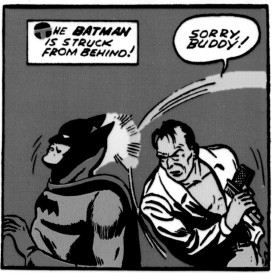

THE **BATMAN** IS STRUCK FROM BEHIND!

SORRY, BUDDY!

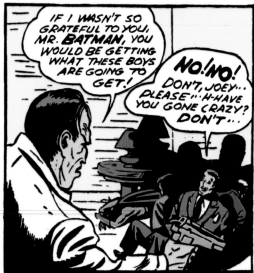

IF I WASN'T SO GRATEFUL TO YOU, MR. **BATMAN**, YOU WOULD BE GETTING WHAT THESE BOYS ARE GOING TO GET!

NO! NO! DON'T, JOEY... PLEASE!... H-HAVE YOU GONE CRAZY? DON'T...

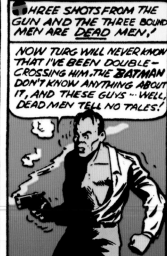

THREE SHOTS FROM THE GUN AND THE THREE BOUND MEN ARE **DEAD MEN!**

NOW TURG WILL NEVER KNOW THAT I'VE BEEN DOUBLE-CROSSING HIM. THE **BATMAN** DON'T KNOW ANYTHING ABOUT IT, AND THESE GUYS... WELL, DEAD MEN TELL NO TALES!

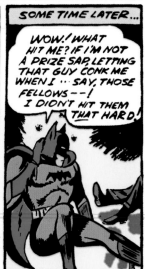

SOME TIME LATER...

WOW! WHAT HIT ME? IF I'M NOT A PRIZE SAP, LETTING THAT GUY CONK ME WHEN I... SAY, THOSE FELLOWS--! I DIDN'T HIT THEM THAT HARD!

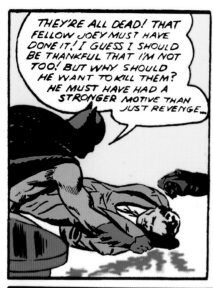

THEY'RE ALL DEAD! THAT FELLOW JOEY MUST HAVE DONE IT! I GUESS I SHOULD BE THANKFUL THAT I'M NOT TOO! BUT WHY SHOULD HE WANT TO KILL THEM? HE MUST HAVE HAD A STRONGER MOTIVE THAN JUST REVENGE...

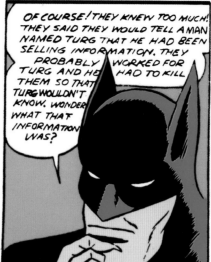

OF COURSE! THEY KNEW TOO MUCH! THEY SAID THEY WOULD TELL A MAN NAMED TURG THAT HE HAD BEEN SELLING INFORMATION. THEY PROBABLY WORKED FOR TURG AND HE HAD TO KILL THEM SO THAT TURG WOULDN'T KNOW. WONDER WHAT THAT INFORMATION WAS?

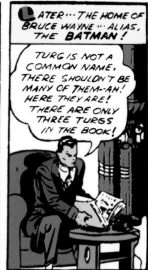

LATER... THE HOME OF BRUCE WAYNE... ALIAS, THE BATMAN!

TURG IS NOT A COMMON NAME. THERE SHOULDN'T BE MANY OF THEM--AH! HERE THEY ARE! THERE ARE ONLY THREE TURGS IN THE BOOK!

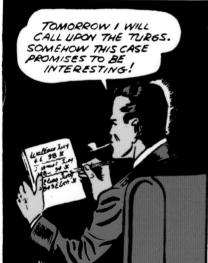

TOMORROW I WILL CALL UPON THE TURGS. SOMEHOW THIS CASE PROMISES TO BE INTERESTING!

WELL, THE OTHER TURGS ARE QUITE RESPECTABLE! NOW I'LL TRY THIS GROCERY STORE WHICH SEEMS TO BE IN A VERY BAD STREET FOR BUSINESS, SEEING THAT THERE AREN'T MANY HOUSES ABOUT!

I'D LIKE A POUND OF SUGAR, PLEASE!

JUS' A MINUTE AN' I'LL GET IT FOR YOU!

35

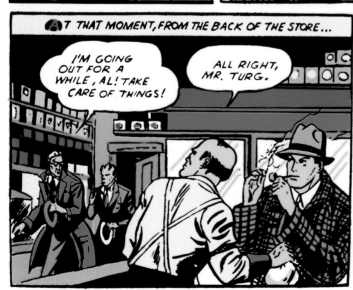

AT THAT MOMENT, FROM THE BACK OF THE STORE...

I'M GOING OUT FOR A WHILE, AL! TAKE CARE OF THINGS!

ALL RIGHT, MR. TURG.

SO! JOEY, MY COMPANION OF THE OLD HOUSE, WITH MR. TURG, WHO CERTAINLY DOESN'T LOOK LIKE A GROCERY MAN! WHAT'S THAT OLD SAYING ABOUT BIRDS OF A FEATHER FLOCK TOGETHER? HMMM --

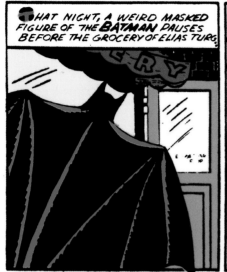

That night, a weird masked figure of the BATMAN pauses before the grocery of Elias Turg.

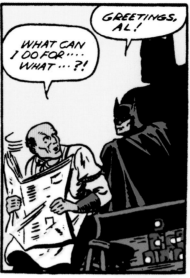

GREETINGS, AL!

WHAT CAN I DO FOR··· WHAT···?!

I'M NOT BUYING ANYTHING THIS TIME!

The BATMAN opens the back door and mounts the stairs.

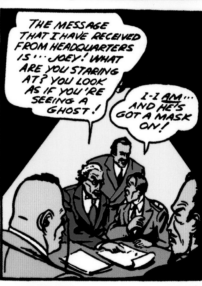

THE MESSAGE THAT I HAVE RECEIVED FROM HEADQUARTERS IS··· JOEY! WHAT ARE YOU STARING AT? YOU LOOK AS IF YOU'RE SEEING A GHOST!

I-I AM··· AND HE'S GOT A MASK ON!

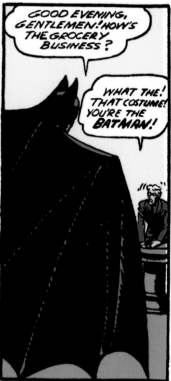

GOOD EVENING, GENTLEMEN! HOW'S THE GROCERY BUSINESS?

WHAT THE! THAT COSTUME! YOU'RE THE BATMAN!

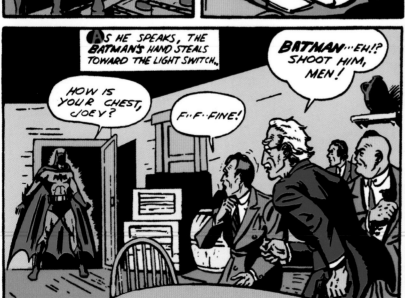

As he speaks, the BATMAN'S hand steals toward the light switch.

HOW IS YOUR CHEST, JOEY?

F··F··FINE!

BATMAN···EH!? SHOOT HIM, MEN!

CLICK ···THEN DARKNESS AND THE RED FLASHES OF GUNFIRE.

THE LIGHTS ARE OUT! GET THEM ON ··· WE CAN'T SEE HIM IN THE DARK!

THE *BATMAN* PULLS OVER HIS EYES A QUEER TYPE OF GLASS FROM ITS ALMOST INVISIBLE SUPPORT UPON THE BLACK COWL..

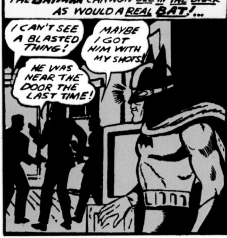

THOUGH HE HIMSELF CANNOT BE SEEN WITH THESE GLASSES OF HIS OWN INVENTION, THE *BATMAN* CAN NOW <u>SEE IN THE DARK</u> AS WOULD A <u>REAL</u> *BAT!*...

I CAN'T SEE A BLASTED THING!

MAYBE I GOT HIM WITH MY SHOTS!

HE WAS NEAR THE DOOR THE LAST TIME!

JUST A KISS IN THE DARK!

THIS GUN WON'T DO YOU ANY GOOD!

HELP!... HE'S OVER HERE...

THE MEN TURN TO SHOOT IN THE DIRECTION OF THE *BATMAN'S* VOICE! THE *BATMAN*, HOWEVER, DEFTLY SHIFTS TO ANOTHER PART OF THE ROOM!...

HIS VOICE CAME FROM OVER THERE!

NO! HE'S <u>OVER HERE</u>!! UGHHHH...

37

THE MEN SHUDDER IN TERROR AS THEY REALIZE THE "<u>SUPERNATURAL</u>" POWER OF THE *BATMAN!*

HE CAN SEE IN THE DARK!

JUST LIKE A <u>REAL</u> *BAT!*

NO WONDER HE'S CALLED THE *BATMAN!*

IT'S UNCANNY!

AND NOW, GENTLEMEN, I MUST LEAVE YOU.... BUT WE SHALL MEET AGAIN, SOON, I PROMISE YOU!

6

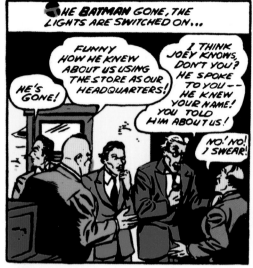

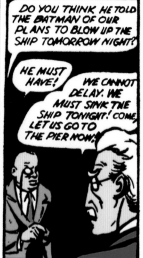

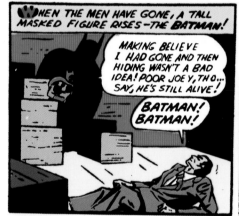

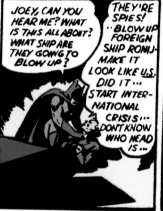

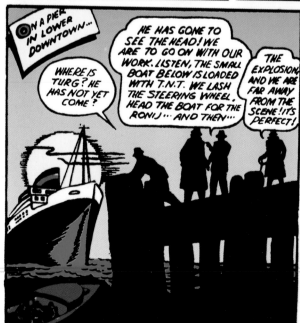

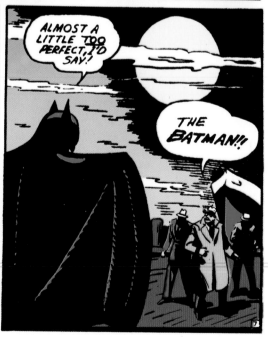

BUT ABOVE THE *BATMAN*...

THE SACK *SMASHES* DOWN UPON THE *BATMAN!*

IT WAS A GOOD THING CARL WAS UP THERE! NOW WE MUST GET RID OF THIS *BATMAN!*

A GOOD IDEA – A VERY GOOD IDEA!

WHY NOT EMPTY THE SACK OF THE GRAIN, PLACE THE *BATMAN* INSIDE AND THROW IT IN THE RIVER?

THERE YOU ARE, MR. *BATMAN!* ALL NICE AND READY FOR A WATERY GRAVE! HA! HA!

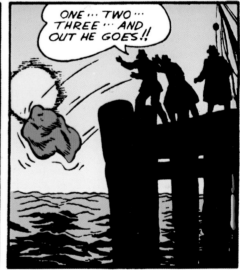

ONE ··· TWO ··· THREE ··· AND OUT HE GOES!!

39

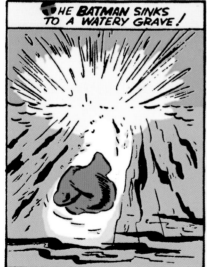

THE BATMAN *SINKS* TO A WATERY GRAVE!

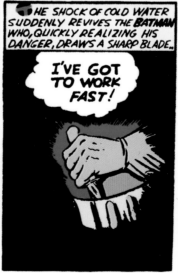

THE SHOCK OF COLD WATER SUDDENLY REVIVES THE *BATMAN* WHO, QUICKLY REALIZING HIS DANGER, DRAWS A SHARP BLADE...

I'VE GOT TO WORK FAST!

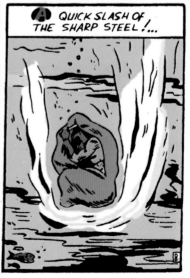

A QUICK SLASH OF THE SHARP STEEL!...

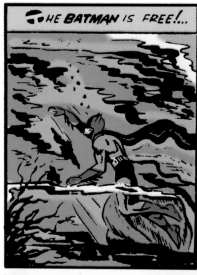

THE BATMAN IS FREE!...

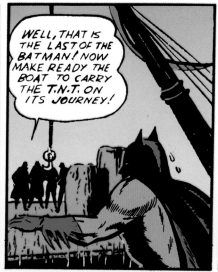

WELL, THAT IS THE LAST OF THE BATMAN! NOW MAKE READY THE BOAT TO CARRY THE T.N.T. ON ITS JOURNEY!

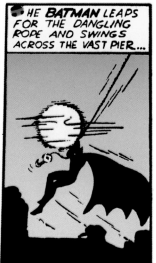

THE BATMAN LEAPS FOR THE DANGLING ROPE AND SWINGS ACROSS THE VAST PIER...

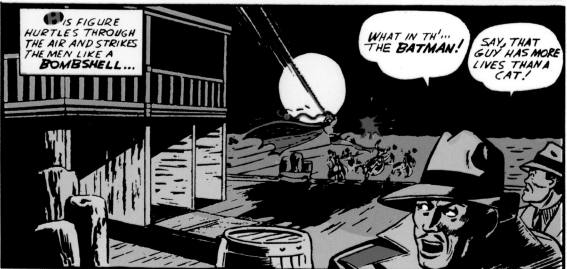

HIS FIGURE HURTLES THROUGH THE AIR AND STRIKES THE MEN LIKE A BOMBSHELL...

WHAT IN TH'... THE BATMAN!

SAY, THAT GUY HAS MORE LIVES THAN A CAT!

COME ON, SUCKERS!

HAPPY LANDINGS!

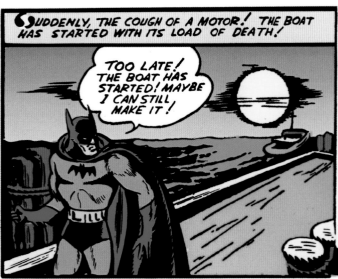

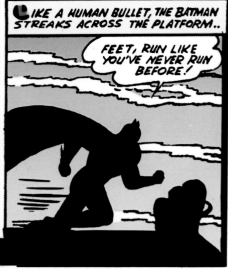

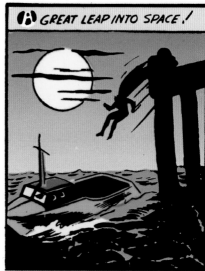

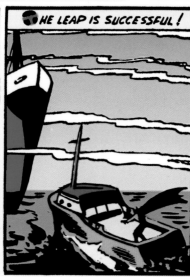

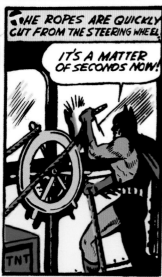

41

WHEW! THAT WAS A CLOSE CALL! NOW I'VE GOT SOME MORE WORK TO DO! I'M GOING TO SEE WHO OWNS THAT PHONE-NUMBER THAT POOR JOEY GAVE ME! IF ITS THE "HEAD"...

THAT PHONE NUMBER BELONGS TO THE SOCIALLY EMINENT COUNT GRUTT! JUST ONE LOOK AT HIM WILL TELL ME IF HE IS THE "HEAD" AND IS ALSO... SOMEONE ELSE!

SOME TIME LATER...

THE COUNT IS BUSY. HE CAN'T SEE ANYBODY!

HE'LL SEE ME!

YOU--

SOMETHING NEW? BUTLERS CARRYING GUNS?

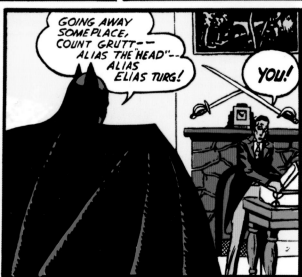

GOING AWAY SOME PLACE, COUNT GRUTT-- ALIAS THE "HEAD"-- ALIAS ELIAS TURG!

YOU!

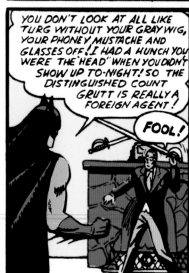

YOU DON'T LOOK AT ALL LIKE TURG WITHOUT YOUR GRAY WIG, YOUR PHONEY MUSTACHE AND GLASSES OFF! I HAD A HUNCH YOU WERE THE "HEAD" WHEN YOU DIDN'T SHOW UP TO-NIGHT! SO THE DISTINGUISHED COUNT GRUTT IS REALLY A FOREIGN AGENT!

FOOL!

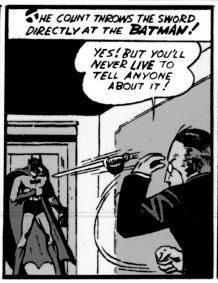

THE COUNT THROWS THE SWORD DIRECTLY AT THE BATMAN!

YES! BUT YOU'LL NEVER LIVE TO TELL ANYONE ABOUT IT!

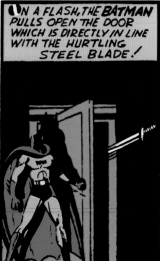

IN A FLASH, THE BATMAN PULLS OPEN THE DOOR WHICH IS DIRECTLY IN LINE WITH THE HURTLING STEEL BLADE!

THE POWERFUL THROW SENDS THE SHARP STEEL HISSING THROUGH THE SOFT WOOD.

NOW LET'S SEE HOW YOU CAN FIGHT WITHOUT YOUR SWORDS, RAT!

NO! NO!

THE COUNT TRIES TO ESCAPE BUT THE BATMAN IS QUICKLY UPON HIM AND....

THE COUNT FALLS BACK TOWARD THE STEEL BLADE STICKING THROUGH THE CLOSET DOOR!

43

A WILD SCREAM-- AND THE FOREIGN AGENT IS IMPALED UPON HIS OWN SWORD!

YA-AA-Aa

DEAD! IT IS BETTER THAT HE SHOULD DIE! HE MIGHT HAVE SENT THOUSANDS OF OTHERS TO THEIR DEATH ON A BATTLE-FIELD IF HIS PLANS HAD BEEN SUCCESS-FUL! THIS HAS BEEN A QUEER CASE... FROM THE OLD HOUSE TO FOREIGN AGENTS ... AND TO THE DEATH OF ITS HEAD! YES... A VERY QUEER CASE!

BOB KANE

Next Month HUGE, TERRIFYING MAN-MONSTERS STALK THE STREETS OF A ONCE PEACEFUL METROPOLIS, BRINGING TO THEM HAVOC AND DESTRUCTION!! YET ONE MAN ALONE HAD THE POWER AND COURAGE TO OPPOSE THEM THAT MAN... THE MIGHTY BATMAN! AMERICA'S GREATEST ADVENTURE MYSTERY ACTION STRIP.

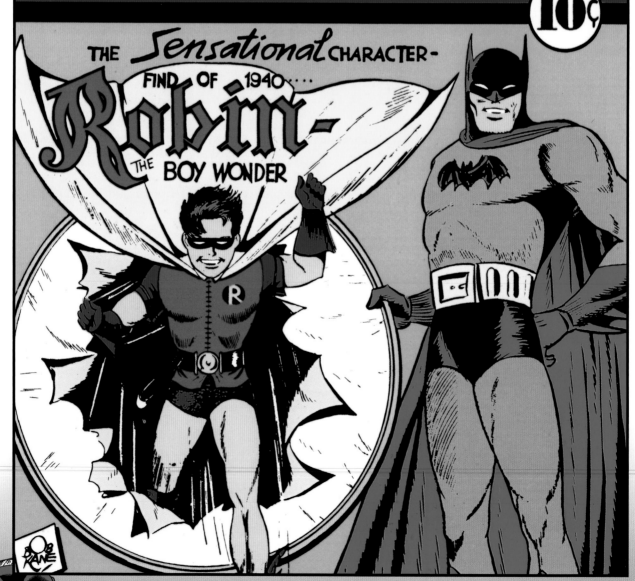

Detective Comics #38 (April 1940) - cover art: Bob Kane (pencils) & Jerry Robinson (inks)

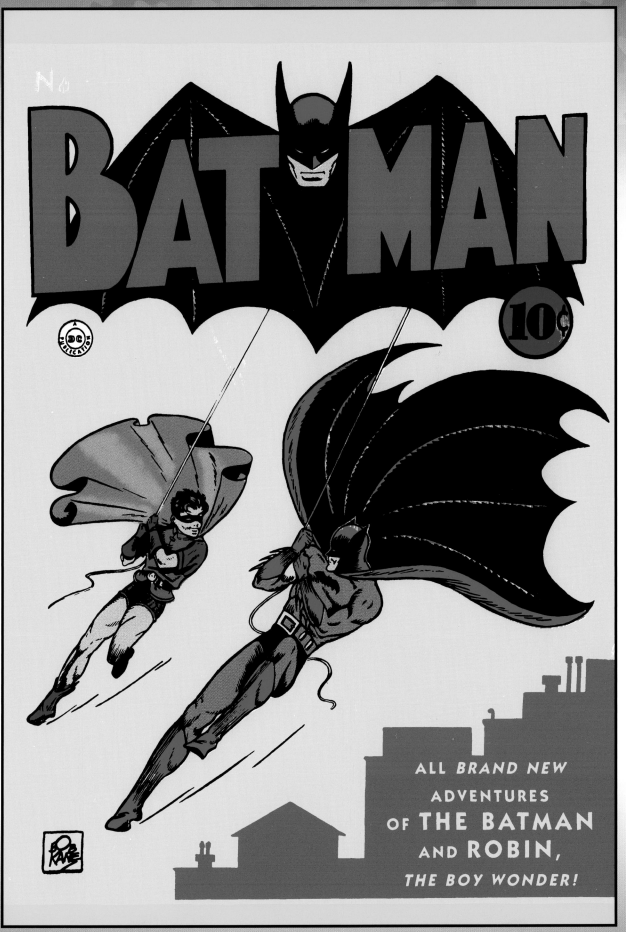

Batman #1 (Spring 1940) - cover art: Bob Kane (pencils) & Jerry Robinson (inks)

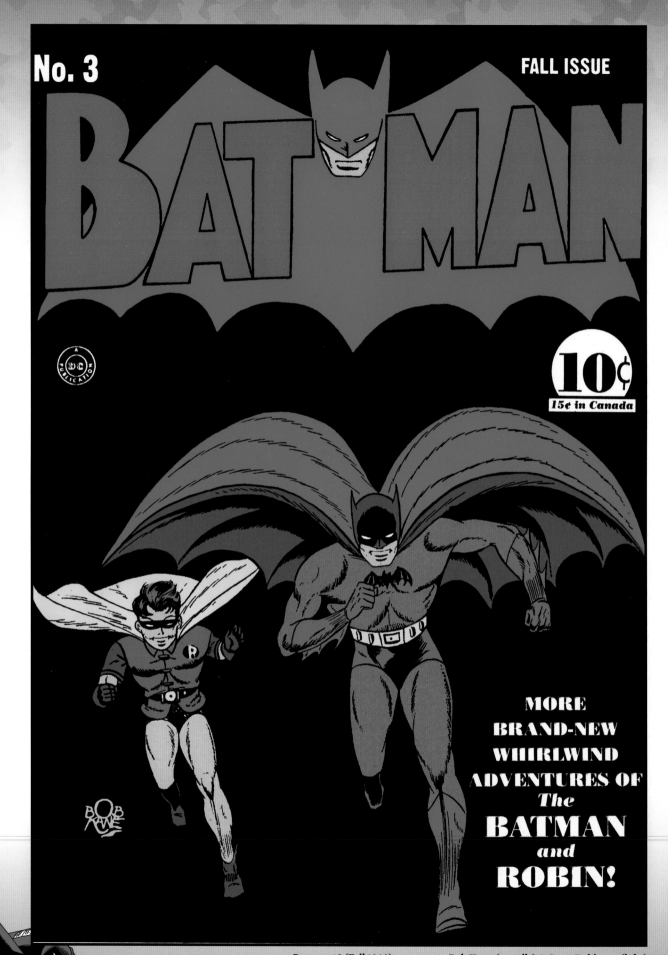

Batman #3 (Fall 1940) - cover art: Bob Kane (pencils) & Jerry Robinson (inks)

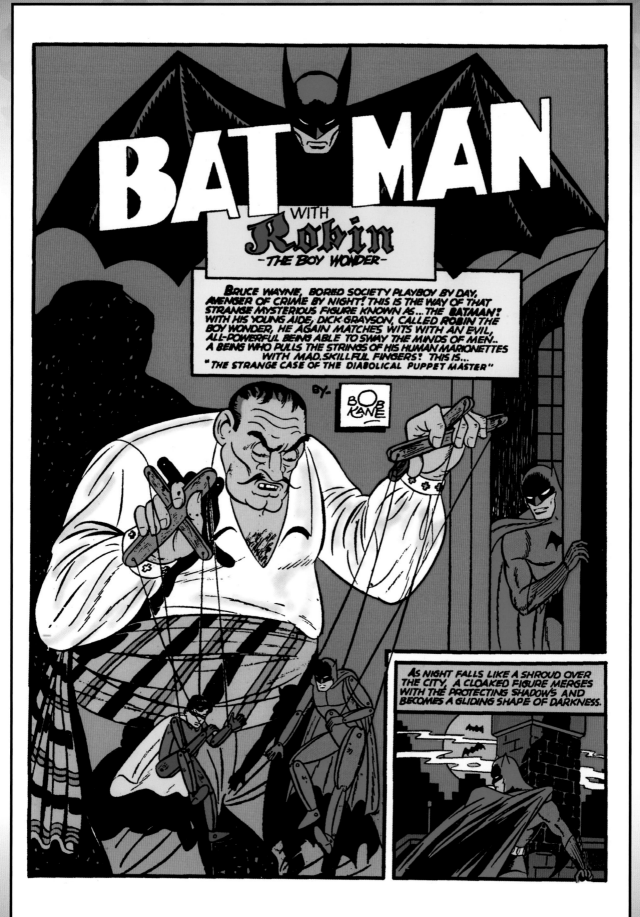

*Batman #3 (Fall 1940) - script: Bill Finger - art: Bob Kane (pencils) &
Jerry Robinson (inks), with George Roussos (backgrounds)*

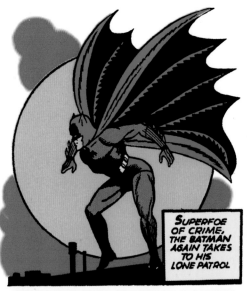

SUPERFOE OF CRIME, THE BATMAN AGAIN TAKES TO HIS LONE PATROL

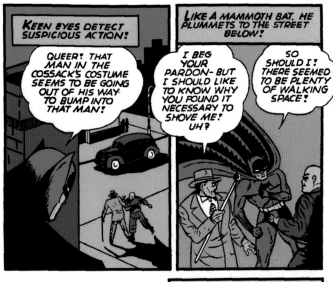

KEEN EYES DETECT SUSPICIOUS ACTION!

QUEER! THAT MAN IN THE COSSACK'S COSTUME SEEMS TO BE GOING OUT OF HIS WAY TO BUMP INTO THAT MAN!

LIKE A MAMMOTH BAT, HE PLUMMETS TO THE STREET BELOW!

I BEG YOUR PARDON- BUT I SHOULD LIKE TO KNOW WHY YOU FOUND IT NECESSARY TO SHOVE ME! UH?

SO SHOULD I! THERE SEEMED TO BE PLENTY OF WALKING SPACE!

ABRUPTLY...

WHAT'S YOUR GAME, BUDDY? WHAT....

I DON'T HAVE TO ANSWER TO YOU! GET OUT OF MY WAY!

THE BATMAN'S FIST FLICKS OUT IN A LIGHTNING MOVE!!

SUDDENLY, THREE FIGURES LEAP FROM A SPEEDING CAR THAT SCREECHES TO A HALT!....

THE MASTER WILL BE DISPLEASED!

I'LL STOP THE CLOAKED ONE!

A CRUSHING BLOW FROM BEHIND!

ARE YOU HURT?

THE MEN MAKE GOOD THEIR ESCAPE!

JUST A LITTLE SORE.... BECAUSE THEY GOT AWAY!

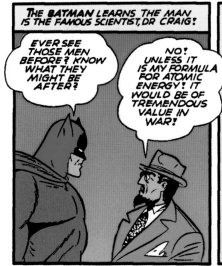

THE BATMAN LEARNS THE MAN IS THE FAMOUS SCIENTIST, DR. CRAIG!

EVER SEE THOSE MEN BEFORE? KNOW WHAT THEY MIGHT BE AFTER?

NO! UNLESS IT IS MY FORMULA FOR ATOMIC ENERGY! IT WOULD BE OF TREMENDOUS VALUE IN WAR!

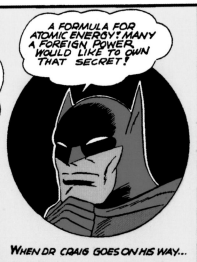

A FORMULA FOR ATOMIC ENERGY! MANY A FOREIGN POWER WOULD LIKE TO OWN THAT SECRET!

WHEN DR. CRAIG GOES ON HIS WAY...

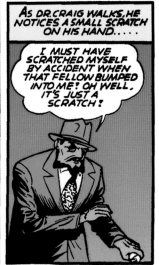

AS DR. CRAIG WALKS, HE NOTICES A SMALL SCRATCH ON HIS HAND.....

I MUST HAVE SCRATCHED MYSELF BY ACCIDENT WHEN THAT FELLOW BUMPED INTO ME! OH WELL, IT'S JUST A SCRATCH!

JUST A SCRATCH... A TINY SCRATCH. YET IT IS THIS SCRATCH THAT IS THE BEGINNING OF WHAT WAS MEANT TO BE A SCHEME SO FANTASTIC AS TO BE ALMOST UNBELIEVABLE!

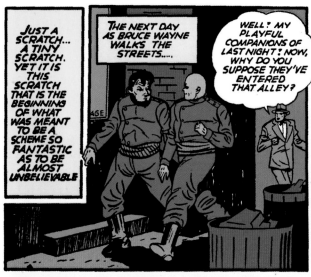

THE NEXT DAY AS BRUCE WAYNE WALKS THE STREETS.....

WELL! MY PLAYFUL COMPANIONS OF LAST NIGHT! NOW, WHY DO YOU SUPPOSE THEY'VE ENTERED THAT ALLEY?

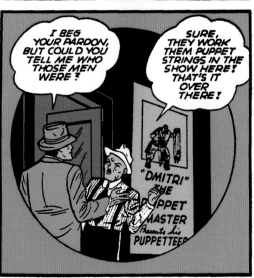

I BEG YOUR PARDON, BUT COULD YOU TELL ME WHO THOSE MEN WERE?

SURE, THEY WORK THEM PUPPET STRINGS IN THE SHOW HERE! THAT'S IT OVER THERE!

"DMITRI" THE PUPPET MASTER Presents his PUPPETEER

49

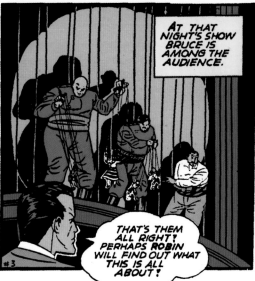

AT THAT NIGHT'S SHOW BRUCE IS AMONG THE AUDIENCE.

THAT'S THEM ALL RIGHT! PERHAPS ROBIN WILL FIND OUT WHAT THIS IS ALL ABOUT!

#3

IN AN EMPTY DRESSING ROOM NEXT TO THE ONE OCCUPIED BY THE PUPPET MASTER.. ROBIN THE BOY WONDER!

THE SHOW IS OVER! THEY'RE ENTERING THE ROOM!

SWIFTLY, ROBIN APPLIES AN INSTRUMENT TO THE WALL, VERY MUCH LIKE A DOCTOR'S STETHOSCOPE, ENABLING HIM TO HEAR ALL THAT TRANSPIRES...

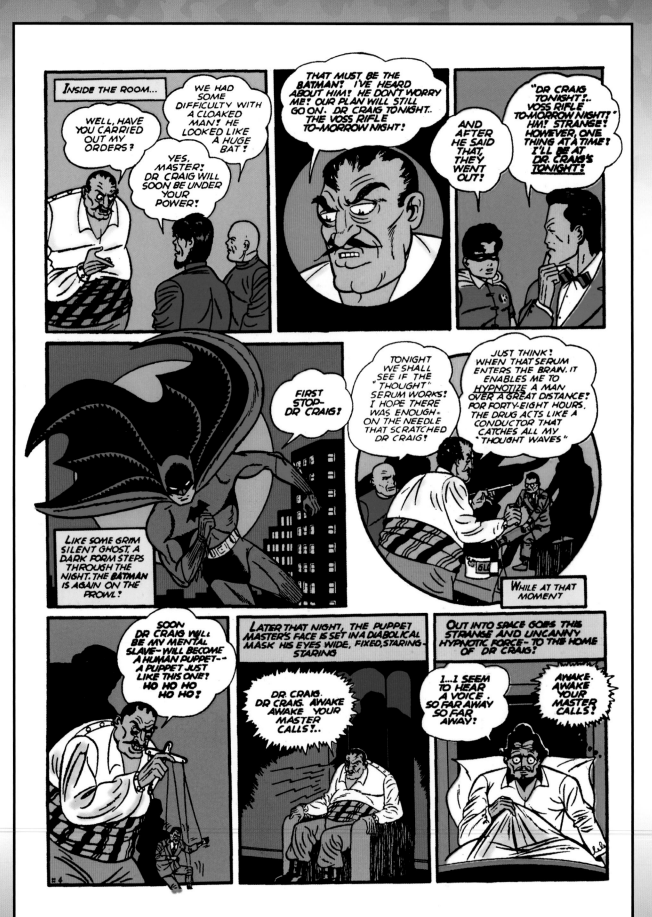

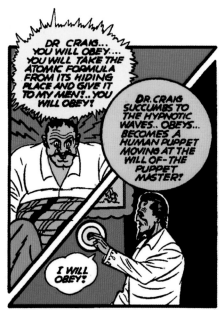

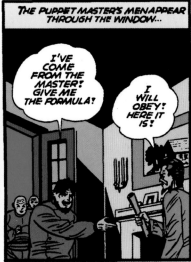

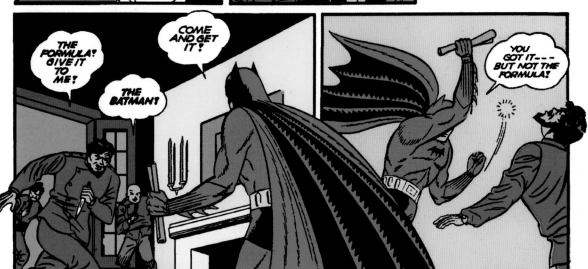

51

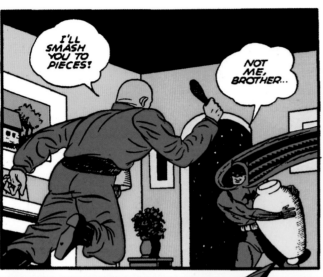

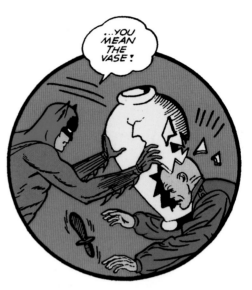

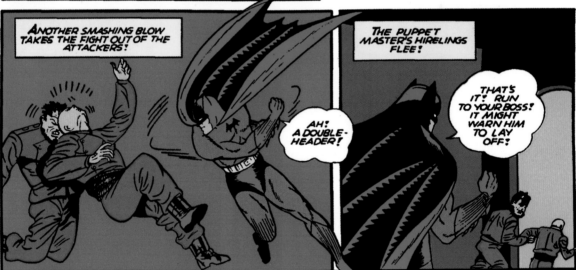

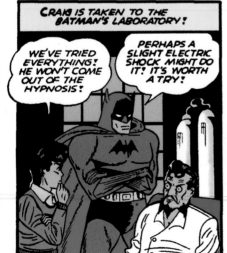

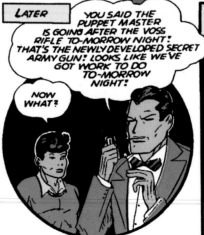

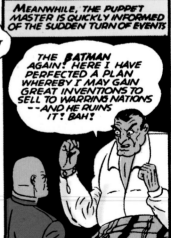

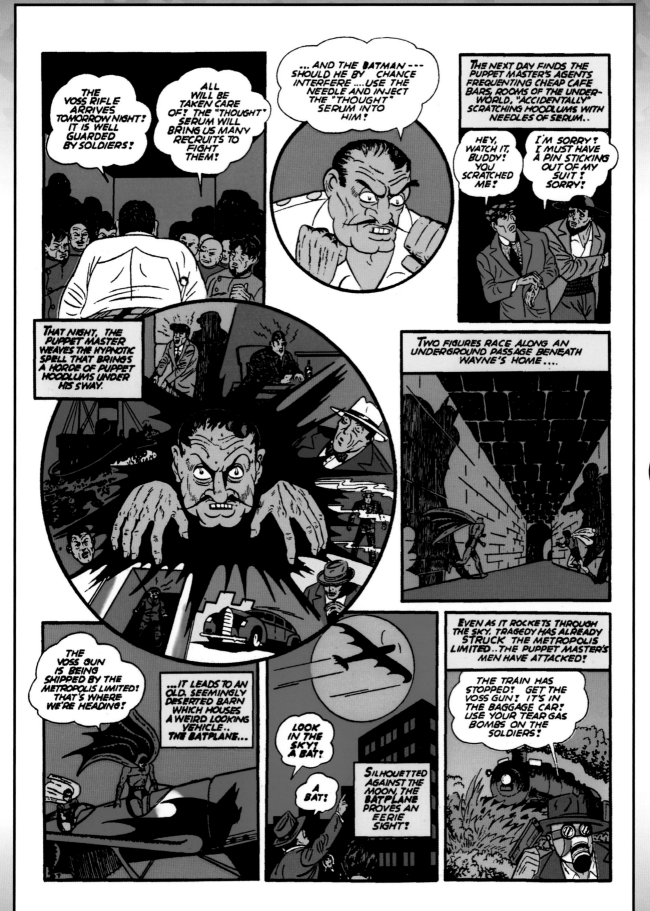

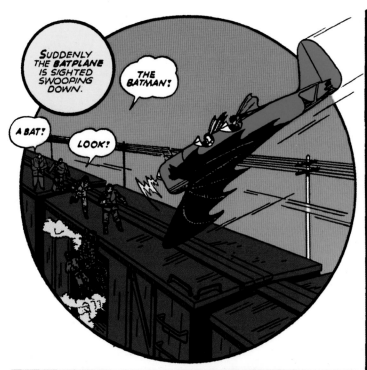
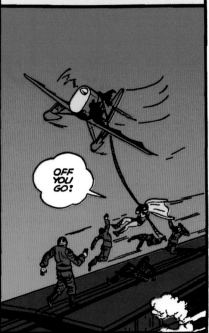
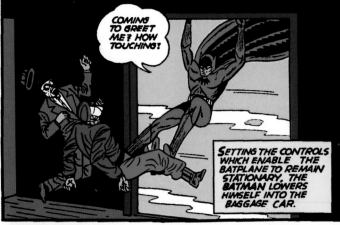

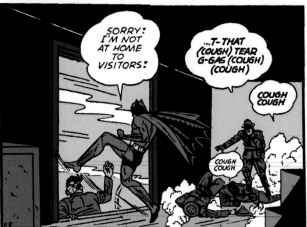

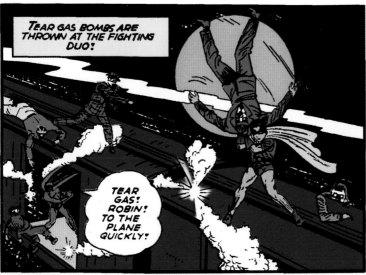

TEAR GAS BOMBS ARE THROWN AT THE FIGHTING DUO!

TEAR GAS! ROBIN! TO THE PLANE QUICKLY!

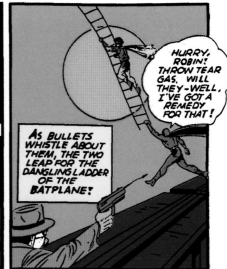

HURRY, ROBIN! THROW TEAR GAS, WILL THEY -WELL, I'VE GOT A REMEDY FOR THAT!

AS BULLETS WHISTLE ABOUT THEM, THE TWO LEAP FOR THE DANGLING LADDER OF THE BATPLANE!

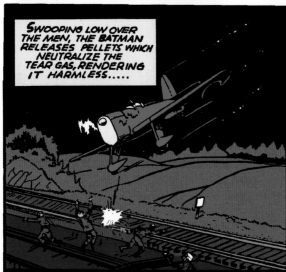

SWOOPING LOW OVER THE MEN, THE BATMAN RELEASES PELLETS WHICH NEUTRALIZE THE TEAR GAS, RENDERING IT HARMLESS.....

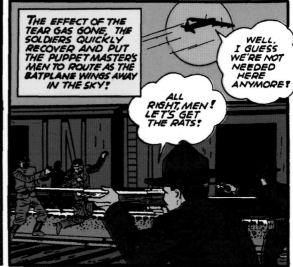

THE EFFECT OF THE TEAR GAS GONE, THE SOLDIERS QUICKLY RECOVER AND PUT THE PUPPET MASTER'S MEN TO ROUTE AS THE BATPLANE WINGS AWAY IN THE SKY!

WELL, I GUESS WE'RE NOT NEEDED HERE ANYMORE!

ALL RIGHT, MEN! LET'S GET THE RATS!

55

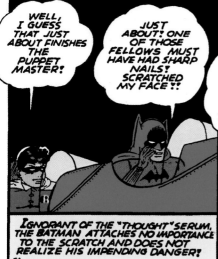

WELL, I GUESS THAT JUST ABOUT FINISHES THE PUPPET MASTER!

JUST ABOUT! ONE OF THOSE FELLOWS MUST HAVE HAD SHARP NAILS! SCRATCHED MY FACE!!

IGNORANT OF THE "THOUGHT" SERUM, THE BATMAN ATTACHES NO IMPORTANCE TO THE SCRATCH AND DOES NOT REALIZE HIS IMPENDING DANGER!

ONE HIRELING ESCAPES TO REPORT TO THE PUPPET MASTER!

.. AND, MASTER, BEFORE HE COULD STOP ME I SCRATCHED HIM WITH THE NEEDLE!

THE BATMAN! SCRATCHED HIM, YOU SAY? GOOD! I'LL FIX THAT MEDDLER ONCE AND FOR ALL!

WITH DEFT FINGERS THE MADMAN BEGINS TO FASHION A PUPPET IN THE FORM OF A FAMILIAR FIGURE...

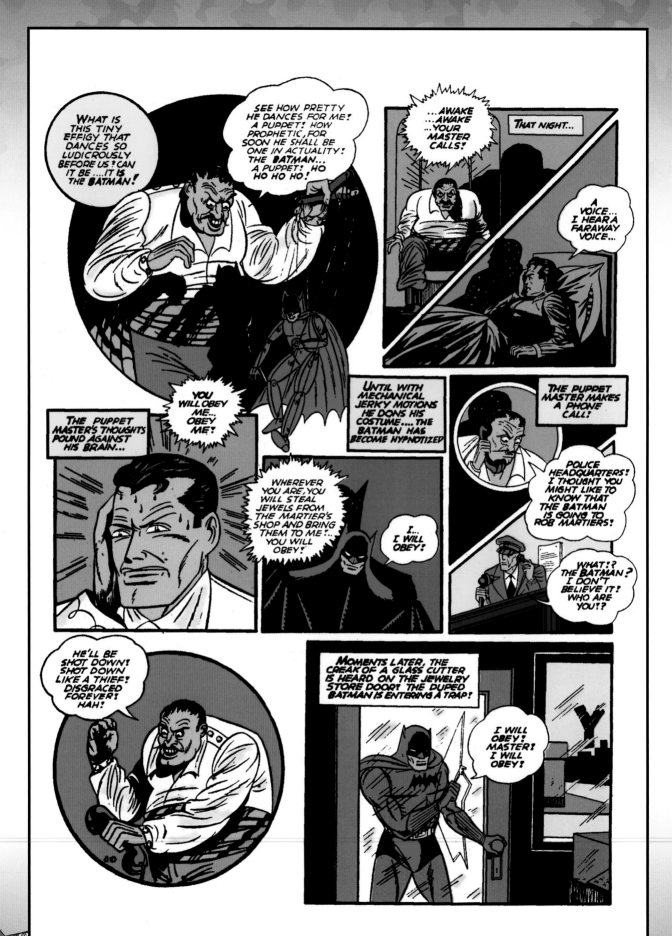

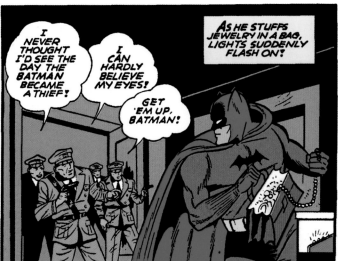

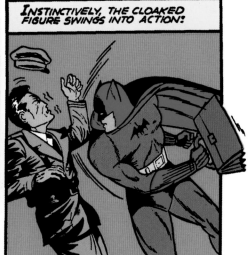

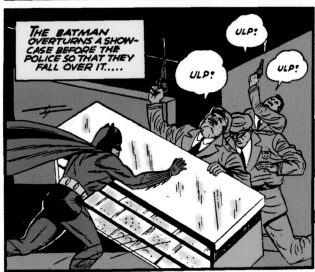

MEANWHILE, DICK, UNABLE TO SLEEP, DISCOVERS THAT BRUCE IS GONE!

HIS COSTUME'S GONE, TOO! HE MUST HAVE GONE TO GET THE PUPPET MASTER! HE MIGHT NEED HELP... THINK I'LL GO THERE!

ROBIN SEES A FAMILIAR FORM APPROACHING THE GROUNDS OF THE PUPPET MASTER'S HOUSE!

GOOD THING THE NEWSPAPERS CARRIED THE PUPPET MASTER'S ADDRESS WHEN THEY WROTE UP HIS PUPPET SHOW!... SAY, THERE'S THE BATMAN, NOW!

GOING AFTER THE PUPPET MASTER WITHOUT ME, WEREN'T YOU? SAY, WHAT HAVE YOU GOT IN THE BAG?

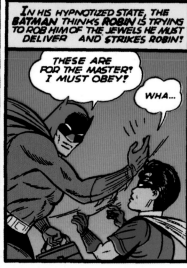

IN HIS HYPNOTIZED STATE, THE BATMAN THINKS ROBIN IS TRYING TO ROB HIM OF THE JEWELS HE MUST DELIVER AND STRIKES ROBIN!

THESE ARE FOR THE MASTER! I MUST OBEY!

WHA...

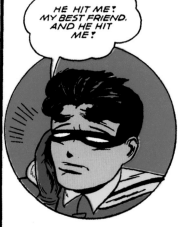

HE HIT ME! MY BEST FRIEND, AND HE HIT ME!

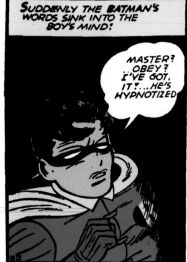

SUDDENLY THE BATMAN'S WORDS SINK INTO THE BOY'S MIND!

MASTER? OBEY? I'VE GOT IT!...HE'S HYPNOTIZED

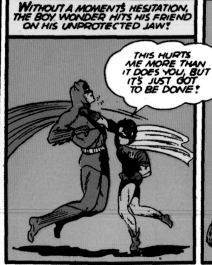

WITHOUT A MOMENT'S HESITATION, THE BOY WONDER HITS HIS FRIEND ON HIS UNPROTECTED JAW!

THIS HURTS ME MORE THAN IT DOES YOU, BUT IT'S JUST GOT TO BE DONE!

I'M GOING TO TAKE YOU HOME, FELLA, AND SEE IF I CAN GET YOU OUT OF YOUR HYPNOTIC STATE!

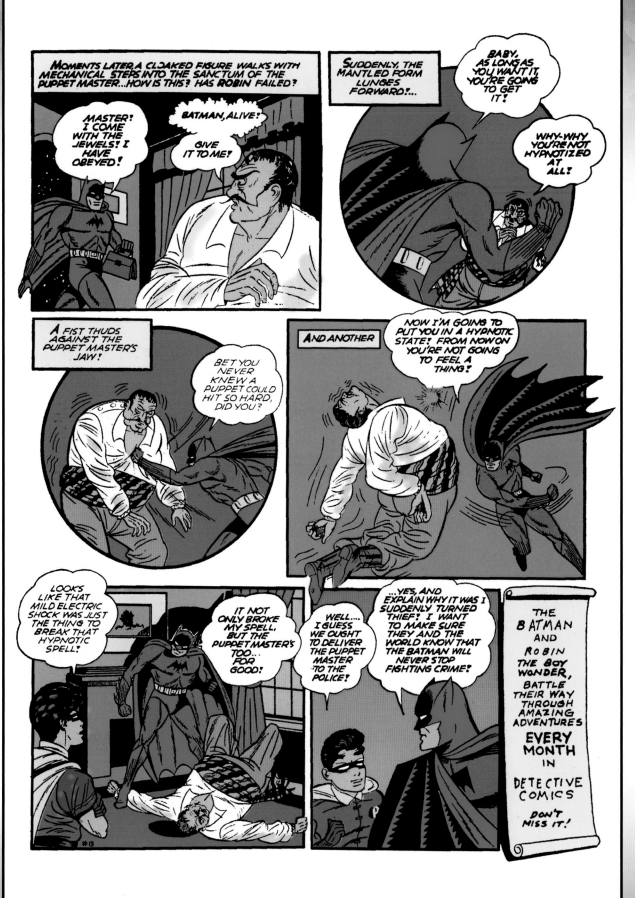

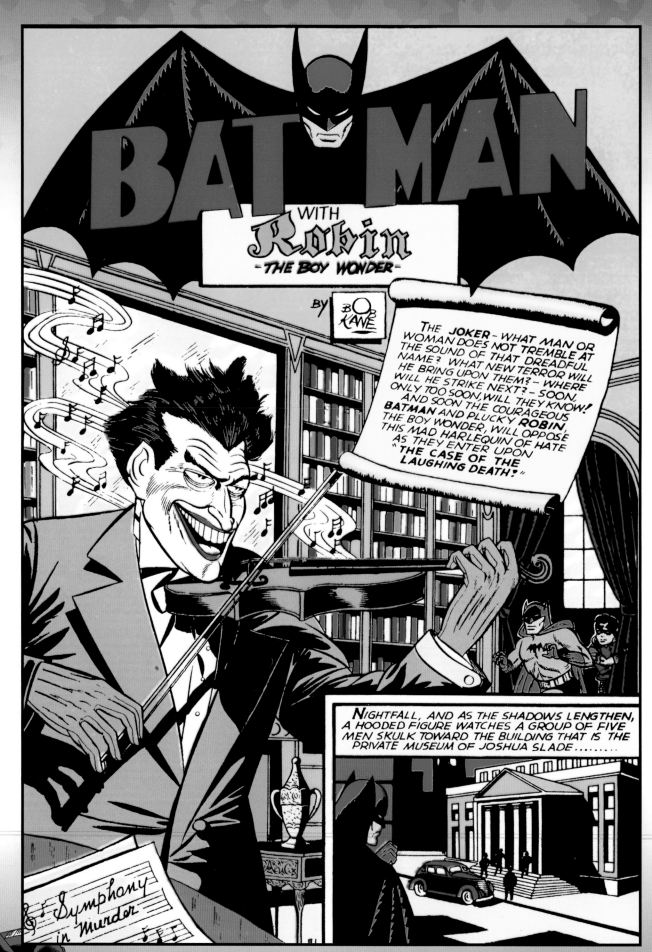

Detective Comics #45 (Nov. 1940) - script: Bill Finger - art: Bob Kane (pencils) & Kane, Jerry Robinson, & George Roussos (inks)

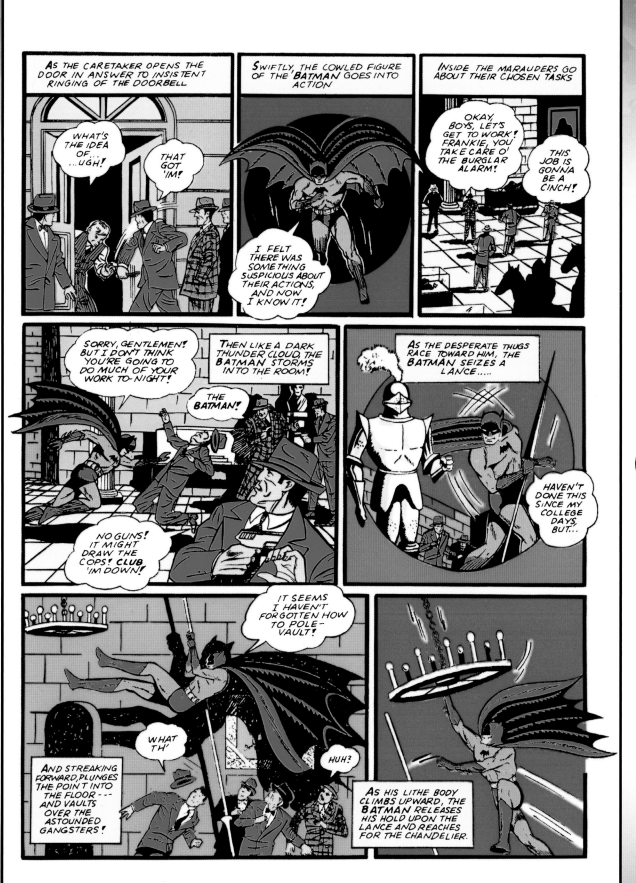

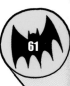

61

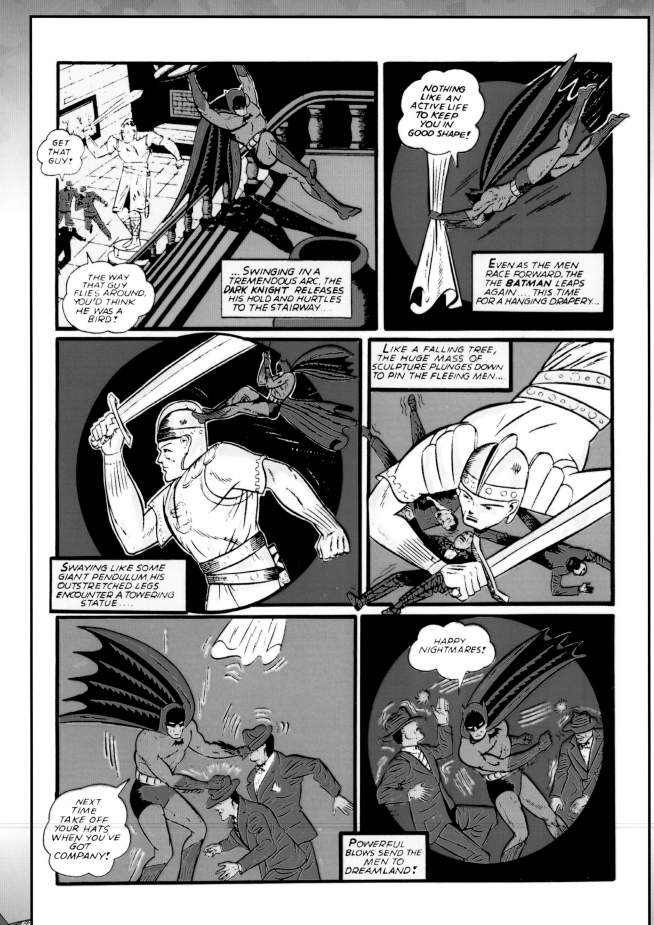

63

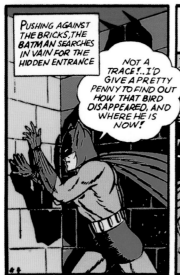

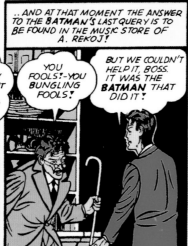

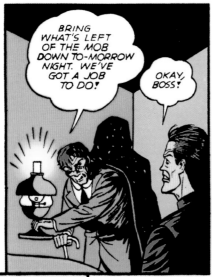

"BRING WHAT'S LEFT OF THE MOB DOWN TO-MORROW NIGHT. WE'VE GOT A JOB TO DO!"

"OKAY, BOSS!"

LOCKING THE DOOR BEHIND THE DEPARTING HOODLUM, THE OLD MAN SHUFFLES TO THE REAR OF THE STORE, AND LIFTING A STRIP OF CARPET, EXPOSES A TRAP DOOR.

DESCENDING TO A ROOM THAT SEEMS TO OVERFLOW WITH ART TREASURES, THE OLD MAN PROCEEDS TO PEEL OFF CLOTHING AND REMOVE MAKEUP...

...TO REVEAL A DEAD-WHITE, MASK-LIKE FACE ..WITH COLD, BLACK EYES... WHILE THE MOUTH IS DRAWN INTO A REPELLENTLY TERRIBLE SMILE ...THE SMILE OF.... **THE JOKER!**

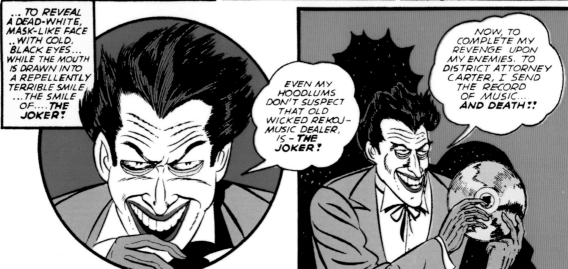

"EVEN MY HOODLUMS DON'T SUSPECT THAT OLD WICKED REKOJ-MUSIC DEALER, IS - **THE JOKER!**"

"NOW, TO COMPLETE MY REVENGE UPON MY ENEMIES. TO DISTRICT ATTORNEY CARTER, I SEND THE RECORD OF MUSIC... **AND DEATH!!**"

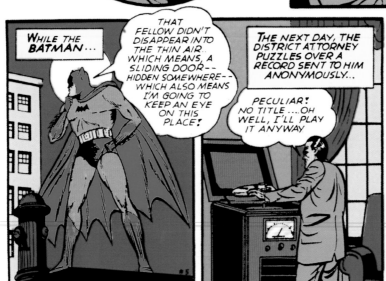

WHILE THE **BATMAN**...

"THAT FELLOW DIDN'T DISAPPEAR INTO THE THIN AIR... WHICH MEANS, A SLIDING DOOR-- HIDDEN SOMEWHERE-- WHICH ALSO MEANS I'M GOING TO KEEP AN EYE ON THIS PLACE!"

THE NEXT DAY, THE DISTRICT ATTORNEY PUZZLES OVER A RECORD SENT TO HIM ANONYMOUSLY...

"PECULIAR! NO TITLEOH WELL, I'LL PLAY IT ANYWAY"

AS THE RECORD REVOLVES, A VIOLIN IS HEARD PLAYING STRANGE, UNEARTHLY MUSIC...

"WHAT EERIE, FORBIDDING MUSIC THAT IS!"

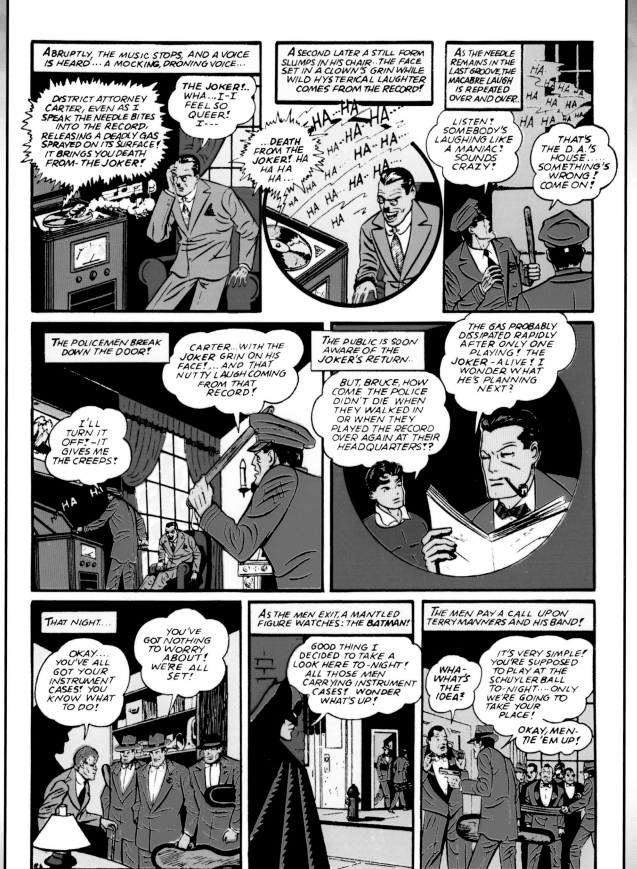

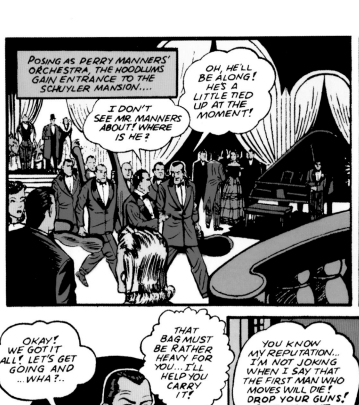

POSING AS PERRY MANNERS' ORCHESTRA, THE HOODLUMS GAIN ENTRANCE TO THE SCHUYLER MANSION....

I DON'T SEE MR. MANNERS ABOUT! WHERE IS HE?

OH, HE'LL BE ALONG! HE'S A LITTLE TIED UP AT THE MOMENT!

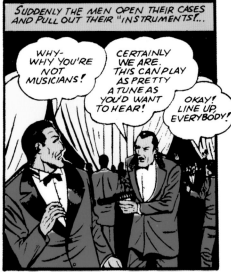

SUDDENLY THE MEN OPEN THEIR CASES AND PULL OUT THEIR "INSTRUMENTS!...

WHY-WHY YOU'RE NOT MUSICIANS!

CERTAINLY WE ARE. THIS CAN PLAY AS PRETTY A TUNE AS YOU'D WANT TO HEAR!

OKAY! LINE UP, EVERYBODY!

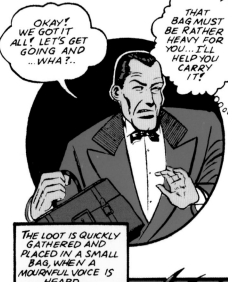

OKAY! WE GOT IT ALL! LET'S GET GOING AND ...WHA?..

THAT BAG MUST BE RATHER HEAVY FOR YOU... I'LL HELP YOU CARRY IT!

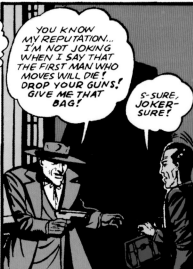

YOU KNOW MY REPUTATION... I'M NOT JOKING WHEN I SAY THAT THE FIRST MAN WHO MOVES WILL DIE! DROP YOUR GUNS! GIVE ME THAT BAG!

S-SURE, JOKER-SURE!

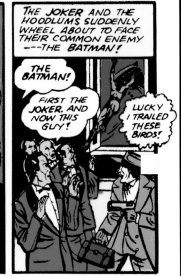

THE JOKER AND THE HOODLUMS SUDDENLY WHEEL ABOUT TO FACE THEIR COMMON ENEMY ---THE BATMAN!

THE BATMAN!

FIRST THE JOKER, AND NOW THIS GUY!

LUCKY I TRAILED THESE BIRDS!

THE LOOT IS QUICKLY GATHERED AND PLACED IN A SMALL BAG, WHEN A MOURNFUL VOICE IS HEARD.....

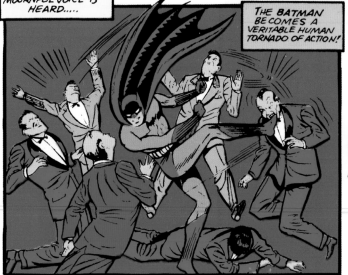

THE BATMAN BECOMES A VERITABLE HUMAN TORNADO OF ACTION!

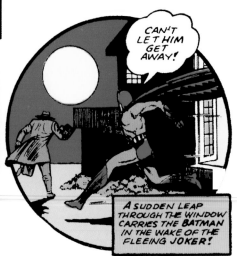

CAN'T LET HIM GET AWAY!

A SUDDEN LEAP THROUGH THE WINDOW CARRIES THE BATMAN IN THE WAKE OF THE FLEEING JOKER!

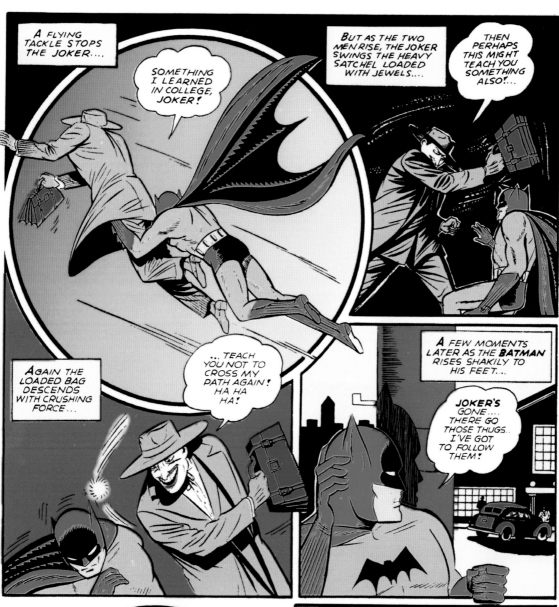

67

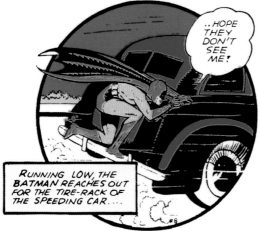

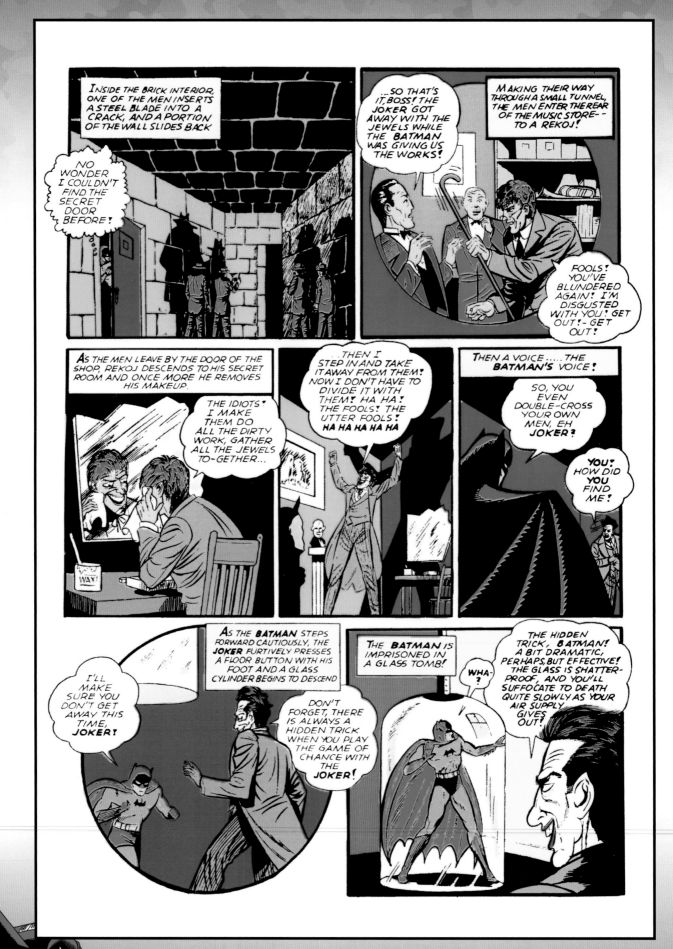

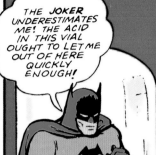

NOW, WHILE YOU DIE, I'LL BE ON MY WAY ACROSS THE OCEAN TO GATHER SOME MORE TREASURE! $500,000 WORTH! HA HA HA HA! ADIEU BATMAN, ADIEU! HA HA HA HA HA

WHEN THE JOKER LEAVES, THE BATMAN DRAWS A CERTAIN VIAL FROM HIS UTILITY BELT

THE JOKER UNDERESTIMATES ME! THE ACID IN THIS VIAL OUGHT TO LET ME OUT OF HERE QUICKLY ENOUGH!

THE POWERFUL ACID EATS AWAY THE SHATTER-PROOF GLASS!

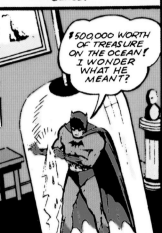

$500,000 WORTH OF TREASURE ON THE OCEAN! I WONDER WHAT HE MEANT?

FREE, THE BATMAN SEARCHES FOR A POSSIBLE CLUE TO THE JOKER'S CRYPTIC WORDS, WHEN HE FINDS.....

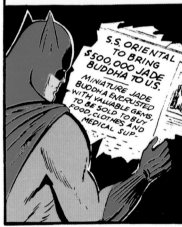

S.S. ORIENTAL TO BRING $500,000 JADE BUDDHA TO U.S.

MINIATURE JADE BUDDHA ENCRUSTED WITH VALUABLE GEMS, TO BE SOLD TO BUY FOOD, CLOTHES AND MEDICAL SUP--

THIS IS WHAT HE MEANT! HE'S GOING TO STEAL THAT BUDDHA! THOSE POOR CHINESE ARE NOT GOING TO BE DONE OUT OF NECESSITIES IF I CAN HELP IT!

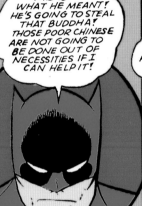

SOME TIME LATER.... ABOARD THE S.S. ORIENTAL ON THE HIGH SEAS...

WHAT HAPPENED?

THAT MAN'S PLANE CRACKED UP AND LANDED IN THE SEA. THE SHIP SENT OUT A RESCUE PARTY!

MUST BE A MUSICIAN! SURE IS CLUTCHING THAT VIOLIN CASE TIGHT ENOUGH!

WHEN THE RESCUED MAN IS LEFT TO REST IN A STATE-ROOM, HE SMILES...THE FRIGHTFUL SMILE – OF THE JOKER!

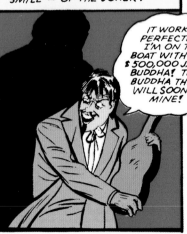

IT WORKED PERFECTLY! I'M ON THE BOAT WITH THE $500,000 JADE BUDDHA! THE BUDDHA THAT WILL SOON BE MINE!

AT THAT MOMENT A FORM LIKE A MAMMOTH BAT WINGS TOWARD THE SHIP THE BATPLANE!

A COWLED FIGURE DIVES INTO THE SEA AS *ROBIN*, THE BOY WONDER, PILOTS THE *BATPLANE* LOWER OVER THE WATERS

GOOD LUCK!

I'LL NEED IT!

SWIMMING TO THE SHIP THE *BATMAN* CLAMBERS UP ITS SIDE

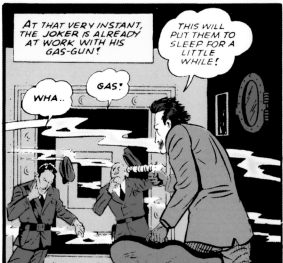

AT THAT VERY INSTANT, THE JOKER IS ALREADY AT WORK WITH HIS GAS-GUN!

THIS WILL PUT THEM TO SLEEP FOR A LITTLE WHILE!

WHA..

GAS!

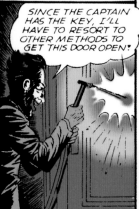

THE *JOKER* TAKES AN ACETYLENE TORCH FROM THE VIOLIN CASE AND PLAYS ITS FLAME UPON THE STEEL DOOR...

SINCE THE CAPTAIN HAS THE KEY, I'LL HAVE TO RESORT TO OTHER METHODS TO GET THIS DOOR OPEN!

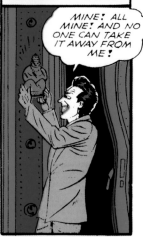

A MOMENT LATER THE *JOKER* HOLDS THE JADE BUDDHA IN HIS HANDS

MINE! ALL MINE! AND NO ONE CAN TAKE IT AWAY FROM ME!

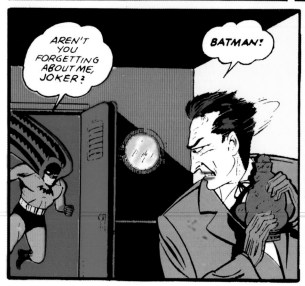

AREN'T YOU FORGETTING ABOUT ME, JOKER?

BATMAN!

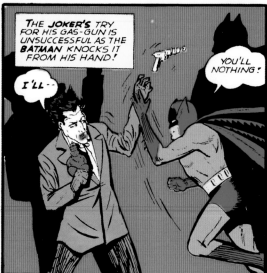

THE *JOKER'S* TRY FOR HIS GAS-GUN IS UNSUCCESSFUL AS THE *BATMAN* KNOCKS IT FROM HIS HAND!

I'LL --

YOU'LL NOTHING!

THE JOKER MAKES FOR THE OPEN DOORWAY....

YOU'LL NEVER TAKE ME, BATMAN!

I'M GOING TO TRY!

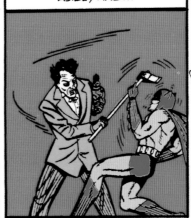

SUDDENLY WHIRLING, THE JOKER SEIZES A FIRE-AXE FROM THE WALL AND STABS OUT AT THE BATMAN, WHO NIMBLY STEPS ASIDE, AND...

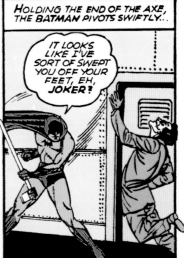

HOLDING THE END OF THE AXE, THE BATMAN PIVOTS SWIFTLY...

IT LOOKS LIKE I'VE SORT OF SWEPT YOU OFF YOUR FEET, EH, JOKER?

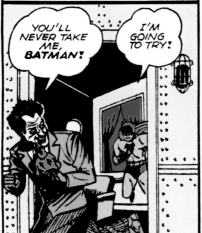

TO SEND THE JOKER FLYING INTO THE WALL!

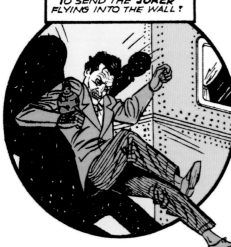

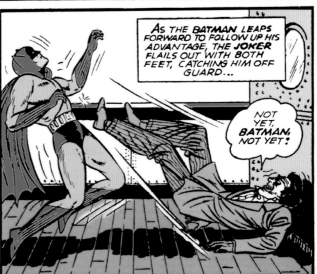

AS THE BATMAN LEAPS FORWARD TO FOLLOW UP HIS ADVANTAGE, THE JOKER FLAILS OUT WITH BOTH FEET, CATCHING HIM OFF GUARD...

NOT YET, BATMAN, NOT YET!

71

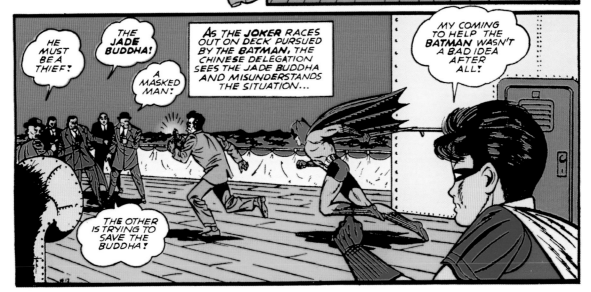

HE MUST BE A THIEF!

THE JADE BUDDHA!

A MASKED MAN!

AS THE JOKER RACES OUT ON DECK PURSUED BY THE BATMAN, THE CHINESE DELEGATION SEES THE JADE BUDDHA AND MISUNDERSTANDS THE SITUATION...

MY COMING TO HELP THE BATMAN WASN'T A BAD IDEA AFTER ALL!

THE OTHER IS TRYING TO SAVE THE BUDDHA!

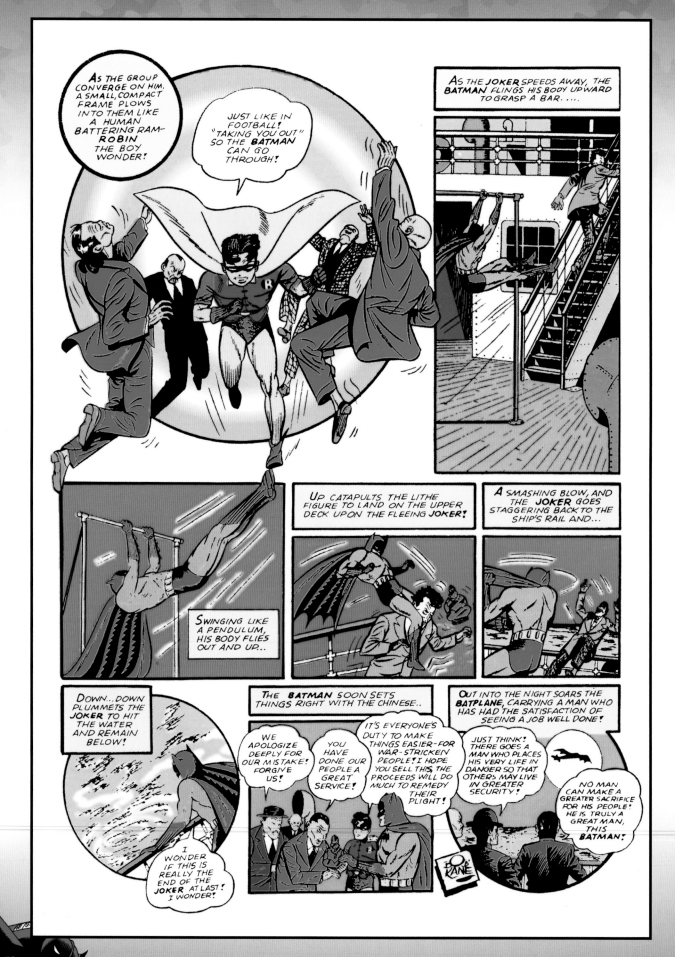

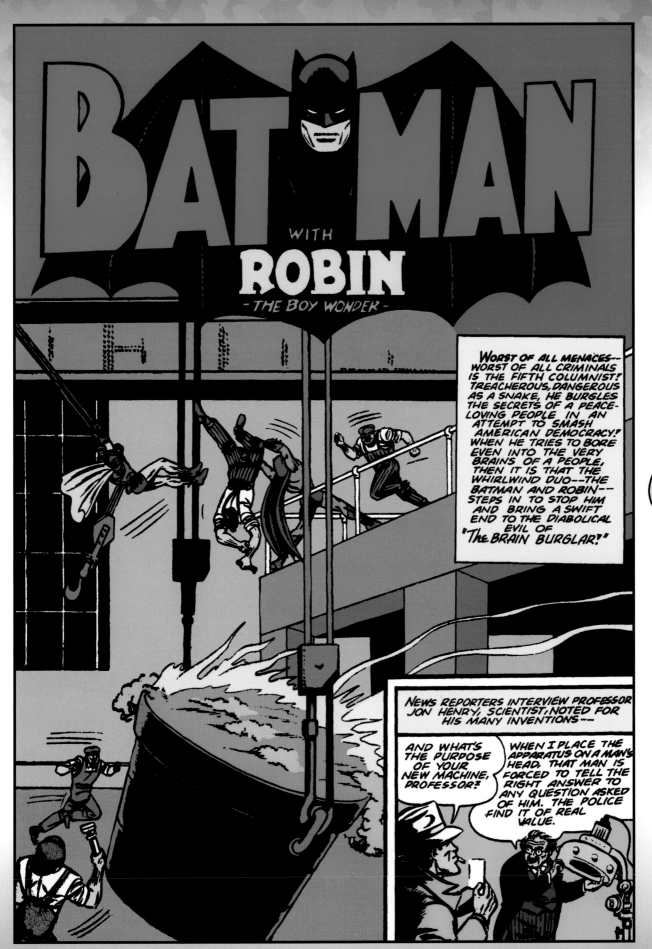

Detective Comics #55 (Sept. 1941) - script: Bill Finger - art: Bob Kane (pencils) & Jerry Robinson & George Roussos (inks)

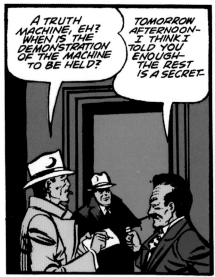

A TRUTH MACHINE, EH? WHEN IS THE DEMONSTRATION OF THE MACHINE TO BE HELD?

TOMORROW AFTERNOON— I THINK I TOLD YOU ENOUGH— THE REST IS A SECRET.

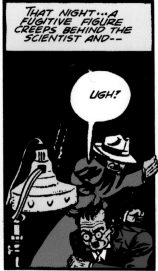

THAT NIGHT...A FUGITIVE FIGURE CREEPS BEHIND THE SCIENTIST AND--

UGH!

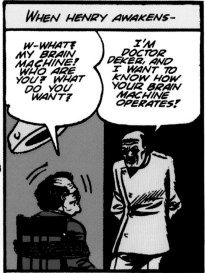

WHEN HENRY AWAKENS—

W-WHAT? MY BRAIN MACHINE! WHO ARE YOU? WHAT DO YOU WANT?

I'M DOCTOR DEKER, AND I WANT TO KNOW HOW YOUR BRAIN MACHINE OPERATES!

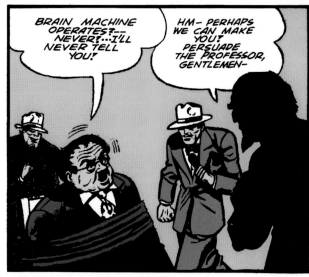

BRAIN MACHINE OPERATES?— NEVER?...I'LL NEVER TELL YOU!

HM— PERHAPS WE CAN MAKE YOU? PERSUADE THE PROFESSOR, GENTLEMEN—

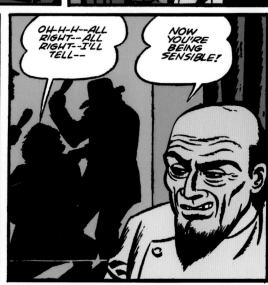

OH-H-H--ALL RIGHT--ALL RIGHT--I'LL TELL--

NOW YOU'RE BEING SENSIBLE!

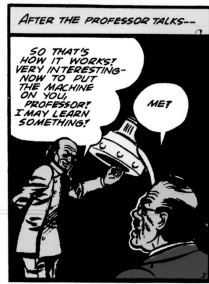

AFTER THE PROFESSOR TALKS--

SO THAT'S HOW IT WORKS! VERY INTERESTING- NOW TO PUT THE MACHINE ON YOU, PROFESSOR! I MAY LEARN SOMETHING!

ME?

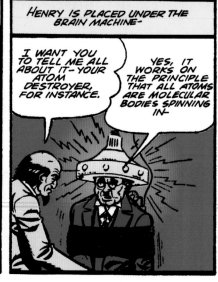

HENRY IS PLACED UNDER THE BRAIN MACHINE-

I WANT YOU TO TELL ME ALL ABOUT IT-YOUR ATOM DESTROYER, FOR INSTANCE.

YES, IT WORKS ON THE PRINCIPLE THAT ALL ATOMS ARE MOLECULAR BODIES SPINNING IN-

WHAT NEW IDEA ARE YOU WORKING ON BESIDES YOUR BRAIN MACHINE?

NEW IDEA? I HAVE ONE? IT'S A TREMENDOUS DISCOVERY-

AFTER THEY HAVE LEARNED THE DETAILS OF PROFESSOR HENRY'S NEWEST DISCOVERY....

IF WHAT HE SAYS IS TRUE WE HAVE STUMBLED ON TO SOMETHING THAT IS INDEED TREMENDOUS!

WE CAN ...CONTROL AN ENTIRE ARMY...WITH IT... CALL IN OUR AGENTS. I WANT TO SPEAK TO THEM!

THE ROOM IS FILLED WITH ENEMY AGENTS--

SO, MY COMRADES, I HAVE TOLD YOU EVERYTHING! ARE YOU WILLING TO SUBMIT TO THIS OPERATION?

GLADLY-- WE KNOW WHAT WILL HAPPEN TO US, BUT NO SACRIFICE IS TOO GREAT FOR THE FATHERLAND!

AND SO, THAT NIGHT, MEN SIT AND AWAIT THEIR TURN AS ONE BY ONE THEIR FANATICAL COMRADES SUBMIT TO A MYSTERIOUS OPERATION--

WHAT IS THE PURPOSE? WHAT EVIL WILL IT BRING? ONLY TIME--INSCRUTABLE TIME CAN TELL!

NEXT DAY--

GOTHAM GAZETTE

PROFESSOR JON HENRY AND BRAIN MACHINE DISAPPEAR!!

THE PRESS WAS AMAZED TO LEARN THIS MORNING OF MYSTIFYING DIS-APPEARANCE OF THE NOTED SCIEN-TIST !!!!

PROFESSOR JON HENRY

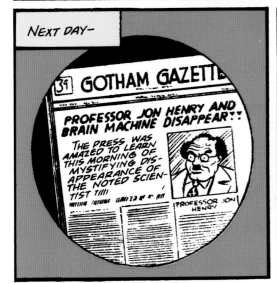

AND THAT IS ONLY THE BEGINNING- FAMOUS SCIENTISTS, KEY MEN IN NATIONAL DEFENSE, INVENTIVE CIRCLES AND OTHERS VANISH, SEEMINGLY PLUCKED AWAY BY INVISIBLE, GHOSTLY HANDS-

75

I THOUGHT YOU HAD A DATE TODAY WITH LINDA PAGE

THAT'S RIGHT! I HAVE-- BUT THIS LATEST DISAPPEARANCE MADE ME LOSE TRACK OF THE TIME!

WHERE ARE YOU GOING WITH HER, ANYWAY?

TO HER UNCLE'S AVIATION PLANT WHERE THEY'RE MAKING A BOMBER FOR THE ARMY!

MINUTES LATER, BRUCE AND LINDA WALK TOWARD THE GREAT AVIATION PLANT!

BRUCE-- IT'S REALLY INSPIRING!

I SEE YOU WANT ME TO GET INTERESTED IN AVIATION SO I'LL FIND MYSELF SOME SORT OF OCCUPATION! SORRY--

I DON'T KNOW WHY I BOTHER TO TRY TO MAKE SOMETHING OF YOU?

MAYBE IT'S BECAUSE YOU LIKE ME, HUH?

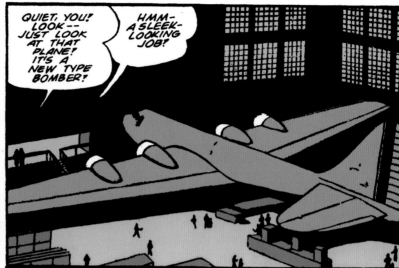

QUIET, YOU! LOOK-- JUST LOOK AT THAT PLANE! IT'S A NEW TYPE BOMBER!

HMM-- A SLEEK-LOOKING JOB!

SUDDENLY, ONE OF THE WORKERS PUTS HIS HAND TO HIS HEAD AS IF IN INTENSE PAIN!

OH-H-H-

HE MUST HAVE A NASTY HEADACHE--

THEN, WITHOUT WARNING, THE WORKMAN RUNS AMOK---

BRUCE! BRUCE!

SOME OTHER WORKERS ALSO GO BERSERK AND START TO SMASH EVERYTHING BEFORE THEM!

UNCLE! BRUCE, HE'S BEEN HURT!

IF WE DON'T GET OUT OF HERE, HE'S GOING TO HAVE COMPANY!

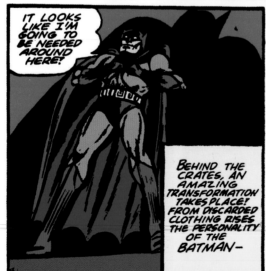

IT LOOKS LIKE I'M GOING TO BE NEEDED AROUND HERE!

BEHIND THE CRATES, AN AMAZING TRANSFORMATION TAKES PLACE! FROM DISCARDED CLOTHING RISES THE PERSONALITY OF THE BATMAN-

LIKE A HORIZONTAL METEOR, THE BATMAN LUNGES FORWARD!

NOW THERE'S A FELLOW WHO IS JUST ASKING FOR TROUBLE--

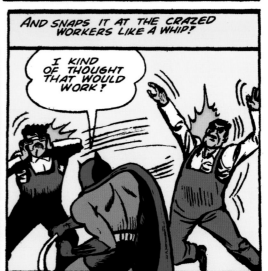

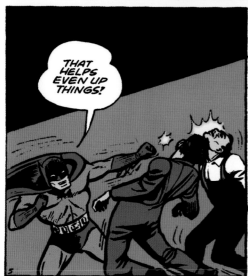

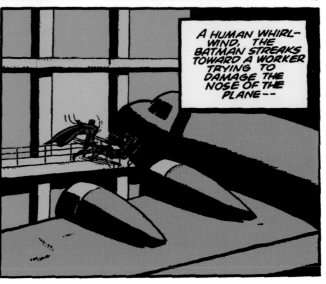

NOW ONE MORE LITTLE BIT OF STRATEGY AND MY WORK IS DONE!

THE BATMAN SLIDES DOWN THE TOP OF THE SLIPPERY PLANE—

HE SENDS A LARGE TIRE WHEEL TOWARD THE REMAINING GROUP OF MADDENED WORKERS!

THE HUGE TIRE LITERALLY MOWS THEM DOWN!

NOW, THE BATMAN SWEEPS FORWARD, HIS TWO FISTS DROPPING THE MAD-MEN LIKE FELLED TREES!

NOTHING LIKE THE OLD ONE-TWO TO MAKE SOMEONE LISTEN TO REASON!

NOW IT'S TIME FOR ME TO GO. THERE'LL BE QUESTIONS AND THAT MIGHT MEAN THE END OF THE BATMAN'S SECRET IDENTITY!

LATER, IT IS BRUCE WAYNE WHO STUMBLES OUT FROM BEHIND THE PACKING CASES!

BRUCE! ARE YOU ALL RIGHT?

OH, MY JAW! WHAT HIT ME? WHAT HAPPENED?

WHAT HAPPENED? ONLY SOME MEN WENT CRAZY AND THE BATMAN CAME OUT OF NOWHERE AND STOPPED THEM— THAT'S ALL—

THE BATMAN— THAT GUY AGAIN?

"THAT GUY" PROBABLY SAVED YOUR LIFE AND MY UNCLE'S PLANT FROM BEING RUINED! WHICH IS MORE THAN YOU DID!

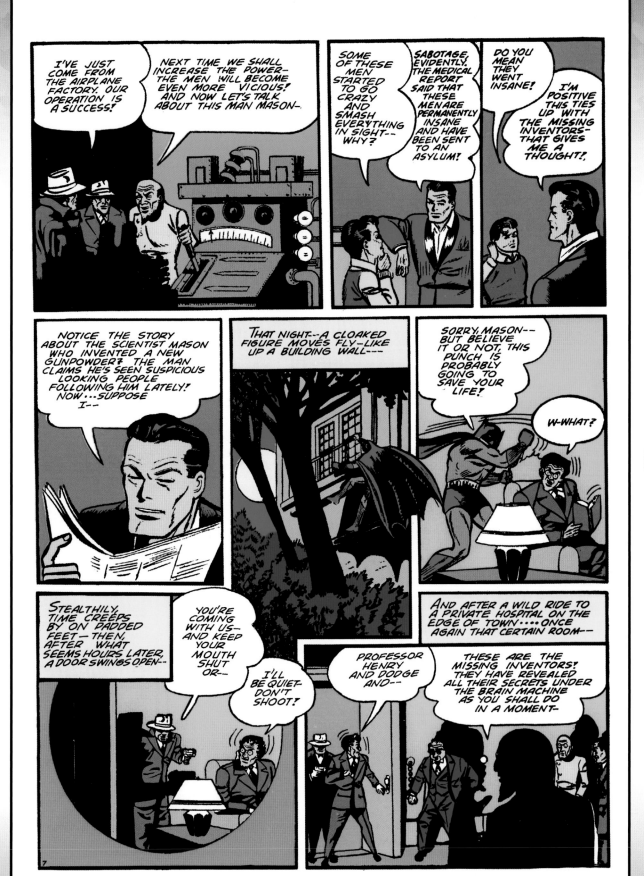

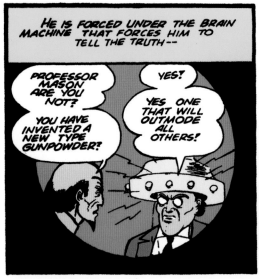

He is forced under the brain machine that forces him to tell the truth--

PROFESSOR MASON ARE YOU NOT?

YOU HAVE INVENTED A NEW TYPE GUNPOWDER?

YES!

YES ONE THAT WILL OUTMODE ALL OTHERS!

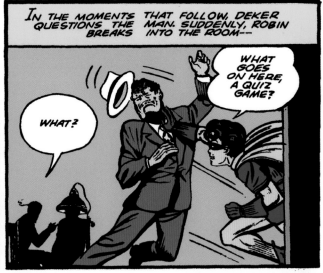

In the moments that follow, Deker questions the man. Suddenly, Robin breaks into the room--

WHAT?

WHAT GOES ON HERE, A QUIZ GAME?

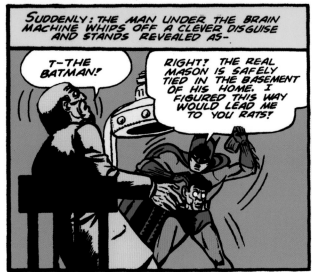

Suddenly: the man under the brain machine whips off a clever disguise and stands revealed as--

T-THE BATMAN!

RIGHT! THE REAL MASON IS SAFELY TIED IN THE BASEMENT OF HIS HOME. I FIGURED THIS WAY WOULD LEAD ME TO YOU RATS!

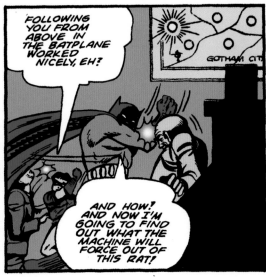

FOLLOWING YOU FROM ABOVE IN THE BATPLANE WORKED NICELY, EH?

GOTHAM CITY

AND HOW! AND NOW I'M GOING TO FIND OUT WHAT THE MACHINE WILL FORCE OUT OF THIS RAT!

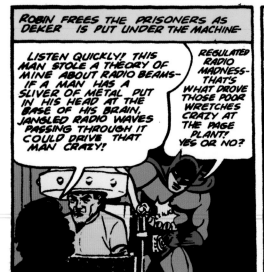

Robin frees the prisoners as Deker is put under the machine--

LISTEN QUICKLY! THIS MAN STOLE A THEORY OF MINE ABOUT RADIO BEAMS-- IF A MAN HAS A SLIVER OF METAL PUT IN HIS HEAD AT THE BASE OF HIS BRAIN, JANGLED RADIO WAVES PASSING THROUGH IT COULD DRIVE THAT MAN CRAZY!

REGULATED RADIO MADNESS-- THAT'S WHAT DROVE THOSE POOR WRETCHES CRAZY AT THE PAGE PLANT! YES OR NO?

YES. WE PERFORMED OPERATIONS ON MANY OF OUR AGENTS AND PUT A SLIVER OF ELECTRICITY-CONDUCTING METAL AT THE BASE OF THEIR BRAINS... AND FOUND JOBS FOR THEM IN VARIOUS PLANTS. OUR COMRADES FULLY REALIZED THAT MADNESS-INDUCED HAVOC WOULD BE MORE DESTRUCTIVE THAN ORDINARY SABOTAGE-

WHEN YOU HIT ME BEFORE, I FELL AGAINST THE LEVER THAT SETS OFF THE JANGLED RADIO BEAMS AND DIRECTED IT AT OUR AGENTS IN THE STEEL FACTORY NEARBY! IN A FEW MINUTES THESE MEN WILL GO MAD, DESTROY, AND DURING THE EXCITEMENT, OTHER SANE AGENTS WILL KIDNAP THE FOREMEN SO WE MAY GAIN THE NEW TYPE STEEL FORMULA YOUR COUNTRY HAS DEVELOPED!

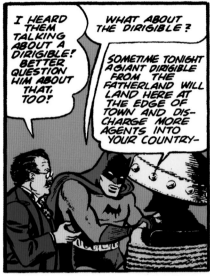

I HEARD THEM TALKING ABOUT A DIRIGIBLE! BETTER QUESTION HIM ABOUT THAT, TOO!

WHAT ABOUT THE DIRIGIBLE?

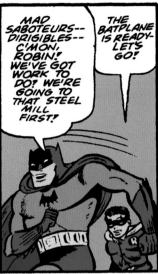

SOMETIME TONIGHT A GIANT DIRIGIBLE FROM THE FATHERLAND WILL LAND HERE AT THE EDGE OF TOWN AND DISCHARGE MORE AGENTS INTO YOUR COUNTRY--

MAD SABOTEURS-- DIRIGIBLES-- C'MON, ROBIN! WE'VE GOT WORK TO DO! WE'RE GOING TO THAT STEEL MILL FIRST!

THE BATPLANE IS READY-- LET'S GO!

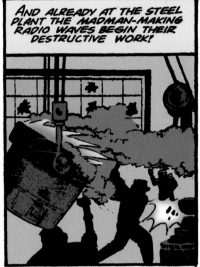

AND ALREADY AT THE STEEL PLANT THE MADMAN-MAKING RADIO WAVES BEGIN THEIR DESTRUCTIVE WORK!

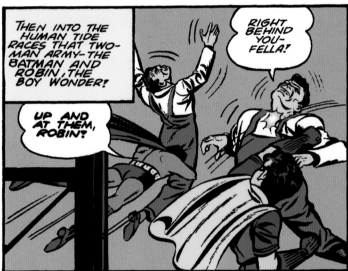

THEN INTO THE HUMAN TIDE RACES THAT TWO-MAN ARMY-- THE BATMAN AND ROBIN, THE BOY WONDER!

RIGHT BEHIND YOU-- FELLA!

UP AND AT THEM, ROBIN!

COOL OFF, BROTHER-- YOU LOOK KIND OF HOT AROUND THE COLLAR!

81

A LITHE SPRING CARRIES THE BOY WONDER ONTO A MOVING FLATCAR.

GIVE ME THAT! I CAN PUT IT TO BETTER USE!

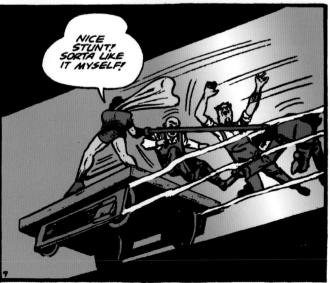

NICE STUNT! SORTA LIKE IT MYSELF!

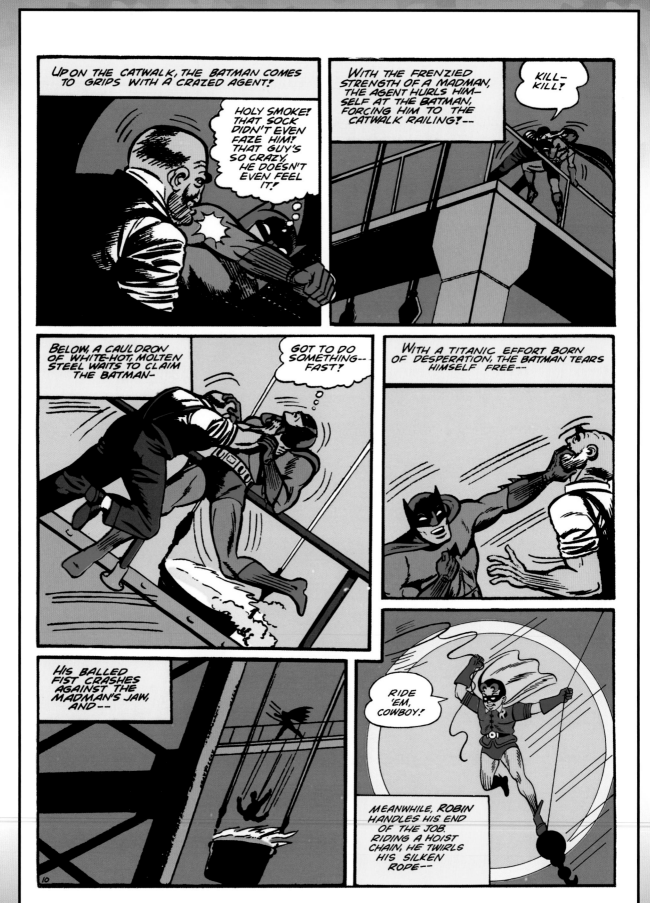

HOG-TIED, EH, FELLAS?

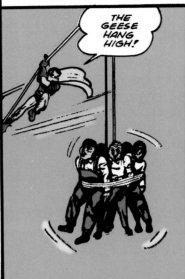

ROBIN THEN LASSOES THE END OF THE ROPE TO A MOVING CRANE AND LO AND BEHOLD--

THE GEESE HANG HIGH!

NICE WORK, KID! THAT TAKES CARE OF THAT! LOOK! THE FOREMAN-- BEING KIDNAPPED BY FOREIGN AGENTS!

THOSE ARE THE BOYS DEKER MENTIONED- LET'S NAB 'EM!

A WINDMILL OF FLYING FISTS, ROUTS THE FIFTH COLUMNISTS....

SORRY TO SPOIL YOUR PLANS, RATS!

-AND YOUR FACES!

AND AS GUARDS TAKE OVER....

WE'VE DONE OUR JOB HERE- C'MON, ROBIN- WE'VE GOT A DATE WITH A DIRIGIBLE!

83

BREATHLESS MOMENTS FLY PAST THEM, AND THEY SEE--

LOOK! WE'RE TOO LATE! THOSE MEN LOOK LIKE FOREIGN AGENTS SHE HAD TO DROP OFF!

NOT TOO LATE YET- MY SLEEPING GAS PELLETS SHOULD TAKE CARE OF THEM VERY NICELY!

FROM HIS UTILITY BELT, THE BATMAN PRODUCES PELLETS AND DASHES THEM TO THE GROUND -

GAS!

ROBOT CONTROLS PACE THE BATPLANE'S SPEED WITH THE DIRIGIBLE'S. THEN- A DARING LEAP THROUGH SPACE-

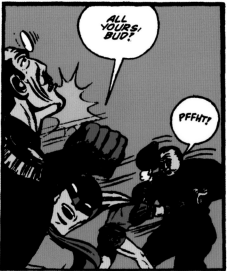

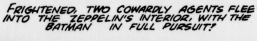
FRIGHTENED, TWO COWARDLY AGENTS FLEE INTO THE ZEPPELIN'S INTERIOR, WITH THE BATMAN IN FULL PURSUIT!

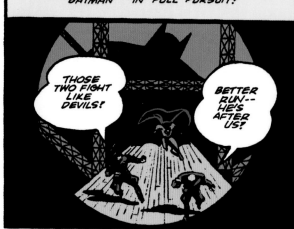

DESPERATELY TRYING TO ELUDE THEIR BAT-WINGED SHADOW, THEY DART UP THE LADDER THAT LEADS TO AN EXIT IN THE VERY TOP OF THE SHIP-

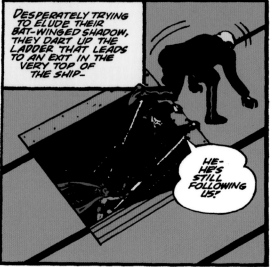

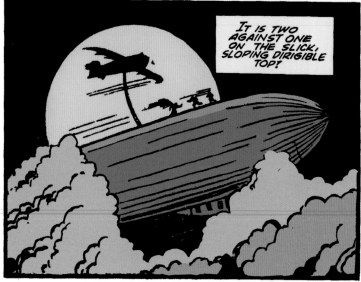

IT IS TWO AGAINST ONE ON THE SLICK, SLOPING DIRIGIBLE TOP!

CAUGHT OFF GUARD FOR AN INSTANT, A SUDDEN BLOW SENDS THE BATMAN STAGGERING BACK--

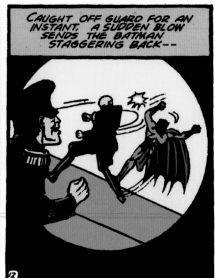

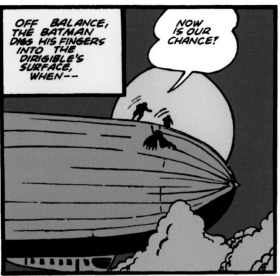

OFF BALANCE, THE BATMAN DIGS HIS FINGERS INTO THE DIRIGIBLE'S SURFACE, WHEN--

NOW IS OUR CHANCE!

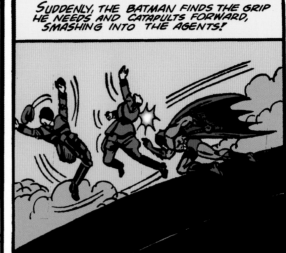

SUDDENLY, THE BATMAN FINDS THE GRIP HE NEEDS AND CATAPULTS FORWARD, SMASHING INTO THE AGENTS!

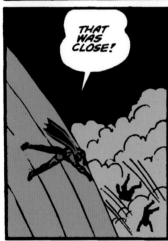

THAT WAS CLOSE!

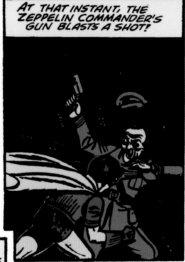

AT THAT INSTANT, THE ZEPPELIN COMMANDER'S GUN BLASTS A SHOT!

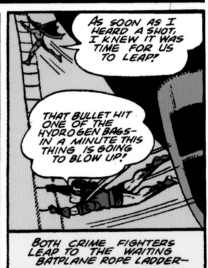

AS SOON AS I HEARD A SHOT, I KNEW IT WAS TIME FOR US TO LEAP!

THAT BULLET HIT ONE OF THE HYDROGEN BAGS-- IN A MINUTE THIS THING IS GOING TO BLOW UP!

BOTH CRIME FIGHTERS LEAP TO THE WAITING BATPLANE ROPE LADDER--

85

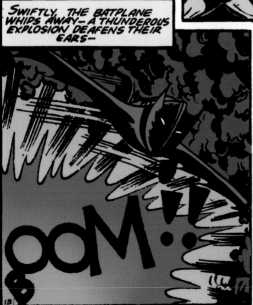

SWIFTLY, THE BATPLANE WHIPS AWAY-- A THUNDEROUS EXPLOSION DEAFENS THEIR EARS--

A BURNING PYRE MAKES THE DIRIGIBLE'S END!

THERE SHE GOES-- AND THE END OF THOSE BIRDS WHO WANTED TO WRECK AMERICAN DEMOCRACY--

WHEN THAT DOCTOR PUT YOU UNDER THE BRAIN MACHINE-- WHY DIDN'T IT FORCE YOU TO TELL THE TRUTH THAT YOU WERE THE BATMAN DISGUISED AS MASON?

OH-- I WAS PREPARED. THE MACHINE WORKED ON AN ELECTRICAL PRINCIPLE, SO I PUT A RUBBER LINING IN THE WIG I WORE-- RUBBER DOESN'T ALLOW ELECTRICAL WAVES TO PASS THROUGH IT, SO I COULD TELL HIM ANYTHING--

THE END --

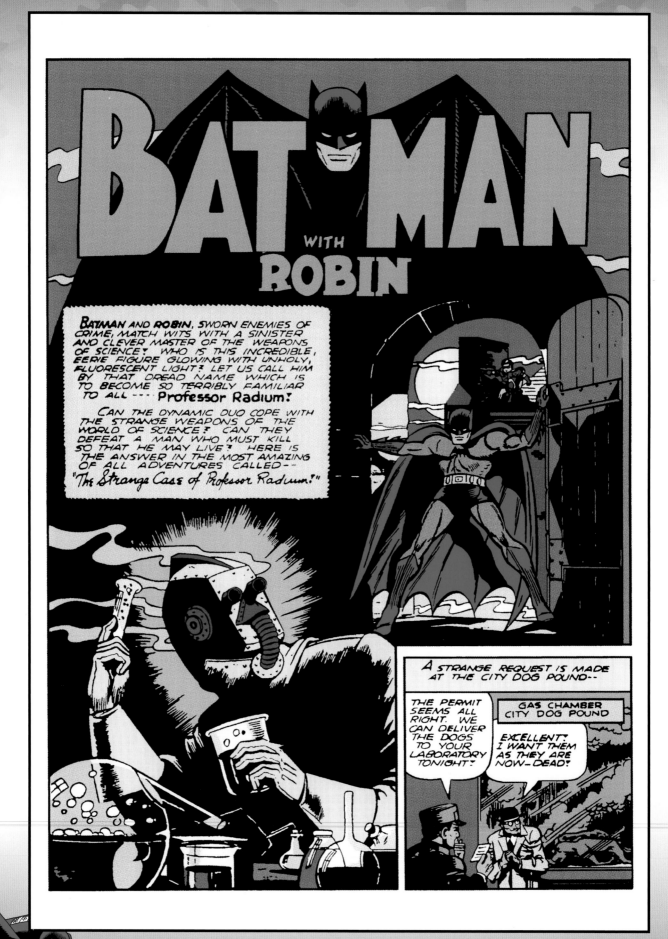

Batman #8 (Dec. 1941-Jan. 1942) - script: Bill Finger - art: Bob Kane (pencils) & Jerry Robinson & George Roussos (inks)

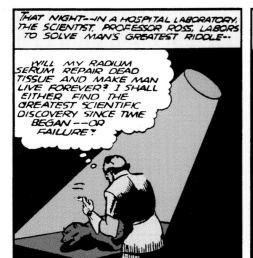

THAT NIGHT--IN A HOSPITAL LABORATORY, THE SCIENTIST, PROFESSOR ROSS, LABORS TO SOLVE MAN'S GREATEST RIDDLE--

WILL MY RADIUM SERUM REPAIR DEAD TISSUE AND MAKE MAN LIVE FOREVER? I SHALL EITHER FIND THE GREATEST SCIENTIFIC DISCOVERY SINCE TIME BEGAN--OR FAILURE!

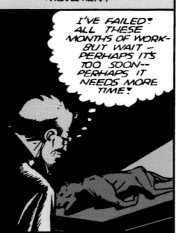

BUT THE SERUM-INJECTED DOGS SHOW NO SIGN OF MOVEMENT--

I'VE FAILED! ALL THESE MONTHS OF WORK--BUT WAIT--PERHAPS IT'S TOO SOON--PERHAPS IT NEEDS MORE TIME!

MINUTES DRAG INTO HOURS, AND AS THE BLEARY-EYED SCIENTIST WAITS AND WATCHES, SLEEP FINALLY CONQUERS HIS EXHAUSTED BODY--

A HAND SHAKES HIM--

HEY--WAKE UP! YOU MUST HAVE SLEPT IN THAT CHAIR ALL NIGHT! AND SAY, WHAT ARE YOU STARTING AROUND HERE--A DOG KENNEL? HA-HA!

ALIVE! THE DOGS ARE ALIVE! RADIUM SERUM CAN REPAIR PROTOPLASM! I MUST SUBMIT A REPORT TO THE DIRECTORS AT ONCE! NEXT I MUST REVIVE A DEAD MAN--THEN I SHALL BE FAMOUS!

87

LATER THAT DAY, IN THE INSTITUTE DIRECTOR'S OFFICE--

THEY LOOK LIKE THE DOGS WE DELIVERED TO THE PROFESSOR, BUT I CAN'T BE SURE!

THESE X-RAYS SHOW NO TRACE OF RADIUM IN THE DOGS! ARE YOU TRYING TO PULL A HOAX ON ME, PROFESSOR!

OF COURSE NOT! I'LL BRING ANOTHER DOG TO LIFE AND PROVE MY CLAIM IS TRUE!

A LIVE DOG COULD BE SUBSTITUTED FOR A DEAD ONE, YOU KNOW! YOUR LIFE-RENEWING CLAIM SEEMS ABSURD! PERHAPS YOU HAVE APPROPRIATED THE RADIUM FOR YOUR OWN PRIVATE USE.

FOR YOUR EXCELLENT WORK IN THE PAST, WE WILL NOT CHARGE YOU WITH THE THEFT OF THOUSANDS OF DOLLARS OF RADIUM, BUT SHALL INSTEAD ASK FOR YOUR RESIGNATION! GOOD DAY, PROFESSOR ROSS!

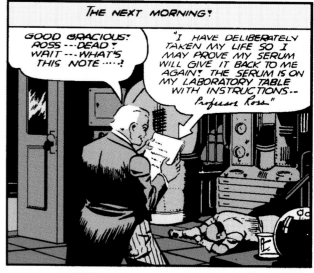

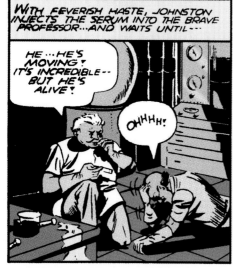

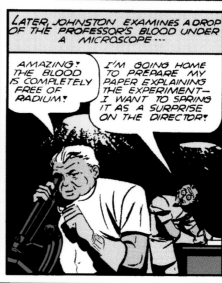

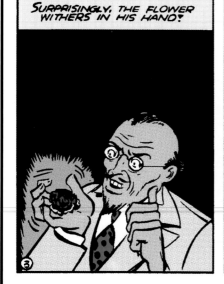

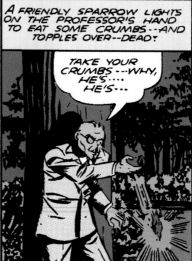

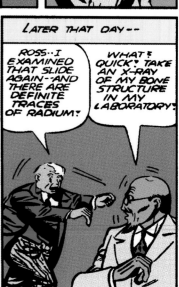

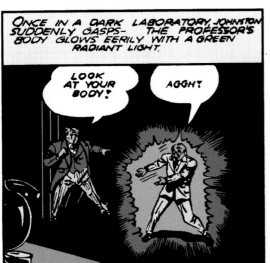

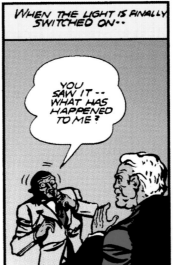

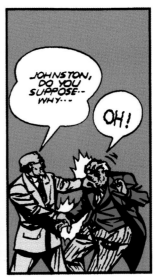

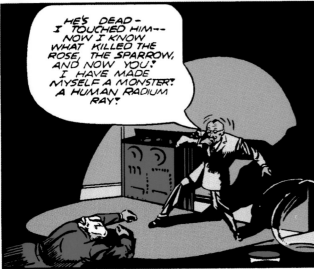

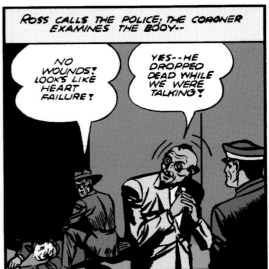

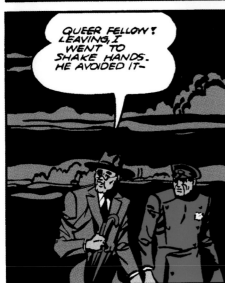

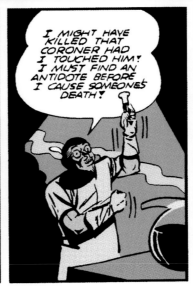

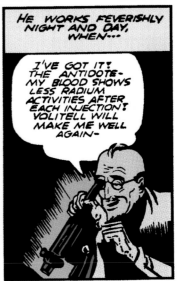

BUT ALL DOESN'T GO WELL--HE FINDS THAT VOLITELL WEARS OFF AFTER TWENTY-FOUR HOURS---

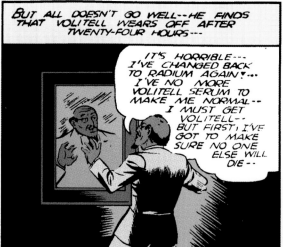

IT'S HORRIBLE--- I'VE CHANGED BACK TO RADIUM AGAIN!... I'VE NO MORE VOLITELL SERUM TO MAKE ME NORMAL-- I MUST GET VOLITELL-- BUT FIRST, I'VE GOT TO MAKE SURE NO ONE ELSE WILL DIE--

HE FASHIONS A SUIT WOVEN FROM A RUBBEROID-LEAD COMPOSITION-- A GARB THROUGH WHICH THE DEADLY RADIUM RAYS WILL NOT PASS--

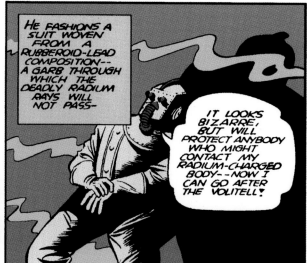

IT LOOKS BIZARRE, BUT WILL PROTECT ANYBODY WHO MIGHT CONTACT MY RADIUM-CHARGED BODY--NOW I CAN GO AFTER THE VOLITELL!

VOLITELL IS AN EXPENSIVE DRUG, AND HE HAS USED HIS FUNDS ON HIS EXPERIMENTS-- THAT NIGHT, HE FURTIVELY ENTERS A HOSPITAL'S SUPPLY ROOM--

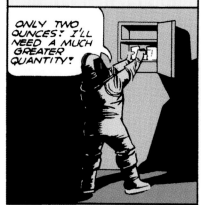

ONLY TWO OUNCES! I'LL NEED A MUCH GREATER QUANTITY!

AS THE DESPERATE SCIENTIST STEALS MORE AND MORE VOLITELL, NEWSPAPERS TELL AN AMAZING STORY----

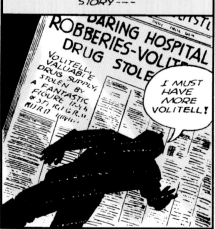

DARING HOSPITAL ROBBERIES-VOLIT... DRUG STOLE...

VOLITELL VALUABLE DRUG SUPPLY STOLEN BY A FANTASTIC FIGURE IN...

I MUST HAVE MORE VOLITELL!

AND IN HIS HOME, BRUCE WAYNE SPEAKS TO HIS YOUNG WARD, DICK GRAYSON--

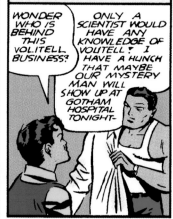

WONDER WHO IS BEHIND THIS VOLITELL BUSINESS?

ONLY A SCIENTIST WOULD HAVE ANY KNOWLEDGE OF VOLITELL! I HAVE A HUNCH THAT MAYBE OUR MYSTERY MAN WILL SHOW UP AT GOTHAM HOSPITAL TONIGHT-

NIGHT--TWO CAPED FIGURES SWING THROUGH EMPTY SPACE--

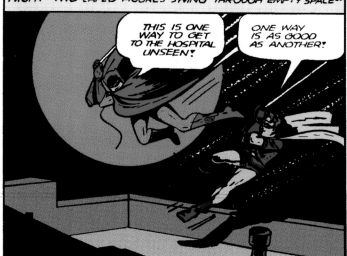

THIS IS ONE WAY TO GET TO THE HOSPITAL UNSEEN!

ONE WAY IS AS GOOD AS ANOTHER!

THE PROFESSOR HAS REMAINED HIDDEN INSIDE THE HOSPITAL ALL DAY LONG-

I CAN SLIP PAST THOSE GUARDS EASILY ENOUGH AND GET INTO THE SUPPLY ROOM!

BUT AS THE PROFESSOR REACHES FOR THE VOLTELL---TWO MANTLED FURIES STORM INTO THE ROOM---

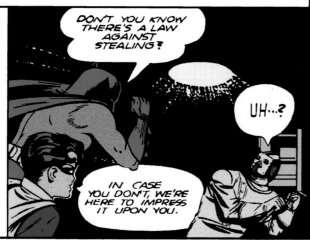

DON'T YOU KNOW THERE'S A LAW AGAINST STEALING?

UH...?

IN CASE YOU DON'T, WE'RE HERE TO IMPRESS IT UPON YOU.

SORRY, MISTER...BUT YOU'RE GOING TO JAIL!

JAIL! I DON'T WANT TO GO TO JAIL! I'VE GOT TO ESCAPE!

UGH!

91

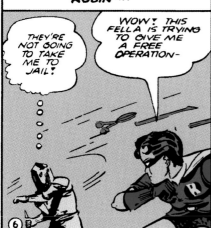

THE FEAR-MADDENED PROFESSOR HURLS RAZOR-EDGED SURGICAL INSTRUMENTS AT THE CHARGING **ROBIN**

THEY'RE NOT GOING TO TAKE ME TO JAIL!

WOW! THIS FELLA IS TRYING TO GIVE ME A FREE OPERATION---

6

AS THE **BATMAN** AND **ROBIN** CHARGE ANEW, THE PROFESSOR PUSHES AN INSTRUMENT CLOSET OVER THEM---

HOLY SMOKE! THIS BABY IS FULL OF TRICKS!

CRASH!

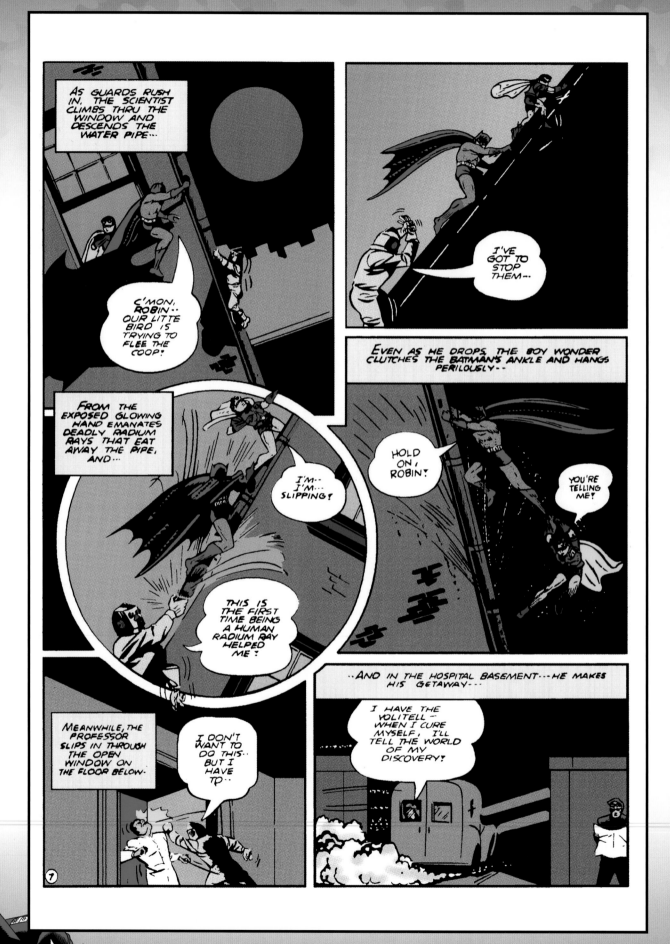

92

MEANWHILE, THE BATMAN SWINGS ROBIN SAFELY IN THRU AN OPEN WINDOW!

OKAY, ROBIN-- LET'S GO!

SWIFTLY THEY RACE THRU THE HOSPITAL--

HE SURE DISAPPEARED!

BUT HE FORGOT THE GLOVE HE DROPPED--

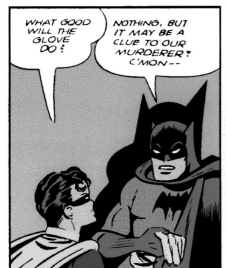

WHAT GOOD WILL THE GLOVE DO?

NOTHING, BUT IT MAY BE A CLUE TO OUR MURDERER! C'MON--

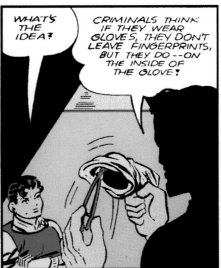

WHAT'S THE IDEA?

CRIMINALS THINK IF THEY WEAR GLOVES, THEY DON'T LEAVE FINGERPRINTS, BUT THEY DO--ON THE INSIDE OF THE GLOVE!

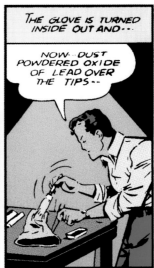

THE GLOVE IS TURNED INSIDE OUT AND--

NOW...DUST POWDERED OXIDE OF LEAD OVER THE TIPS--

93

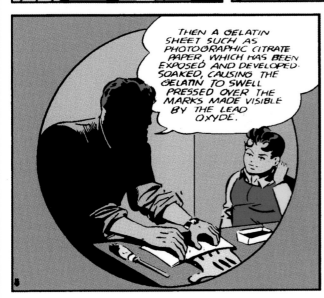

THEN A GELATIN SHEET SUCH AS PHOTOGRAPHIC CITRATE PAPER, WHICH HAS BEEN EXPOSED AND DEVELOPED. SOAKED, CAUSING THE GELATIN TO SWELL PRESSED OVER THE MARKS MADE VISIBLE BY THE LEAD OXYDE.

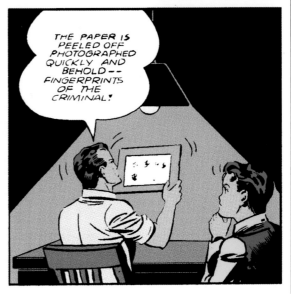

THE PAPER IS PEELED OFF PHOTOGRAPHED QUICKLY AND BEHOLD-- FINGERPRINTS OF THE CRIMINAL!

THE NEXT MORNING!

THE INJECTION OF VOLITELL SERUM I TOOK HAS MADE ME NORMAL AGAIN! NOW TO SEE MARY AND TELL HER ABOUT MY GREAT DISCOVERY-

HENRY DARLING-- YOU LOOK EXCITED!

THE MOST WONDERFUL THING HAS HAPPENED, MARY!

BUT HE DOES NOT NOTICE THE GLOW ABOUT HIS BODY GROWING STRONGER--AS HE LEANS FORWARD! -

MARY, YOU'RE GOING TO BE SURPRI--- MARY!...

OHHH!

THE GLOW IS BACK! THE INJECTION I TOOK WASN'T STRONG ENOUGH-- I KILLED HER!

I'VE KILLED HER--- I-

KILLED HER--- HELP! POLICE!

POLICE COMMISSIONER GORDON'S OFFICE-- WHERE NOW THE POLICE AND BATMAN WORK HAND IN HAND---

THESE PRINTS MATCH THOSE OF A PROFESSOR ROSS-- HE'S A CIVIL SERVICE EMPLOYEE SO THE STATE HAS HIS FINGERPRINTS ON FILE!

ROSS, EH? HE WAS INVOLVED IN THE DEATH OF HIS ASSOCIATE PROFESSOR-

RING!

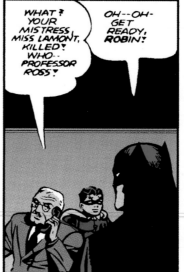

WHAT? YOUR MISTRESS MISS LAMONT, KILLED? WHO-- PROFESSOR ROSS?

OH--OH-- GET READY, ROBIN!

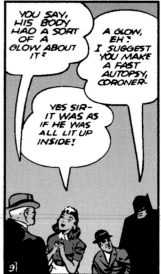

YOU SAY, HIS BODY HAD A SORT OF A GLOW ABOUT IT?

A GLOW, EH? I SUGGEST YOU MAKE A FAST AUTOPSY, CORONER-

YES SIR-- IT WAS AS IF HE WAS ALL LIT UP INSIDE!

9

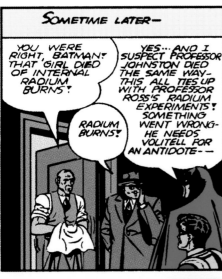
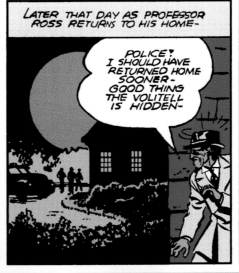
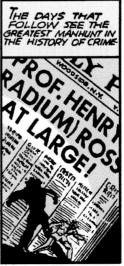
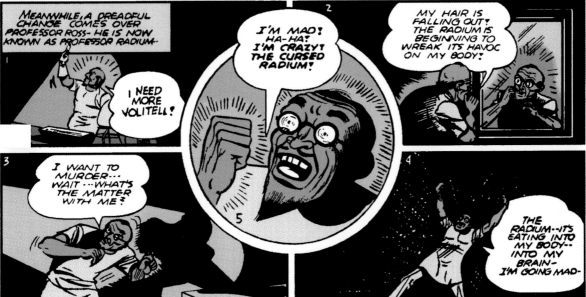

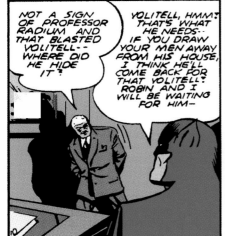

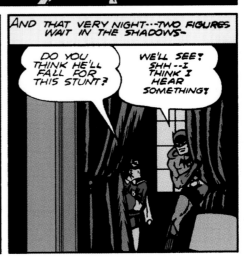

95

SO STRONG IS THE RADIUM—CHARGED BODY OF THE PROFESSOR THAT HE LITERALLY SEARS HIS WAY THROUGH THE DOOR!

GOOD! IT'S EMPTY!

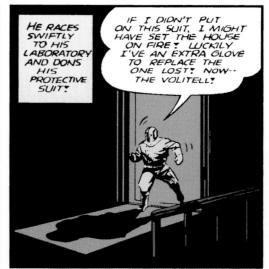

HE RACES SWIFTLY TO HIS LABORATORY AND DONS HIS PROTECTIVE SUIT!

IF I DIDN'T PUT ON THIS SUIT, I MIGHT HAVE SET THE HOUSE ON FIRE! LUCKILY I'VE AN EXTRA GLOVE TO REPLACE THE ONE LOST! NOW-- THE VOLITELL!

HE WITHDRAWS A LARGE BOOK, AND....

THE VOLITELL! THE POLICE NEVER THOUGHT OF LOOKING IN A BOOK FOR IT!

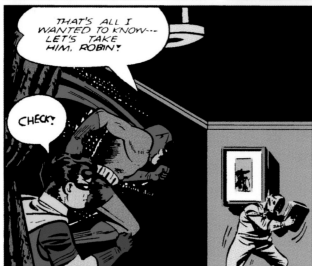

THAT'S ALL I WANTED TO KNOW--- LET'S TAKE HIM, ROBIN!

CHECK!

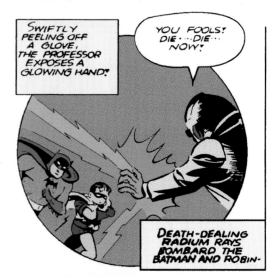

SWIFTLY PEELING OFF A GLOVE, THE PROFESSOR EXPOSES A GLOWING HAND!

YOU FOOLS! DIE....DIE... NOW!

DEATH-DEALING RADIUM RAYS BOMBARD THE BATMAN AND ROBIN-

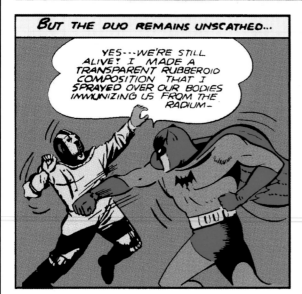

BUT THE DUO REMAINS UNSCATHED...

YES---WE'RE STILL ALIVE! I MADE A TRANSPARENT RUBBEROID COMPOSITION THAT I SPRAYED OVER OUR BODIES IMMUNIZING US FROM THE RADIUM-

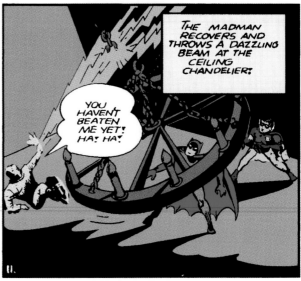

THE MADMAN RECOVERS AND THROWS A DAZZLING BEAM AT THE CEILING CHANDELIER!

YOU HAVEN'T BEATEN ME YET! HA! HA!

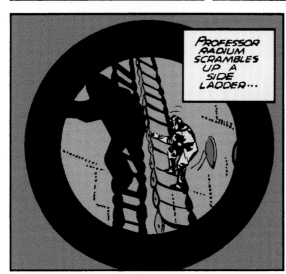

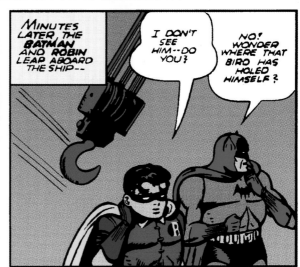

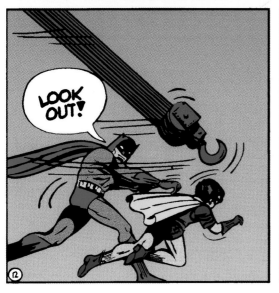

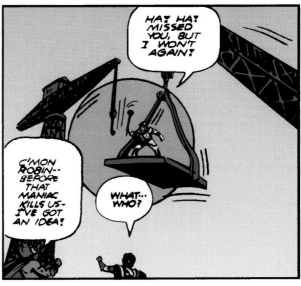

TAKING THE LIFT UP TO THE TOP OF A NEARBY CRANE—THE *BATMAN* CAREFULLY PICKS HIS WAY OVER THE FRAMEWORK OF A JUTTING ARM FROM WHICH A GIANT HOOK DANGLES...

WITH *ROBIN* AT THE CONTROLS, THE GREAT CRANE SWINGS AROUND—THE *BATMAN* SWAYING PERILOUSLY FROM THE DANGLING HOISTING HOOK!

PROFESSOR RADIUM IS READY AND WAITING! EXPOSING HIS HAND, HE SENDS OUT SEARING RAYS THAT PART THE CABLE!

HA— TRY TO GET OUT OF THIS, *BATMAN!*

BUT THE TERRIFIC MOMENTUM OF THE SWINGING HOOK IS ENOUGH TO SEND THE *BATMAN* SHOOTING FORWARD AS THE CABLE PARTS...

PROFESSOR RADIUM'S ARMS FLAIL WILDLY AS HE TRIES TO KEEP HIS BALANCE...

—AND THEN PLUNGES BACKWARD INTO SPACE!

—HE MUST HAVE SUNK LIKE A LOG! I MIGHT AS WELL GO BACK TO RECOVER THE VOLITELL AND RETURN IT TO THE HOSPITAL—

SOMETIME LATER—

WHY THE FROWN, BRUCE?

I WAS THINKING—— HERE WAS A MAN WHO TRIED TO DISCOVER SOMETHING THAT WOULD GIVE LIFE TO PEOPLE—— BUT IN SO DOING HE CREATED FRANKENSTEIN'S MONSTER THAT DESTROYED HIS OWN LIFE!

The End

BUT HAS THE RIVER SEALED THE TOMB OF THIS UNUSUAL MAN! OR DOES HE STILL LIVE ON AS THE NOW MAD *Professor Radium*!

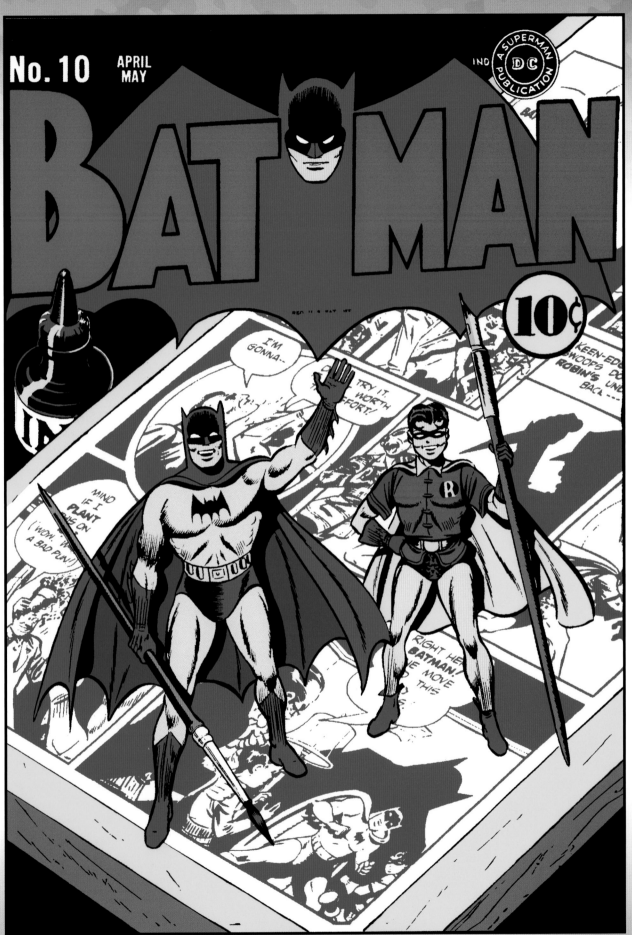

Batman #10 (April-May 1942) - cover art: Fred Ray (pencils) & Jerry Robinson

Part Two

By the time Pearl Harbor was bombed, Superman and Batman didn't have the comic book super-hero stage all to themselves.

THE HOME FRONT WAR

The Human Torch, Sub-Mariner, Captain America, and other colorful cut-ups exploded from the pages of rival Timely's *Marvel Mystery Comics* and other titles. The original Captain Marvel was only the most popular of maybe a dozen costumed heroes at Fawcett Publications. And more such characters were popping up on the newsstands every month!

At DC Comics and its sister company All-American Comics alone—both of whose covers sported the "DC" bullet—there were the Flash, Green Lantern, Hawkman, the Spectre, Dr. Fate, Sandman, Starman, Dr. Mid-Nite, Green Arrow, Aquaman, Johnny Quick, and a number of others . . . including Wonder Woman, who made her dramatic debut in *All-Star Comics* #8 (Dec. 1941–Jan. 1942), right before America went to war. The majority of the above stalwarts were also members of *All-Star*'s Justice Society of America, a group of super-heroes who teamed up against evils that were allegedly too powerful for any of them to defeat alone. Batman and Superman were honorary members of the JSA, but were officially "too busy" to attend meetings. Well, why not? They *were* already appearing in three magazines each!

The third title for those two superstars—augmenting *Action Comics, Superman, Detective Comics,* and *Batman*—was the extra-thick, 15¢ *World's Finest Comics.* This magazine was descended from the 1939 one-shot *World's Fair Comics* that had starred Superman and others (but not the spanking-new Batman) in stories set at the New York World's Fair that opened that year. A second *World's Fair* special was published in 1940 and this time, Superman

shared the cover with Batman and Robin! These editions were such a success that DC soon launched the quarterly *World's Best Comics,* changing its title to *World's Finest* with #2. The Superman and Batman stories served as each issue's bookends, but they never co-starred in an actual *story* in those days, appearing together only on covers. That of #5 (Spring 1942), showing the trio saluting as U.S. fighter aircraft pass overhead, was probably the first *World's Finest* cover produced after Pearl Harbor; issue #7's cover sported a similar military theme.

If DC's problem with Superman during World War II was that he was so powerful he could have ended the conflict overnight, the trouble with Batman and Robin was virtually the opposite. Thrown into the front lines, Batman—for all his acrobatic skill and Holmesian powers of deduction—would have been just one more un-bulletproof bit of cannon fodder. . . and one wearing a highly impractical cape, at that! Robin, of course, would have never been allowed anywhere near the battlefront.

Batman and Robin, DC's editors quickly decided, were best utilized on the Home Front, defending the populace and war industries from Axis agents. They'd already done that in occasional stories, but once we were at war with Japan, Germany, and Italy, there was no shyness about saying precisely who the enemy was, as per the two 1942 stories included in this section.

In *Detective Comics* #69 (Nov. 1942), the Joker is just out for number one, and the "war" tie-in is that the climactic battle between him and Batman

takes place on a bomber assembly line. Still, when (SPOILER ALERT!) he escapes in a test plane, he yells down that he'll return it "so it can drop a few 'eggs' on the Japs!" The idea of an American criminal who nonetheless felt the stirrings of patriotism was also on display in several movies during this era, including *All through the Night* starring Humphrey Bogart and *Lucky Jordan* with Alan Ladd. (The racial epithet hurled by the Joker in the quotation is, of course, offensive now—but most Americans had no qualms about using it in the aftermath of Pearl Harbor—and it would be a disservice to have blacked out the word in his balloon. After all, the book you hold in your hands was created to show what comic books were like in the World War II era, not what they might be like if they were written *today*.)

In *Batman* #14 (Dec. 1942–Jan. 1943), we find perhaps the most overtly war-related Batman story: "Swastika over the White House!" You can't get much more direct than that!

Incidentally, it may puzzle many readers that, though it was the Japanese who had attacked Pearl Harbor, there are more Germanic agents in these comics stories than Japanese ones. The reason: sure, the natural inclination of John Q. Public after December 7, 1941, would have been to defeat the warlords of Tokyo first, then turn to Germany and Italy; but the governments of both the United States and Britain felt that, from a strategic point of view, the Nazis should be defeated first, in Europe, while the U.S. Navy held the line against Japanese forces in the Pacific. Once it was made clear that the "Germany first" policy would be pursued, movies and other mass media mostly fell into place. The comic book industry featured a number of anti-Japanese stories in the issues that came out in the months after Pearl Harbor. Then, having gotten the message, most comics switched to an emphasis on the Nazis, although the Japanese were still the antagonists in some tales.

This section, though, consists of more covers than stories, since that's where Batman and Robin (occasionally with Superman) could be found most engaged in the war effort. The most startling cover image herein, perhaps, is that of *Batman* #15 (Feb.–March 1943), on which Gotham City's heroes are shown firing a machine gun, doubtless at enemy soldiers off-panel. Many readers in 1942 didn't remember, or never knew, that in a couple of early exploits, Batman had used a gun, before DC's powers-that-be decided he would henceforth use only his fists. Besides, when that cover was drawn, the U.S. was at war—and Americans would use any weapon at hand to decimate the enemy.

101

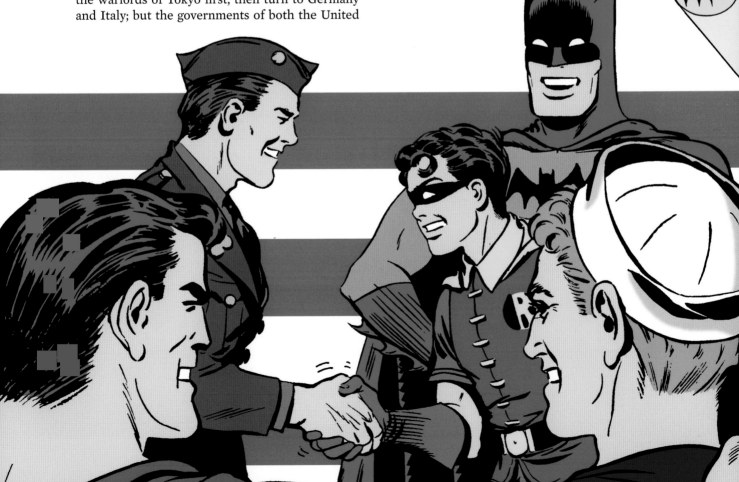

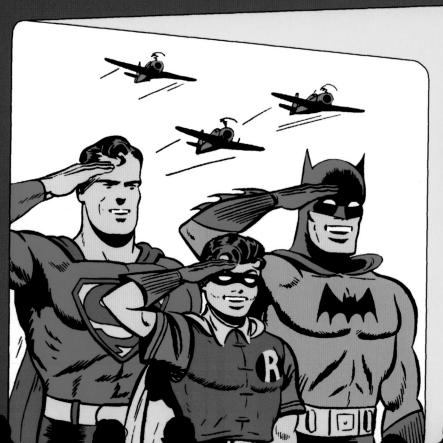

No. 5　SPRING ISSUE

WORLD'S FINEST
COMICS

15¢

A SUPERMAN PUBLICATION DC

96 THRILLING PAGES!

SUPERMAN·BATMAN AND ROBIN
SANDMAN · ZATARA
RED, WHITE & BLUE

World's Finest Comics #5 (Spring 1942) - cover art: Fred Ray

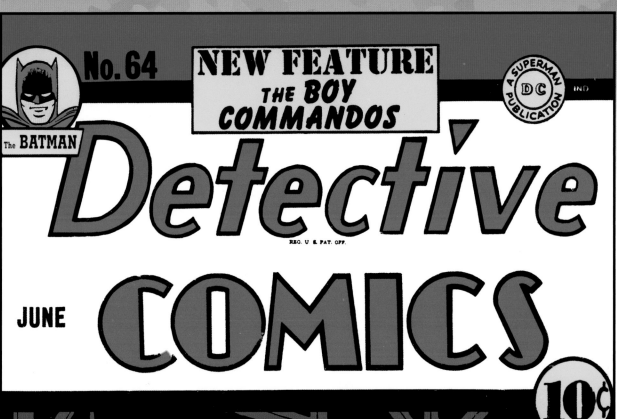

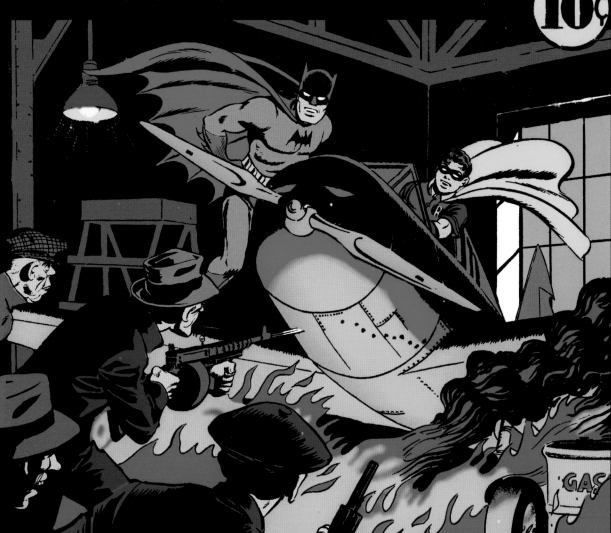

Detective Comics #64 (June 1942) - cover art: Jerry Robinson

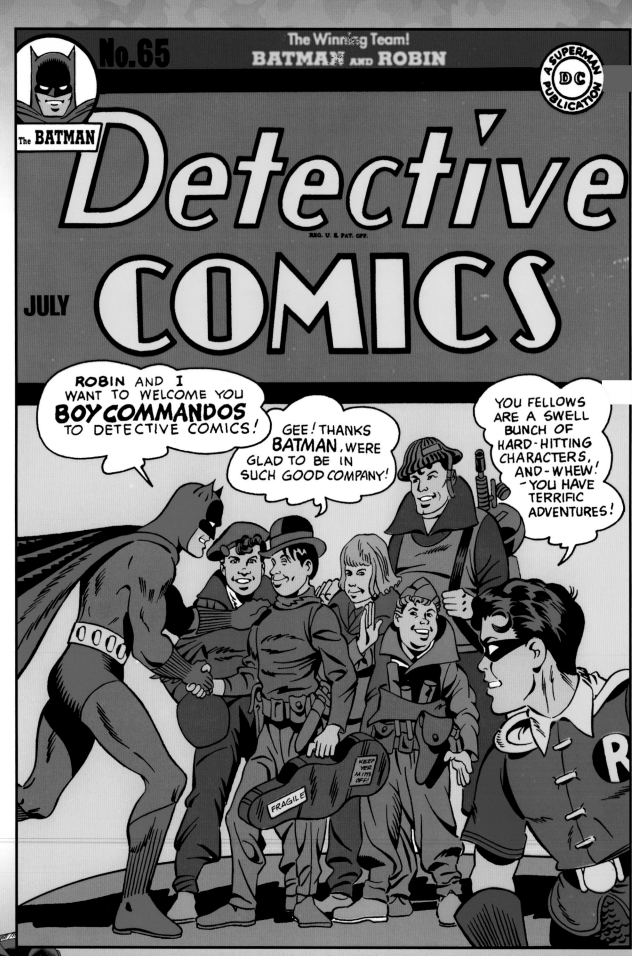

Detective Comics #65 (July 1942) - cover art: Jack Kirby (pencils), with Joe Simon (inks on Boy Commandos) & Jerry Robinson (inks on Batman & Robin)

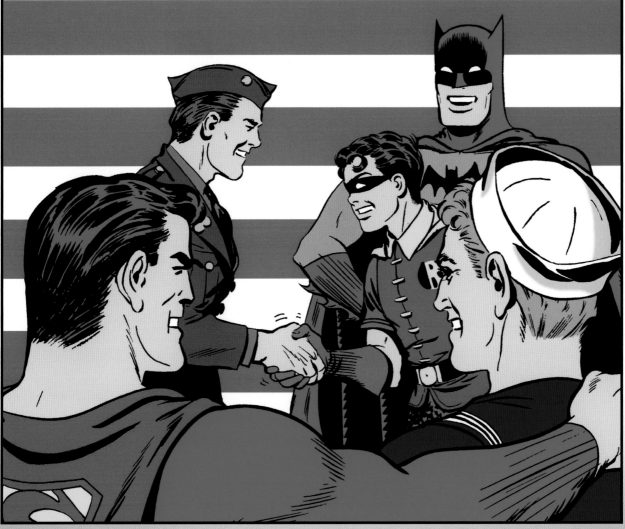

No.6
SUMMER ISSUE
WORLD'S FINEST COMICS
96 PAGES
15¢

105

World's Finest Comics #6 (Summer 1942) - cover art: Fred Ray

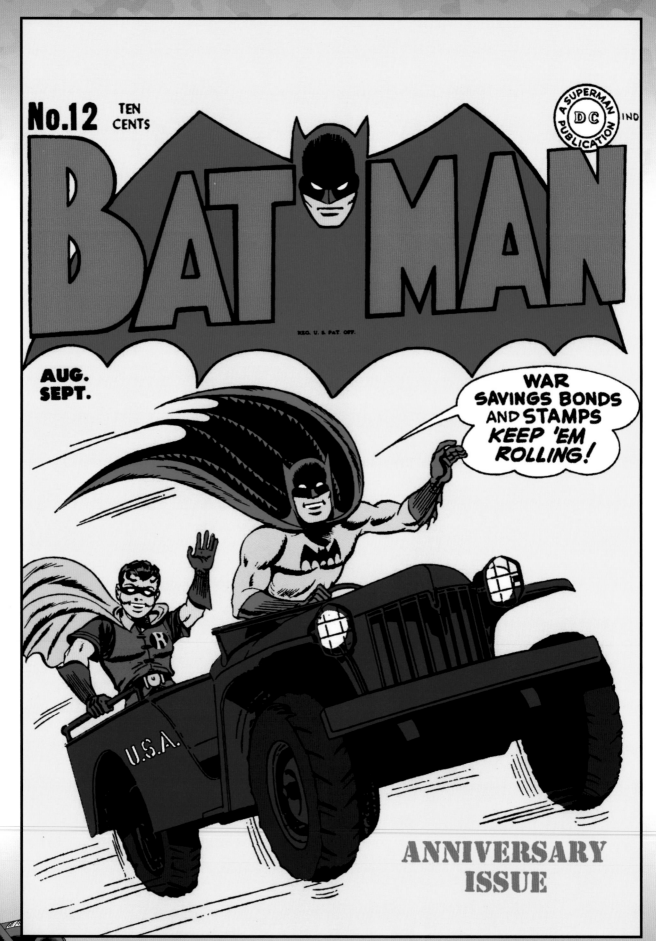

Batman #12 (Aug-Sept. 1942) - cover art: Jerry Robinson (pencils) & Robinson & George Roussos (inks)

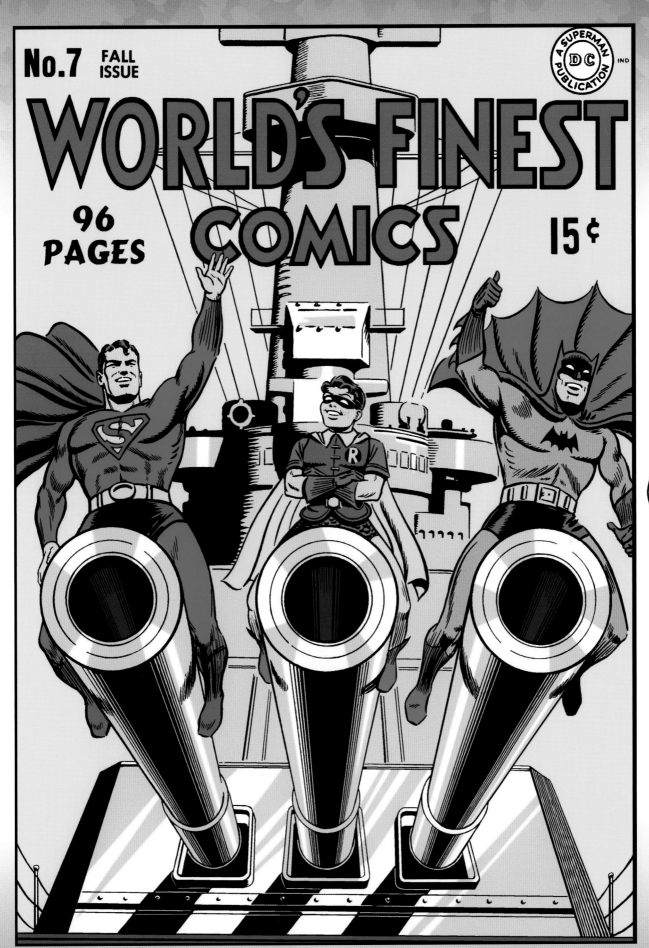

World's Finest Comics #7 (Fall 1942) - cover art: Jack Burnley

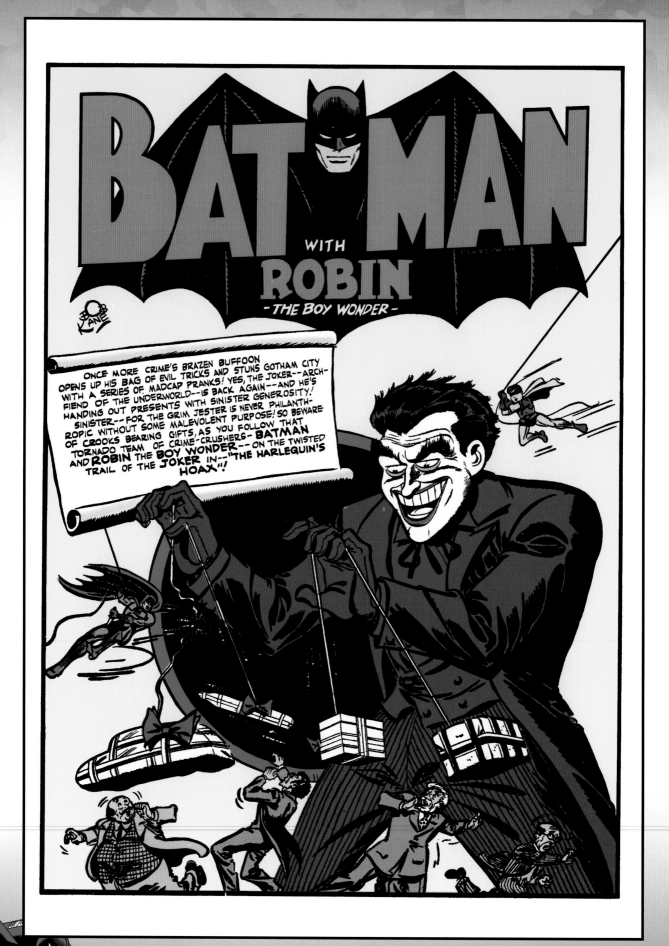

*Detective Comics #69 (Nov. 1942) - script: Joe Greene - art: Bob Kane (pencils) &
Jerry Robinson & George Roussos (inks)*

IN THE HEART OF PEACEFUL GOTHAM CITY, A MELANCHOLY MAN WITH LAUGHING FACE PLOTS AN EVIL GAME!

HA! HA! THIS SHALL BE MY GREATEST COUP!

THAT SAME MORNING, AT THE HOME OF CHARLES SAUNDERS...

PACKAGE FOR YOU, MR. SAUNDERS!

HMM-- WONDER WHAT IT CAN BE? BRING IT IN, WILL YOU, BILL?

A RADIO WITHOUT A LOUDSPEAKER! WHAT KIND OF GAG IS THAT?

THERE'S A CARD ENCLOSED!

A gift from the Joker! Quite valuable to you, eh, Saunders?

VALUABLE? THIS IS ANOTHER OF THE JOKER'S CRAZY TRICKS!

I--I DON'T THINK SO! YOU SEE.... THIS IS VALUABLE TO ME!

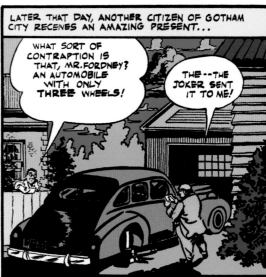

LATER THAT DAY, ANOTHER CITIZEN OF GOTHAM CITY RECEIVES AN AMAZING PRESENT...

WHAT SORT OF CONTRAPTION IS THAT, MR. FORDNEY? AN AUTOMOBILE WITH ONLY THREE WHEELS!

THE--THE JOKER SENT IT TO ME!

109

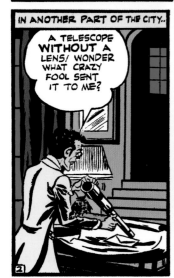

IN ANOTHER PART OF THE CITY..

A TELESCOPE WITHOUT A LENS! WONDER WHAT CRAZY FOOL SENT IT TO ME?

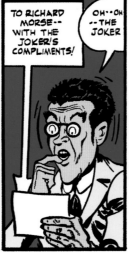

TO RICHARD MORSE-- WITH THE JOKER'S COMPLIMENTS!

OH--OH --THE JOKER

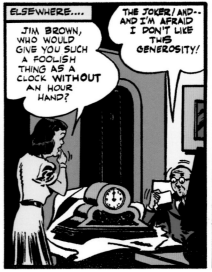

ELSEWHERE....

JIM BROWN, WHO WOULD GIVE YOU SUCH A FOOLISH THING AS A CLOCK WITHOUT AN HOUR HAND?

THE JOKER! AND-- AND I'M AFRAID I DON'T LIKE THIS GENEROSITY!

THE JOKER'S OFF AGAIN! CAN YOU MATCH WITS WITH THIS MASTER OF CRIME? CAN YOU GUESS, BEFORE THE BATMAN DOES, THE MOTIVE FOR THESE QUEER GIFTS? WHAT'S THE JOKER'S GAME THIS TIME?

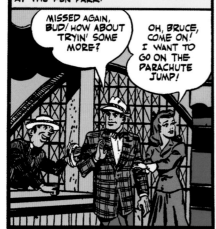

MEANWHILE OTHER PERSONS PLAY A GAME-- A GAME OF CHANCE! BRUCE WAYNE AND LINDA PAGE MAKE MERRY AT THE FUN PARK!

MISSED AGAIN, BUD! HOW ABOUT TRYIN' SOME MORE?

OH, BRUCE, COME ON! I WANT TO GO ON THE PARACHUTE JUMP!

MINUTES LATER... BRUCE AND LINDA ARE BEING PULLED UP 200 FEET INTO THE SKY!

SAY, I HADN'T REALIZED THESE THINGS GO UP SO HIGH!

SISSY! DON'T TELL ME YOU'RE SCARED, BRUCE?

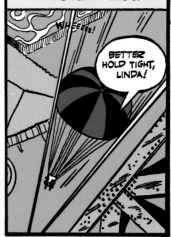

THE 'CHUTE REACHES THE TOP! CONTACT--AND THE DUO BEGINS A THRILLING PLUNGE THRU SPACE!

WHEEEE!

BETTER HOLD TIGHT, LINDA!

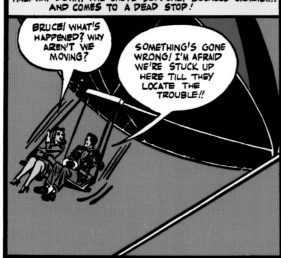

HALFWAY DOWN, THE CHUTE SUDDENLY BOUNCES CRAZILY... AND COMES TO A DEAD STOP!

BRUCE! WHAT'S HAPPENED? WHY AREN'T WE MOVING?

SOMETHING'S GONE WRONG! I'M AFRAID WE'RE STUCK UP HERE TILL THEY LOCATE THE TROUBLE!!

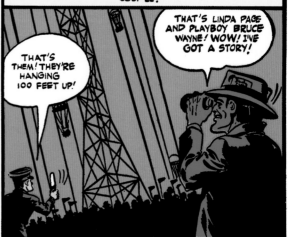

THE NEWS SPREADS LIKE WILDFIRE! SHOUTING, EXCITED HUMANS PUSH FORWARD, EYES TURNED UP TO THE HELPLESS COUPLE!

THAT'S THEM! THEY'RE HANGING 100 FEET UP!

THAT'S LINDA PAGE AND PLAYBOY BRUCE WAYNE! WOW! I'VE GOT A STORY!

ONE INSANE HOUR LATER! SANDWICHES AND A MIKE ARE HAULED UP TO THE PAIR ...

IF ANY OF MY FAMILY ARE LISTENING IN, I DON'T WANT THEM TO WORRY IF I'M LATE FOR SUPPER!

AND IF MY WARD, DICK, IS LISTENING TO MY VOICE, DON'T WORRY IF I'M LATE FOR SUPPER!

2.

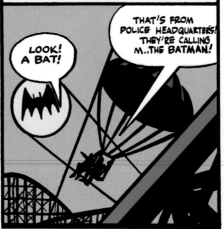

ANOTHER HOUR PASSES... SLOWLY! THEN A MILE-LONG FLOOD OF LIGHT BLAZONS A WEIRD SYMBOL AGAINST THE SKY!

LOOK! A BAT!

THAT'S FROM POLICE HEADQUARTERS! THEY'RE CALLING M...THE BATMAN!

JUST THINK, BRUCE! SOME- WHERE THE BATMAN IS GOING INTO ACTION NOW!

LIKE FUN! HE'S STUCK HERE IN A PARACHUTE!

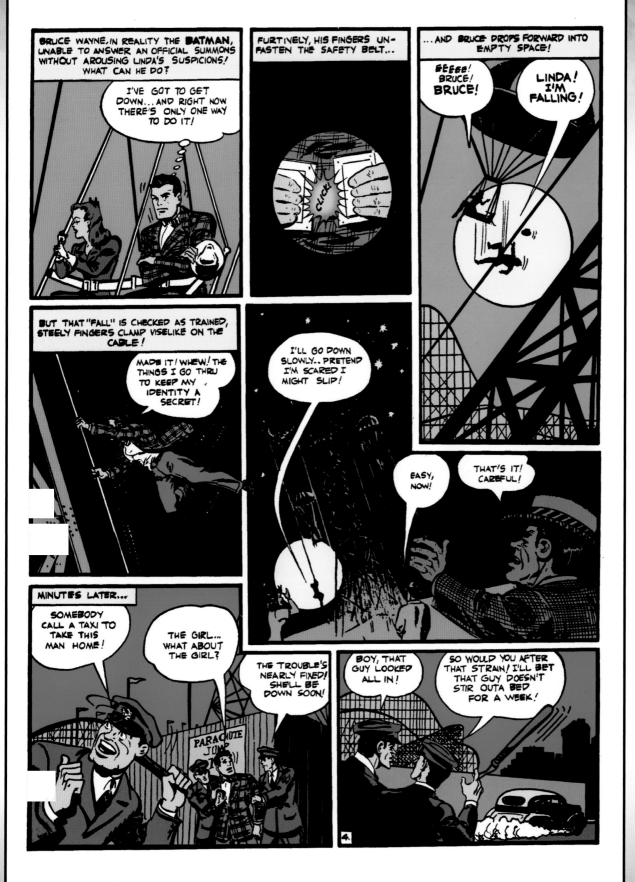

ON THE CONTRARY... FOR, MINUTES AFTER, CLAD IN WEIRD ACTION GARB, THE BATMAN IS DEFINITELY ON THE MOVE!

I'M LATE... GORDON'S PROBABLY WORRYING... WONDER WHAT HE'S GOT ON THE FIRE?

LATER... POLICE HEADQUARTERS... AND BATMAN LISTENS TO THE LATEST CLOWNING OF THE JOKER...

THAT'S OUR CASE! A RADIO WITHOUT A LOUDSPEAKER... AN AUTO WITH THREE WHEELS... A TELESCOPE WITHOUT A LENS...

AND A CLOCK WITHOUT AN HOUR HAND! I KNOW... IT ALL SEEMS ILLOGICAL, CRAZY... LIKE A JIGSAW OF MISMATCHING PARTS...

... BUT THE JOKER ALWAYS FITS THOSE PARTS TOGETHER TO FORM A CRIME PATTERN! I'VE GOT TO STOP THAT MAN... I'VE GOT TO!

WHAT MADCAP MENACE, INDEED, IS THE CUNNING CRIME CLOWN PLANNING? WHAT HAS THE JOKER GOT UP HIS TRICKY SLEEVE?

BUT THE ANSWER IS SOON FORTHCOMING! THE FOLLOWING NIGHT, AS DARKNESS BLANKETS GOTHAM CITY IN ITS SOOTHING FOLDS...

OKAY, JOKER, THE WINDOW'S OPEN!

GOOD! THE COAST IS CLEAR— LET'S GO!

HEY! WHAT ARE YOU DOING BACK HERE?

JUST ROBBING A STORE, OFFICER! ANY OBJECTIONS? HA! HA!

UH!

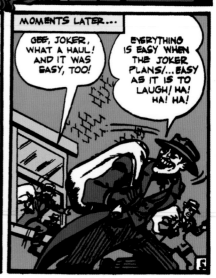

MOMENTS LATER...

GEE, JOKER, WHAT A HAUL! AND IT WAS EASY, TOO!

EVERYTHING IS EASY WHEN THE JOKER PLANS!... EASY AS IT IS TO LAUGH! HA! HA! HA!

MORNING... AND NEWSPAPER HEADLINES SCREAM CRIME AT CITIZENS OF GOTHAM CITY!

WUXTRY! JOKER ROBS DEPARTMENT STORE! WUXTRY!

..AND POLICE FOUND THE BURGLAR ALARMS OFF, BRUCE! THAT'S HOW THE JOKER PULLED THE JOB SO EASILY!

YES... AND NOTICE THE NAME OF THE MANAGER OF THAT STORE... CHARLES SAUNDERS!

WHY... HE'S THE FELLOW WHO RECEIVED THAT RADIO WITHOUT A LOUDSPEAKER FROM THE JOKER! SAY, THINK IT WAS AN INSIDE JOB?

MIGHTY QUEER, DICK! BATMAN AND ROBIN ARE GOING TO DO SOME DETECTIVE WORK TONIGHT!

SNAP

NIGHT COMES... AND LIKE NOCTURNAL, AWAKENING CREATURES OF THE DARKNESS, THE BATMAN AND ROBIN MOVE ON THE PROWL!

ONE OF THE MEN, FORDNEY, IS SUPERINTENDENT OF A CAMERA CONCERN! ROBIN, IF THE JOKER STICKS TO FORMULA AS IN THE PAST... WE'LL MEET HIM TONIGHT!

MAYBE... BUT I DON'T SEE WHY A MAN SHOULD HELP THE JOKER IN RETURN FOR A CRAZY GIFT!

THE STORAGE WAREHOUSE OF THE SHUTTER CAMERA CO...

THESE BARRELS WERE STORED HERE TONIGHT, AND FORDNEY SAID NOT TO TOUCH 'EM! WONDER WHAT'S IN 'EM?

YOU WON'T HAVE TO WONDER LONG! HA! HA!

OHH-HH-HH...

113

HAW! HAW! THAT WAS A SWELL STUNT, JOKER, SNEAKING US IN INSIDE THE BARRELS!

YES.. FORDNEY WAS VERY OBLIGING, WASN'T HE? NOW LET'S GET AT THOSE EXPENSIVE CAMERAS STORED IN HERE!

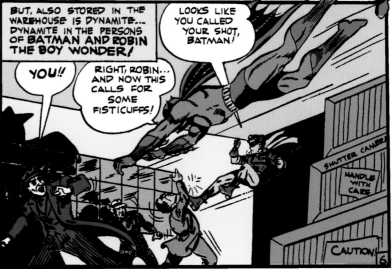
BUT, ALSO STORED IN THE WAREHOUSE IS DYNAMITE... DYNAMITE IN THE PERSONS OF BATMAN AND ROBIN THE BOY WONDER!

YOU!!

RIGHT, ROBIN... AND NOW THIS CALLS FOR SOME FISTICUFFS!

LOOKS LIKE YOU CALLED YOUR SHOT, BATMAN!

SHUTTER CAMERA

HANDLE WITH CARE

CAUTION!

6

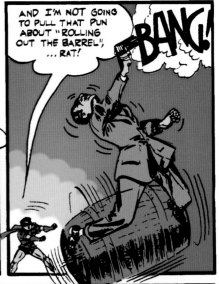

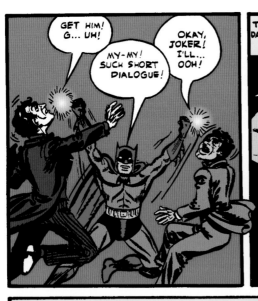
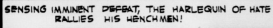

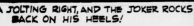
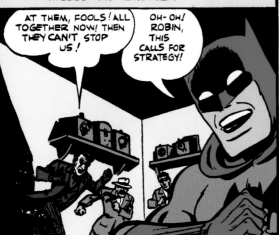
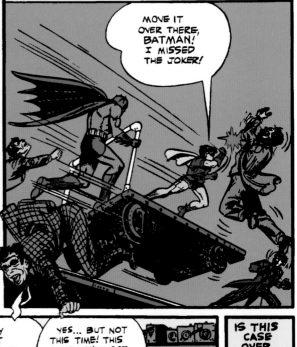

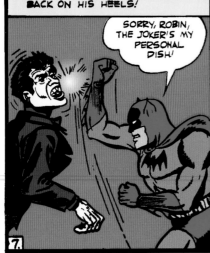
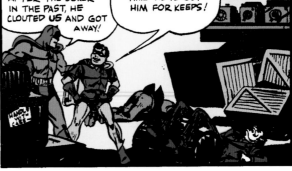

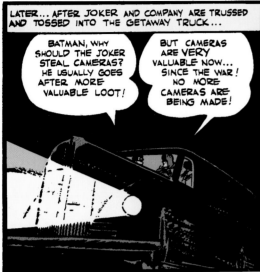

LATER... AFTER JOKER AND COMPANY ARE TRUSSED AND TOSSED INTO THE GETAWAY TRUCK...

BATMAN, WHY SHOULD THE JOKER STEAL CAMERAS? HE USUALLY GOES AFTER MORE VALUABLE LOOT!

BUT CAMERAS ARE VERY VALUABLE NOW... SINCE THE WAR! NO MORE CAMERAS ARE BEING MADE!

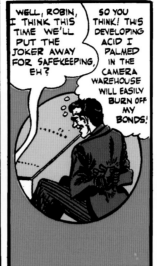

WELL, ROBIN, I THINK THIS TIME WE'LL PUT THE JOKER AWAY FOR SAFEKEEPING, EH?

SO YOU THINK! THIS DEVELOPING ACID I PALMED IN THE CAMERA WAREHOUSE WILL EASILY BURN OFF MY BONDS!

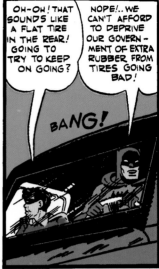

OH-OH! THAT SOUNDS LIKE A FLAT TIRE IN THE REAR! GOING TO TRY TO KEEP ON GOING?

NOPE!.. WE CAN'T AFFORD TO DEPRIVE OUR GOVERNMENT OF EXTRA RUBBER FROM TIRES GOING BAD!

BANG!

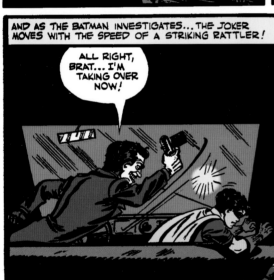

AND AS THE BATMAN INVESTIGATES... THE JOKER MOVES WITH THE SPEED OF A STRIKING RATTLER!

ALL RIGHT, BRAT... I'M TAKING OVER NOW!

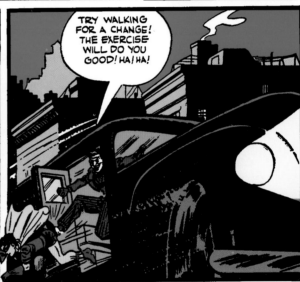

TRY WALKING FOR A CHANGE! THE EXERCISE WILL DO YOU GOOD! HA! HA!

115

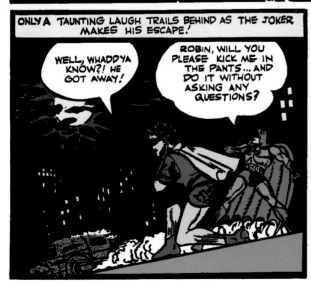

ONLY A TAUNTING LAUGH TRAILS BEHIND AS THE JOKER MAKES HIS ESCAPE!

WELL, WHADDYA KNOW?! HE GOT AWAY!

ROBIN, WILL YOU PLEASE KICK ME IN THE PANTS... AND DO IT WITHOUT ASKING ANY QUESTIONS?

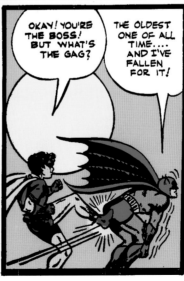

OKAY! YOU'RE THE BOSS! BUT WHAT'S THE GAG?

THE OLDEST ONE OF ALL TIME.... AND I'VE FALLEN FOR IT!

BEHOLD! OUR "BLOWOUT!" IT WAS JUST A FLASH BULB, DROPPED BY THE JOKER!

8.

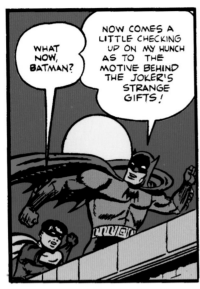

WHAT NOW, BATMAN?

NOW COMES A LITTLE CHECKING UP ON MY HUNCH AS TO THE MOTIVE BEHIND THE JOKER'S STRANGE GIFTS!

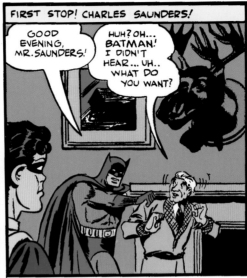

FIRST STOP! CHARLES SAUNDERS!

GOOD EVENING, MR. SAUNDERS!

HUH? OH... BATMAN! I DIDN'T HEAR... UH.. WHAT DO YOU WANT?

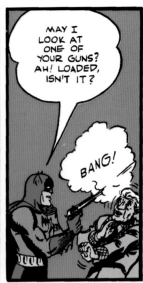

MAY I LOOK AT ONE OF YOUR GUNS? AH! LOADED, ISN'T IT?

BANG!

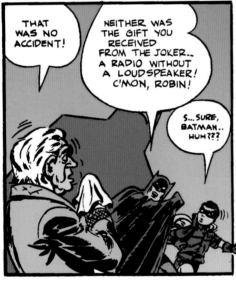

THAT WAS NO ACCIDENT!

NEITHER WAS THE GIFT YOU RECEIVED FROM THE JOKER.. A RADIO WITHOUT A LOUDSPEAKER! C'MON, ROBIN!

S...SURE, BATMAN.. HUH???

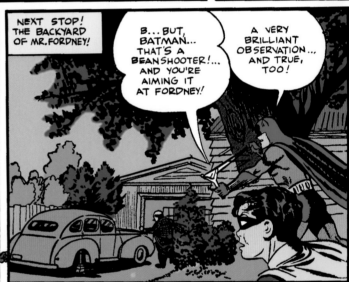

NEXT STOP! THE BACKYARD OF MR. FORDNEY!

B...BUT, BATMAN... THAT'S A BEANSHOOTER!... AND YOU'RE AIMING IT AT FORDNEY!

A VERY BRILLIANT OBSERVATION... AND TRUE, TOO!

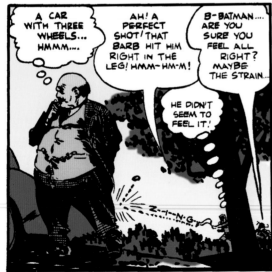

A CAR WITH THREE WHEELS... HMMM....

AH! A PERFECT SHOT! THAT BARB HIT HIM RIGHT IN THE LEG! HMM-HM-M!

B-BATMAN.... ARE YOU SURE YOU FEEL ALL RIGHT? MAYBE THE STRAIN...

HE DIDN'T SEEM TO FEEL IT!

Z-I-N-G-

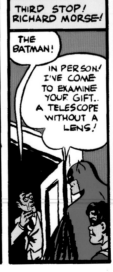

THIRD STOP! RICHARD MORSE!

THE BATMAN!

IN PERSON! I'VE COME TO EXAMINE YOUR GIFT.. A TELESCOPE WITHOUT A LENS!

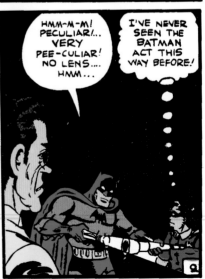

HMM-M-M! PECULIAR!... VERY PEE-CULIAR! NO LENS.... HMM...

I'VE NEVER SEEN THE BATMAN ACT THIS WAY BEFORE!

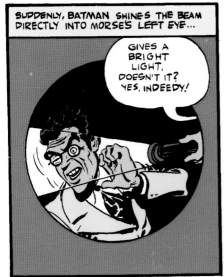

SUDDENLY, BATMAN SHINES THE BEAM DIRECTLY INTO MORSE'S LEFT EYE...

GIVES A BRIGHT LIGHT, DOESN'T IT? YES, INDEEDY!

BATMAN! WHAT'S WRONG WITH YOU? YOU'RE ACTING...

?

... CRAZY, IS THE WORD, ROBIN! TUM-DE-DUM! C'MON, WATSON..... SHERLOCK HOLMES HAS ONE MORE STOP TO MAKE!

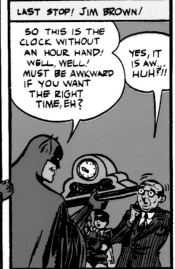

LAST STOP! JIM BROWN!

SO THIS IS THE CLOCK WITHOUT AN HOUR HAND! WELL, WELL! MUST BE AWKWARD IF YOU WANT THE RIGHT TIME, EH?

YES, IT IS AW... HUH?!!

OOPS! SORRY! BUTTERFINGERS, THAT'S ME!

THAT'S ALL RIGHT! IT DIDN'T HURT MY HAND!

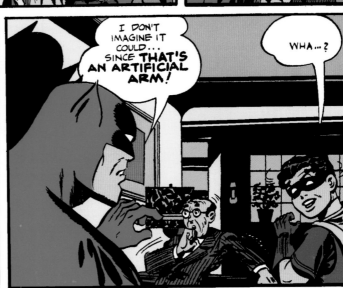

I DON'T IMAGINE IT COULD... SINCE **THAT'S AN ARTIFICIAL ARM!**

WHA...?

117

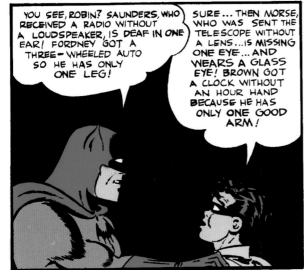

YOU SEE, ROBIN? SAUNDERS, WHO RECEIVED A RADIO WITHOUT A LOUDSPEAKER, IS DEAF IN ONE EAR! FORDNEY GOT A THREE-WHEELED AUTO SO HE HAS ONLY ONE LEG!

SURE... THEN MORSE, WHO WAS SENT THE TELESCOPE WITHOUT A LENS...IS MISSING ONE EYE... AND WEARS A GLASS EYE! BROWN GOT A CLOCK WITHOUT AN HOUR HAND BECAUSE HE HAS ONLY ONE GOOD ARM!

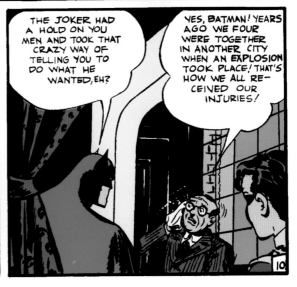

THE JOKER HAD A HOLD ON YOU MEN AND TOOK THAT CRAZY WAY OF TELLING YOU TO DO WHAT HE WANTED, EH?

YES, BATMAN! YEARS AGO WE FOUR WERE TOGETHER IN ANOTHER CITY WHEN AN EXPLOSION TOOK PLACE! THAT'S HOW WE ALL RE-CEIVED OUR INJURIES!

10

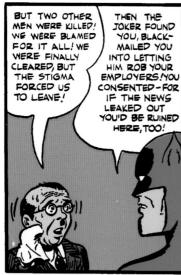

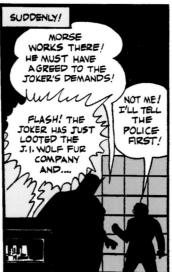

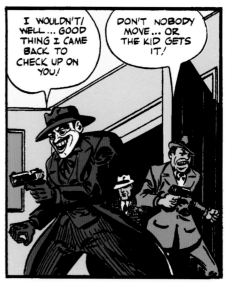

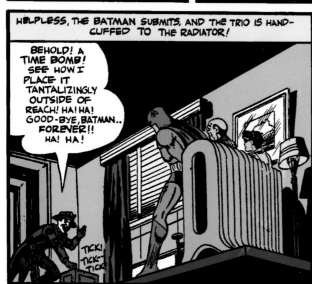

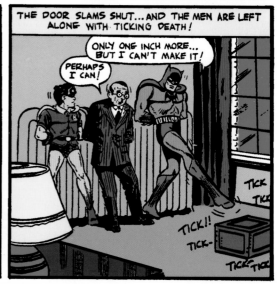

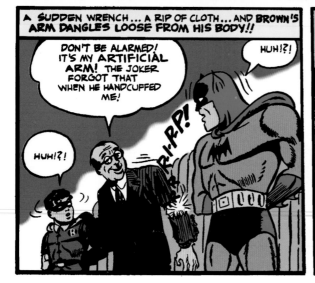

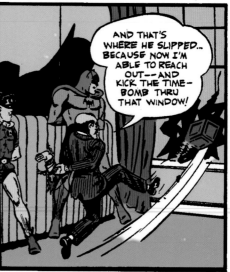

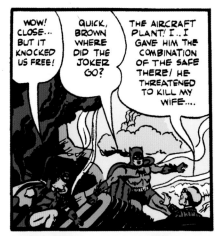

WOW! CLOSE... BUT IT KNOCKED US FREE!

QUICK, BROWN WHERE DID THE JOKER GO?

THE AIRCRAFT PLANT! I..I GAVE HIM THE COMBINATION OF THE SAFE THERE! HE THREATENED TO KILL MY WIFE....

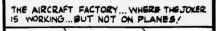

THE AIRCRAFT FACTORY... WHERE THE JOKER IS WORKING... BUT NOT ON PLANES!

THAT KNOCKOUT GAS SURE TOOK CARE OF THE GUARDS!

YES... AND SOON THE DIAMONDS INSIDE WILL BE MINE!

DIAMONDS? WHAT'S DIAMONDS DOIN' IN THIS PLACE?

THEY'RE PUT IN TOOLS USED FOR SPECIAL, DELICATE DRILLING JOBS!

NOT IN THIS PLACE THEY WON'T! HA! HA!

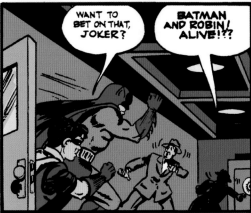

WANT TO BET ON THAT, JOKER?

BATMAN AND ROBIN, ALIVE!!?

TERROR-STRICKEN, THE MOBSTERS FLEE FROM THE CRIME-BUSTERS WHO REFUSE TO DIE!

THEY AIN'T HUMAN!

I'M LEAVIN'!

YOU CURSED, INTERFERING DEVILS!

119

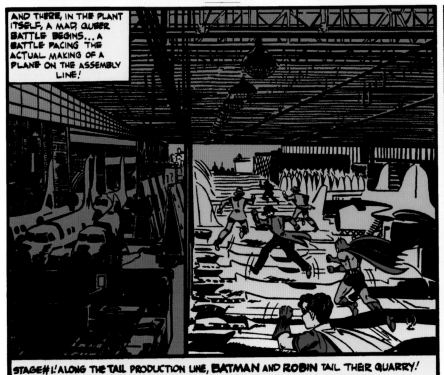

AND THERE, IN THE PLANT ITSELF, A MAD, QUEER BATTLE BEGINS... A BATTLE PACING THE ACTUAL MAKING OF A PLANE ON THE ASSEMBLY LINE!

STAGE #1! ALONG THE TAIL PRODUCTION LINE, BATMAN AND ROBIN TAIL THEIR QUARRY!

STAGE #2! WHERE FIXTURES FOR OUTBOARD WING PANELS ARE SET UP, ROBIN DOES SOME FIXING!

BOY, WHAT A SET-UP!

12.

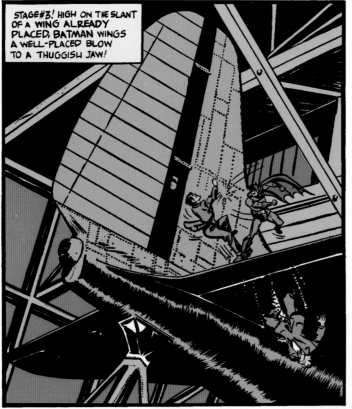

STAGE#3! HIGH ON THE SLANT OF A WING ALREADY PLACED, BATMAN WINGS A WELL-PLACED BLOW TO A THUGGISH JAW!

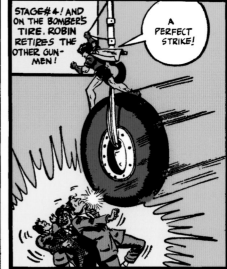

STAGE#4! AND ON THE BOMBER'S TIRE, ROBIN RETIRES THE OTHER GUN-MEN!

A PERFECT STRIKE!

THE MAD CHASE LEADS OUTSIDE INTO THE YARD OF THE HUGE PLANT. AS THE JOKER CLAMBERS TO A PROPELLERLESS BOMBER, THE BATMAN PROPELS HIMSELF THRU THE AIR!

NOT SO FAST, JOKER!

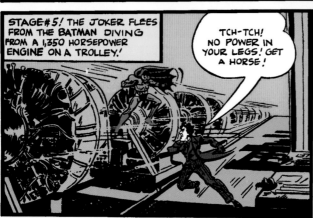

STAGE#5! THE JOKER FLEES FROM THE BATMAN DIVING FROM A 1,350 HORSEPOWER ENGINE ON A TROLLEY!

TCH-TCH! NO POWER IN YOUR LEGS! GET A HORSE!

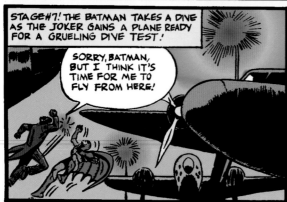

STAGE#7! THE BATMAN TAKES A DIVE AS THE JOKER GAINS A PLANE READY FOR A GRUELING DIVE TEST!

SORRY, BATMAN, BUT I THINK IT'S TIME FOR ME TO FLY FROM HERE!

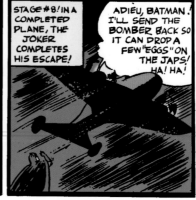

STAGE #8! IN A COMPLETED PLANE, THE JOKER COMPLETES HIS ESCAPE!

ADIEU, BATMAN! I'LL SEND THE BOMBER BACK SO IT CAN DROP A FEW "EGGS" ON THE JAPS! HA! HA!

AND SO THE BOMBER DWINDLES TO A MERE SPECK ON THE HORIZON...

WELL, THERE HE GOES!

HE'LL BE BACK! AND WHEN HE DOES, WE'LL MEET HIM... AND BOY, WILL THAT BE A SCRAP!

THE END

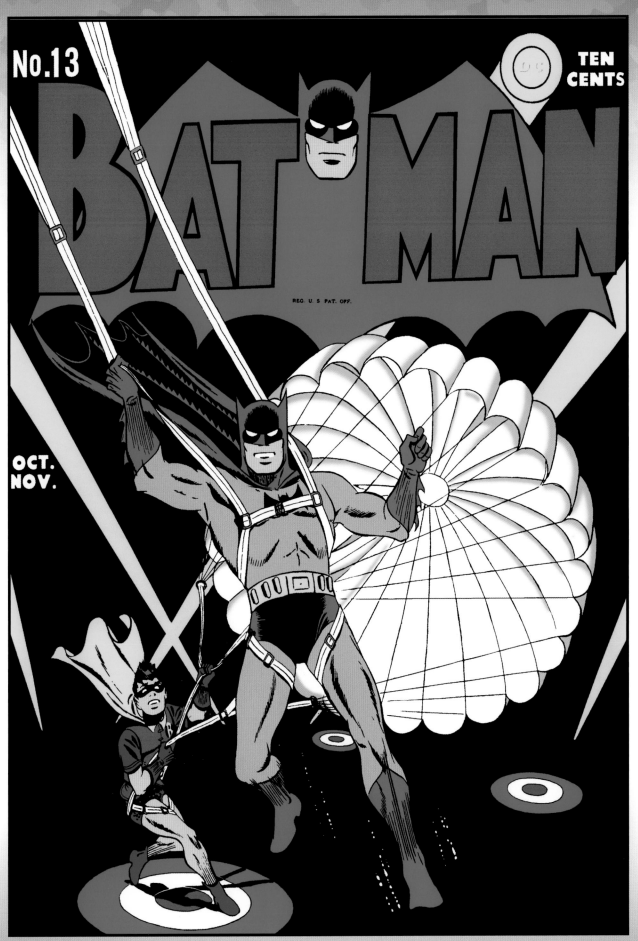

Batman #13 (Oct.-Nov. 1942) - cover art: Jerry Robinson

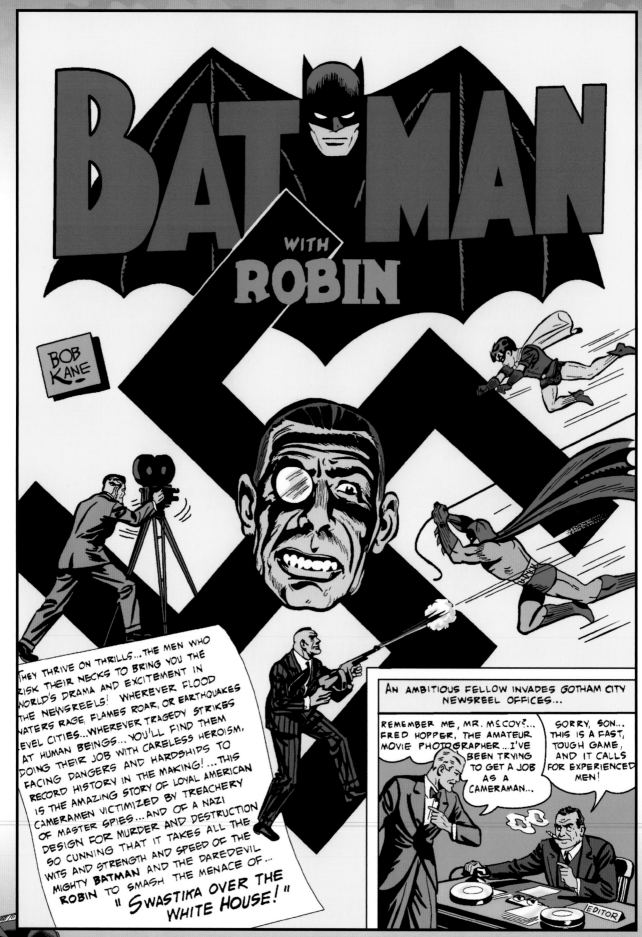

Batman #14 (Oct.-Nov. 1942) - script: Don Cameron - art: Jack Burnley (pencils) & Jack & Ray Burnley (inks)

BUT HOW CAN I GET EXPERIENCE WITHOUT A JOB? I'LL WORK FOR NOTHING TO LEARN THE ROPES! I'LL..

PERSISTENT, AREN'T YOU? WELL, I'LL GIVE YOU A CHANCE!

J. PEERLESS MORTON, THE MULTI-MILLIONAIRE, IS HAVING A BIRTHDAY PARTY GET PICTURES OF THAT, AND I'LL HIRE YOU!

GEE, THAT'S SWELL, MR. McCOY, I'LL DO IT!

BUT ANY RESEMBLANCE TO BIG-HEARTEDNESS IN EDITOR McCOY'S OFFER IS PURELY ACCIDENTAL...

THERE'S ONE AMATEUR WHO WON'T PESTER ME AGAIN! I ONLY HOPE MORTON'S GUARDS DON'T SMASH HIS HEAD AS WELL AS HIS CAMERA!

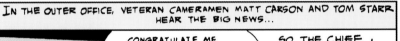

IN THE OUTER OFFICE, VETERAN CAMERAMEN MATT CARSON AND TOM STARR HEAR THE BIG NEWS...

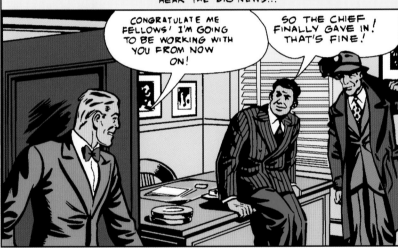

CONGRATULATE ME FELLOWS! I'M GOING TO BE WORKING WITH YOU FROM NOW ON!

SO THE CHIEF FINALLY GAVE IN! THAT'S FINE!

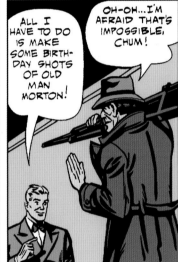

ALL I HAVE TO DO IS MAKE SOME BIRTH-DAY SHOTS OF OLD MAN MORTON!

OH-OH...I'M AFRAID THAT'S IMPOSSIBLE, CHUM!

123

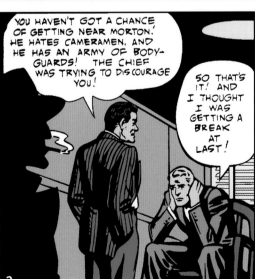

YOU HAVEN'T GOT A CHANCE OF GETTING NEAR MORTON! HE HATES CAMERAMEN, AND HE HAS AN ARMY OF BODY-GUARDS! THE CHIEF WAS TRYING TO DISCOURAGE YOU!

SO THAT'S IT! AND I THOUGHT I WAS GETTING A BREAK AT LAST!

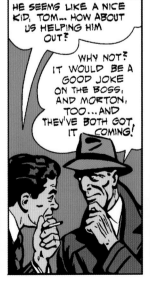

HE SEEMS LIKE A NICE KID, TOM... HOW ABOUT US HELPING HIM OUT?

WHY NOT? IT WOULD BE A GOOD JOKE ON THE BOSS, AND MORTON, TOO... AND THEY'VE BOTH GOT IT COMING!

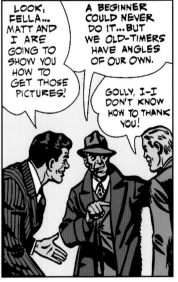

LOOK, FELLA... MATT AND I ARE GOING TO SHOW YOU HOW TO GET THOSE PICTURES!

A BEGINNER COULD NEVER DO IT...BUT WE OLD-TIMERS HAVE ANGLES OF OUR OWN.

GOLLY, I-I DON'T KNOW HOW TO THANK YOU!

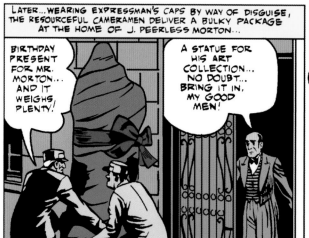

LATER...WEARING EXPRESSMAN'S CAPS BY WAY OF DISGUISE, THE RESOURCEFUL CAMERAMEN DELIVER A BULKY PACKAGE AT THE HOME OF J. PEERLESS MORTON...

BIRTHDAY PRESENT FOR MR. MORTON... AND IT WEIGHS PLENTY!

A STATUE FOR HIS ART COLLECTION... NO DOUBT... BRING IT IN, MY GOOD MEN!

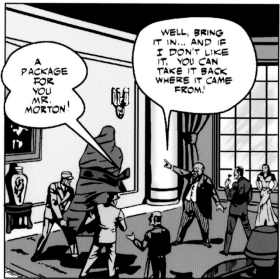

A PACKAGE FOR YOU MR. MORTON!

WELL, BRING IT IN... AND IF I DON'T LIKE IT, YOU CAN TAKE IT BACK WHERE IT CAME FROM!

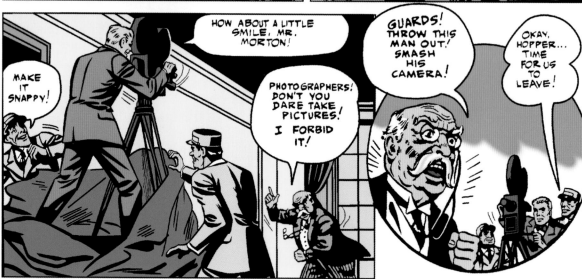

HOW ABOUT A LITTLE SMILE, MR. MORTON!

MAKE IT SNAPPY!

PHOTOGRAPHERS! DON'T YOU DARE TAKE PICTURES! I FORBID IT!

GUARDS! THROW THIS MAN OUT! SMASH HIS CAMERA!

OKAY, HOPPER... TIME FOR US TO LEAVE!

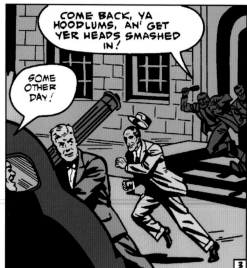

COME BACK, YA HOODLUMS, AN' GET YER HEADS SMASHED IN!

SOME OTHER DAY!

WHEW! THAT WAS CLOSE! McCOY WAS RIGHT WHEN HE SAID IT WAS A TOUGH GAME!

YOU'LL LIKE IT WHEN YOU LEARN THE ROPES... AND WE'LL TEACH 'EM TO YOU!

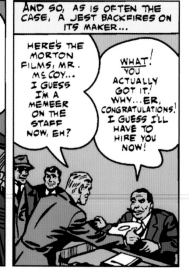

AND SO, AS IS OFTEN THE CASE, A JEST BACKFIRES ON ITS MAKER...

HERE'S THE MORTON FILMS, MR. McCOY... I GUESS I'M A MEMBER ON THE STAFF NOW, EH?

WHAT! YOU ACTUALLY GOT IT! WHY...ER, CONGRATULATIONS! I GUESS I'LL HAVE TO HIRE YOU NOW!

WITH THE EASY-GOING COMRADESHIP OF THEIR CALLING, THE NEWS-REEL VETERANS "ADOPT" YOUNG FRED HOPPER... GUIDE HIM THROUGH HIS FIRST ASSIGNMENTS... EVEN INVITE HIM TO SHARE THEIR APARTMENT...

WE'RE GOING TO MAKE WAR INDUSTRY PICTURES NEXT...AND THE CHIEF SAYS THE THREE OF US CAN WORK TOGETHER!

YOU'RE REAL PALS! I'D HAVE BEEN SUNK WITHOUT YOU...

HA! I'VE DONE IT! I'M IN! I'VE TRICKED THOSE AMERICANS! THE LEADER WILL BE PLEASED!

WHAT'S THIS ABOUT "THE LEADER?" PERHAPS WE'D BETTER KEEP AN EYE ON THIS YOUNG STRANGER AS HE WALKS ALONE, LATE AT NIGHT...

AH, MY YOUNG FRIEND ... CAN I SHOW YOU SOMETHING VERY OLD, OUT OF THE PAST?

NO, BUT YOU MAY SHOW ME SOMETHING NEW, HAVING TO DO WITH THE FUTURE!

...TO AN OUT-OF-THE WAY ANTIQUE SHOP IN A SIDE STREET.

YOU KNOW THE PASS-WORD... I TRUST YOU BRING GOOD NEWS!

THAT IS FOR THE LEADER TO JUDGE! YOU HAVE NO RIGHT TO QUESTION ME.

A HIDDEN BUTTON SLIDES BACK A SECRET PANEL IN THE REAR WALL...

YOU WILL FIND THE COUNT IN THE CONFERENCE ROOM...

I KNOW... I HAVE BEEN HERE BEFORE!

125

COUNT FELIX... OUR PLAN HAS SUCCEEDED! I AM A NEWSREEL CAMERAMAN ASSIGNED TO PHOTOGRAPH WAR INDUSTRIES!

AH! FRITZ HOFFNER! THE FUEHRER HIMSELF SHALL HEAR OF THIS!

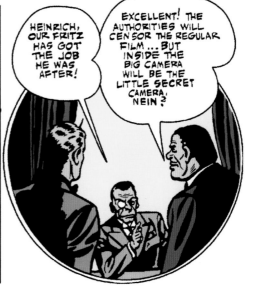

HEINRICH, OUR FRITZ HAS GOT THE JOB HE WAS AFTER!

EXCELLENT! THE AUTHORITIES WILL CENSOR THE REGULAR FILM ... BUT INSIDE THE BIG CAMERA WILL BE THE LITTLE SECRET CAMERA, NEIN?

4

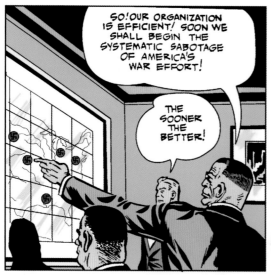

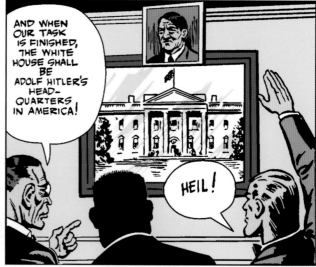

At last we know! Fred Hopper... alias Fritz Hoffner... is a Nazi spy! Already his cunning brain and pleasant manners have made him the friend of Americans and gained him entry to the places where vital secrets are hidden... and now his treachery is about to be turned against the BATMAN himself!

Next day, an awesome team of battlers perform in the projection room of the newsreel company...

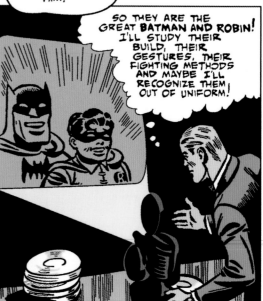

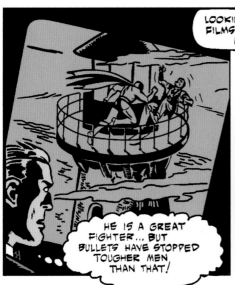

LOOKING OVER THE OLD FILMS IN THE FILES, EH, FRED?

MATT AND I MADE THOSE PICTURES OF THE *BATMAN* MONTHS AGO!

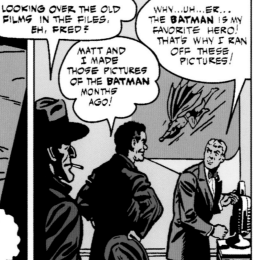

WHY...UH...ER... THE *BATMAN* IS MY FAVORITE HERO! THAT'S WHY I RAN OFF THESE PICTURES!

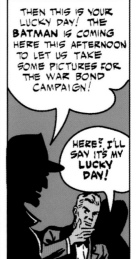

THEN THIS IS YOUR LUCKY DAY! THE *BATMAN* IS COMING HERE THIS AFTERNOON TO LET US TAKE SOME PICTURES FOR THE WAR BOND CAMPAIGN!

HERE? I'LL SAY IT'S MY LUCKY DAY!

HE IS A GREAT FIGHTER... BUT BULLETS HAVE STOPPED TOUGHER MEN THAN THAT!

MINUTES LATER, THE NAZI SPYMASTER RECEIVES A PHONE CALL IN HIS SECRET OFFICE...

THE *BATMAN?* AH, FRITZ...YOU SHOULD RECEIVE THE IRON CROSS FOR THIS! I SHALL SEND OUR MOST DEPENDABLE ASSASSIN IMMEDIATELY!

THAT AFTERNOON... A FAMOUS PAIR PREPARES TO AID THE NATION'S WAR EFFORT...

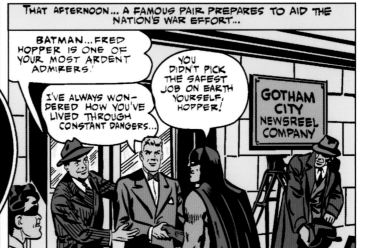

BATMAN...FRED HOPPER IS ONE OF YOUR MOST ARDENT ADMIRERS!

I'VE ALWAYS WONDERED HOW YOU'VE LIVED THROUGH CONSTANT DANGERS...

YOU DIDN'T PICK THE SAFEST JOB ON EARTH YOURSELF, HOPPER!

GOTHAM CITY NEWSREEL COMPANY

127

UNNOTICED, A BLACK SEDAN CREEPS NEAR THE LITTLE GROUP...

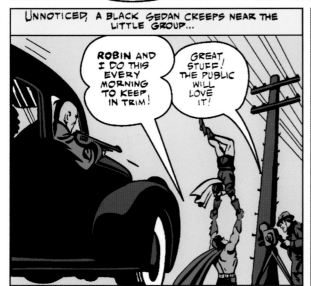

ROBIN AND I DO THIS EVERY MORNING TO KEEP IN TRIM!

GREAT STUFF! THE PUBLIC WILL LOVE IT!

Suddenly...

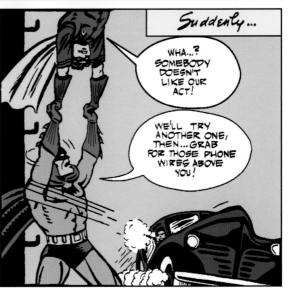

WHA...? SOMEBODY DOESN'T LIKE OUR ACT!

WE'LL TRY ANOTHER ONE, THEN...GRAB FOR THOSE PHONE WIRES ABOVE YOU!

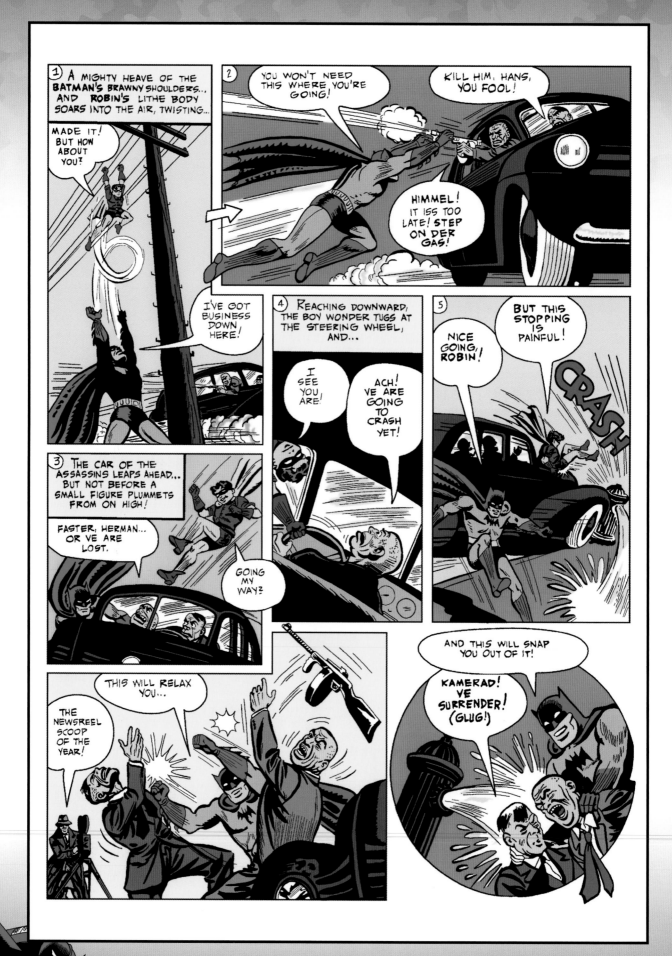

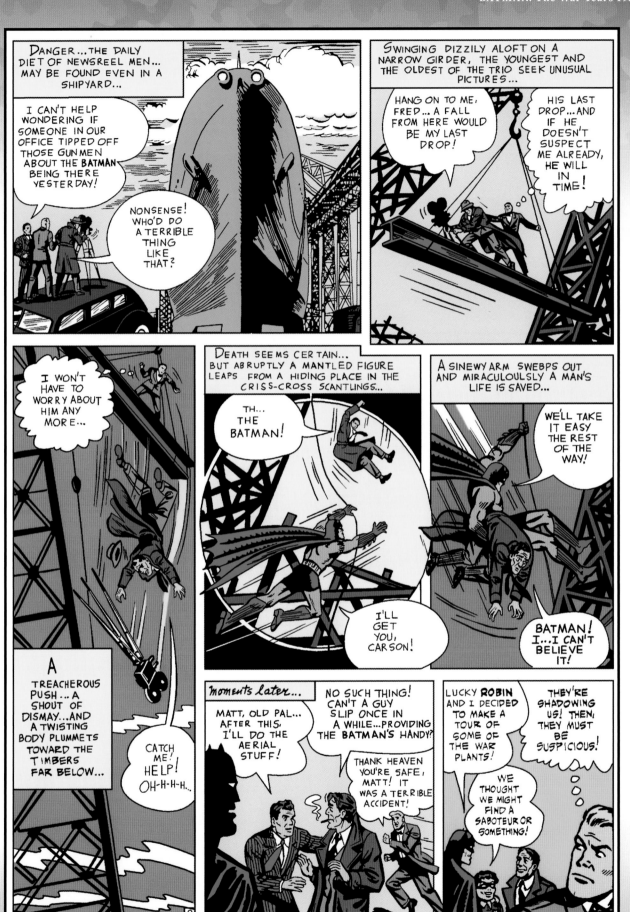

Regulations require that all films of war production be censored before showing...

HERES EVERYTHING MY CAMERA GOT, CAPTAIN!

WE'LL DEVELOP AND CHECK THEM, AND SEND THEM TO YOUR OFFICE... EXCEPT FOR THE PARTS WE CUT OUT!

But as soon as the young Nazi agent is alone...

HOW EASY IT IS TO TRICK PEOPLE OF THESE TRUSTING DEMOCRACIES! IN THIS MINIATURE CAMERA ARE ALL THE PICTURES THE LARGER ONE TOOK... BUT UNCENSORED!

In the heart of the enemy spy web, a very private show takes place...

ONE OF THE BIG BOMBER PLANTS... I HAVE MADE NOTES ABOUT THE MANNER IN WHICH IT IS GUARDED!

WHEN IT IS BLOWN UP BY OUR AGENTS, IT WILL MAKE A PRETTIER PICTURE! HA! HA! HA!

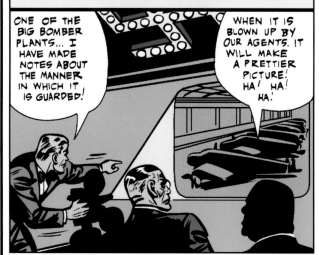

STOP THE FILM! THESE WILL MAKE A SPECTACULAR BEGINNING FOR ONE CAMPAIGN OF SABOTAGE!

STORAGE TANKS FOR THE SPECIAL HIGH-TEST GASOLINE THAT TAKES AMERICAN BOMBERS ACROSS THE OCEAN...

Meanwhile, in the home of Bruce Wayne and his young ward Dick Grayson, who in reality are the BATMAN and ROBIN...

THOSE FELLOWS WHO TRIED TO KILL US WON'T TALK TO THE POLICE...BUT THERE'S NO DOUBT THEY'RE MEMBERS OF A NAZI SPY GROUP!

AND YOU STILL THINK SOMEONE IN THAT NEWSREEL OFFICE PUT US ON THE SPOT?

NO ONE ELSE KNEW WE WERE GOING TO BE THERE... THAT'S WHY WE'RE KEEPING AN EYE EVERY NIGHT ON THE PLACES THOSE CAMERAMEN HAVE VISITED!

ALL THE NEWSREEL FELLOWS I'VE MET HAVE BEEN SWELL...I'D HATE TO THINK OF ANY OF THEM MIXED UP IN A SABOTAGE!

Night... and a swift black shape streaks through the industrial suburbs of Gotham City... *THE BATMOBILE*...

EVERYTHING'S UNDER CONTROL AT THE PLANE FACTORY AND SHIPYARDS. WHERE DO WE GO FROM HERE?

YOU'LL SEE!

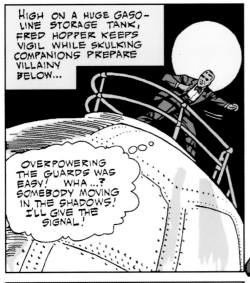

HIGH ON A HUGE GASO-LINE STORAGE TANK, FRED HOPPER KEEPS VIGIL WHILE SKULKING COMPANIONS PREPARE VILLAINY BELOW...

OVERPOWERING THE GUARDS WAS EASY! WHA...? SOMEBODY MOVING IN THE SHADOWS! I'LL GIVE THE SIGNAL!

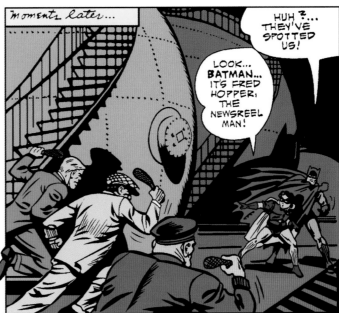

moments later...

HUH?... THEY'VE SPOTTED US!

LOOK... BATMAN... IT'S FRED HOPPER, THE NEWSREEL MAN!

CLUBS RISE AND FALL SAVAGELY BEFORE THE SURPRISED HEROES CAN DEFEND THEMSELVES AND...

YOU ROTTEN DOUBLE-CROSSER, I'LL...AHH...

THE STUPID BRAT, TRYING TO FIGHT WITH ME... FRITZ HOFFNER!

DER BATMAN'S FINISHED! HEIL HITLER!

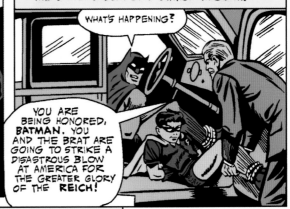

FINISHED? IT BEGINS TO LOOK THAT WAY, AS THE DAZED PAIR TIGHTLY BOUND, IS THRUST INTO THE DRIVER'S SEAT OF A STATION WAGON...

WHAT'S HAPPENING?

YOU ARE BEING HONORED, BATMAN. YOU AND THE BRAT ARE GOING TO STRIKE A DISASTROUS BLOW AT AMERICA FOR THE GREATER GLORY OF THE REICH!

131

THE HOOD OF THIS CAR IS LOADED WITH DYNAMITE, AND THE BODY IS WITH OIL-SOAKED RAGS WHICH WE SHALL SET AFIRE! WE SHALL RETIRE TO A SAFE DISTANCE AND AIM IT AT THE GASOLINE TANKS!...

YOU, AND YOUR CRIMINAL NAZI MASTERS WILL BE DESTROYED, NO MATTER WHAT HAPPENS TO US!

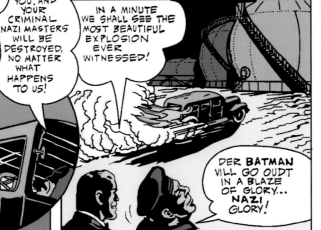

Presently, A FLAMING TORPEDO OF DOOM STREAKS ACROSS THE OPEN GROUND TOWARD THE SILVERED SPHERES OF THE EXPLOSIVE TANKS...

IN A MINUTE WE SHALL SEE THE MOST BEAUTIFUL EXPLOSION EVER WITNESSED!

DER BATMAN VILL GO OUDT IN A BLAZE OF GLORY... NAZI GLORY!

WHILE THE HELPLESS VICTIMS OF THE MONSTROUS CRIME STRAIN VAINLY AT THEIR BONDS...

...CAN'T LOOSE ROPES... CAN'T MOVE STEERING WHEEL OR STOP MOTOR...IT LOOKS BAD, ROBIN, OLD FELLA!

THOSE GADGETS IN THE DASHBOARD, BATMAN... TRY PUSHING THEM!

10

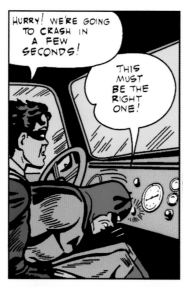

HURRY! WE'RE GOING TO CRASH IN A FEW SECONDS!

THIS MUST BE THE RIGHT ONE!

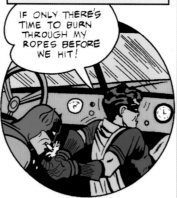

THE BATMAN'S TEETH CLOSE FIRMLY ON A KNOB... WITHDRAW IT...AND REVEAL THE GLOWING TIP OF A CIGARETTE LIGHTER...

IF ONLY THERE'S TIME TO BURN THROUGH MY ROPES BEFORE WE HIT!

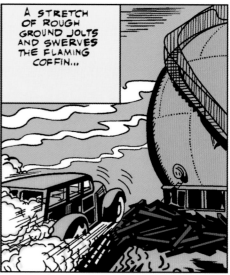

A STRETCH OF ROUGH GROUND JOLTS AND SWERVES THE FLAMING COFFIN...

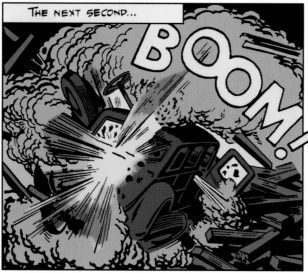

THE NEXT SECOND...

BOOM!

AS THE THUNDEROUS ECHOES OF THE BLAST DIE AWAY, THE SABOTEURS DEPART IN HASTE...

ACH...TOO BAD DER MACHINE TURNED UND EGGSPLODED ONLY A PILE OF RAILROAD TIES!

AT LEAST, WE'VE GOT RID OF THE BATMAN! FROM NOW ON WE CAN EXPECT COMPLETE SUCCESS WHENEVER WE STRIKE!

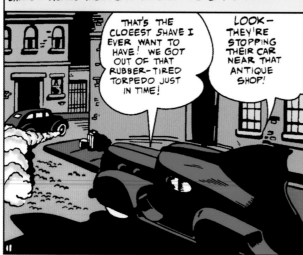

BUT THE TERRORISTS HAVE GLOATED TOO SOON...FOR A FLITTING SHADOW TRAILS THEIR CAR THROUGH THE CITY STREETS...

THAT'S THE CLOSEST SHAVE I EVER WANT TO HAVE! WE GOT OUT OF THAT RUBBER-TIRED TORPEDO JUST IN TIME!

LOOK— THEY'RE STOPPING THEIR CAR NEAR THAT ANTIQUE SHOP!

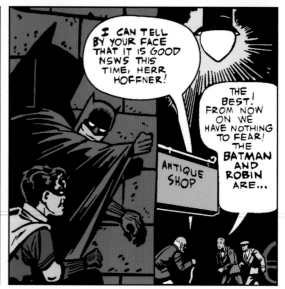

I CAN TELL BY YOUR FACE THAT IT IS GOOD NEWS THIS TIME, HERR HOFFNER!

THE BEST! FROM NOW ON WE HAVE NOTHING TO FEAR! THE BATMAN AND ROBIN ARE...

ANTIQUE SHOP

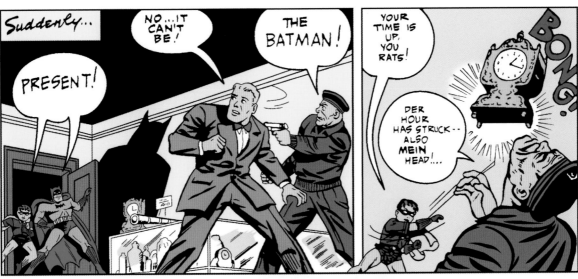

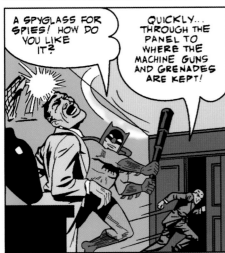

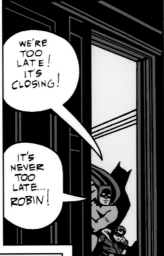

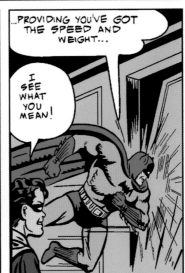

133

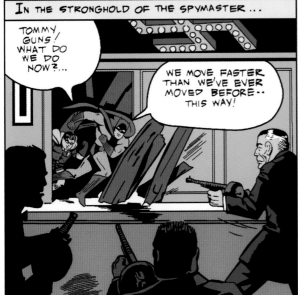

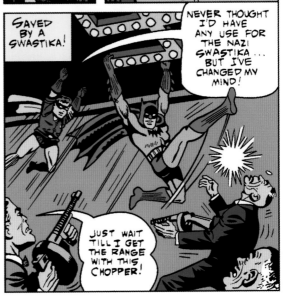

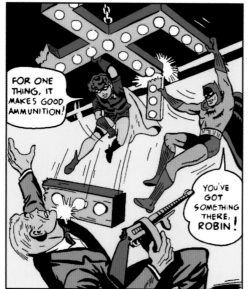

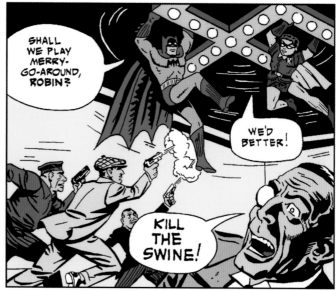

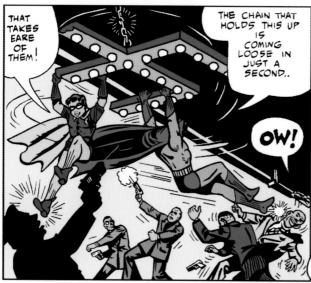

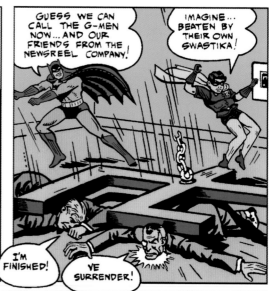

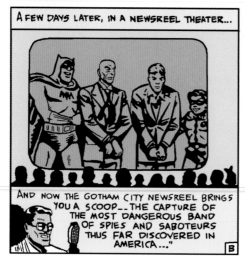

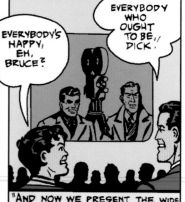

Part Three

Once the pattern had been set during 1942, Batman and Robin stuck to the script.

GUARDING THE HOME FRONT

In *Detective Comics* #73 (March 1943), the Scarecrow, another recurring foe of Batman's, robs the receipts of a wrestling match being held for the benefit of war bonds. This is fairly close to the theme of the Joker story back in *Detective* #69, except without any redeeming promise by the Scarecrow to "send back the bomber." But then, the Scarecrow doesn't escape at story's end as the Joker had in the earlier yarn.

All of the references to "war bonds and stamps," though ubiquitous in the comics books, film shorts, magazines, and radio spots of the time, may be a bit confusing to the modern reader. The purpose of war bonds, purchased by members of the general public, was twofold: first, the money used to buy them would immediately be available for the purchase of weapons and other means of carrying on the war; and second, and more curiously, they helped reduce the risk of inflation during the war years. During that period, there was an increasing shortage of consumer goods—when they weren't downright rationed or forbidden—and if most of the workers' wages went to purchasing the relatively few optional items that were available, the price of them was liable to go up and start a perilous spiral of prices and wages. War bonds could be bought in various locations at any time, but a large number of "war bond drives" were held to whip up patriotic feeling and cause people to put some of their money into the bonds right then and there! War savings stamps were related to the bonds, being of small denominations, some as small as a dime, with the money thus saved going to buy war bonds when

enough of it had been accumulated to do so. And that, hopefully, should be just about all you need to know about "war bonds and stamps" for the duration of this book!

To emphasize just how important war bonds were held to be: in this section of the book alone, in addition to the above story, there are covers that show Batman and Robin astride a giant eagle as they plug war bonds (*Batman* #17, June–July 1943) and Superman and Batman throwing baseballs at Hitler, Mussolini, and General Tojo to earn money for war bonds (*World's Finest Comics* #9 (Spring 1943). And there'd be more, before the war was over.

Batman #15 (Feb.–March 1943) contains no fewer than *two* somewhat war-related tales: one, featuring Robin, that's set in a military academy . . . the other, in some ways almost an alternate version of "Swastika over the White House!" in the previous issue, devoted to the possibilities of "Two Futures"—one of which reveals what America would be like if conquered by the Axis powers. Some of the images in the latter are fairly grim, especially coming in a Batman story for children. But this yarn at last gives Batman and his young ward a chance to go into warfront action against Nazi and Japanese soldiers, perhaps because it's set in an imaginary future and thus doesn't really "count." It's a bit of a chiller, nonetheless.

In *World's Finest* #9 (behind that War Bond cover noted earlier), Batman and Robin save a war relief drive from being robbed by heartless criminals. War relief drives were held to get people to donate

money in order to, well, relieve the burdens of war from people, insofar as that was possible. Often, the beneficiary was the Red Cross or some particular charity. For instance, an article in an Ann Arbor, Michigan, newspaper dated December 11, 1941, just a few days after Pearl Harbor, was headlined: "War Relief Drive Begun by Red Cross." The accompanying article told of a "mammoth war relief drive" being launched to raise $19,000 for the American Red Cross in a single Michigan county—a campaign that would be "part of a national endeavor to build a fund of 50 million dollars." According to the piece, the local Red Cross had made the announcement, having been asked by the national body to do its part as the nation geared up for war with the Axis.

There might be rallies and people collecting money door to door or in stalls set up at public events . . . any way that might be imagined to reach people and persuade them to donate money to a good cause. It was also thought that the funds would be needed in case of attacks on the Home Front itself. After all, hadn't Japanese planes bombed Hawaii— and weren't Nazi U-boats even now prowling the waters off the country's Eastern coasts and sinking American shipping bound for besieged Britain? The characters' dialogue in this and other war-relief stories published during the war makes it clear that robbing a war-relief rally or War Bond drive was one of the lowest things any crook could

do—and thus well worthy of the attention of Batman and Robin.

The war—at least on the Home Front—was a strong presence in a 15-chapter *Batman* movie serial released to theatres in 1943. Its Fu Manchu-style Japanese villain was Prince (a.k.a. Dr.) Daka— played by Italian-American J. Carrol Naish!

But, amidst all the horror of a growing war, not to mention counterespionage stories such as the Batman adventure in *World's Finest* #10 (Summer 1943), there would be moments of occasional peace and quiet, as well. Hence the supreme peace of the cover of *World's Finest* #11 (Fall 1943), which shows Superman, Batman, and Robin tending a Victory Garden—raising fruits and vegetables on their own so that other foodstuffs could be reserved for sending to such places as military bases, where millions of young men were training to fight a relentless foe.

That cover scene is a welcome light-hearted moment— in a world at war.

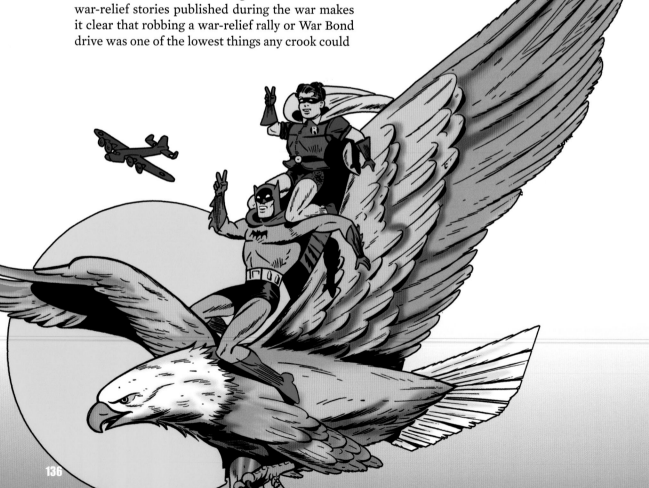

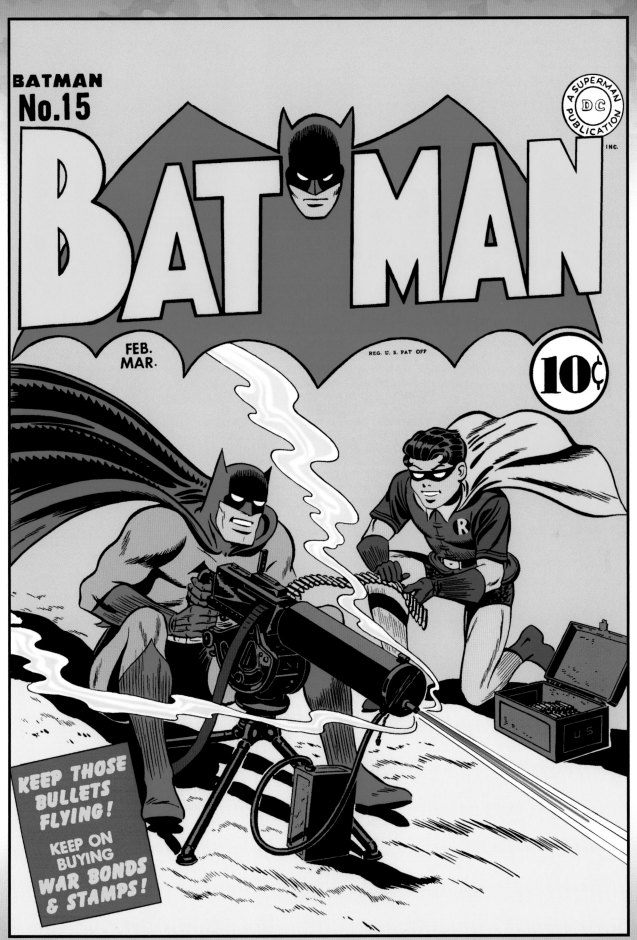

137

Batman #15 (Feb.-March 1943) - cover art: Jack Burnley

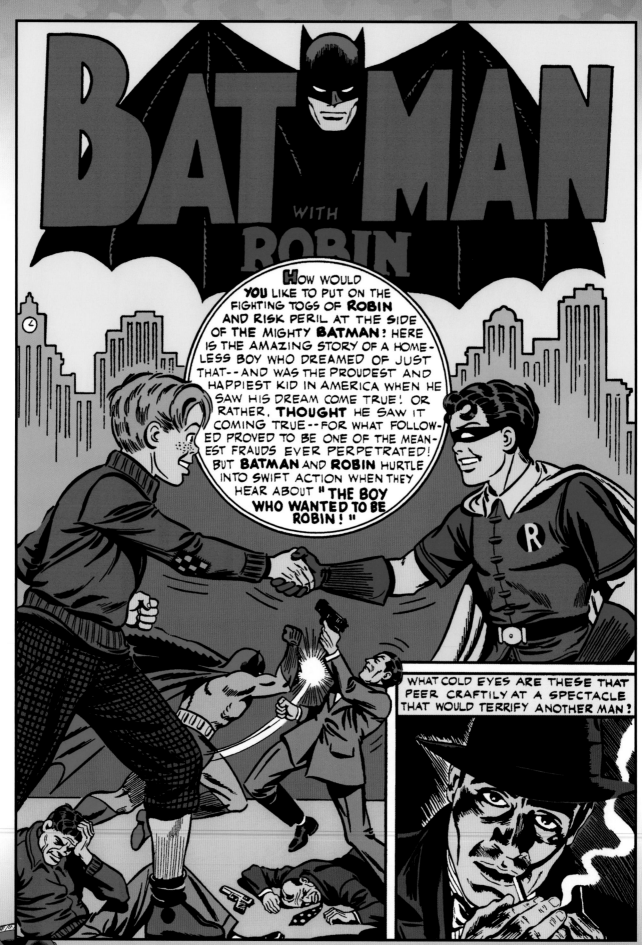

Batman #15 (Feb.-March 1943) - script: Don Cameron - art: Jack Burnley (pencils) & Jack & Ray Burnley (inks)

WHO IS THIS DARK-CLAD AUDIENCE OF ONE, LURKING UNSEEN IN THE SHADOWS OF THE WATERFRONT?

WAREHOUSE NO 58

WE SHALL KNOW PRESENTLY... BUT FIRST LET US SEE WHAT IT IS THAT HOLDS HIS ATTENTION SO CLOSELY...

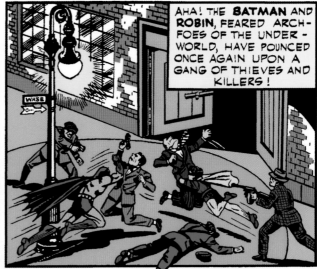

AHA! THE **BATMAN** AND **ROBIN**, FEARED ARCH-FOES OF THE UNDER-WORLD, HAVE POUNCED ONCE AGAIN UPON A GANG OF THIEVES AND KILLERS!

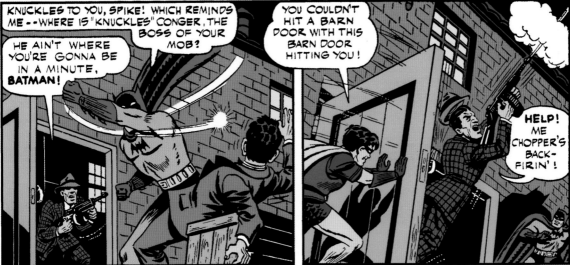

KNUCKLES TO YOU, SPIKE! WHICH REMINDS ME--WHERE IS "KNUCKLES" CONGER, THE BOSS OF YOUR MOB?

HE AIN'T WHERE YOU'RE GONNA BE IN A MINUTE, **BATMAN!**

YOU COULDN'T HIT A BARN DOOR WITH THIS BARN DOOR HITTING YOU!

HELP! ME CHOPPER'S BACK-FIRIN'!

HEY--IT GIVES ME DIZZY SPELLS TO GET TOSSED AROUND!

SWING AND SWAY THE **BATMAN'S** WAY!

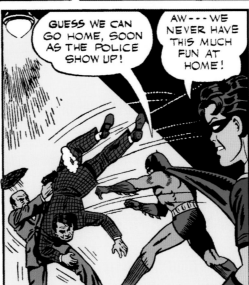

GUESS WE CAN GO HOME, SOON AS THE POLICE SHOW UP!

AW---WE NEVER HAVE THIS MUCH FUN AT HOME!

THEY'RE "KNUCKLES" CONGER'S RATS ALL RIGHT! TOO BAD WE COULDN'T HAVE GOT HIM, TOO-- THE SLICKEST OF THEM ALL!

IF ONLY WE KNEW WHERE "KNUCKLES" WAS, WE WOULDN'T KNOCK OFF SO EARLY!

2

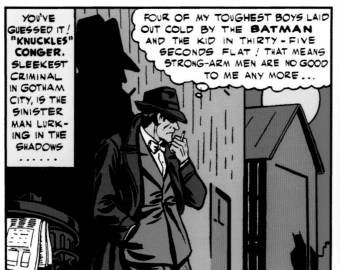

YOU'VE GUESSED IT! "KNUCKLES" CONGER. SLEEKEST CRIMINAL IN GOTHAM CITY, IS THE SINISTER MAN LURKING IN THE SHADOWS

FOUR OF MY TOUGHEST BOYS LAID OUT COLD BY THE BATMAN AND THE KID IN THIRTY-FIVE SECONDS FLAT! THAT MEANS STRONG-ARM MEN ARE NO GOOD TO ME ANY MORE...

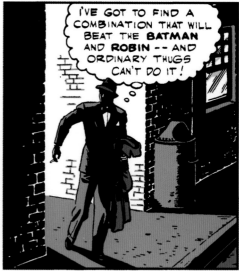

I'VE GOT TO FIND A COMBINATION THAT WILL BEAT THE BATMAN AND ROBIN -- AND ORDINARY THUGS CAN'T DO IT!

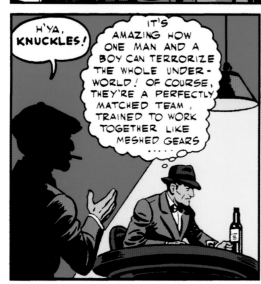

H'YA, KNUCKLES!

IT'S AMAZING HOW ONE MAN AND A BOY CAN TERRORIZE THE WHOLE UNDER-WORLD! OF COURSE, THEY'RE A PERFECTLY MATCHED TEAM, TRAINED TO WORK TOGETHER LIKE MESHED GEARS

I'VE BEEN A TRACK ATH-LETE... AN ACROBAT... A BOXER. I COULD GET IN SHAPE FOR FAST ACTION...

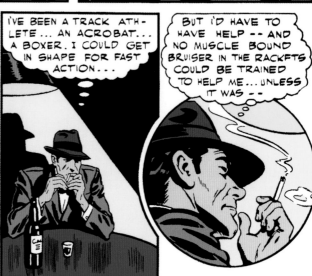

BUT I'D HAVE TO HAVE HELP -- AND NO MUSCLE BOUND BRUISER IN THE RACKETS COULD BE TRAINED TO HELP ME...UNLESS IT WAS --

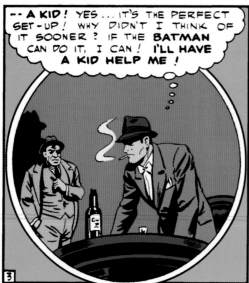

-- A KID! YES... IT'S THE PERFECT SET-UP! WHY DIDN'T I THINK OF IT SOONER? IF THE BATMAN CAN DO IT, I CAN! I'LL HAVE A KID HELP ME!

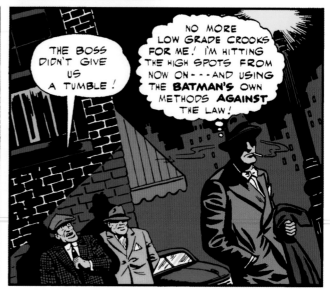

THE BOSS DIDN'T GIVE US A TUMBLE!

NO MORE LOW GRADE CROOKS FOR ME! I'M HITTING THE HIGH SPOTS FROM NOW ON --- AND USING THE BATMAN'S OWN METHODS AGAINST THE LAW!

AND NOW LET US MAKE THE ACQUAINTANCE OF A CERTAIN YOUNG MAN OF GREAT IMPORTANCE TO OUR STORY..

SHINE 'EM UP, KID!

SHINE 5¢

BOBBY DEEN, HOMELESS BOOT-BLACK, HAS A CUSTOMER...

HUH?..OH -- SURE, MISTER

WHAT'S THAT YOU'RE READING, SON?

IT'S ABOUT TH' BATMAN . . . YOU KNOW-- TH' ONE WHO ROUNDS UP ALL THE CROOKS!

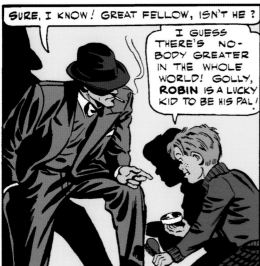

SURE, I KNOW! GREAT FELLOW, ISN'T HE?

I GUESS THERE'S NO-BODY GREATER IN THE WHOLE WORLD! GOLLY, ROBIN IS A LUCKY KID TO BE HIS PAL!

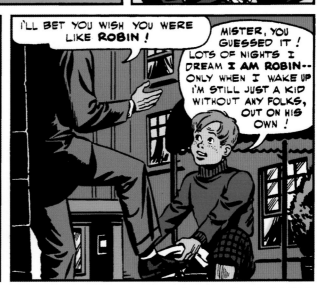

I'LL BET YOU WISH YOU WERE LIKE ROBIN!

MISTER, YOU GUESSED IT! LOTS OF NIGHTS I DREAM I AM ROBIN-- ONLY WHEN I WAKE UP I'M STILL JUST A KID WITHOUT ANY FOLKS, OUT ON HIS OWN!

141

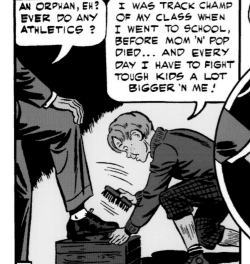

AN ORPHAN, EH? EVER DO ANY ATHLETICS?

I WAS TRACK CHAMP OF MY CLASS WHEN I WENT TO SCHOOL, BEFORE MOM 'N' POP DIED... AND EVERY DAY I HAVE TO FIGHT TOUGH KIDS A LOT BIGGER 'N ME!

KID, I'M THE ANSWER TO YOUR DREAMS!

A TEN SPOT! YOU AIN'T FOOLIN'? AND WHAT WAS THAT ABOUT DREAMS?

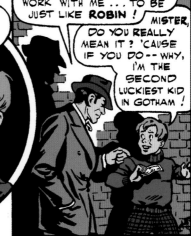

I'M LIKE THE BATMAN, SEE? I HUNT CROOKS! IF YOU'D LIKE, I'LL TRAIN YOU TO WORK WITH ME ... TO BE JUST LIKE ROBIN!

MISTER, DO YOU REALLY MEAN IT? 'CAUSE IF YOU DO -- WHY, I'M THE SECOND LUCKIEST KID IN GOTHAM!

4

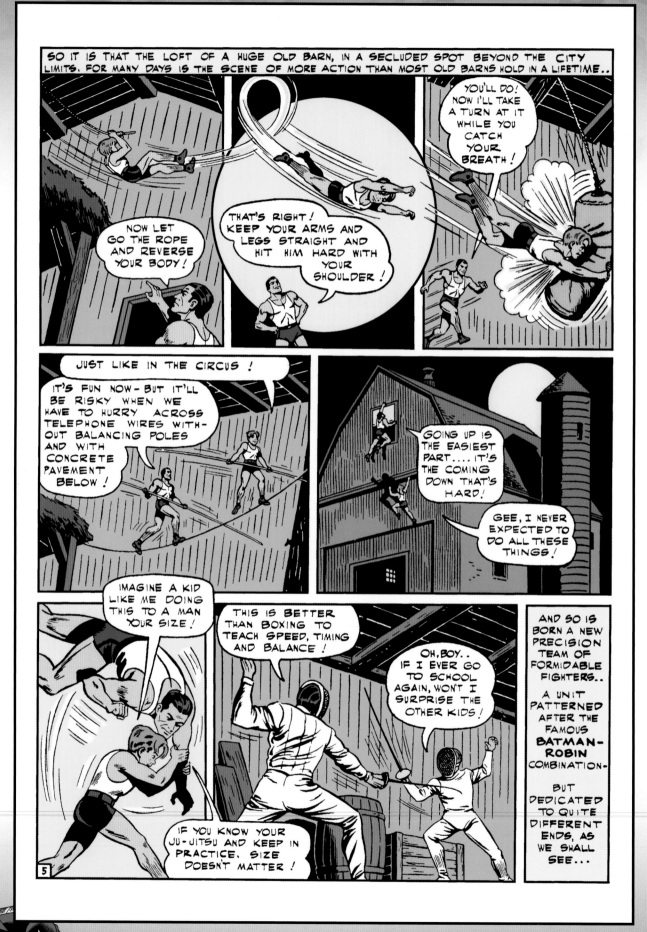

FINALLY...

TONIGHT WE PULL OUR FIRST JOB--ER--I MEAN, STRIKE OUR FIRST BLOW AT CRIME! I'VE GOT A LINE ON A CROOKED JEWELER!

GOSH! I'M ALL GOOSE-PIMPLES! I CAN HARDLY WAIT TO GET INTO A UNI-FORM LIKE ROBIN!

UNIFORM! NIX ON THAT STUFF, YOUNGSTER! WE'LL GET ALONG BETTER WEARING PLAIN DARK CLOTHES!

BUT I THOUGHT... OH, WELL--JUST AS YOU SAY, KNUCKLES!

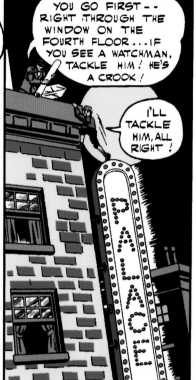

NIGHT -- AND AN EAGER BOY INNOCENTLY FOLLOWS A MASTER CRIMINAL ALONG A DARK AND CROOKED ROAD...

YOU GO FIRST -- RIGHT THROUGH THE WINDOW ON THE FOURTH FLOOR...IF YOU SEE A WATCHMAN, TACKLE HIM! HE'S A CROOK!

I'LL TACKLE HIM, ALL RIGHT!

143

MOMENTS LATER...

NICE GOING, PAL!

GOT HIM!

UHH!

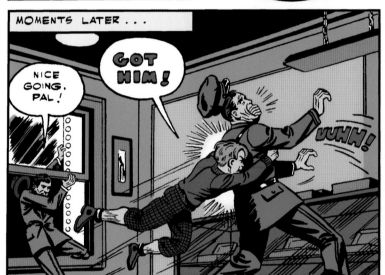

FIRST THING IS TO GATHER THE EVIDENCE!

ALL STOLEN BY CROOKS, AND PEDDLED TO THE PHONEY JEWELER, HUH?

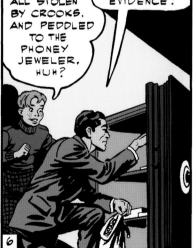

BUT UNKNOWINGLY THE PROWLERS HAVE TOUCHED OFF AN ALARM!

IT'S THE ACME JEWELRY SHOP IN THE PALACE THEATRE BUILDING. WE'LL HAVE THE PLACE SURROUNDED IN A MINUTE!

COPS! QUICK -- WE'LL MAKE OUR GETAWAY FROM THE ROOF!

BUT IF WE EXPLAINED-- WOULDN'T THEY LET US GO? THE BATMAN DOES LOTSA SPECIAL JOBS FOR COMMISSIONER GORDON...

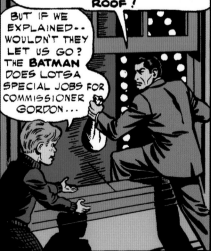

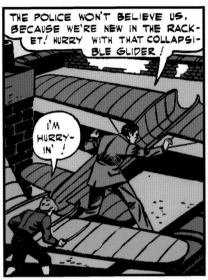

THE POLICE WON'T BELIEVE US, BECAUSE WE'RE NEW IN THE RACKET! HURRY WITH THAT COLLAPSIBLE GLIDER!

I'M HURRY-IN'!

SILENTLY, TWO DARK, WINGED SHAPES GLIDE UNSEEN ABOVE THE HEADS OF THE GRIM POLICEMEN...

I'LL BE GLAD WHEN TH' COPS GET T' KNOW US!

DON'T WORRY! I'LL TAKE CARE OF EVERYTHING!

NEXT DAY...

THAT'S HOW IT IS.. NOT EVEN THE COPS KNOW ABOUT THE JEWELER BEING CROOKED

UH - HUH...

THIEVES GET GEMS DODGE POLICE NET

LIGHTNING-SWIFT--PERFECTLY CO-ORDINATED--THE WILY **KNUCKLES** AND HIS YOUNG HELPER STRIKE AGAIN AND AGAIN!

OKAY--NOW WE'LL RUSH IN, GRAB WHAT WE CAN, AND GET AWAY FAST!

I NEVER HEARD O' TH' **BATMAN** DESTROYING PROPERTY!

BUT WHAT IF YA SLUGGED THAT BANKER -- I MEAN, THAT CROOK WHO'S PRETENDING T' BE A BANKER -- TOO HARD?

I TOLD YOU TO LET ME DO THE WORRYING! YOUR JOB IS TO FOLLOW ORDERS!

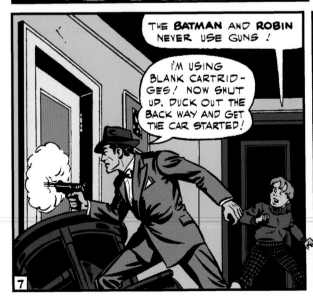

THE **BATMAN** AND **ROBIN** NEVER USE GUNS!

I'M USING BLANK CARTRIDGES! NOW SHUT UP, DUCK OUT THE BACK WAY AND GET THE CAR STARTED!

ALTOGETHER, THE BEWILDERED **BOBBY** ISN'T HAVING AS MUCH FUN AS HE EXPECTED..

I WONDER IF **ROBIN** HAS IT THIS TOUGH? HE CAN WEAR A UNIFORM... AND IF **KNUCKLES** IS REALLY ON THE LEVEL, I'D LIKE TO SEE HIM PUT SOME CROOKS BEHIND BARS..

IF YOU ARE BEGINNING TO THINK THAT PERHAPS **BOBBY** HASN'T BEEN TOO BRIGHT, REMEMBER THAT HE IS IN THE HANDS OF THE MAN WHOM THE **BATMAN** HIMSELF TERMED THE SLICKEST CRIMINAL IN TOWN! REMEMBER, TOO, THAT **BOBBY** IS A SMALL BOY ALONE IN THE WORLD!

7

...YET NOT ALTOGETHER HOPELESS - FOR AT BRUCE WAYNE'S HOME KEEN INTEREST AWAKENS!

THE KID, BOBBY, MUST BE SMART, BRUCE! I'D LIKE TO MEET HIM!

IF THE BATMAN AND ROBIN KEEP HUNTING, DICK, YOU'RE BOUND TO, SOONER OR LATER!

THIS NIGHT, AS ON OTHERS, A WEIRD CAR LEAVES THE WAYNE HOME TO PROWL - THE BATMOBILE!

WHERE TO THIS TIME, BATMAN?

THE FINANCIAL DISTRICT, ROBIN! OUR FRIENDS HAVEN'T BOTHERED IT YET, BUT IT'S ONLY A QUESTION OF TIME BEFORE THEY DO!

AS LUCK WOULD HAVE IT, TWO FIGURES ARE ENTERING A WINDOW THERE AT THIS MOMENT...

WHEW! EVEN IF I WAS A REAL FLY, I'D HATE TO MAKE THAT CLIMB OVER AGAIN!

WE'LL GET DOWN WITH OUR NEW WIRE REELS AND FRICTION GRIPS!

YOU SAY THOSE ARE ALL COUNTERFEIT? HOW DO YOU KNOW?

I HAVE MY OWN SOURCES OF INFORMATION!

SEEMS FUNNY NOTHIN' EVER HAPPENS TO THESE CROOKS YOU TELL ABOUT AND THE COPS KEEP CALLIN' US ROBBERS!

FUNNY? WHAT DO YOU MEAN BY THAT?

NYBA

NOTHIN'-- ONLY IF YA BEEN KIDDIN' ME--

WHY, YOU BRAT!

145

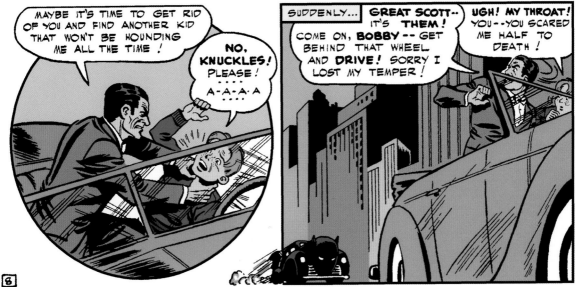

MAYBE IT'S TIME TO GET RID OF YOU AND FIND ANOTHER KID THAT WON'T BE HOUNDING ME ALL THE TIME!

NO, KNUCKLES! PLEASE! · · · · A·A·A·A · · · ·

SUDDENLY...

GREAT SCOTT-- IT'S THEM! COME ON, BOBBY -- GET BEHIND THAT WHEEL AND DRIVE! SORRY I LOST MY TEMPER!

UGH! MY THROAT! YOU--YOU SCARED ME HALF TO DEATH!

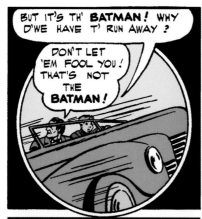

BUT IT'S TH' **BATMAN**! WHY D'WE HAVE T' RUN AWAY?

DON'T LET 'EM FOOL YOU! THAT'S NOT THE **BATMAN**!

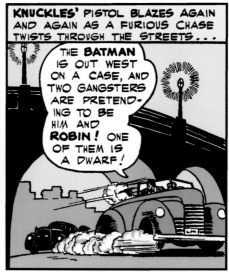

KNUCKLES' PISTOL BLAZES AGAIN AND AGAIN AS A FURIOUS CHASE TWISTS THROUGH THE STREETS...

THE **BATMAN** IS OUT WEST ON A CASE, AND TWO GANGSTERS ARE PRETENDING TO BE HIM AND **ROBIN**! ONE OF THEM IS A DWARF!

NO USE! THEIR CAR'S TOO FAST AND IT'S ALL BULLETPROOF! WE'LL WAIT TILL THEY'RE ALMOST UP TO US. THEN --

STEEL RODS REACH UP FROM THE FUGITIVE CAR -- HOOK THE CROSS BARS OF STREET LAMPS -- AND..

WE'RE GOING TO RUN RIGHT UNDER THEM!

CAN'T BE HELPED **ROBIN**! THE **BATMOBILE** CAN'T STOP ON A DIME WHEN IT'S DOING NINETY MILES AN HOUR!

CRASH

NOW THAT WE'VE COME THIS CLOSE, WE'VE GOT TO CATCH THEM!

WE'LL DO THE BEST WE CAN!

MEANWHILE THE FUGITIVES PREPARE FOR A RETURN ENGAGEMENT...

NATIONAL BANK

THEY'LL BE BACK, BUT WE'LL HANDLE THEM! YOU TAKE THE DWARF AND I'LL TAKE THE **BATM**- THE BIG FELLOW!

PRESENTLY...

THIS IS WHERE WE SAW THEM LAST... WHERE'D THEY GO?

MAYBE THEY DIDN'T LOOK OUT FOR TRICKS!

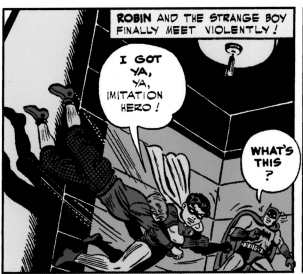

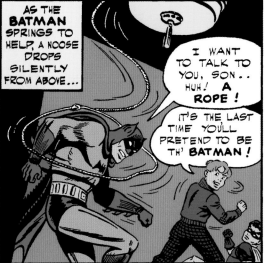

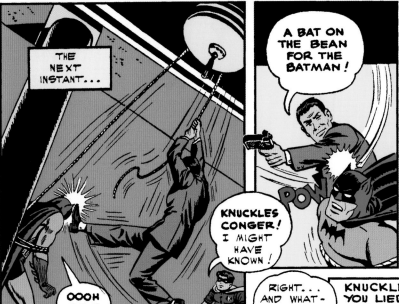

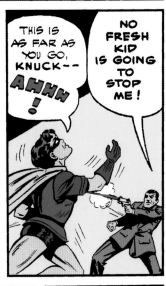

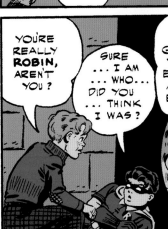

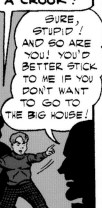

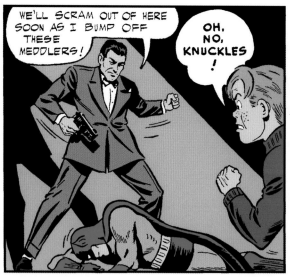

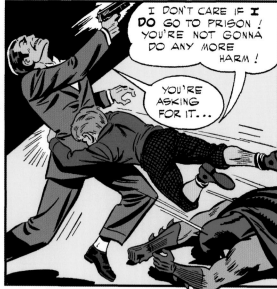

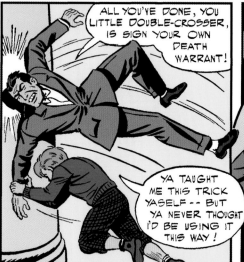

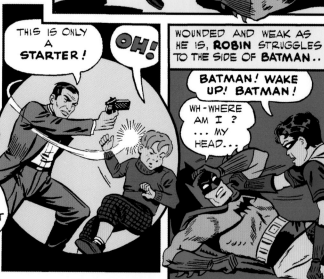

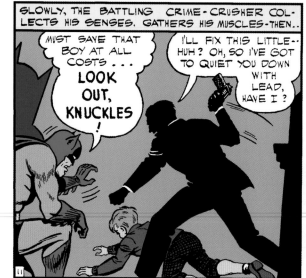

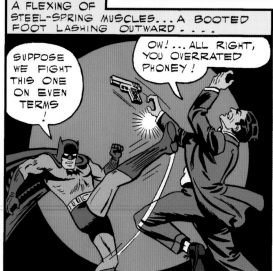

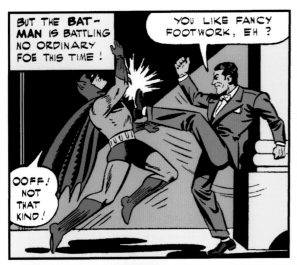

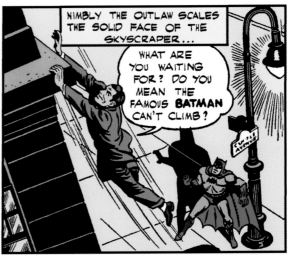

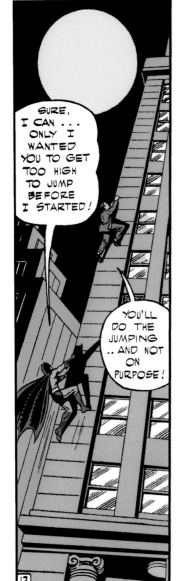

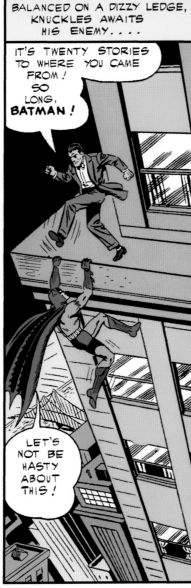

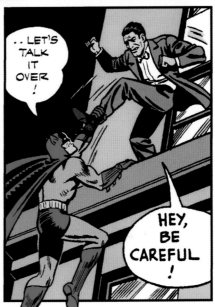

149

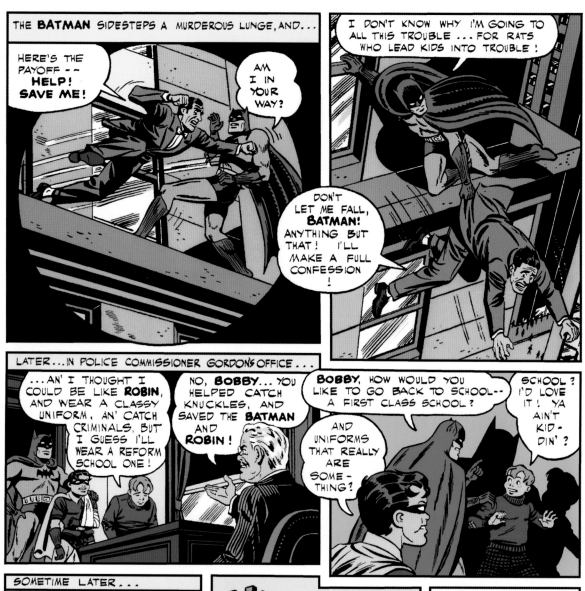

THE **BATMAN** SIDESTEPS A MURDEROUS LUNGE, AND...

HERE'S THE PAYOFF -- **HELP! SAVE ME!**

AM I IN YOUR WAY?

I DON'T KNOW WHY I'M GOING TO ALL THIS TROUBLE ... FOR RATS WHO LEAD KIDS INTO TROUBLE!

DON'T LET ME FALL, **BATMAN!** ANYTHING BUT THAT! I'LL MAKE A FULL CONFESSION!

LATER...IN POLICE COMMISSIONER GORDON'S OFFICE...

...AN' I THOUGHT I COULD BE LIKE **ROBIN**, AND WEAR A CLASSY UNIFORM, AN' CATCH CRIMINALS, BUT I GUESS I'LL WEAR A REFORM SCHOOL ONE!

NO, **BOBBY**... YOU HELPED CATCH KNUCKLES, AND SAVED THE **BATMAN** AND **ROBIN**!

BOBBY, HOW WOULD YOU LIKE TO GO BACK TO SCHOOL-- A FIRST CLASS SCHOOL?

AND UNIFORMS THAT REALLY ARE SOME- THING?

SCHOOL? I'D LOVE IT! YA AIN'T KID- DIN'?

SOMETIME LATER...

QUITE A PLACE, EH, **DICK?**

YOU KNOW, SOME- TIMES I CATCH MYSELF WISHING I WAS **BOBBY!**

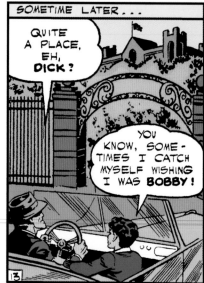

WE RAN INTO THE **BATMAN** AND **ROBIN** AND THEY ASKED US TO STOP BY AND SEE HOW YOU'RE DOING!

GEE, YOU KNOW THEM, SIR!? LOOKIT MY UNIFORM AN' ALL THE MEDALS I WON ALREADY!

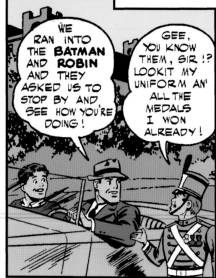

TELL 'EM I'LL NEVER FORGET WHAT THEY DID FOR ME ... AND TELL **ROBIN** I WANT TO BE LIKE HIM!

I'LL TELL HIM, **BOB!** IT'S THE FINEST COMPLIMENT HE'S EVER HAD!

The End.

13

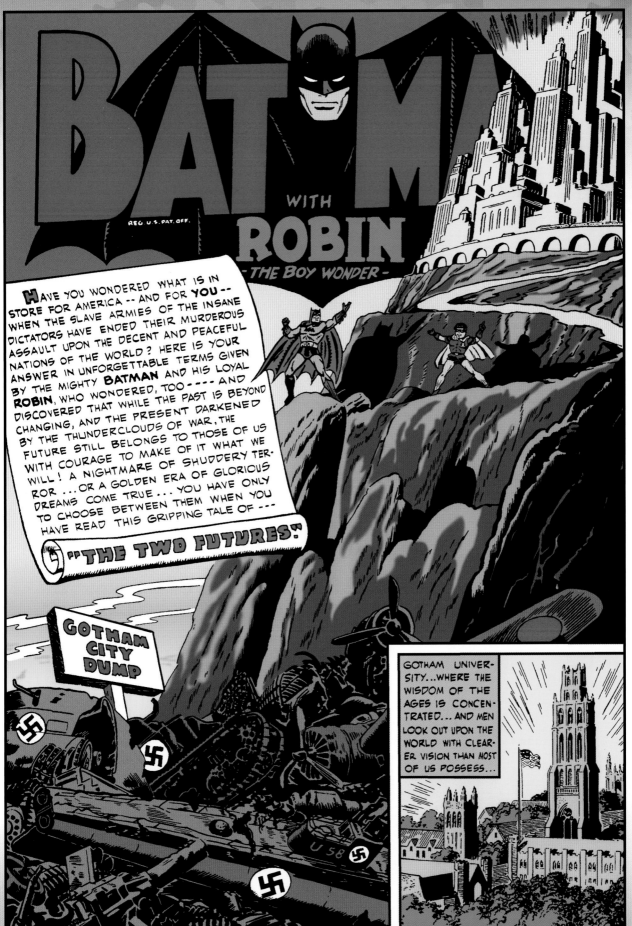

151

BATMAN WITH ROBIN — THE BOY WONDER —

REG. U.S. PAT. OFF.

HAVE YOU WONDERED WHAT IS IN STORE FOR AMERICA -- AND FOR YOU -- WHEN THE SLAVE ARMIES OF THE INSANE DICTATORS HAVE ENDED THEIR MURDEROUS ASSAULT UPON THE DECENT AND PEACEFUL NATIONS OF THE WORLD? HERE IS YOUR ANSWER IN UNFORGETTABLE TERMS GIVEN BY THE MIGHTY BATMAN AND HIS LOYAL ROBIN, WHO WONDERED, TOO ---- AND DISCOVERED THAT WHILE THE PAST IS BEYOND CHANGING, AND THE PRESENT DARKENED BY THE THUNDERCLOUDS OF WAR, THE FUTURE STILL BELONGS TO THOSE OF US WITH COURAGE TO MAKE OF IT WHAT WE WILL! A NIGHTMARE OF SHUDDERY TERROR ... OR A GOLDEN ERA OF GLORIOUS DREAMS COME TRUE ... YOU HAVE ONLY TO CHOOSE BETWEEN THEM WHEN YOU HAVE READ THIS GRIPPING TALE OF ---

"THE TWO FUTURES"

GOTHAM CITY DUMP

U 58

GOTHAM UNIVERSITY...WHERE THE WISDOM OF THE AGES IS CONCENTRATED... AND MEN LOOK OUT UPON THE WORLD WITH CLEARER VISION THAN MOST OF US POSSESS...

Batman #15 (Feb.-March 1943) - script: Bill Finger - art: Jack Burnley (pencils) & Jack & Ray Burnley (inks)

ACROSS THE SHADED CAMPUS STRIDE TWO FIGURES WHOSE COSTUMES BLEND STRANGELY WITH THE CLASSICAL BACKGROUND.

I DIDN'T EXPECT TO GO TO COLLEGE FOR A COUPLE OF YEARS, **BATMAN**, AND I THOUGHT **YOUR** EDUCATION WAS FINISHED!

AN INTELLIGENT PERSON IS NEVER THROUGH LEARNING, **ROBIN**!

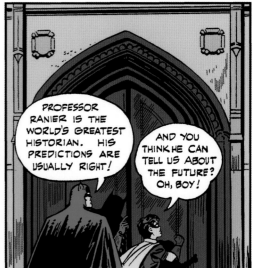

PROFESSOR RANIER IS THE WORLD'S GREATEST HISTORIAN. HIS PREDICTIONS ARE USUALLY RIGHT!

AND YOU THINK HE CAN TELL US ABOUT THE FUTURE? OH, BOY!

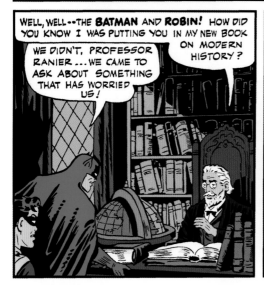

WELL, WELL--THE **BATMAN** AND **ROBIN**! HOW DID YOU KNOW I WAS PUTTING YOU IN MY NEW BOOK ON MODERN HISTORY?

WE DIDN'T, PROFESSOR RANIER...WE CAME TO ASK ABOUT SOMETHING THAT HAS WORRIED US!

SO YOU WANT TO KNOW WHAT WILL HAPPEN TO OUR DEMOCRATIC WAY OF LIFE WHEN THIS WAR IS OVER? HMMM--A LARGE ORDER!

MILLIONS OF PEOPLE ARE ANXIOUS TO KNOW THE ANSWER, SIR! EVEN IF IT'S BAD, WE THINK THEY HAVE A RIGHT TO KNOW!

HERE ARE PROFESSORS PROE AND CON...WE THREE HAVE GONE INTO THIS THOROUGHLY!

WE CAN GIVE YOU THE WHOLE STORY--BUT CAN YOU TAKE IT?

NOTHING GOOD EVER CAME WITHOUT LABOR AND SAC-RIFICE..

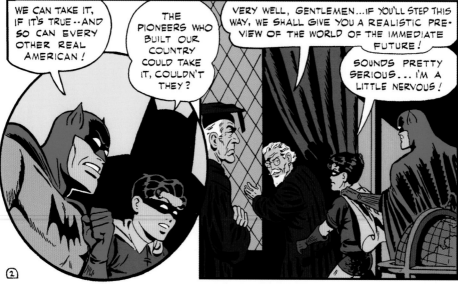

WE CAN TAKE IT, IF IT'S TRUE--AND SO CAN EVERY OTHER REAL AMERICAN!

THE PIONEERS WHO BUILT OUR COUNTRY COULD TAKE IT, COULDN'T THEY?

VERY WELL, GENTLEMEN...IF YOU'LL STEP THIS WAY, WE SHALL GIVE YOU A REALISTIC PRE-VIEW OF THE WORLD OF THE IMMEDIATE FUTURE!

SOUNDS PRETTY SERIOUS...I'M A LITTLE NERVOUS!

A PREVIEW OF THE FUTURE! BY STRETCHING OUR IMAGINATIONS JUST A LITTLE, WE MAY SEE IT AS VIVIDLY AS IT IS SHOWN TO THE **BATMAN** AND **ROBIN**!... WE WILL REMEM-BER THAT WHAT-EVER A MAN CAN IMAGINE IS POSSIBLE! YET ITS OPPOSITE IS POSSIBLE ALSO! THUS MEN CAN DECIDE TO SINK OR STRIVE TOWARD THE LIGHT!

②

THE WAR THAT EVIL MEN PLOTTED THROUGH LONG YEARS WILL HARDLY END TOMORROW OR NEXT WEEK...

... YET THE DAY WILL SURELY COME WHEN THE DEMONS OF DESTRUCTION ARE GLUTTED, AND THE DOVE OF PEACE STRETCHES ITS WINGS ONCE MORE...

BUT WHAT KIND OF A PEACE IS THIS THAT HAS COME TO GOTHAM CITY? AND WHO ARE THESE SOLDIERS WHO MARCH THE STREETS?

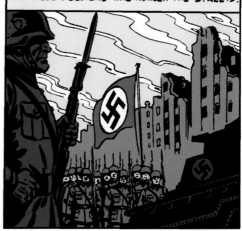

THE THUNDER OF BOMBS HAS CEASED... BUT NOT THE CHATTER OF MURDEROUS GUNFIRE...

ALL AMERICANS WHO REFUSE TO KNEEL TO HONORABLE JAPANESE EMPEROR MUST BE EXECUTED!

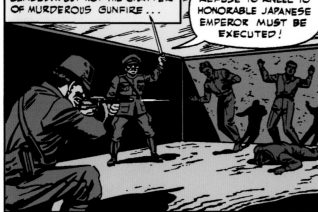

FOR THE FIRST TIME IN CENTURIES, THE GIBBET REARS ITS UGLY BEAMS IN THE PUBLIC SQUARE...

THIS IS VERY RICH CITY! THE LOOTING IS VERY GOOD, YES?

ACH! WE ARE SENDING VALUABLES TO DER FUEHRER IN BERLIN!

153

AND THE CROWNING HORROR OF THE CONCENTRATION CAMP COMES INTO BEING...

HUSH, MY LITTLE BABY! PERHAPS THEY WILL GIVE US FOOD BEFORE THE DAY IS OVER!

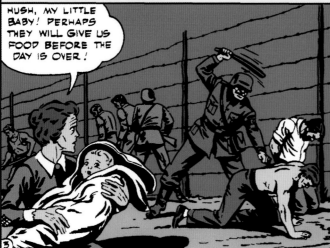

LITTLE BOBBY LOGAN BRAVES THE WRATH OF THE CONQUERORS TO COMFORT HIS MOTHER AND BABY BROTHER...

IT'S ALL THE FOOD I COULD FIND, MOM... BUT I'LL KEEP ON LOOKING!

BOBBY, YOU MUST BE CAREFUL! I COULDN'T BEAR IT IF THEY CAUGHT YOU, TOO!

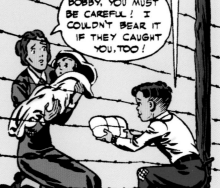

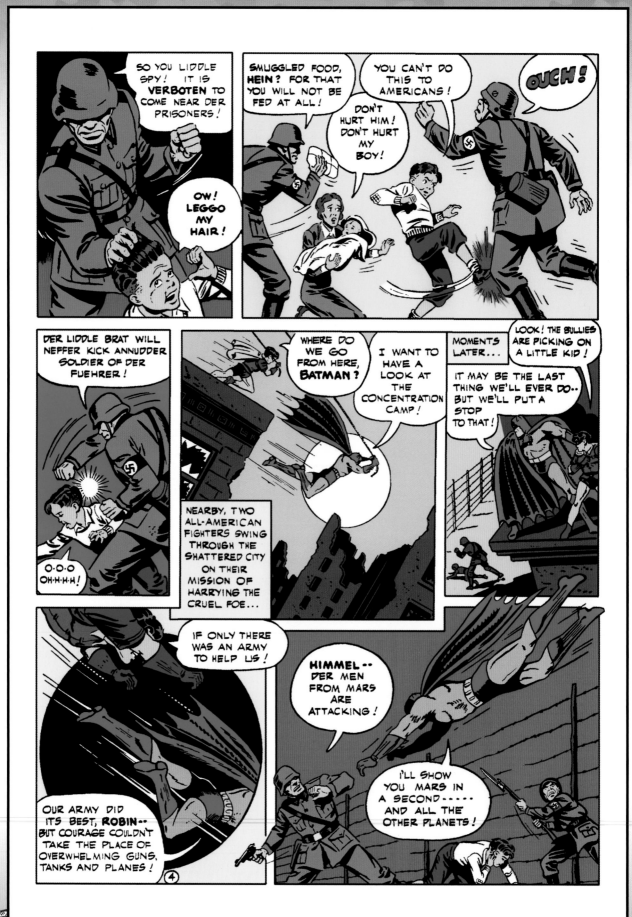

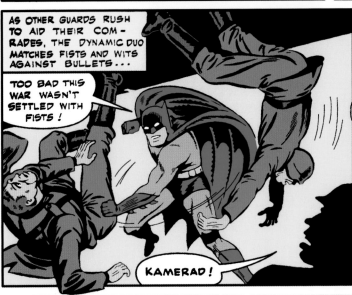

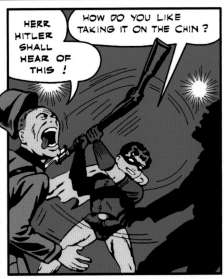

155

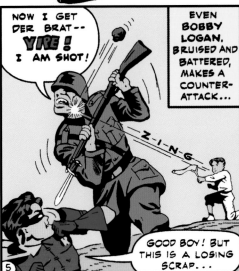

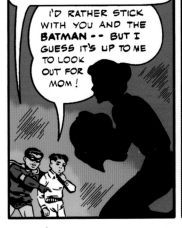

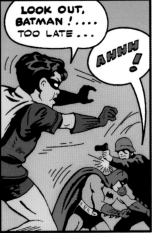

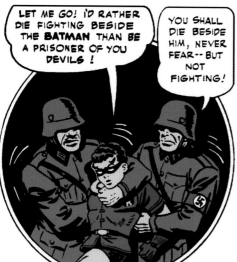

LET ME GO! I'D RATHER DIE FIGHTING BESIDE THE **BATMAN** THAN BE A PRISONER OF YOU DEVILS!

YOU SHALL DIE BESIDE HIM, NEVER FEAR--BUT NOT FIGHTING!

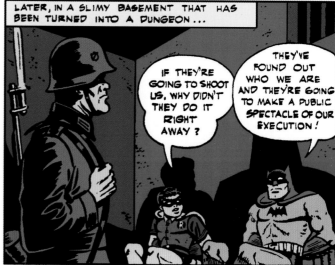

LATER, IN A SLIMY BASEMENT THAT HAS BEEN TURNED INTO A DUNGEON...

IF THEY'RE GOING TO SHOOT US, WHY DIDN'T THEY DO IT RIGHT AWAY?

THEY'VE FOUND OUT WHO WE ARE AND THEY'RE GOING TO MAKE A PUBLIC SPECTACLE OF OUR EXECUTION!

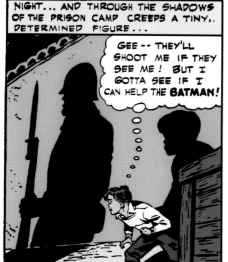

NIGHT... AND THROUGH THE SHADOWS OF THE PRISON CAMP CREEPS A TINY, DETERMINED FIGURE...

GEE -- THEY'LL SHOOT ME IF THEY SEE ME! BUT I GOTTA SEE IF I CAN HELP THE **BATMAN**!

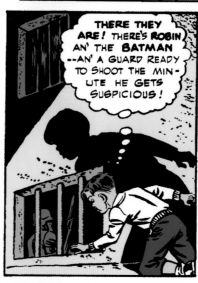

THERE THEY ARE! THERE'S **ROBIN** AN' THE **BATMAN** --AN' A GUARD READY TO SHOOT THE MIN- UTE HE GETS SUSPICIOUS!

GOTTA MAKE HIM BEND DOWN SO I CAN HIT HIM WHERE HIS HELMET WONT DO ANY GOOD!

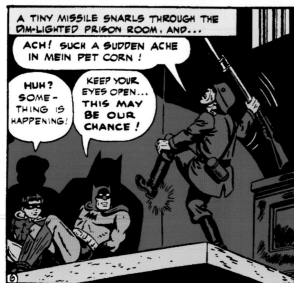

A TINY MISSILE SNARLS THROUGH THE DIM-LIGHTED PRISON ROOM, AND...

ACH! SUCH A SUDDEN ACHE IN MEIN PET CORN!

HUH? SOME- THING IS HAPPENING!

KEEP YOUR EYES OPEN... THIS MAY BE OUR CHANCE!

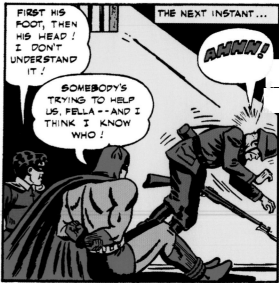

FIRST HIS FOOT, THEN HIS HEAD! I DON'T UNDERSTAND IT!

SOMEBODY'S TRYING TO HELP US, FELLA -- AND I THINK I KNOW WHO!

THE NEXT INSTANT...

AHNN!

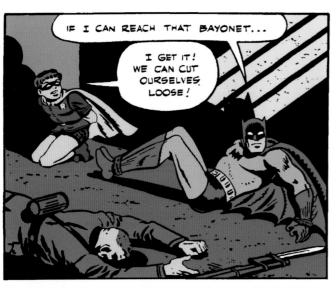

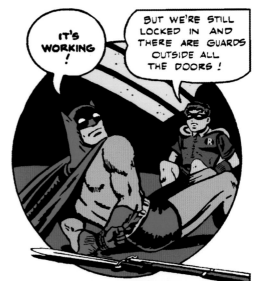

157

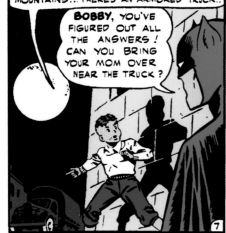

OOPS, SORRY --- I THOUGHT YOU WERE ADOLF!

HERE COMES BOBBY WITH HIS FAMILY!

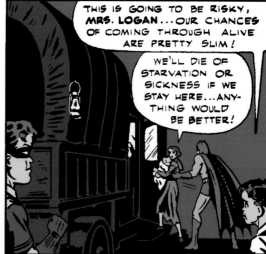

THIS IS GOING TO BE RISKY, MRS. LOGAN...OUR CHANCES OF COMING THROUGH ALIVE ARE PRETTY SLIM!

WE'LL DIE OF STARVATION OR SICKNESS IF WE STAY HERE...ANY-THING WOULD BE BETTER!

BATMAN'S RINGING CRY STARTLES THE CAMP'S INMATES AND GUARDS ALIKE...

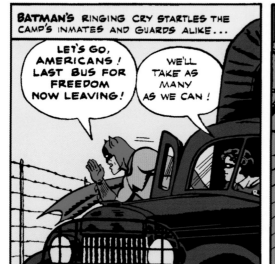

LET'S GO, AMERICANS! LAST BUS FOR FREEDOM NOW LEAVING!

WE'LL TAKE AS MANY AS WE CAN!

FROM FILTHY BARRACKS AND JAM-PACKED BUILDINGS, MEN BRAVE THE GUNS OF THEIR BRUTAL GUARDS TO JOIN THE ESCAPE...

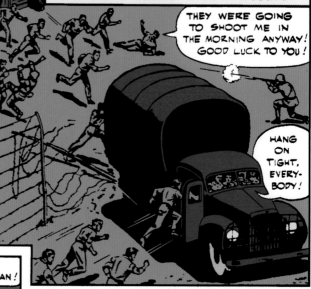

THEY WERE GOING TO SHOOT ME IN THE MORNING ANYWAY! GOOD LUCK TO YOU!

HANG ON TIGHT, EVERY-BODY!

WE'LL FORM A GUERRILLA ARMY AND CHASE 'EM BACK ACROSS THE OCEAN!

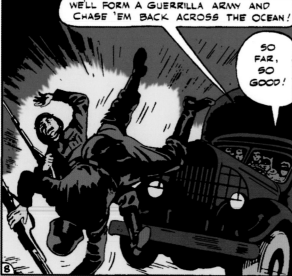

SO FAR, SO GOOD!

BUT AN ARMORED PATROL CAR, MANNED BY JAP ALLIES OF THE NAZIS, TAKE UP THE CHASE...

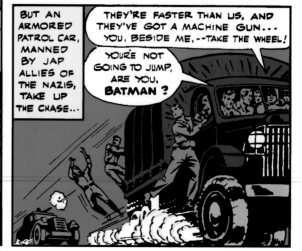

THEY'RE FASTER THAN US, AND THEY'VE GOT A MACHINE GUN... YOU, BESIDE ME, --TAKE THE WHEEL!

YOU'RE NOT GOING TO JUMP, ARE YOU, BATMAN?

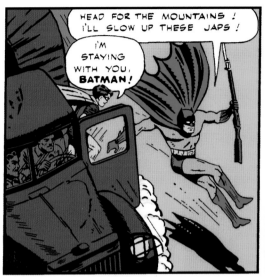

HEAD FOR THE MOUNTAINS! I'LL SLOW UP THESE JAPS!

I'M STAYING WITH YOU, BATMAN!

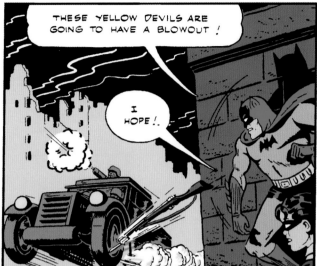

THESE YELLOW DEVILS ARE GOING TO HAVE A BLOWOUT!

I HOPE!.

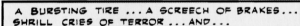

A BURSTING TIRE ... A SCREECH OF BRAKES... SHRILL CRIES OF TERROR ... AND ...

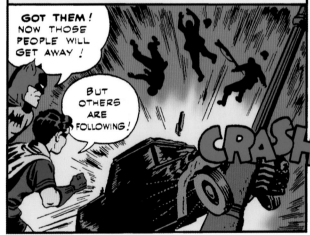

GOT THEM! NOW THOSE PEOPLE WILL GET AWAY!

BUT OTHERS ARE FOLLOWING!

CRASH

STEEL-JACKETED SLUGS SNARL LIKE ANGRY HORNETS AROUND THE HEROIC DUO AS THEY DART INTO THE PATH OF THE PURSUERS...

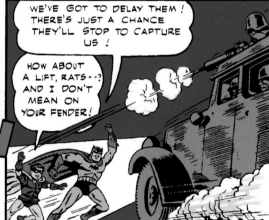

WE'VE GOT TO DELAY THEM! THERE'S JUST A CHANCE THEY'LL STOP TO CAPTURE US!

HOW ABOUT A LIFT, RATS--? AND I DON'T MEAN ON YOUR FENDER!

159

... AND SOME OF THE SLUGS FIND THEIR MARK ...

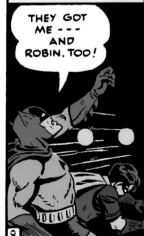

THEY GOT ME --- AND ROBIN, TOO!

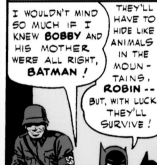

NEXT MORNING...

I WOULDN'T MIND SO MUCH IF I KNEW BOBBY AND HIS MOTHER WERE ALL RIGHT, BATMAN!

THEY'LL HAVE TO HIDE LIKE ANIMALS IN THE MOUN-TAINS, ROBIN -- BUT, WITH LUCK THEY'LL SURVIVE!

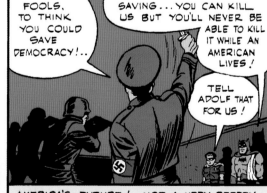

FOOLS, TO THINK YOU COULD SAVE DEMOCRACY!..

DEMOCRACY DOESN'T NEED SAVING ... YOU CAN KILL US BUT YOU'LL NEVER BE ABLE TO KILL IT WHILE AN AMERICAN LIVES!

TELL ADOLF THAT FOR US!

AMERICA'S FUTURE! NOT A VERY PRETTY ONE, IF WE ARE TO LET THIS VERSION OF IT STAND.... BUT WAIT! THE BATMAN AND ROBIN ARE PROTESTING AND THE WISE HISTORIANS HAVE MORE TO SAY ON THE SUBJECT...

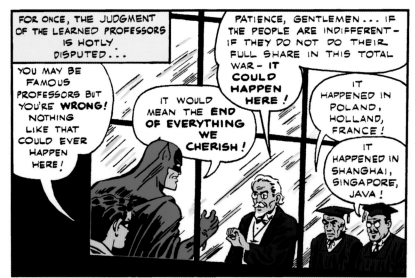
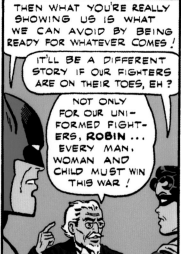
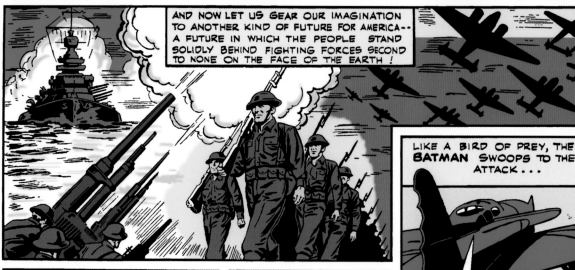
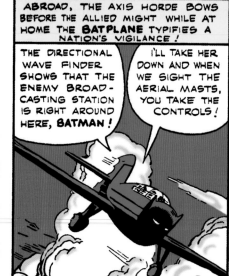
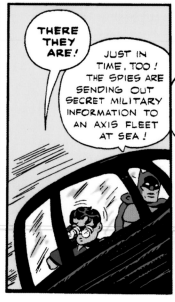
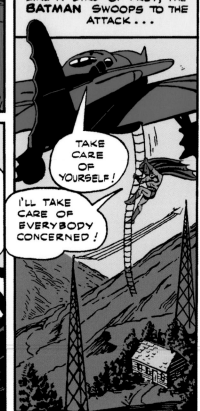

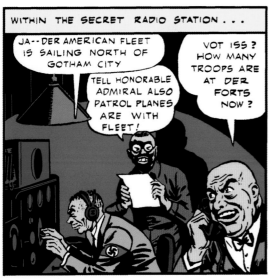

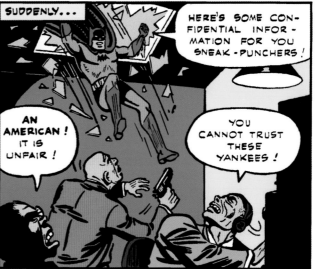

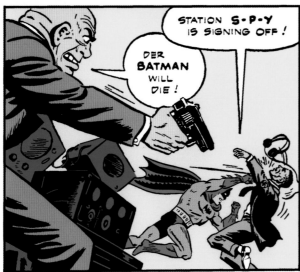

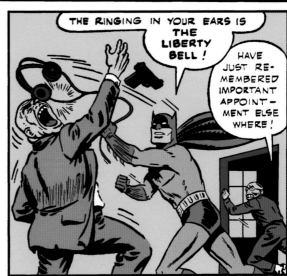

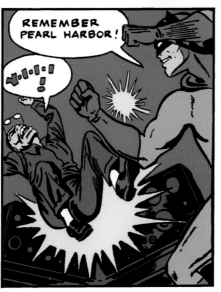

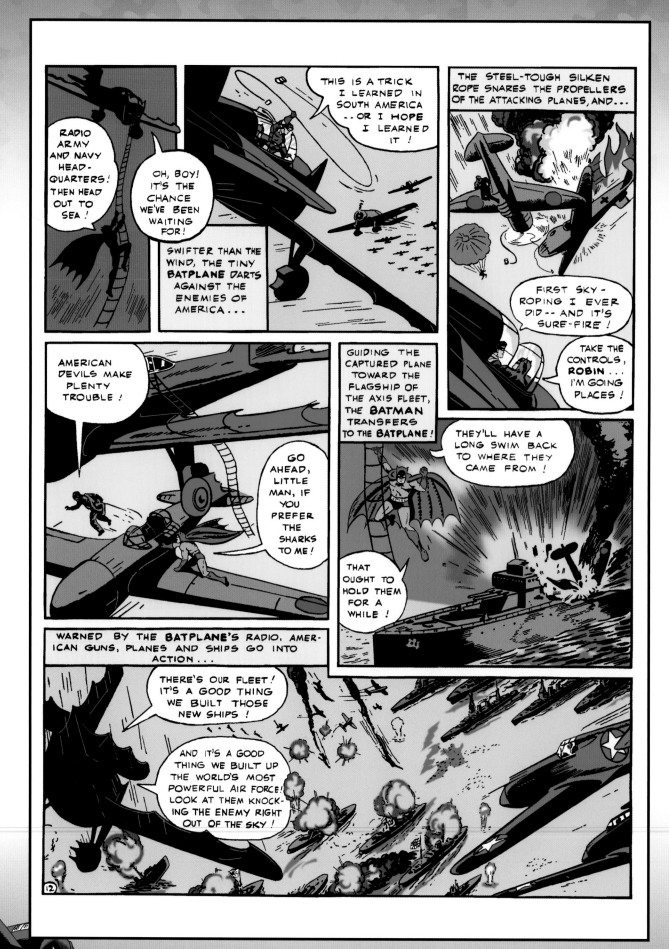

162

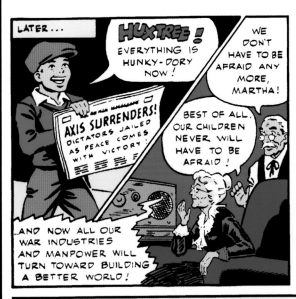

LATER...

HUXTREE! EVERYTHING IS HUNKY-DORY NOW!

WE DON'T HAVE TO BE AFRAID ANY MORE, MARTHA!

AXIS SURRENDERS! DICTATORS JAILED AS PEACE COMES WITH VICTORY!

BEST OF ALL, OUR CHILDREN NEVER WILL HAVE TO BE AFRAID!

..AND NOW ALL OUR WAR INDUSTRIES AND MANPOWER WILL TURN TOWARD BUILDING A BETTER WORLD!

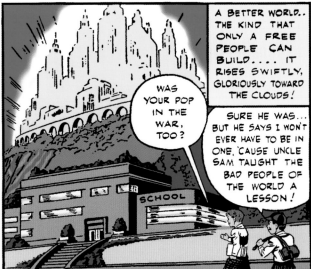

A BETTER WORLD.. THE KIND THAT ONLY A FREE PEOPLE CAN BUILD.... IT RISES SWIFTLY, GLORIOUSLY TOWARD THE CLOUDS!

WAS YOUR POP IN THE WAR, TOO?

SURE HE WAS... BUT HE SAYS I WON'T EVER HAVE TO BE IN ONE, 'CAUSE UNCLE SAM TAUGHT THE BAD PEOPLE OF THE WORLD A LESSON!

SCHOOL

AND NOW WE UNDERSTAND BETTER WHAT THE WISE HISTORIANS WERE DRIVING AT WHEN THEY SHOWED US THAT OTHER, HORRIBLE FUTURE, WHICH NEVER NEED BE...

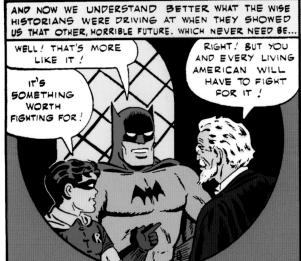

WELL! THAT'S MORE LIKE IT!

IT'S SOMETHING WORTH FIGHTING FOR!

RIGHT! BUT YOU AND EVERY LIVING AMERICAN WILL HAVE TO FIGHT FOR IT!

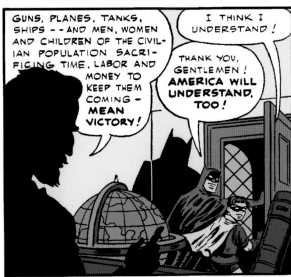

GUNS, PLANES, TANKS, SHIPS -- AND MEN, WOMEN AND CHILDREN OF THE CIVILIAN POPULATION SACRIFICING TIME, LABOR AND MONEY TO KEEP THEM COMING - MEAN VICTORY!

I THINK I UNDERSTAND!

THANK YOU, GENTLEMEN! AMERICA WILL UNDERSTAND, TOO!

163

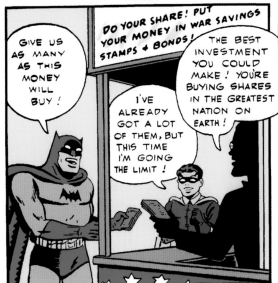

GIVE US AS MANY AS THIS MONEY WILL BUY!

DO YOUR SHARE! PUT YOUR MONEY IN WAR SAVINGS STAMPS & BONDS!

THE BEST INVESTMENT YOU COULD MAKE! YOU'RE BUYING SHARES IN THE GREATEST NATION ON EARTH!

I'VE ALREADY GOT A LOT OF THEM, BUT THIS TIME I'M GOING THE LIMIT!

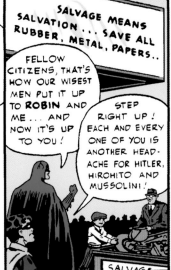

SALVAGE MEANS SALVATION... SAVE ALL RUBBER, METAL, PAPERS..

FELLOW CITIZENS, THAT'S HOW OUR WISEST MEN PUT IT UP TO ROBIN AND ME ... AND NOW IT'S UP TO YOU!

STEP RIGHT UP! EACH AND EVERY ONE OF YOU IS ANOTHER HEADACHE FOR HITLER, HIROHITO AND MUSSOLINI!

SALVAGE

THE END

IT'S YOUR BATTLE... YOUR FUTURE... YOUR AMERICA!!! KEEP FAITH WITH YOUR COUNTRY.. WORK AND SAVE FOR UNCLE SAM-- AND IT WILL BE YOUR VICTORY!

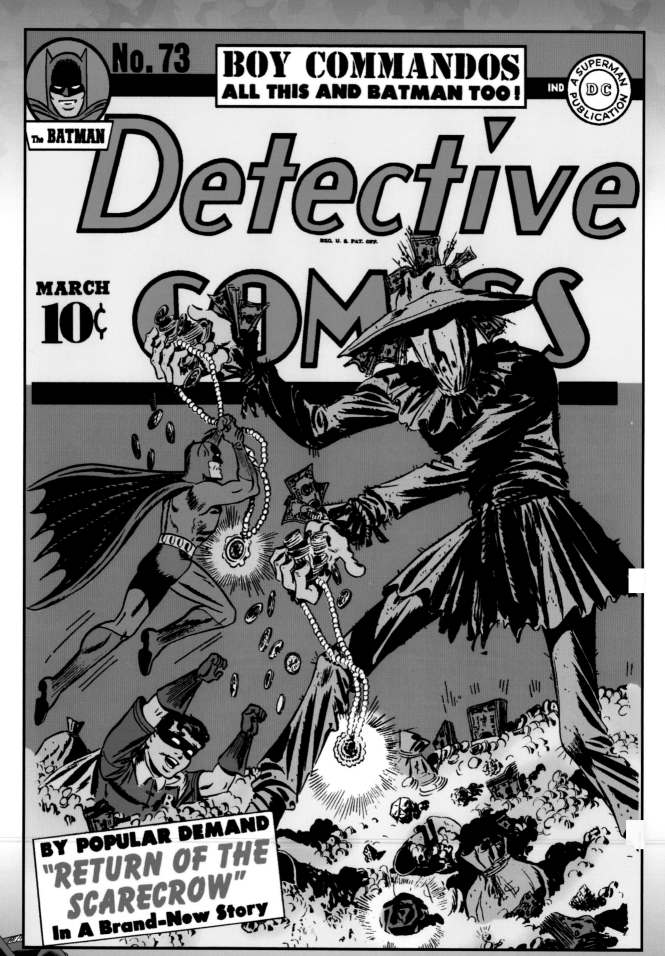

Detective Comics #73 (March 1943) - cover art: Bob Kane (pencils) & Jerry Robinson & George Roussos (inks)

Detective Comics #73 (March 1943) - script: Don Cameron - art: Bob Kane (pencils) & Jerry Robinson & George Roussos (inks)

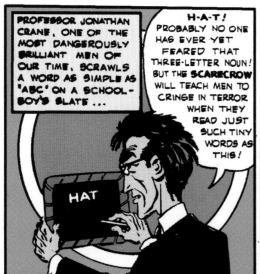

PROFESSOR JONATHAN CRANE, ONE OF THE MOST DANGEROUSLY BRILLIANT MEN OF OUR TIME, SCRAWLS A WORD AS SIMPLE AS 'ABC' ON A SCHOOLBOY'S SLATE...

H-A-T! PROBABLY NO ONE HAS EVER YET FEARED THAT THREE-LETTER NOUN! BUT THE SCARECROW WILL TEACH MEN TO CRINGE IN TERROR WHEN THEY READ JUST SUCH TINY WORDS AS THIS!

HAT

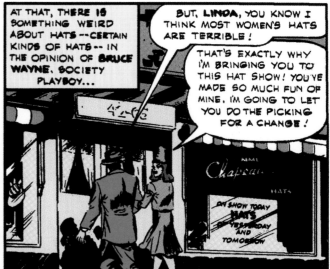

AT THAT, THERE IS SOMETHING WEIRD ABOUT HATS--CERTAIN KINDS OF HATS--IN THE OPINION OF BRUCE WAYNE, SOCIETY PLAYBOY...

BUT, LINDA, YOU KNOW I THINK MOST WOMEN'S HATS ARE TERRIBLE!

THAT'S EXACTLY WHY I'M BRINGING YOU TO THIS HAT SHOW! YOU'VE MADE SO MUCH FUN OF MINE, I'M GOING TO LET YOU DO THE PICKING FOR A CHANGE!

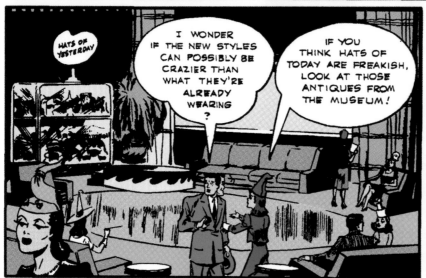

HATS OF YESTERDAY

I WONDER IF THE NEW STYLES CAN POSSIBLY BE CRAZIER THAN WHAT THEY'RE ALREADY WEARING?

IF YOU THINK HATS OF TODAY ARE FREAKISH, LOOK AT THOSE ANTIQUES FROM THE MUSEUM!

HMMM -- REAL PEARLS AND PRECIOUS STONES! THEY'RE WORTH A FORTUNE!

AT THE PRICES MME. CHAPEAU IS ASKING, HERS OUGHT TO BE STUDDED WITH JEWELS!

AH -- THE INDUSTRIAL MOTIF!

AREN'T THEY QUAINT?

THAT'S ONE WORD FOR IT!

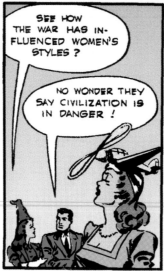

SEE HOW THE WAR HAS INFLUENCED WOMEN'S STYLES?

NO WONDER THEY SAY CIVILIZATION IS IN DANGER!

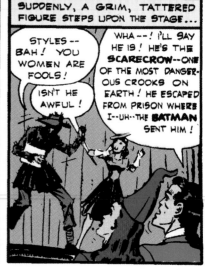

SUDDENLY, A GRIM, TATTERED FIGURE STEPS UPON THE STAGE...

STYLES -- BAH! YOU WOMEN ARE FOOLS!

ISN'T HE AWFUL!

WHA --! I'LL SAY HE IS! HE'S THE SCARECROW--ONE OF THE MOST DANGEROUS CROOKS ON EARTH! HE ESCAPED FROM PRISON WHERE I--UH--THE BATMAN SENT HIM!

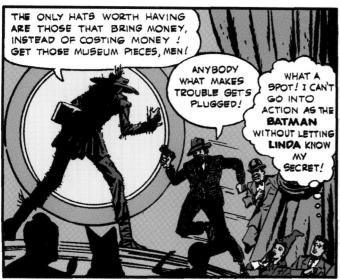

THE ONLY HATS WORTH HAVING ARE THOSE THAT BRING MONEY, INSTEAD OF COSTING MONEY! GET THOSE MUSEUM PIECES, MEN!

ANYBODY WHAT MAKES TROUBLE GETS PLUGGED!

WHAT A SPOT! I CAN'T GO INTO ACTION AS THE **BATMAN** WITHOUT LETTING **LINDA** KNOW MY SECRET!

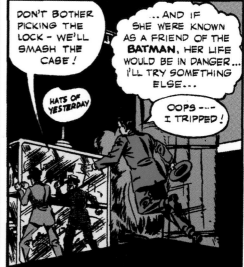

DON'T BOTHER PICKING THE LOCK — WE'LL SMASH THE CASE!

...AND IF SHE WERE KNOWN AS A FRIEND OF THE **BATMAN**, HER LIFE WOULD BE IN DANGER... I'LL TRY SOMETHING ELSE...

HATS OF YESTERDAY

OOPS — I TRIPPED!

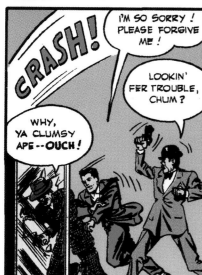

CRASH!

I'M SO SORRY! PLEASE FORGIVE ME!

LOOKIN' FER TROUBLE, CHUM?

WHY, YA CLUMSY APE — OUCH!

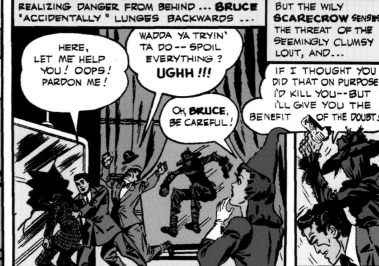

REALIZING DANGER FROM BEHIND... **BRUCE** "ACCIDENTALLY" LUNGES BACKWARDS...

HERE, LET ME HELP YOU! OOPS! PARDON ME!

WADDA YA TRYIN' TA DO — SPOIL EVERYTHING? UGHH!!!

OH, **BRUCE**, BE CAREFUL!

BUT THE WILY **SCARECROW** SENSES THE THREAT OF THE SEEMINGLY CLUMSY LOUT, AND...

IF I THOUGHT YOU DID THAT ON PURPOSE, I'D KILL YOU — BUT I'LL GIVE YOU THE BENEFIT OF THE DOUBT!

167

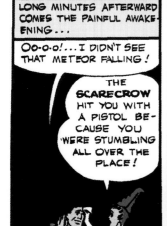

LONG MINUTES AFTERWARD COMES THE PAINFUL AWAKENING...

OO-O-O!... I DIDN'T SEE THAT METEOR FALLING!

THE **SCARECROW** HIT YOU WITH A PISTOL BECAUSE YOU WERE STUMBLING ALL OVER THE PLACE!

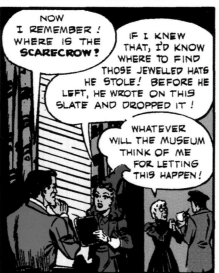

NOW I REMEMBER! WHERE IS THE **SCARECROW**?

IF I KNEW THAT, I'D KNOW WHERE TO FIND THOSE JEWELLED HATS HE STOLE! BEFORE HE LEFT, HE WROTE ON THIS SLATE AND DROPPED IT!

WHATEVER WILL THE MUSEUM THINK OF ME FOR LETTING THIS HAPPEN!

HMMM — A SCHOOL SLATE... AND THE **SCARECROW** USED TO BE A TEACHER! I CAN UNDERSTAND THE "HAT" PART — BUT WHAT DOES HE MEAN BY "MAT"?

HAT — CAME OFF NICELY MAT

LATER...

GOODBYE, **BRUCE** — I'M SORRY YOU GOT HURT! IF ONLY THE **BATMAN** HAD BEEN THERE, IT WOULDN'T HAVE HAPPENED!

YOU BET IT WOULDN'T HAVE!

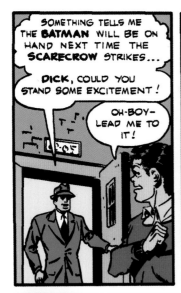

SOMETHING TELLS ME THE **BATMAN** WILL BE ON HAND NEXT TIME THE **SCARECROW** STRIKES...

DICK, COULD YOU STAND SOME EXCITEMENT!

OH-BOY- LEAD ME TO IT!

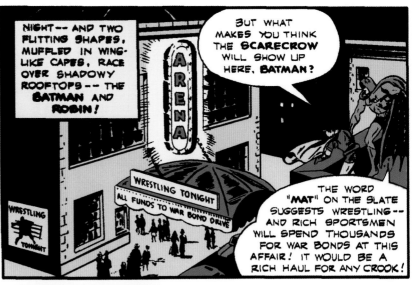

NIGHT-- AND TWO FLITTING SHAPES, MUFFLED IN WING- LIKE CAPES, RACE OVER SHADOWY ROOFTOPS -- THE **BATMAN** AND **ROBIN!**

BUT WHAT MAKES YOU THINK THE **SCARECROW** WILL SHOW UP HERE, BATMAN?

THE WORD **"MAT"** ON THE SLATE SUGGESTS WRESTLING -- AND RICH SPORTSMEN WILL SPEND THOUSANDS FOR WAR BONDS AT THIS AFFAIR! IT WOULD BE A RICH HAUL FOR ANY CROOK!

IT DOESN'T SEEM VERY PATRIOTIC, OUR SNEAKING IN WITHOUT EVEN PAYING ADMISSION!

I GUESS PEOPLE WOULD FORGIVE US IF THEY KNEW OUR MOTIVE WAS TO SEE THAT THEIR MONEY GOES TO HELP THE WAR EFFORT, INSTEAD OF INTO THE POCKETS OF CROOKS!

THIS WILL LET US INTO THE TOP GALLERY, WHICH IS CLOSED OFF... WE'LL BE ABLE TO SEE WITHOUT BEING SEEN!

IF THE **SCARECROW** DOESN'T SHOW UP, I HOPE THE WRESTLING MATCHES ARE GOOD!

QUITE A CROWD!

WHEN YOU COMBINE SPORT AND PATRIOTISM, YOU'VE GOT A POPULAR MIXTURE!

LOOK -- THAT TALL, SKINNY FELLOW BUYING POPCORN FROM THE VENDOR! COULD HE BE--?

HE NOT ONLY COULD BE -- HE IS! THAT'S PROFESSOR CRANE --THE **SCARECROW** WITHOUT THE TRIMMINGS!

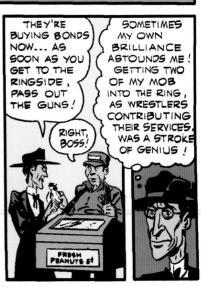

THEY'RE BUYING BONDS NOW... AS SOON AS YOU GET TO THE RINGSIDE, PASS OUT THE GUNS!

RIGHT, BOSS!

SOMETIMES MY OWN BRILLIANCE ASTOUNDS ME! GETTING TWO OF MY MOB INTO THE RING, AS WRESTLERS CONTRIBUTING THEIR SERVICES, WAS A STROKE OF GENIUS!

FRESH PEANUTS 5¢



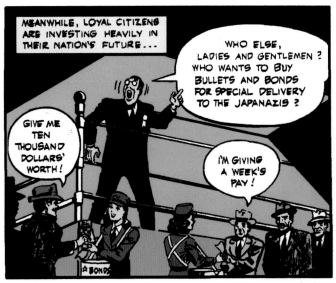

MEANWHILE, LOYAL CITIZENS ARE INVESTING HEAVILY IN THEIR NATION'S FUTURE...

WHO ELSE, LADIES AND GENTLEMEN? WHO WANTS TO BUY BULLETS AND BONDS FOR SPECIAL DELIVERY TO THE JAPANAZIS?

GIVE ME TEN THOUSAND DOLLARS' WORTH!

I'M GIVING A WEEK'S PAY!

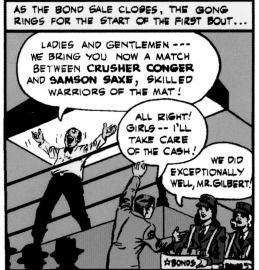

AS THE BOND SALE CLOSES, THE GONG RINGS FOR THE START OF THE FIRST BOUT...

LADIES AND GENTLEMEN --- WE BRING YOU NOW A MATCH BETWEEN CRUSHER CONGER AND SAMSON SAXE, SKILLED WARRIORS OF THE MAT!

ALL RIGHT! GIRLS -- I'LL TAKE CARE OF THE CASH!

WE DID EXCEPTIONALLY WELL, MR. GILBERT!

AND ON THEIR WAY TO THE RING, THE SUPPOSED WRESTLERS TRANSACT STRANGE BUSINESS WITH THE POPCORN VENDOR!

SH-H-H! NOT SO LOUD, CRUSHER!

POPCORN AN' POPGUNS, HUH? HAW, HAW, HAW!

MAKE IT SNAPPY!

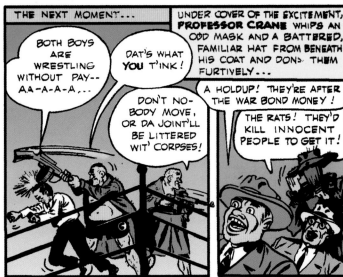

THE NEXT MOMENT...

BOTH BOYS ARE WRESTLING WITHOUT PAY-- AA-A-A-A,...

DAT'S WHAT YOU T'INK!

DON'T NO-BODY MOVE, OR DA JOINT'LL BE LITTERED WIT' CORPSES!

UNDER COVER OF THE EXCITEMENT, PROFESSOR CRANE WHIPS AN ODD MASK AND A BATTERED, FAMILIAR HAT FROM BENEATH HIS COAT AND DONS THEM FURTIVELY...

A HOLDUP! THEY'RE AFTER THE WAR BOND MONEY!

THE RATS! THEY'D KILL INNOCENT PEOPLE TO GET IT!

169

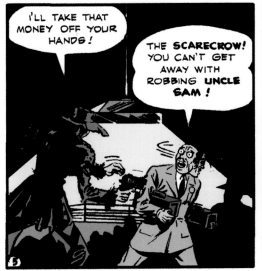

I'LL TAKE THAT MONEY OFF YOUR HANDS!

THE SCARECROW! YOU CAN'T GET AWAY WITH ROBBING UNCLE SAM!

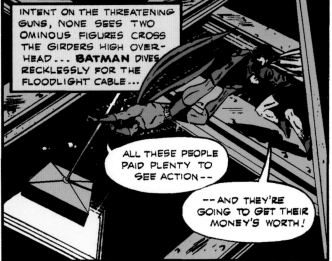

INTENT ON THE THREATENING GUNS, NONE SEES TWO OMINOUS FIGURES CROSS THE GIRDERS HIGH OVER-HEAD... BATMAN DIVES RECKLESSLY FOR THE FLOODLIGHT CABLE...

ALL THESE PEOPLE PAID PLENTY TO SEE ACTION--

--AND THEY'RE GOING TO GET THEIR MONEY'S WORTH!

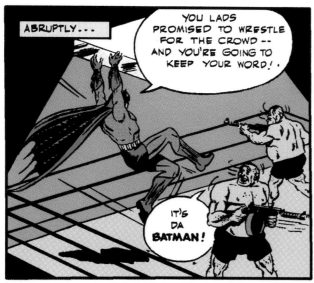

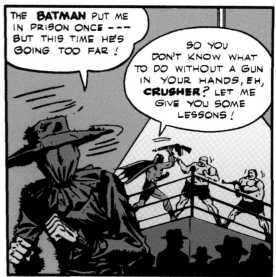

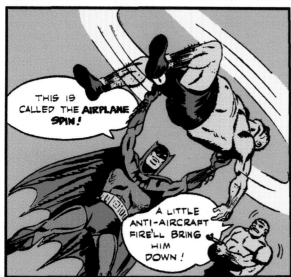

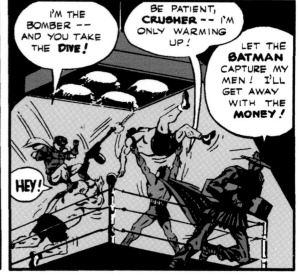

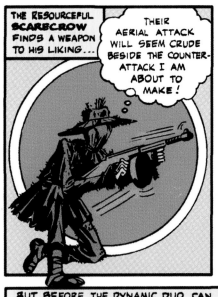

THE RESOURCEFUL **SCARECROW** FINDS A WEAPON TO HIS LIKING...

THEIR AERIAL ATTACK WILL SEEM CRUDE BESIDE THE COUNTER-ATTACK I AM ABOUT TO MAKE!

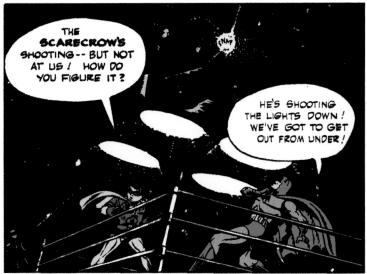

THE **SCARECROW'S** SHOOTING -- BUT NOT AT US! HOW DO YOU FIGURE IT?

HE'S SHOOTING THE LIGHTS DOWN! WE'VE GOT TO GET OUT FROM UNDER!

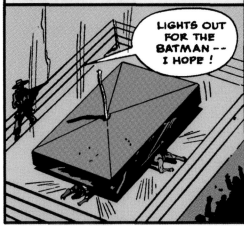

BUT BEFORE THE DYNAMIC DUO CAN MOVE, STEEL-JACKETED SLUGS SEVER THE CHAIN SUPPORTING THE BATTERY OF FLOODLAMPS -- AND...

LIGHTS OUT FOR THE BATMAN -- I HOPE!

BUT KNOCKING HIM OUT ISN'T ENOUGH! I'LL HAVE TO KILL HIM BEFORE I CAN MAKE A SUCCESS OF MY CAMPAIGN OF TERROR! HMMM... HOW CAN I TRAP HIM?

AS POLICE RESERVES CHARGE THROUGH THE EXCITED CROWD, THE **SCARECROW** FLEES WITH QUEER GRASSHOPPER LEAPS...

TOO BAD I HAVE TO LEAVE THE MONEY -- BUT ONCE I GET RID OF THE **BATMAN**, THERE'LL BE PLENTY MORE FOR THE TAKING!

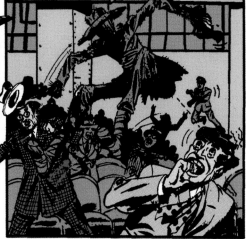

171

FRIENDLY HANDS LIFT THE MASS OF BROKEN GLASS AND TWISTED METAL FROM THE STILL FORMS OF THE FAMOUS HEROES...

THEY KEPT THE CROOKS FROM GETTING THE MONEY -- BUT IT WON'T BE WORTH IT IF THEY'RE DEAD!

IF THEY ARE, THERE'LL BE A BIG CELEBRATION IN THE UNDER-WORLD TONIGHT!

AND UNDER THE MINISTRATIONS OF A DOCTOR...

IF THIS IS HEAVEN, WHY HAVEN'T I GOT WINGS?

YOU'LL HAVE TO WAIT AWHILE, SON!

SO ALL OF THEM GOT AWAY?... THEN WE **FAILED!**

7

FAILED, NOTHING! BESIDES SAVING THE CASH, YOU TREATED THIS CROWD TO THE BEST FIGHT THEY'VE EVER SEEN! IS ANYTHING MORE IMPORTANT THAN THAT?

THE SCARECROW IS MORE IMPORTANT! UNLESS HE'S PUT AWAY FOR GOOD, HE'LL TERRORIZE THE WHOLE CITY!

I FOUND THIS SLATE WITH SOME SILLY STUFF ON IT BY THE RINGSIDE!

"HAT"-"MAT"-- AND NEXT IS "VAT"... THAT'S GOING TO BE A TOUGH ONE TO FIGURE OUT!

MAYBE THIS CARD STUCK IN THE FRAME OF THE SLATE WILL THROW SOME LIGHT ON THE SUBJECT!

HAT-CAME OFF NICELY! MAT-FELL FLAT VAT-

JUST AN ADVERTISEMENT FOR THE VORTEX CLEANERS & DYERS AT 13 HOOKE STREET -- AND AN OLD ONE, AT THAT!

DOESN'T MEAN A THING! PROBABLY SOME CARD THAT WAS KICKING AROUND AND GOT CAUGHT ACCIDENTALLY!

BUT THE SUBTLEST CLUE IS ENOUGH FOR THE BATMAN, ACE CRIMINOLOGIST -- AND PRESENTLY...

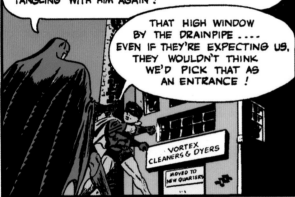

DYERS USE VATS IT'S SO PLAIN, THE SCARECROW MIGHT HAVE INTENDED IT AS A TRAP -- BUT I'D HATE TO PASS UP THE CHANCE OF TANGLING WITH HIM AGAIN!

THAT HIGH WINDOW BY THE DRAINPIPE EVEN IF THEY'RE EXPECTING US, THEY WOULDN'T THINK WE'D PICK THAT AS AN ENTRANCE!

VORTEX CLEANERS & DYERS

MOVED TO NEW QUARTERS

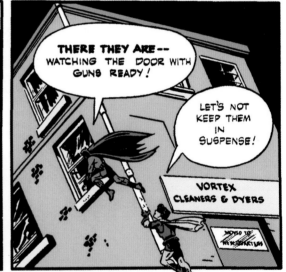

THERE THEY ARE -- WATCHING THE DOOR WITH GUNS READY!

LET'S NOT KEEP THEM IN SUSPENSE!

VORTEX CLEANERS & DYERS

MOVED TO NEW HEADQUARTERS

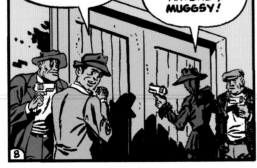

WITHIN THE GLOOMY STRUCTURE...

CHEE, SCARECROW -- DIS JOINT GIVES ME DA CREEPS! I FEEL LIKE SOMEONE WAS SNEAKIN' UP ON ME!

A COMMON PSYCHOLOGICAL PHENOMENON WHEN ONE HAS REASON TO BE FRIGHTENED OF ANYONE, MUGGSY!

8

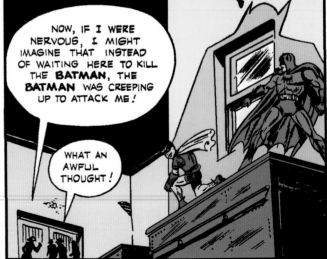

NOW, IF I WERE NERVOUS, I MIGHT IMAGINE THAT INSTEAD OF WAITING HERE TO KILL THE BATMAN, THE BATMAN WAS CREEPING UP TO ATTACK ME!

WHAT AN AWFUL THOUGHT!

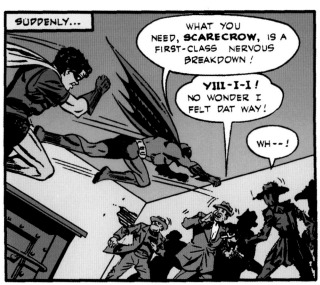

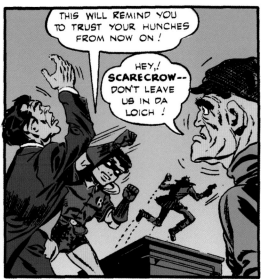

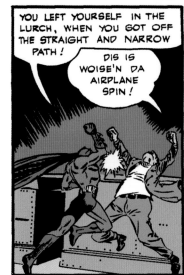

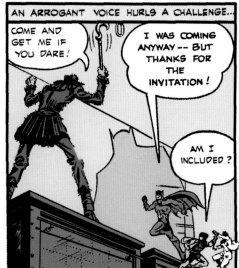

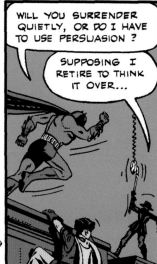

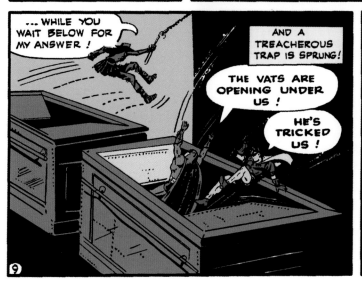

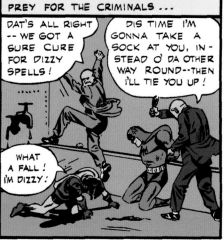

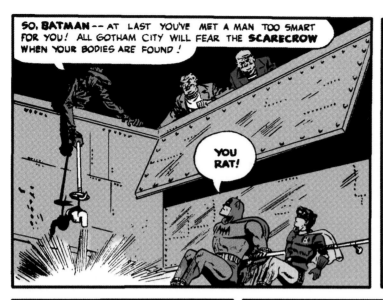

SO, BATMAN-- AT LAST YOU'VE MET A MAN TOO SMART FOR YOU! ALL GOTHAM CITY WILL FEAR THE **SCARECROW** WHEN YOUR BODIES ARE FOUND!

YOU RAT!

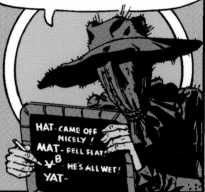

YOU SEE I WAS AFTER **BAT** --- MEANING YOU--- ALL ALONG! THE **VAT** WAS ONLY TO GET YOU HERE -- WITH THE **BRAT!** AND AS FOR CALLING ME A **RAT**-- YOU'RE GOING TO DROWN LIKE ONE! HA, HA, HA!

HAT-CAME OFF NICELY!
MAT-FELL FLAT!
✓ᴮ HE'S ALL WET!
YAT-

SWIFTLY, STEADILY, RELENTLESSLY, THE WATER RISES ABOUT THE TRAPPED PAIR TUGGING VAINLY AT THEIR BONDS...

THEY'VE GONE AND WE'RE GOING FAST-- AND I'LL NEVER-KNOW WHAT CROOKEDNESS THE **SCARECROW** HAS LABELED "YAT."

NOT A CHANCE OF BREAKING THESE ROPES, AND NO WAY OF SHUTTING OFF THE WATER-- AND YELLING WOULD ONLY BE A WASTE OF BREATH!

IT'S AN UGLY WAY TO WIND THINGS UP, **BATMAN** --- BUT AT LEAST, I'M CHECKING OUT IN GOOD COMPANY!

DON'T GIVE UP YET, **ROBIN** ... SEE THAT STICK WITH THE POINTED HOOK THE **SCARECROW** DROPPED? IT'S FLOATING!

FLOATING, YES -- BUT NOT OUR WAY!

MAYBE WE CAN CHANGE THAT BY CREATING A CURRENT!

THE **BATMAN'S** THRASHING FEET SET UP A SLOW CIRCULAR MOTION IN THE WATER -- AND AFTER AGONIZING SECONDS OF DOUBT...

GOT IT! BUT IF IT HAD BEEN HALF AN INCH FARTHER AWAY WE'D HAVE BEEN SUNK -- AND I MEAN **SUNK!**

WE WILL BE ANYWAY, IF YOU DON'T HURRY!

WRISTS STRAINING CLUMSILY, THE **BATMAN** FUMBLES WITH THE HOOK FOR WATERSOAKED KNOTS HE CANNOT SEE ...

THIS IS ONE OF THE MOST AWKWARD JOBS I EVER TACKLED!

ANOTHER INCH OR TWO AND OUR AIR WILL BE CUT OFF!

WILL THE DAREDEVIL DUO ESCAPE IN TIME OR WILL THE DIABOLIC PLOT OF THE SCHEMING **SCARECROW** WRITE "FINIS" TO THEIR DRAMATIC CAREER OF CRIME-FIGHTING?...

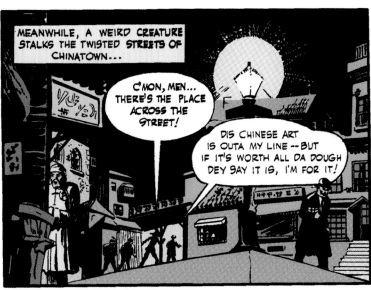

MEANWHILE, A WEIRD CREATURE STALKS THE TWISTED STREETS OF CHINATOWN...

C'MON, MEN... THERE'S THE PLACE ACROSS THE STREET!

DIS CHINESE ART IS OUTA MY LINE -- BUT IF IT'S WORTH ALL DA DOUGH DEY SAY IT IS, I'M FOR IT!

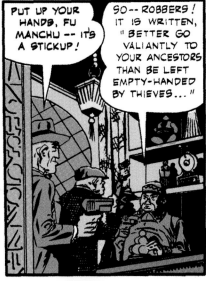

PUT UP YOUR HANDS, FU MANCHU -- IT'S A STICKUP!

SO -- ROBBERS! IT IS WRITTEN, "BETTER GO VALIANTLY TO YOUR ANCESTORS THAN BE LEFT EMPTY-HANDED BY THIEVES..."

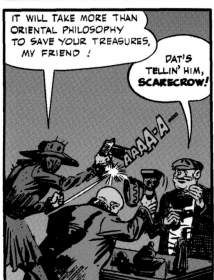

IT WILL TAKE MORE THAN ORIENTAL PHILOSOPHY TO SAVE YOUR TREASURES, MY FRIEND!

DAT'S TELLIN' HIM, SCARECROW!

A'A'A'A-A--

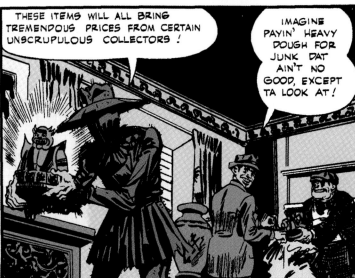

THESE ITEMS WILL ALL BRING TREMENDOUS PRICES FROM CERTAIN UNSCRUPULOUS COLLECTORS!

IMAGINE PAYIN' HEAVY DOUGH FOR JUNK DAT AIN'T NO GOOD, EXCEPT TA LOOK AT!

175

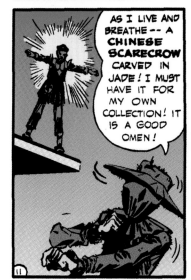

AS I LIVE AND BREATHE -- A CHINESE SCARECROW CARVED IN JADE! I MUST HAVE IT FOR MY OWN COLLECTION! IT IS A GOOD OMEN!

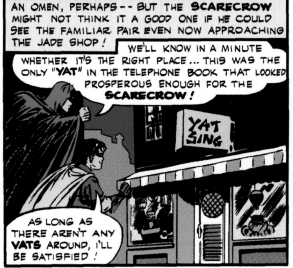

AN OMEN, PERHAPS -- BUT THE SCARECROW MIGHT NOT THINK IT A GOOD ONE IF HE COULD SEE THE FAMILIAR PAIR EVEN NOW APPROACHING THE JADE SHOP!

WE'LL KNOW IN A MINUTE WHETHER IT'S THE RIGHT PLACE... THIS WAS THE ONLY "YAT" IN THE TELEPHONE BOOK THAT LOOKED PROSPEROUS ENOUGH FOR THE SCARECROW!

YAT SING

AS LONG AS THERE AREN'T ANY VATS AROUND, I'LL BE SATISFIED!

11

THERE THEY ARE!

AND HERE WE GO AGAIN!

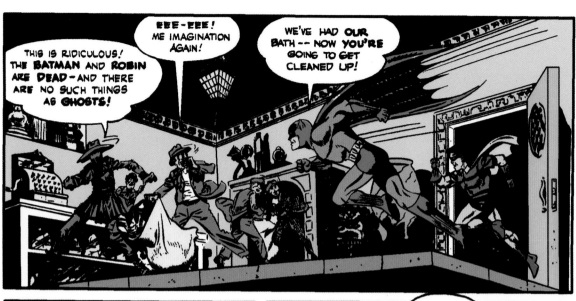

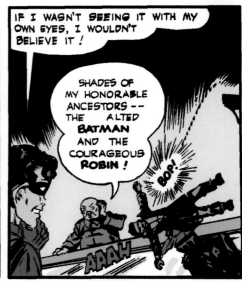

177

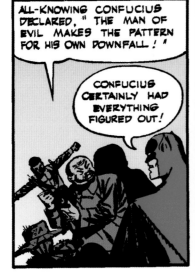

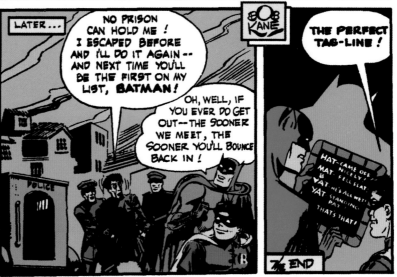

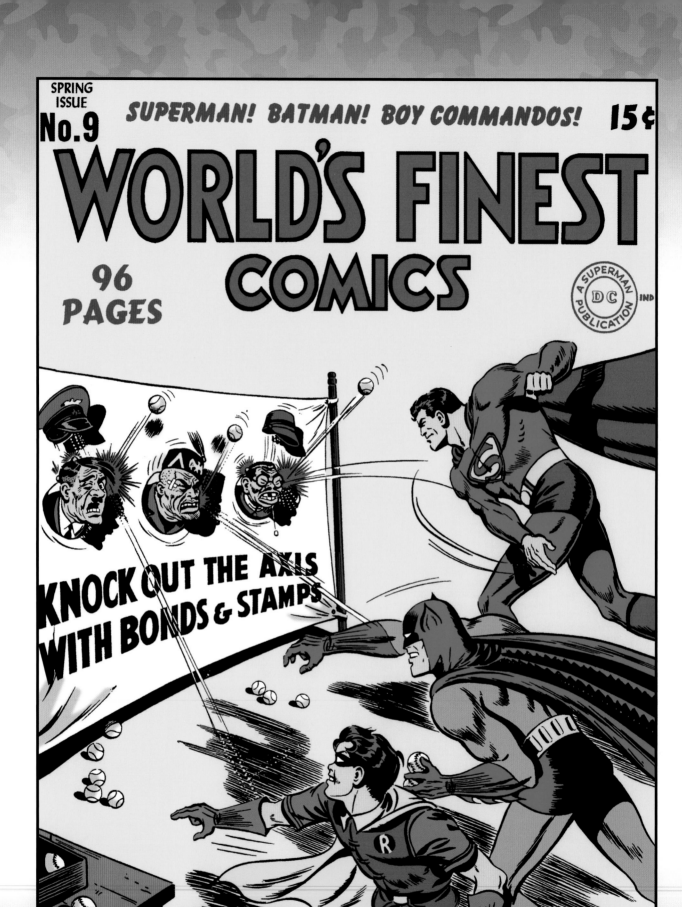

World's Finest Comics #9 (Spring 1943) - cover art: Jack Burnley

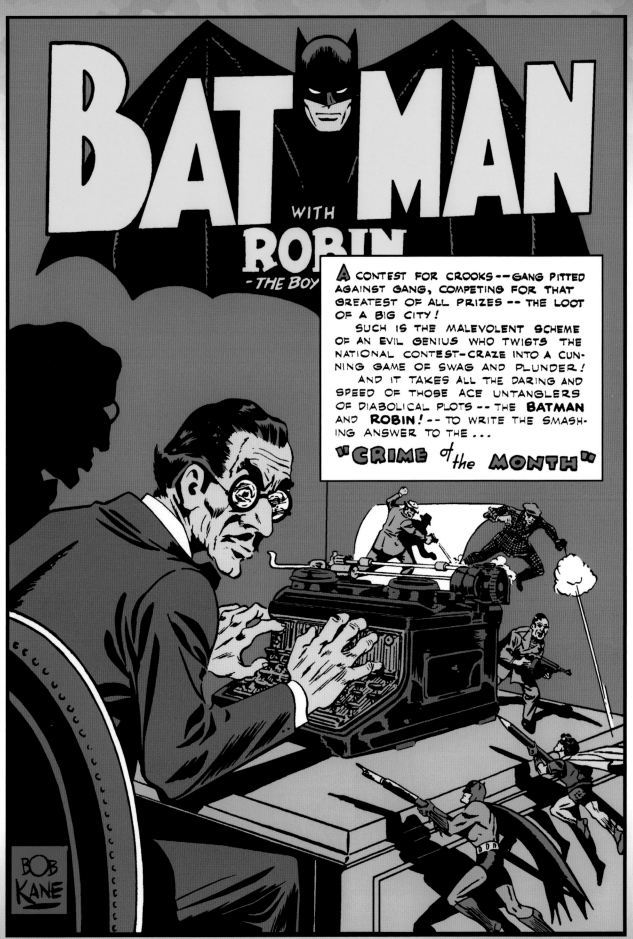

World's Finest Comics #9 (Spring 1943) - script: Bill Finger - art: Jerry Robinson (pencils) & George Roussos (inks)

THE GRIM RIDDLE OPENS WITH AN ORDINARY, NEATLY ENGRAVED INVITATION...

BUT ITS RECIPIENTS ARE THE STRANGEST ONE COULD IMAGINE!

AND AS A CHILL MARCH WIND WHIPS AROUND THE AUTHOR'S GLOOMY CASTLE, A PROCESSION OF BULLETPROOF CARS ARRIVES AT THE RENDEZVOUS...

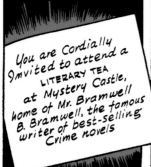

You are Cordially Invited to attend a LITERARY TEA at Mystery Castle, home of Mr. Bramwell B. Bramwell, the famous writer of best-selling Crime novels

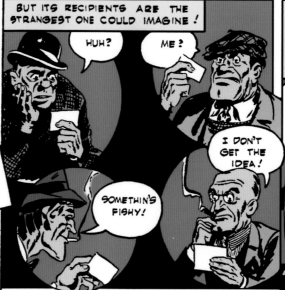

HUH?

ME?

I DON'T GET THE IDEA!

SOMETHIN'S FISHY!

MAYBE BRAMWELL WANTS TO PUT US IN A BOOK!

NAH! HE KNOWS PLENTY ABOUT CROOKS WITHOUT STUDYIN' US! I DON'T LIKE THE LOOKS OF THIS!

MEANWHILE, UNSEEN FROM BELOW, THE NOTED HOST TAKES STOCK OF HIS ODD GUESTS...

...THE CRIME BOSSES OF GOTHAM CITY -- INVITED TO A LITERARY TEA!

A STROKE OF SHEER GENIUS, INVITING THOSE GANG LEADERS HERE! THEY DON'T KNOW IT YET, BUT THEY'RE GOING TO HAND ME A FORTUNE! NOT ONE OF THEM IS A MATCH FOR ME!

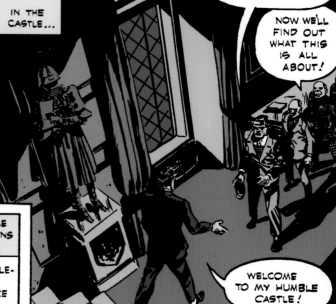

IN THE CASTLE...

HERE COMES BRAMWELL NOW!

NOW WE'LL FIND OUT WHAT THIS IS ALL ABOUT!

WELCOME TO MY HUMBLE CASTLE!

IMPATIENTLY, THE MOB BOSSES WAIT WHILE TEA IS SERVED... THEN BRAMWELL BEGINS TO SPEAK...

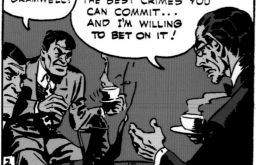

WHAT'S THE IDEA BACK O' THIS LITERARY TEA, BRAMWELL?

IT'S VERY SIMPLE, GENTLEMEN! FOR YEARS, I'VE BEEN OUTWITTING THE POLICE IN MY BOOKS! NOW I'M CONVINCED I CAN OUTDO THE BEST CRIMES YOU CAN COMMIT... AND I'M WILLING TO BET ON IT!

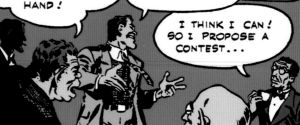

YER CRAZY, BRAMWELL! I BET YA NEVER EVEN HAD A GAT IN YER HAND!

WHY, YOU COULDN'T PULL A REAL JOB... LET ALONE BEAT ANY OF OURS!

I THINK I CAN! SO I PROPOSE A CONTEST...

2

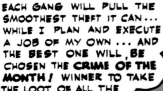

EACH GANG WILL PULL THE SMOOTHEST THEFT IT CAN... WHILE I PLAN AND EXECUTE A JOB OF MY OWN ... AND THE BEST ONE WILL, BE CHOSEN THE **CRIME OF THE MONTH!** WINNER TO TAKE THE LOOT OF ALL THE OTHER GANGS!

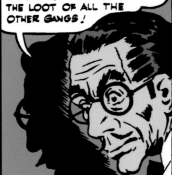

THE STARTLING PROPOSAL MEETS WITH STUNNED SILENCE, AND THEN...

I'M GAME, BRAMWELL! BUT HOW DO WE PICK THE WINNER?

OKAY WITH US!

BY APPOINTING A COMMITTEE OF JUDGES! I SUGGEST THE FOUR OF YOU-- BRIGHT GUY WARNER--SLIM RYAN, CHOPPER GANT AND MUSCLES HARDY -- AND MYSELF!

AND SO, IN THE NEXT FEW DAYS, A WAVE OF CRIME SPREADS PANIC THROUGH GOTHAM CITY...

GOTHAM GAZETTE
WAREHOUSE DARINGLY RIFLED-LABELED CRIME OF THE MONTH

GOTHAM GAZETTE
CRIME OF THE MONTH STRIKES CROWDED DEPARTMENT STORE

AND THEN, IN THE BUSY LOBBY OF THE NATIONAL COUNTY BANK...

MAKE IT FAST, TELLER! I'M IN A HURRY!

BRIGHT GUY SURE CAN FIGURE 'EM! THIS BEATS ANYTHIN' THE OTHER GANG PULLED!

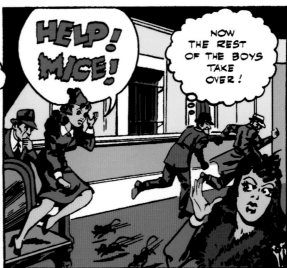

HELP! MICE!

NOW THE REST OF THE BOYS TAKE OVER!

181

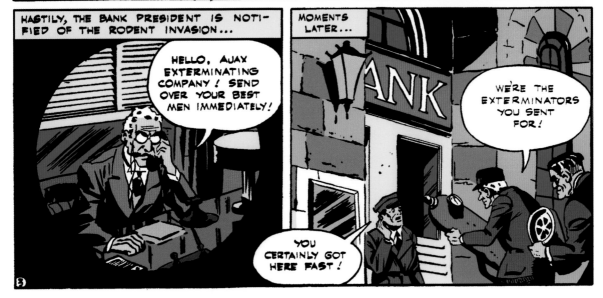

HASTILY, THE BANK PRESIDENT IS NOTIFIED OF THE RODENT INVASION...

HELLO, AJAX EXTERMINATING COMPANY! SEND OVER YOUR BEST MEN IMMEDIATELY!

MOMENTS LATER...

WE'RE THE EXTERMINATORS YOU SENT FOR!

YOU CERTAINLY GOT HERE FAST!

THE GAS FROM THIS MACHINE CAN'T HURT HUMAN BEINGS... BUT IT KILLS MICE IN A JIFFY! JUST MAKE SURE ALL THE DOORS AND WINDOWS ARE SHUT!

OKAY!

SOON AFTER THE "EXTERMINATORS" LEAVE...

GOSH, AM I SLEEPY ALL OF A SUDDEN!

ME, TOO! NO MORE BIG BREAKFASTS FOR ME!

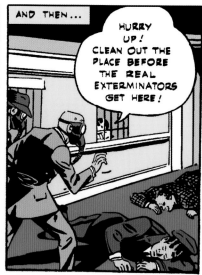

AND THEN...

HURRY UP! CLEAN OUT THE PLACE BEFORE THE REAL EXTERMINATORS GET HERE!

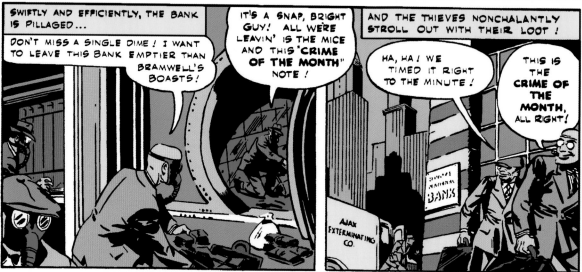

SWIFTLY AND EFFICIENTLY, THE BANK IS PILLAGED...

DON'T MISS A SINGLE DIME! I WANT TO LEAVE THIS BANK EMPTIER THAN BRAMWELL'S BOASTS!

IT'S A SNAP, BRIGHT GUY! ALL WE'RE LEAVIN' IS THE MICE AND THIS 'CRIME OF THE MONTH' NOTE!

AND THE THIEVES NONCHALANTLY STROLL OUT WITH THEIR LOOT!

HA, HA! WE TIMED IT RIGHT TO THE MINUTE!

THIS IS THE CRIME OF THE MONTH, ALL RIGHT!

AJAX EXTERMINATING CO.

BANK

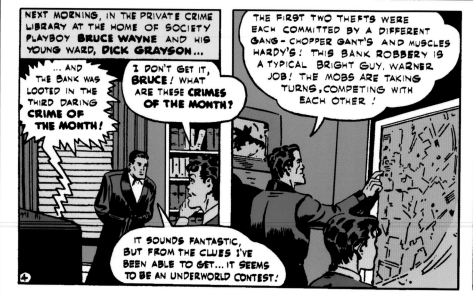

NEXT MORNING, IN THE PRIVATE CRIME LIBRARY AT THE HOME OF SOCIETY PLAYBOY **BRUCE WAYNE** AND HIS YOUNG WARD, **DICK GRAYSON**...

... AND THE BANK WAS LOOTED IN THE THIRD DARING **CRIME OF THE MONTH!**

I DON'T GET IT, **BRUCE!** WHAT ARE THESE **CRIMES OF THE MONTH?**

IT SOUNDS FANTASTIC, BUT FROM THE CLUES I'VE BEEN ABLE TO GET... IT SEEMS TO BE AN UNDERWORLD CONTEST!

THE FIRST TWO THEFTS WERE EACH COMMITTED BY A DIFFERENT GANG - CHOPPER GANT'S AND MUSCLES HARDY'S! THIS BANK ROBBERY IS A TYPICAL BRIGHT GUY, WARNER JOB! THE MOBS ARE TAKING TURNS, COMPETING WITH EACH OTHER!

AND THE CLEVEREST THEFT IS TO BE THE **CRIME OF THE MONTH!** THE ONLY IMPORTANT GANG LEFT IS SLIM RYAN'S... AND SLIM NEVER MISSES UP ON ANYTHING GOOD! SO THAT'S THE MOB WE'LL WATCH...

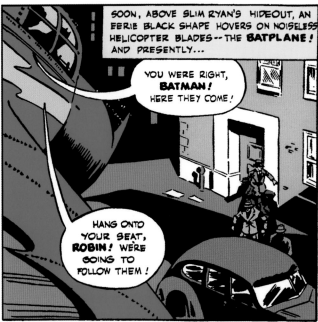

SOON, ABOVE SLIM RYAN'S HIDEOUT, AN EERIE BLACK SHAPE HOVERS ON NOISELESS HELICOPTER BLADES -- THE **BATPLANE**! AND PRESENTLY...

YOU WERE RIGHT, **BATMAN**! HERE THEY COME!

HANG ONTO YOUR SEAT, **ROBIN**! WE'RE GOING TO FOLLOW THEM!

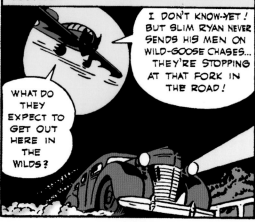

THROUGH CROWDED CITY STREETS, OUT INTO THE COUNTRY, ROARS THE GANGSTERS' CAR... PURSUED BY THE FLITTING SHADOW OF JUSTICE!

I DON'T KNOW-YET! BUT SLIM RYAN NEVER SENDS HIS MEN ON WILD-GOOSE CHASES... THEY'RE STOPPING AT THAT FORK IN THE ROAD!

WHAT DO THEY EXPECT TO GET OUT HERE IN THE WILDS?

SWIFTLY, UNAWARE OF WATCHFUL EYES ABOVE, THE MOBSTERS DRAG A BIG SAWHORSE ACROSS THE HIGHWAY...

HAW, HAW! AND BRIGHT GUY THINKS HIS BANK JOB IS THE **CRIME OF THE MONTH**! WAIT'LL HE HEARS ABOUT THIS!

DETOUR HIGHWAY UNDER CONSTRUCTION

WE'LL GET THE PRIZE SURE... HIS SWAG AND ALL THE OTHER GANGS'!

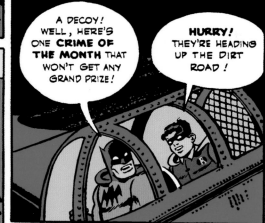

A DECOY! WELL, HERE'S ONE **CRIME OF THE MONTH** THAT WON'T GET ANY GRAND PRIZE!

HURRY! THEY'RE HEADING UP THE DIRT ROAD!

183

MEANWHILE, IN THE **BATPLANE** HOVERING ABOVE...

GOLLY, **BATMAN**, HERE COMES AN ARMORED CAR!

ONLY A FEW MINUTES BEFORE IT'LL REACH THE BRIDGE!... WE'LL HAVE TO WORK FAST!

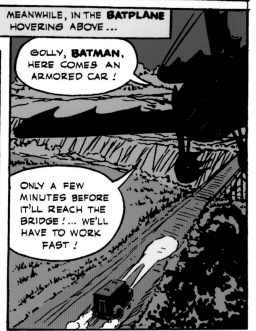

OVER DESOLATE WOODLANDS THE PURSUIT CONTINUES... AND ENDS AT A WOODEN BRIDGE SPANNING A DEEP RAVINE!

REMEMBER--WHEN THE ARMORED CAR STARTS CROSSING THIS BRIDGE, PUSH THAT PLUNGER DOWN!

I GOT YA, SLIM! THEN WE CLIMB DOWN THE GULCH AND CLEAN OUT THE WRECKED CAR!

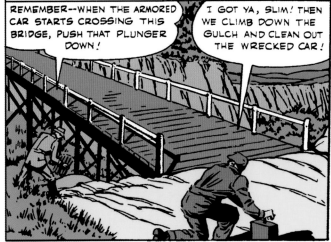

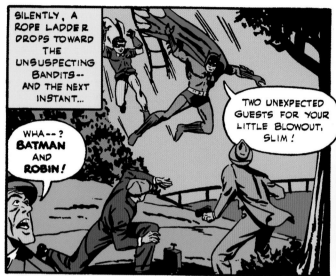

SILENTLY, A ROPE LADDER DROPS TOWARD THE UNSUSPECTING BANDITS-- AND THE NEXT INSTANT...

WHA--? BATMAN AND ROBIN!

TWO UNEXPECTED GUESTS FOR YOUR LITTLE BLOWOUT, SLIM!

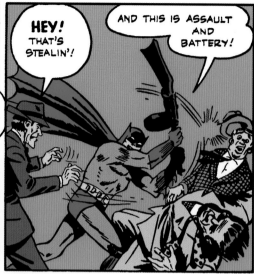

HEY! THAT'S STEALIN'!

AND THIS IS ASSAULT AND BATTERY!

A FLURRY OF FLASHING FISTS DRIVES THE HOODLUMS BACK TOWARD THE BRIDGE OF DOOM!

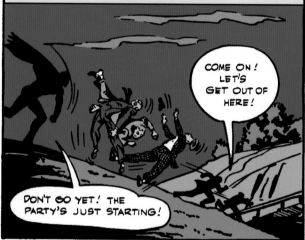

COME ON! LET'S GET OUT OF HERE!

DON'T GO YET! THE PARTY'S JUST STARTING!

ROBIN, MEANWHILE, HAS CORNERED A RAT OF HIS OWN...

IF I CAN PUT HIM OUT OF COMMISSION, IT'LL REMOVE THE DANGER TO THE ARMORED CAR!

I'LL GET YOU, WONDER BRAT!

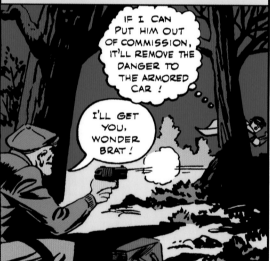

RECKLESSLY, ROBIN LEAPS TOWARD AN OVERHANGING BRANCH, AND..

NOT IF I GET YOU FIRST!

HEY, LOOK OUT! I'M GONNA HIT THE PLUNGER!

A SECOND LATER...

BOOM!

6

RUSH HIM!

LOOKS LIKE YOU'LL HAVE TO ESCAPE OVER MY DEAD BODY! ANYBODY CARE TO TRY?

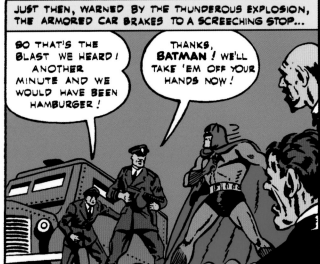

JUST THEN, WARNED BY THE THUNDEROUS EXPLOSION, THE ARMORED CAR BRAKES TO A SCREECHING STOP...

SO THAT'S THE BLAST WE HEARD! ANOTHER MINUTE AND WE WOULD HAVE BEEN HAMBURGER!

THANKS, BATMAN! WE'LL TAKE 'EM OFF YOUR HANDS NOW!

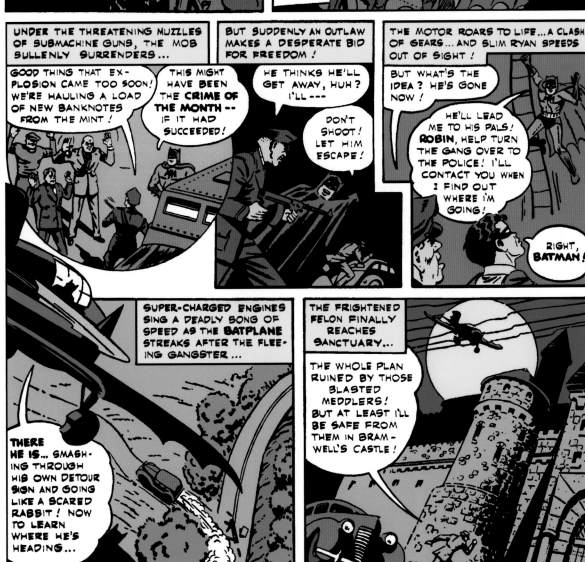

UNDER THE THREATENING MUZZLES OF SUBMACHINE GUNS, THE MOB SULLENLY SURRENDERS...

GOOD THING THAT EXPLOSION CAME TOO SOON! WE'RE HAULING A LOAD OF NEW BANKNOTES FROM THE MINT!

THIS MIGHT HAVE BEEN THE CRIME OF THE MONTH -- IF IT HAD SUCCEEDED!

BUT SUDDENLY AN OUTLAW MAKES A DESPERATE BID FOR FREEDOM!

HE THINKS HE'LL GET AWAY, HUH? I'LL ---

DON'T SHOOT! LET HIM ESCAPE!

THE MOTOR ROARS TO LIFE...A CLASH OF GEARS...AND SLIM RYAN SPEEDS OUT OF SIGHT!

BUT WHAT'S THE IDEA? HE'S GONE NOW!

HE'LL LEAD ME TO HIS PALS! ROBIN, HELP TURN THE GANG OVER TO THE POLICE! I'LL CONTACT YOU WHEN I FIND OUT WHERE I'M GOING!

RIGHT, BATMAN!

185

SUPER-CHARGED ENGINES SING A DEADLY SONG OF SPEED AS THE BATPLANE STREAKS AFTER THE FLEEING GANGSTER...

THERE HE IS... SMASHING THROUGH HIS OWN DETOUR SIGN AND GOING LIKE A SCARED RABBIT! NOW TO LEARN WHERE HE'S HEADING...

THE FRIGHTENED FELON FINALLY REACHES SANCTUARY...

THE WHOLE PLAN RUINED BY THOSE BLASTED MEDDLERS! BUT AT LEAST I'LL BE SAFE FROM THEM IN BRAMWELL'S CASTLE!

⑦

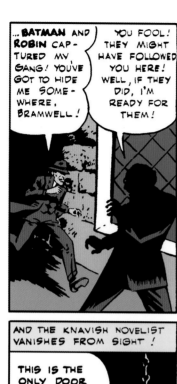

...**BATMAN** AND **ROBIN** CAPTURED MY GANG! YOU'VE GOT TO HIDE ME SOMEWHERE, BRAMWELL!

YOU FOOL! THEY MIGHT HAVE FOLLOWED YOU HERE! WELL, IF THEY DID, I'M READY FOR THEM!

MEANWHILE, ABOVE THE STRONGHOLD'S FROWNING BATTLEMENTS, **BATMAN** QUICKLY CONTACTS HIS YOUNG AIDE...

RYAN SLIPPED INTO BRAMWELL'S CASTLE? BUT WHAT'S BRAMWELL GOT TO DO WITH GANGSTERS?

HE'S OBVIOUSLY CONNECTED WITH THE **CRIME OF THE MONTH** IN SOME WAY! I'M GOING AFTER RYAN NOW! STAND BY IN CASE I NEED HELP!

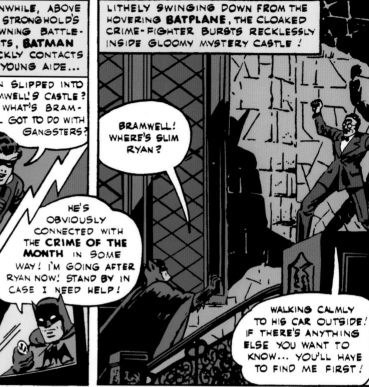

LITHELY SWINGING DOWN FROM THE HOVERING **BATPLANE**, THE CLOAKED CRIME-FIGHTER BURSTS RECKLESSLY INSIDE GLOOMY MYSTERY CASTLE!

BRAMWELL! WHERE'S SLIM RYAN?

WALKING CALMLY TO HIS CAR OUTSIDE! IF THERE'S ANYTHING ELSE YOU WANT TO KNOW... YOU'LL HAVE TO FIND ME FIRST!

AND THE KNAVISH NOVELIST VANISHES FROM SIGHT!

THIS IS THE ONLY DOOR HERE! HE MUST BE IN THAT ROOM!

UH-HUH! HE MUST'VE DISAPPEARED THROUGH A SLIDING PANEL! AND I HEAR MACHINERY STARTING UP SOMEWHERE! SOMETHING'S GOING TO HAPPEN!

SLAM

SOMETHING **IS** HAPPENING RIGHT NOW! FOR **BATMAN** SUDDENLY FEELS EVERY METAL OBJECT ON HIM BECOMING UNBEARABLY HOT!

WHEW! IT-- IT'S GETTING HOT! I FEEL AS THOUGH I'M BURNING UP!

AN INDUCTION FURNACE! IT GENERATES STATIC ELECTRICITY IN METALS AND MAKES THEM MELT! LUCKY I HAVE NO DENTAL FILLINGS! THEY'D HEAT UP TO 3000 DEGREES AND COOK MY BRAIN!

NO KNOB ON THE DOOR...NO WINDOWS TO CLIMB THROUGH... AND ALL THE TOOLS FROM MY UTILITY BELT JUST A PUDDLE! IF I COULD ONLY CALL **ROBIN**! BUT MY PORTABLE WIRELESS SET IS USELESS TOO! WHAT A SPOT TO BE IN...

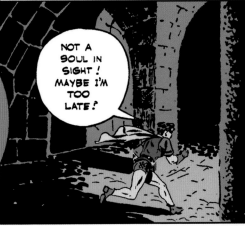

MEANWHILE, IN DISTANT GOTHAM CITY, SOME SIXTH SENSE STIRS WARNINGLY IN THE BOY WONDER'S ALERT MIND...

IT'S OVER AN HOUR SINCE BATMAN CALLED! SOMETHING MUST BE WRONG! HE WOULDN'T WAIT THIS LONG TO GET IN TOUCH WITH ME!

BATMAN MUST BE IN TROUBLE! I'VE GOT TO GET TO BRAMWELL'S CASTLE -- BUT FAST!

AT BREAKNECK SPEED, THE BOY WONDER SWIFTLY REACHES THE FORBIDDING STRUCTURE AND BURSTS INSIDE!

NOT A SOUL IN SIGHT! MAYBE I'M TOO LATE!

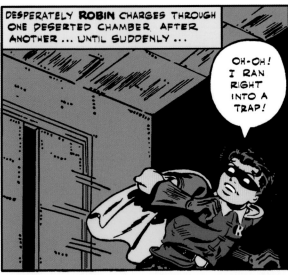

187

DESPERATELY ROBIN CHARGES THROUGH ONE DESERTED CHAMBER AFTER ANOTHER ... UNTIL SUDDENLY ...

OH-OH! I RAN RIGHT INTO A TRAP!

THICK - OR ISN'T IT? I DON'T SEE ANY-THING HERE THAT CAN HARM ME!

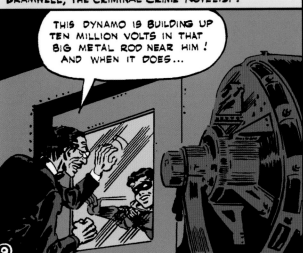

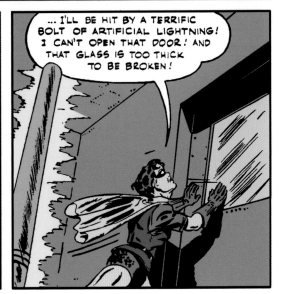

BUT, NO? YOU FORGET, ROBIN, YOU'RE DEALING WITH BRAMWELL, THE CRIMINAL CRIME NOVELIST!

THIS DYNAMO IS BUILDING UP TEN MILLION VOLTS IN THAT BIG METAL ROD NEAR HIM! AND WHEN IT DOES...

... I'LL BE HIT BY A TERRIFIC BOLT OF ARTIFICIAL LIGHTNING! I CAN'T OPEN THAT DOOR! AND THAT GLASS IS TOO THICK TO BE BROKEN!

9

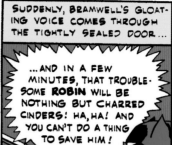

WHILE **ROBIN** FACES SEARING DOOM IN ANOTHER PART OF THE CASTLE, BATMAN SEEKS A WAY OF ESCAPE... **AND FINDS NONE!**

SUDDENLY, BRAMWELL'S GLOATING VOICE COMES THROUGH THE TIGHTLY SEALED DOOR...

AND AS BRAMWELL'S FOOTFALLS FADE DOWN THE CAVERNOUS CORRIDOR...

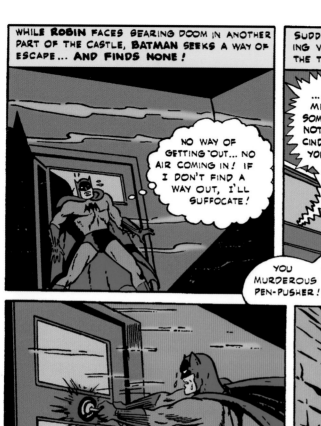

NO WAY OF GETTING OUT... NO AIR COMING IN! IF I DON'T FIND A WAY OUT, I'LL SUFFOCATE!

...AND IN A FEW MINUTES, THAT TROUBLESOME **ROBIN** WILL BE NOTHING BUT CHARRED CINDERS! HA, HA! AND YOU CAN'T DO A THING TO SAVE HIM!

THAT DOOR-- THERE'S NO KNOB ON IT... METAL WOULD MELT IN THIS ELECTRIC FURNACE!

YOU MURDEROUS PEN-PUSHER!

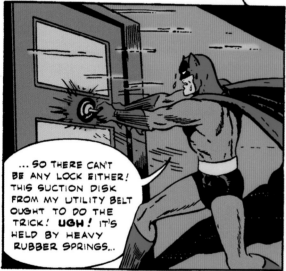

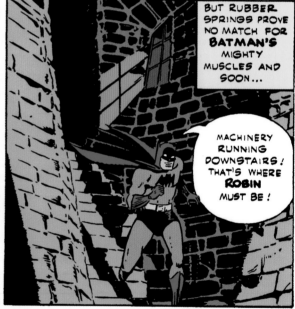

BUT RUBBER SPRINGS PROVE NO MATCH FOR **BATMAN'S** MIGHTY MUSCLES AND SOON...

...SO THERE CAN'T BE ANY LOCK EITHER! THIS SUCTION DISK FROM MY UTILITY BELT OUGHT TO DO THE TRICK! **UGH!** IT'S HELD BY HEAVY RUBBER SPRINGS...

MACHINERY RUNNING DOWNSTAIRS! THAT'S WHERE **ROBIN** MUST BE!

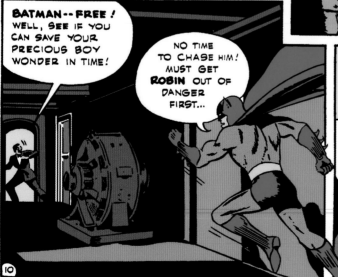

BATMAN--FREE! WELL, SEE IF YOU CAN SAVE YOUR PRECIOUS BOY WONDER IN TIME!

NO TIME TO CHASE HIM! MUST GET **ROBIN** OUT OF DANGER FIRST...

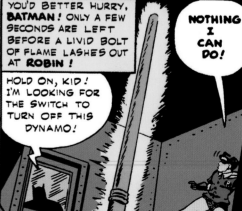

YOU'D BETTER HURRY, **BATMAN!** ONLY A FEW SECONDS ARE LEFT BEFORE A LIVID BOLT OF FLAME LASHES OUT AT **ROBIN!**

HOLD ON, KID! I'M LOOKING FOR THE SWITCH TO TURN OFF THIS DYNAMO!

NOTHING I CAN DO!

⑩

BUT THE DYNAMO, **BATMAN** LEARNS, IS SYNCHRONIZED WITH THE SLIDING DOORS!

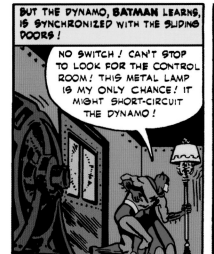

NO SWITCH! CAN'T STOP TO LOOK FOR THE CONTROL ROOM! THIS METAL LAMP IS MY ONLY CHANCE! IT MIGHT SHORT-CIRCUIT THE DYNAMO!

ABRUPTLY, HE HURLS THE LAMP INTO THE WHIRLING MACHINE...

...AND SMASHES THE THICK WINDOW WITH A STOUT CHAIR...

WHEW! THAT HAD ME SWEATING SO MUCH, I FEEL LIKE A DRY CELL NOW!

THE FUN ISN'T OVER! BRAMWELL'S STILL LOOSE! LET'S GO!

THERE HE IS NOW!

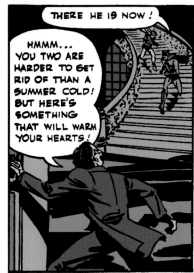

HMMM... YOU TWO ARE HARDER TO GET RID OF THAN A SUMMER COLD! BUT HERE'S SOMETHING THAT WILL WARM YOUR HEARTS!

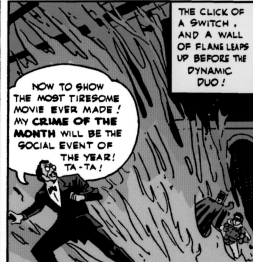

NOW TO SHOW THE MOST TIRESOME MOVIE EVER MADE! MY **CRIME OF THE MONTH** WILL BE THE SOCIAL EVENT OF THE YEAR! TA-TA!

THE CLICK OF A SWITCH, AND A WALL OF FLAME LEAPS UP BEFORE THE DYNAMIC DUO!

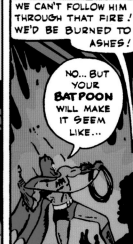

WE CAN'T FOLLOW HIM THROUGH THAT FIRE! WE'D BE BURNED TO ASHES!

NO... BUT YOUR **BATPOON** WILL MAKE IT SEEM LIKE...

189

INTO AN OAKEN BEAM THUDS THE SHARP TIP OF THE **BATPOON**...

...JUMPING THROUGH A FIERY HOOP AT THE CIRCUS!

BUT WHEN THE POWERHOUSE PAIR PLUNGES OUT OF THE GRIM CASTLE...

HE'S VANISHED!

TAKE THE **BATMOBILE** AND SEARCH FOR HIM! I'LL CLIMB UP TO THE ROOF AND GO AFTER HIM IN THE **BATPLANE**! WE'LL MEET AT THE HOUSE LATER, IF WE DON'T CATCH HIM!

HE CAN'T GET AWAY FROM THE **BATPLANE** AND THE **BATMOBILE** BOTH!

ABOARD THE **BATPLANE**, THE MANTLED MANHUNTER FLASHES SKYWARD... AND A FEW MINUTES LATER...

THERE'S **ROBIN!** BUT NOT A TRACE OF BRAMWELL! HE MUST'VE TAKEN A PRIVATE ROAD THROUGH THE WOODS TO BE SHIELDED FROM THE TREES!

EYES NARROWED, THE HOODED SLEUTH PONDERS A SINGLE SLIM CLUE ...

SO BRAMWELL'S **CRIME OF THE MONTH** WILL BE THE SOCIAL EVENT OF THE YEAR, EH? HMM... THAT FITS THE ALLIED WAR RELIEF DRIVE THAT SOCIETY IS GIVING TONIGHT! AND THAT PHRASE, "THE MOST TIRESOME MOVIE EVER MADE," IS FAMILIAR! WHERE DID I COME ACROSS IT BEFORE---?

MEANWHILE, IN A TREE-SHADOWED LANE FAR FROM MYSTERY CASTLE...

THOSE SIMPLETONS WILL NEVER FIND ME! AND NOW TO WIN THE BIGGEST PRIZE... THE LOOT THOSE IGNORANT GANGSTERS GARNERED--ALL FOR ME!

AND THAT NIGHT, AT SOCIETY'S GLITTERING WAR RELIEF DRIVE...

LADIES AND GENTLEMEN, MR. BRAMWELL B. BRAMWELL, THE FAMOUS MYSTERY WRITER, WILL NOW HONOR US WITH A PRIVATE SHOWING OF AN EXPERIMENTAL MOVIE HE HAS MADE! LIGHTS OUT, PLEASE!

YOU ARE SLEEPY...YOU ARE FALLING A·S·L·E·E·P...

GOODNESS I'M GETTING SO DROWSY!

I CAN HARDLY KEEP MY EYES OPEN!

RICH FOOLS! MY HYPNOTIC FILM IS PUTTING THEM TO SLEEP! ALL I HAVE TO DO IS TO ROB THEM LEISURELY, ORDER THEM TO FORGET THE INCIDENT, AND AWAKEN THEM! NOTHING CAN STOP ME! NOTHING!

SO NOW WE KNOW THE WILY WRITER'S SHREWD STRATEGY! BUT AT THAT MOMENT...

WHAT--? BATMAN AND ROBIN!

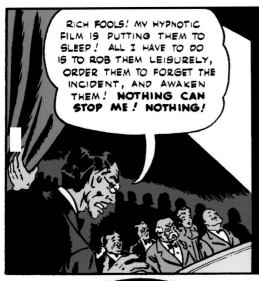

NOW SHOWING!

IN PERSON!

OVER THE HEADS OF THE STARTLED AUDIENCE SWOOPS THE DYNAMIC DUO!

191

A CLEVER PLOT, BUT YOUR ENDING ISN'T GOOD ENOUGH. WE'LL HAVE TO GIVE YOU A REJECTION... AND THIS TIME YOU'RE NOT SLIPPING FREE!

A SWIFT SUMMONS BRINGS THE POLICE RUSHING TO THE SCENE...

BUT HOW DID YOU KNOW MY SCHEME? WHAT MADE YOU BRING ANOTHER FILM TO REPLACE MY HYPNOTIC MOVIE?

THAT'S EASY! AUTHORS OFTEN USE PET PHRASES... AND YOU USED "THE MOST TIRESOME MOVIE EVER MADE" IN ONE OF YOUR EARLIER NOVELS! IT WAS THE SAME PLAN AS THE ONE YOU USED TONIGHT!

LATER, AT HOME...

SO BRAMWELL PLAGIARIZED FROM ONE OF HIS OWN BOOKS! WELL, THAT'S A PRETTY GOOD ENDING FOR THE CRIME OF THE MONTH!

YES... BUT BRAMWELL IS JUST BEGINNING A NEW CHAPTER!

BAH! THEY WON'T KEEP ME HERE LONG!

ONLY ABOUT TWENTY YEARS!

PRISONER OF THE MONTH

STOP KICKING, BRAMWELL! A FAMOUS WRITER LIKE YOU OUGHT TO BE USED TO PENS!

THE END

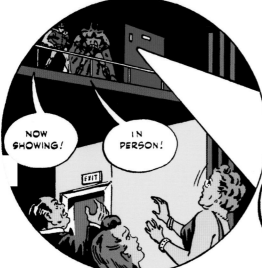

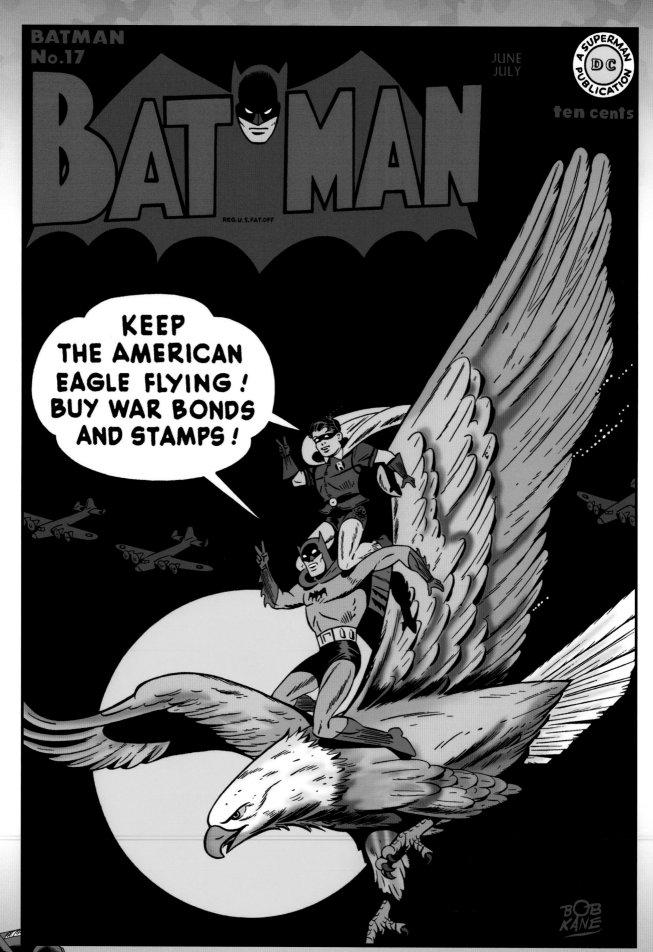

Batman #17 (June-July 1943) - cover art: Jerry Robinson

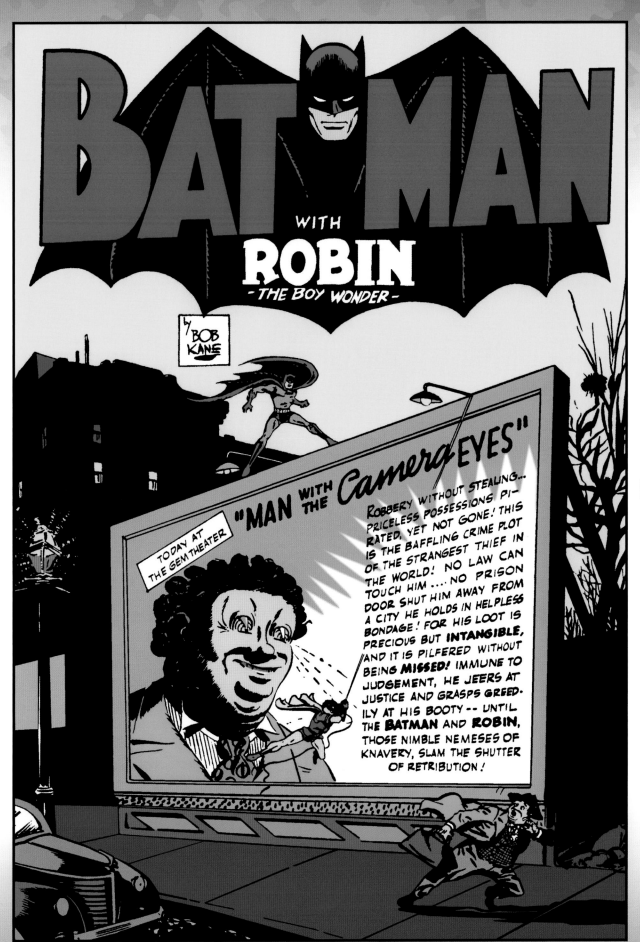

World's Finest Comics #10 (Summer 1943) - script: Bill Finger - art: Jerry Robinson (pencils) & George Roussos (inks)

AT GOTHAM CITY'S ORNATE GEM THEATER...

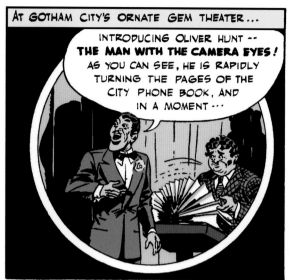

INTRODUCING OLIVER HUNT -- **THE MAN WITH THE CAMERA EYES!** AS YOU CAN SEE, HE IS RAPIDLY TURNING THE PAGES OF THE CITY PHONE BOOK, AND IN A MOMENT...

... MR. HUNT WILL RECITE BACK THE NAMES, ADDRESSES AND PHONE NUMBERS UNDER ANY LETTER YOU ASK FOR!

START WITH "L"!

VERY WELL, LAAS, HENRY 115 UNION STREET GOTHAM 1993! LABEN, ANTHONY 86 ESSEX AVENUE GOTHAM 7246! LABER ...

AMAZING!

THE SPECTACULAR PERFORMANCE OVER, TWO FAMILIAR FIGURES PREPARE TO LEAVE -- SOCIETY PLAYBOY, **BRUCE WAYNE** AND HIS YOUNG WARD, **DICK GRAYSON**...

GOLLY, HE'S GOOD! BUT IT'S A FAKE, ISN'T IT **BRUCE**?

FAR FROM IT, **DICK!** OLIVER HUNT'S INCREDIBLE MEMORY HAS BEEN FAMOUS EVER SINCE HE WAS A BOY...

"AT SCHOOL, HE STARTLED HIS TEACHERS BY MEMORIZING HIS TEXT BOOKS WORD FOR WORD... THOUGH HE SPENT LESS TIME STUDYING THAN ANY OF HIS CLASSMATES!"

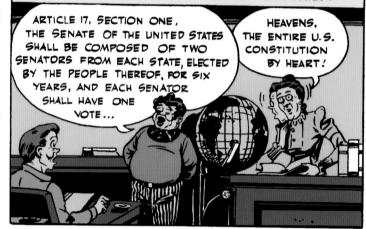

ARTICLE 17, SECTION ONE, THE SENATE OF THE UNITED STATES SHALL BE COMPOSED OF TWO SENATORS FROM EACH STATE, ELECTED BY THE PEOPLE THEREOF, FOR SIX YEARS, AND EACH SENATOR SHALL HAVE ONE VOTE...

HEAVENS, THE ENTIRE U.S. CONSTITUTION BY HEART!

"A CONCLAVE OF WORLD-FAMOUS SCIENTISTS GATHERED TO ANALYZE THE LAD'S PHENOMENAL MEMORY..."

PRENUMBRA, NOUN, PARTLY LIGHTED SHADOW ON THE SKIRTS OF A TOTAL SHADOW! PRENUMBRAE, ADJECTIVE! FROM THE LATIN, PAENE -ALMOST, UMBRA - SHADE! PENURY, NOUN, DESTITUTION, POVERTY: LACK OF! PENURIOUS, ADJECTIVE...

ASTOUNDING! A SINGLE GLANCE AT THE PAGES OF A DICTIONARY...

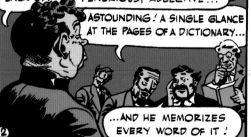

...AND HE MEMORIZES EVERY WORD OF IT!

"FOR DAYS, THE EMINENT RESEARCHERS PROBED AND ARGUED, THEN RELEASED THEIR VERDICT TO AN EAGER PUBLIC...'

GOTHAM GAZETTE

SCIENTISTS CLAIM HUNT HAS PHOTO-GRAPHIC MEMORY

"CAMERA EYES" ENABLE BOY TO TAKE MENTAL "PICTURES" FOR FUTURE REFERENCE

THEN, WHEN HUNT GOT OUT OF COLLEGE WITH EVERY POSSIBLE KIND OF DEGREE, HE DECIDED TO USE HIS AMAZING POWERS TO MAKE A LIVING! SO HE WENT INTO VAUDEVILLE! NO -- HE'S NOT A FAKE ... HE HAS A GIFT THAT CAN BE USED FOR **GREAT GOOD OR GREAT EVIL!**

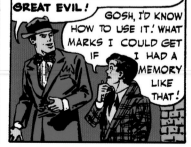

GOSH, I'D KNOW HOW TO USE IT! WHAT MARKS I COULD GET IF I HAD A MEMORY LIKE THAT!

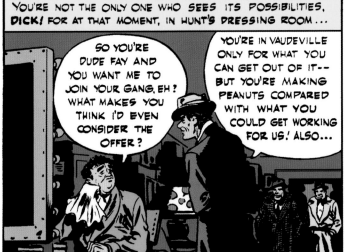

YOU'RE NOT THE ONLY ONE WHO SEES ITS POSSIBILITIES, **DICK!** FOR AT THAT MOMENT, IN HUNT'S DRESSING ROOM...

SO YOU'RE DUDE FAY AND YOU WANT ME TO JOIN YOUR GANG, EH? WHAT MAKES YOU THINK I'D EVEN CONSIDER THE OFFER?

YOU'RE IN VAUDEVILLE ONLY FOR WHAT YOU CAN GET OUT OF IT-- BUT YOU'RE MAKING PEANUTS COMPARED WITH WHAT YOU COULD GET WORKING FOR US! ALSO...

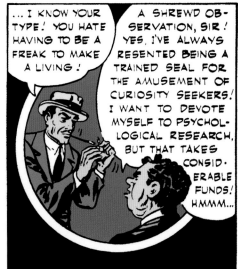

... I KNOW YOUR TYPE! YOU HATE HAVING TO BE A FREAK TO MAKE A LIVING!

A SHREWD OBSERVATION, SIR! YES, I'VE ALWAYS RESENTED BEING A TRAINED SEAL FOR THE AMUSEMENT OF CURIOSITY SEEKERS! I WANT TO DEVOTE MYSELF TO PSYCHOLOGICAL RESEARCH, BUT THAT TAKES CONSIDERABLE FUNDS! HMMM...

FATE HOLDS ITS BREATH AS THE MAN WITH THE CAMERA EYES PONDERS HIS PROBLEM! AND THEN -- THE DIE IS CAST!

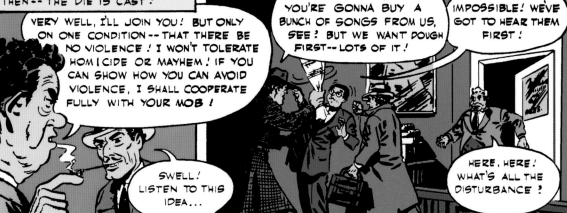

VERY WELL, I'LL JOIN YOU! BUT ONLY ON ONE CONDITION -- THAT THERE BE NO VIOLENCE! I WON'T TOLERATE HOMICIDE OR MAYHEM! IF YOU CAN SHOW HOW YOU CAN AVOID VIOLENCE, I SHALL COOPERATE FULLY WITH YOUR MOB!

SWELL! LISTEN TO THIS IDEA...

SOMETIME LATER, A VIOLENT ARGUMENT CREATES TURMOIL IN A MUSIC PUBLISHER'S OFFICE...

YOU HEARD ME, BUD! YOU'RE GONNA BUY A BUNCH OF SONGS FROM US, SEE? BUT WE WANT DOUGH FIRST -- LOTS OF IT!

BUT THAT'S IMPOSSIBLE! WE'VE GOT TO HEAR THEM FIRST!

HERE, HERE! WHAT'S ALL THE DISTURBANCE?

195

MEANWHILE, A FURTIVE FIGURE TAKES ADVANTAGE OF THE UPROAR -- **OLIVER HUNT, THE MAN WITH THE CAMERA EYES!**

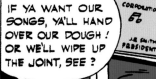

IF YA WANT OUR SONGS, YA'LL HAND OVER OUR DOUGH! OR WE'LL WIPE UP THE JOINT, SEE?

NOW, NOW! LET'S BE CALM...

VERY INGENIOUS, THIS IDEA OF DUDE FAY'S! THE SQUABBLE WILL KEEP THE OFFICE STAFF OCCUPIED WHILE I STEP INTO THE PRESIDENT'S INNER SANCTUM...

... AND MEMORIZE THESE FUTURE SMASH HITS WITH A SINGLE GLANCE! THERE, I'M FINISHED! SLIPPING OUT WILL BE A SIMPLE MATTER, AFTER WHICH THE BOYS WILL PRETEND TO BE CONVINCED THEY WERE WRONG AND LEAVE QUIETLY!

LATER, AT THE GANG'S HIDEOUT...

THERE YOU ARE, MORE MONEY FOR FIVE MINUTES' WORK THAN YOU COULD MAKE IN A MONTH OF VAUDEVILLING! PEDDLING THESE SONGS YOU MEMORIZED TO A RIVAL PUBLISHER WAS A CINCH!

IT SEEMS TO PAY! AND JUST THINK-- EVEN IF I'D BEEN CAUGHT, NOBODY COULD PROVE I WAS STEALING!

NOW, WHAT DO YOU THINK OF CRIME?

THE LOOT WAS ALL IN MY BRAIN!

GOADED BY SUCCESS, THE MAN WITH THE CAMERA EYES BEGINS A SERIES OF MYSTERIOUS THEFTS! IN THE OFFICE OF THE DISTRICT ATTORNEY...

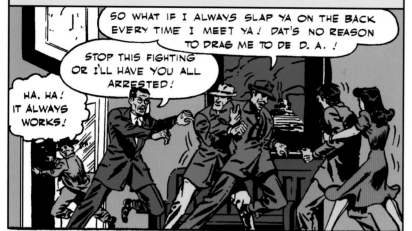

SO WHAT IF I ALWAYS SLAP YA ON THE BACK EVERY TIME I MEET YA! DAT'S NO REASON TO DRAG ME TO DE D.A.!

STOP THIS FIGHTING OR I'LL HAVE YOU ALL ARRESTED!

HA, HA! IT ALWAYS WORKS!

THE WHOLE PLAN OF PROSECUTION AGAINST ONE OF THE RICHEST SWINDLERS IN THE CITY -- AND ALL I HAVE TO DO IS SCAN THE BRIEF TO BREAK IT!

THEN A VISIT TO THE ATTORNEY DEFENDING THE NOTORIOUS SWINDLER!

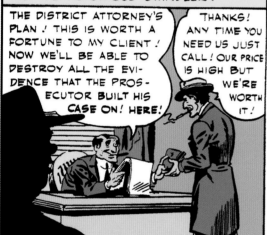

THE DISTRICT ATTORNEY'S PLAN! THIS IS WORTH A FORTUNE TO MY CLIENT! NOW WE'LL BE ABLE TO DESTROY ALL THE EVIDENCE THAT THE PROSECUTOR BUILT HIS CASE ON! HERE!

THANKS! ANY TIME YOU NEED US JUST CALL! OUR PRICE IS HIGH BUT WE'RE WORTH IT!

THE WEEKS SPEED BY, UNTIL...

LOOK, BRUCE! A FIRE!

HMM! AND THERE ARE TWO OF DUDE FAY'S GANGSTERS! WHAT WOULD THEY BE DOING IN A PUBLISHING OFFICE? DON'T TELL ME -- THAT FIRE IS THE ANSWER, I THINK! LET'S GO M'LAD!

HELP! FIRE!

FIELD PUBLISHING CO.!

BUT AT THAT MOMENT...

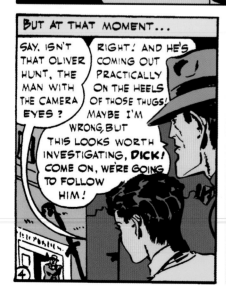

SAY, ISN'T THAT OLIVER HUNT, THE MAN WITH THE CAMERA EYES?

RIGHT! AND HE'S COMING OUT PRACTICALLY ON THE HEELS OF THOSE THUGS! MAYBE I'M WRONG, BUT THIS LOOKS WORTH INVESTIGATING, DICK! COME ON, WE'RE GOING TO FOLLOW HIM!

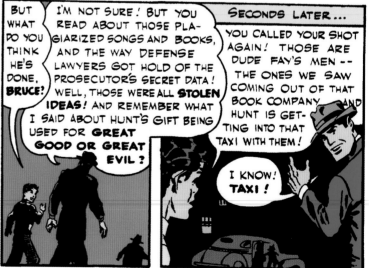

BUT WHAT DO YOU THINK HE'S DONE, BRUCE?

I'M NOT SURE! BUT YOU READ ABOUT THOSE PLAGIARIZED SONGS AND BOOKS, AND THE WAY DEFENSE LAWYERS GOT HOLD OF THE PROSECUTOR'S SECRET DATA! WELL, THOSE WERE ALL STOLEN IDEAS! AND REMEMBER WHAT I SAID ABOUT HUNT'S GIFT BEING USED FOR GREAT GOOD OR GREAT EVIL?

SECONDS LATER...

YOU CALLED YOUR SHOT AGAIN! THOSE ARE DUDE FAY'S MEN -- THE ONES WE SAW COMING OUT OF THAT BOOK COMPANY, AND HUNT IS GETTING INTO THAT TAXI WITH THEM!

I KNOW! TAXI!

THE MAN WITH THE MIRACULOUS MEMORY AND HIS CRIMINAL COMPANIONS SPEED TO THE GANG'S HIDEOUT, UNAWARE THAT THEY ARE BEING PURSUED!

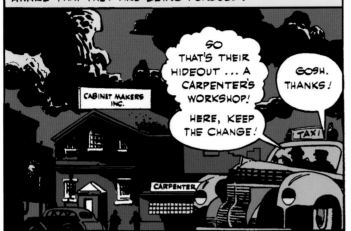

SO THAT'S THEIR HIDEOUT ... A CARPENTER'S WORKSHOP!

HERE, KEEP THE CHANGE!

GOSH. THANKS!

CABINET MAKERS INC.

TAXI

CARPENTER

A LIGHTNING SWITCH BEHIND A DARK CORNER AND TWO FLITTING, SILENT SHADOWS INVADE THE LAIR-- BATMAN AND ROBIN, THE BOY WONDER!

MAYBE WE'LL FIND OUT WHAT THIS IS ALL ABOUT! I CAN'T FIGURE IT OUT!

SH-H! THEY'RE PLANNING A NEW CRIME!

...TONIGHT AT ARTHUR MEDWICK'S OFFICE! YOU KNOW WHAT TO DO, OF COURSE-- YOU'VE DONE IT OFTEN ENOUGH! I HAVE SOME MANUFACTURERS LINED UP WHO'LL PAY PLENTY FOR A FEW OF THOSE IDEAS HE HAS CONTROL OF!

SUDDENLY, FOOTSTEPS APPROACH, AND BEFORE THE CAPED COMRADES CAN CONCEAL THEMSELVES...

WHA--! HEY, DUDE! IT'S BATMAN AND ROBIN!

OH-OH! JUST WHAT I DIDN'T WANT TO HAPPEN!

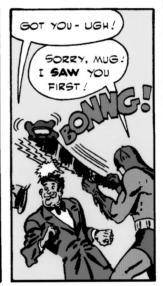

GOT YOU - UGH!

SORRY, MUG! I SAW YOU FIRST!

BONNG!

HUH? WHAT'S THE IDEA OF GIVIN' ME A PRISON HAIRCUT?

197

JUST THOUGHT I'D MAKE YOU FEEL AT HOME!

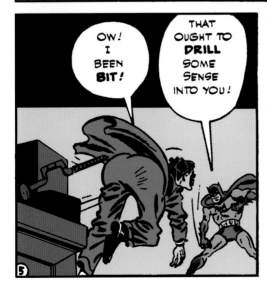

OW! I BEEN BIT!

THAT OUGHT TO DRILL SOME SENSE INTO YOU!

BUT ABRUPTLY...

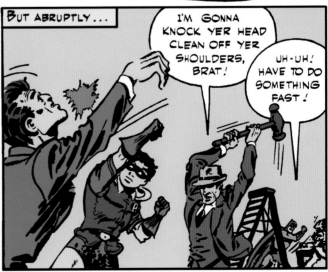

I'M GONNA KNOCK YER HEAD CLEAN OFF YER SHOULDERS, BRAT!

UH-UH! HAVE TO DO SOMETHING FAST!

SWIFT STRATEGY ALONE ENABLES THE EMBATTLED **BATMAN** TO WARD OFF DANGER TO HIS YOUNG AIDE!

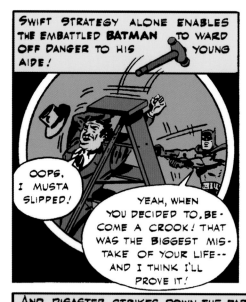

OOPS, I MUSTA SLIPPED!

YEAH, WHEN YOU DECIDED TO BECOME A CROOK! THAT WAS THE BIGGEST MISTAKE OF YOUR LIFE-- AND I THINK I'LL PROVE IT!

THEN, SUDDENLY, THE MEMORY MARVEL RALLIES HIS GANG!

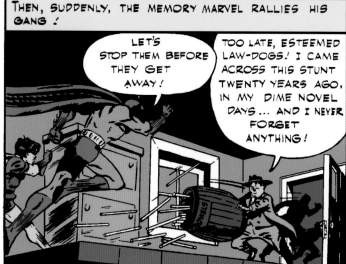

LET'S STOP THEM BEFORE THEY GET AWAY!

TOO LATE, ESTEEMED LAW-DOGS! I CAME ACROSS THIS STUNT TWENTY YEARS AGO, IN MY DIME NOVEL DAYS ... AND I NEVER FORGET ANYTHING!

AND DISASTER STRIKES DOWN THE PARTNERS IN PERIL AS THE GANG MAKES ITS GETAWAY!

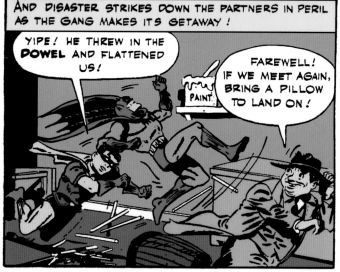

YIPE! HE THREW IN THE **DOWEL** AND FLATTENED US!

PAINT

FAREWELL! IF WE MEET AGAIN, BRING A PILLOW TO LAND ON!

WELL, THEY GOT CLEAN AWAY! NOW WHAT?

WE'LL MEET THEM LATER! ALL WE HAVE TO DO IS LOOK UP THAT NAME THEY MENTIONED -- ARTHUR MEDWICK -- IN OUR PRIVATE FILES! THEY'RE ROBBING HIS PLACE TONIGHT!

AS DARKNESS GATHERS...

WELL, WE FOUND MEDWICK'S A PATENT ATTORNEY! AND THAT'S HIS OFFICE DOWN THERE! HE MUST BE WORKING LATE!

WE'LL DESCEND LOWER AND KEEP AN EYE OUT FOR HUNT AND HIS DEADLY LITTLE PLAYMATES!

MEANWHILE...

OUR PAL HERE JUST HAD A SPELL AND PASSED OUT COLD! IS IT OKAY IF WE BRING HIM IN?

YES, YES, OF COURSE! PUT HIM ON THIS SOFA! I'LL GET HIM SOME WATER RIGHT AWAY!

WE'LL GO ALONG TO HELP YOU!

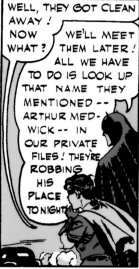

THE INSTANT THE DOOR CLOSES, THE "UNCONSCIOUS" MAN REVIVES WITH AMAZING SPEED!

THERE'S NOTHING TO THIS! THE BOYS WILL KEEP MEDWICK OCCUPIED UNTIL I'VE HAD TIME TO EXAMINE SOME OF HIS MORE PRICELESS PAPERS!

ARTHUR B MEDWICK PATENT ATTORNEY

PRIVATE NO ADMITTANCE

SLAM

6

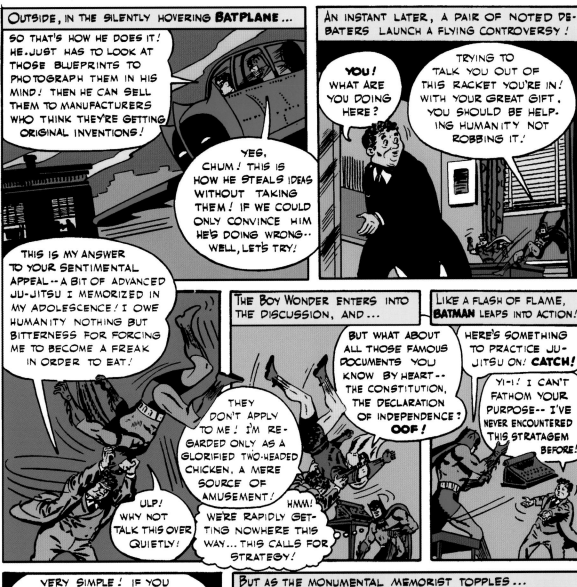

OUTSIDE, IN THE SILENTLY HOVERING **BATPLANE**...

SO THAT'S HOW HE DOES IT! HE.JUST HAS TO LOOK AT THOSE BLUEPRINTS TO PHOTOGRAPH THEM IN HIS MIND! THEN HE CAN SELL THEM TO MANUFACTURERS WHO THINK THEY'RE GETTING ORIGINAL INVENTIONS!

YES, CHUM! THIS IS HOW HE STEALS IDEAS WITHOUT TAKING THEM! IF WE COULD ONLY CONVINCE HIM HE'S DOING WRONG-- WELL, LET'S TRY!

AN INSTANT LATER, A PAIR OF NOTED DEBATERS LAUNCH A FLYING CONTROVERSY!

YOU! WHAT ARE YOU DOING HERE?

TRYING TO TALK YOU OUT OF THIS RACKET YOU'RE IN! WITH YOUR GREAT GIFT, YOU SHOULD BE HELPING HUMANITY NOT ROBBING IT!

THIS IS MY ANSWER TO YOUR SENTIMENTAL APPEAL--A BIT OF ADVANCED JU-JITSU I MEMORIZED IN MY ADOLESCENCE! I OWE HUMANITY NOTHING BUT BITTERNESS FOR FORCING ME TO BECOME A FREAK IN ORDER TO EAT!

THE BOY WONDER ENTERS INTO THE DISCUSSION, AND...

BUT WHAT ABOUT ALL THOSE FAMOUS DOCUMENTS YOU KNOW BY HEART-- THE CONSTITUTION, THE DECLARATION OF INDEPENDENCE? **OOF!**

THEY DON'T APPLY TO ME! I'M REGARDED ONLY AS A GLORIFIED TWO-HEADED CHICKEN, A MERE SOURCE OF AMUSEMENT!

ULP! WHY NOT TALK THIS OVER QUIETLY!

HMM! WE'RE RAPIDLY GETTING NOWHERE THIS WAY... THIS CALLS FOR STRATEGY!

LIKE A FLASH OF FLAME, **BATMAN** LEAPS INTO ACTION!

HERE'S SOMETHING TO PRACTICE JUJITSU ON! **CATCH!**

YI-I! I CAN'T FATHOM YOUR PURPOSE-- I'VE NEVER ENCOUNTERED THIS STRATAGEM BEFORE!

199

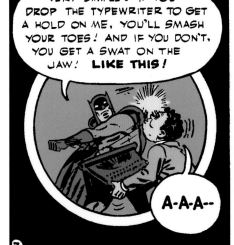

VERY SIMPLE! IF YOU DROP THE TYPEWRITER TO GET A HOLD ON ME, YOU'LL SMASH YOUR TOES! AND IF YOU DON'T, YOU GET A SWAT ON THE JAW! **LIKE THIS!**

A-A-A--

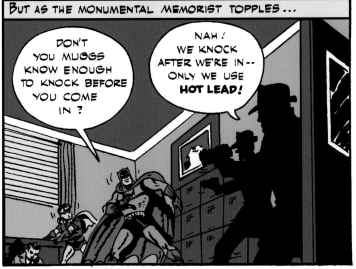

BUT AS THE MONUMENTAL MEMORIST TOPPLES...

DON'T YOU MUGGS KNOW ENOUGH TO KNOCK BEFORE YOU COME IN?

NAH! WE KNOCK AFTER WE'RE IN-- ONLY WE USE **HOT LEAD!**

7

But **BATMAN'S** WITS ARE SWIFTER THAN TRIGGERS AND...

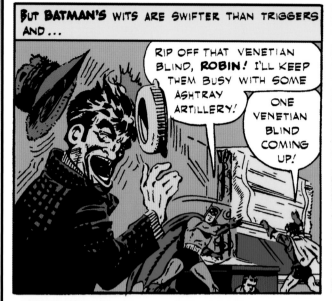

RIP OFF THAT VENETIAN BLIND, **ROBIN!** I'LL KEEP THEM BUSY WITH SOME ASHTRAY ARTILLERY!

ONE VENETIAN BLIND COMING UP!

AND TWO RATS GOING DOWN!

THAT PUTS 'EM IN THE SHADE! NOW LET'S GET OUT OF HERE WITH OUR CAPTIVE!

HELICOPTERS HUM A SUPER-CHARGED SIGH OF SPEED AS THE **BATPLANE** FLASHES UPWARD, THEN LEVELS OFF TO STREAK ACROSS THE SLUMBERING CITY! AND THEN...

WHERE TO, **BATMAN**?

SOME QUIET SPOT WHERE WE CAN QUESTION HUNT! IF HE WON'T TALK WE'LL TURN HIM OVER TO THE POLICE!

WHAT A BLOW! AND WHAT A PREDICAMENT! I WON'T GO TO PRISON -- NEVER! BUT WHAT AM I TO DO? THERE ISN'T ONE SINGLE WEAPON IN THE PLANE.

BUT AN OLD ANATOMY BOOK I SKIMMED THROUGH YEARS AGO MENTIONED THIS DEVICE! PRESSURE ON A CERTAIN NERVE AT THE BASE OF THE SKULL CAUSES INSTANTANEOUS UNCONSCIOUSNESS! NOW TO PUSH THEM ASIDE AND TAKE OVER THE CONTROLS... MY READINGS IN AERONAUTICS SHOULD ENABLE ME TO FLY IT!..

BUT **BATMAN'S** HEAD FALLS FORWARD, STRIKING THE CONTROL PANEL -- AND SMASHING THE GASOLINE FEED LINE!

OH! THE MOTOR IS STUTTERING! WE'RE GOING TO CRASH!

SWIFTLY, THOUGH, THE FOOLPROOF AUTOMATIC PILOT SWITCHES IN THE BATTERIES... THE HURTLING FALL IS CHECKED... AND THE GIANT PLANE EASES TO A GENTLE LANDING...

THEY'LL BE REVIVING IN TWENTY MINUTES OR SO! NO TIME TO REPAIR THE DAMAGED FEED LINE AND PURLOIN THE CRAFT! BUT THERE IS SOMETHING I CAN DO IMMEDIATELY --

-- I CAN MEMORIZE EVERY DETAIL OF THE FAMOUS **BATPLANE**! IT IS POSITIVELY AMAZING... SUCH INGENUITY OF DESIGN... SUCH SUPER-POWER CONCENTRATED IN SO SMALL A SPACE! BUT MY TIME IS UP NOW! I MUST ESCAPE BEFORE THEY COME TO!

AND, PRESENTLY, THERE TAKES SHAPE THE MOST POWERFUL WEAPON EVER CLUTCHED IN CRIMINAL HANDS -- A DUPLICATE OF THE **BATPLANE** -- TO USE AGAINST HELPLESS SOCIETY!

GOOD WORK, HUNT, GETTING THE DESIGN OF THE **BATPLANE**! IT'S A TERRIFIC SHIP!... BUT I STILL DON'T UNDERSTAND! WHY DIDN'T YOU KILL **BATMAN** AND THAT BRAT WHILE YOU HAD THE CHANCE?

BECAUSE I REFUSE TO COUNTENANCE BLOODSHED! I MAY BE CROOKED, BUT I AM NOT A MURDERER! REMEMBER THAT, DUDE! THE FIRST ATTEMPT AT VIOLENCE AND WE PART COMPANY!

THAT NIGHT...

LOWER AWAY! THAT'S HENRI LONGVIEUX'S PENTHOUSE DOWN BELOW! HE'S THE FAMOUS DRESS DESIGNER, HUNT!

AND WE'RE GOING TO ROB HIS ORIGINAL DESIGNS? GOOD! THEY'RE WORTH A FORTUNE!

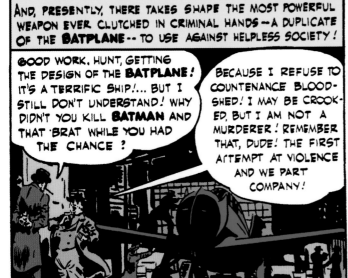

A MOMENT LATER...

OKAY, HE'S OUTA DE WAY! TELL HUNT HE CAN COME IN NOW!

BOY, DIS ROBBERY BUSINESS IS A CINCH WID HUNT AND DIS HERE **BATPLANE** OF OURS!

VERY WELL, ESTEEMED COLLEAGUES! I HAVE COMMITTED THE DESIGNS TO MEMORY! AND VERY LOVELY ONES THEY ARE, TOO!

ANYT'ING DAT BRINGS IN DE DOUGH IS BEE-YOOTIFUL TO ME! LET'S BLOW!

BACK AGAIN AT THE SECRET HANGAR, A FURTIVE CONFAB TAKES PLACE AS SOON AS HUNT IS OUT OF EARSHOT...

HUNT THINKS THIS IS THE SAME AS THE **BATPLANE**, ONLY I PUT IN SOME IMPROVEMENTS! LIKE THOSE CONCEALED MACHINE GUNS! TOMORROW, WE'RE GOING TO BLAST **BATMAN** OUT OF THE SKY!

201

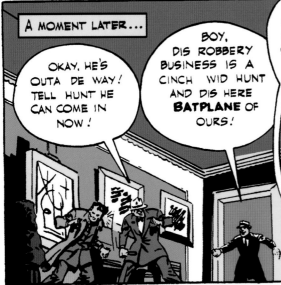

NEXT DAY AT THE GOLD-REFINING PLANT OUTSIDE THE CITY...

DIS HOITS ME PRIDE, POIPOSELY SETTIN' OFF A BOIGLAR ALARM! PEOPLE'LL T'INK I'M A AMACHOOR!

YEAH, DAT'S HOW I FEEL! BUT DUDE SAYS WE GOTTA TOIN IT ON SO DE **BATMAN'LL** GET ON OUR TRAIL! AND DEN...

SHREWD STRATEGY! FOR WHEN THE POWERHOUSE PAIR STREAKS ACROSS THE SKY IN ANSWER TO THE SUMMONS...

WHA...? AM I SEEING THINGS?

NO, **ROBIN**! IT'S A SECOND **BATPLANE** -- AND IT'S DRIVING STRAIGHT AT US!

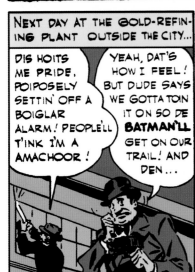

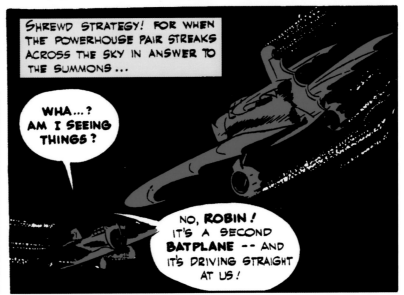

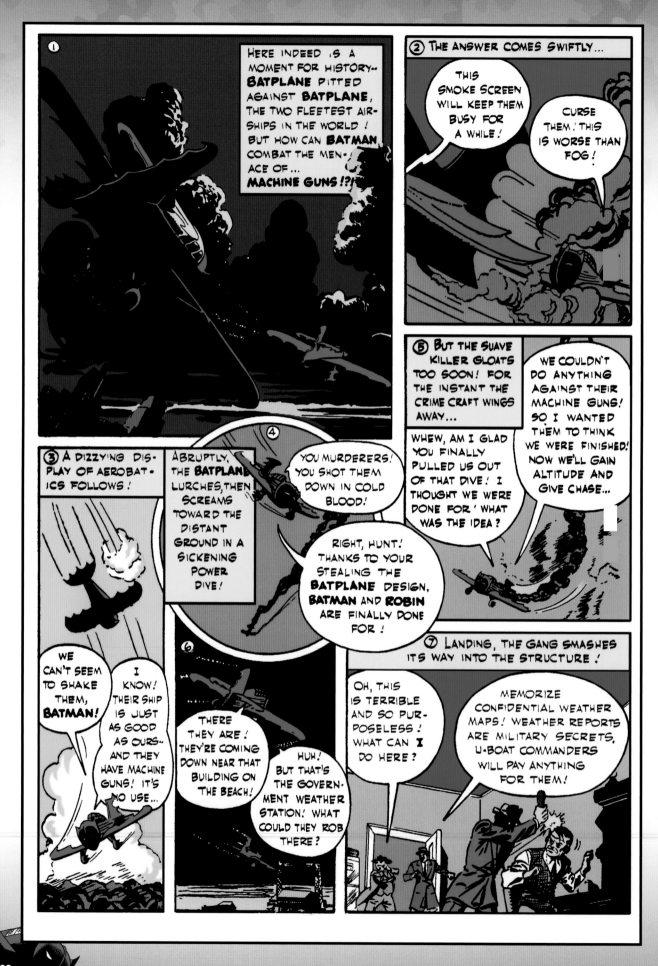

U-BOATS? THAT'S ESPIONAGE... TREASON! YOU'LL NEVER GET ME TO DO IT! NEVER! A·A·A·G·G·H·H..!

I CAN'T, EH? I'LL BEAT THE LIFE OUT OF YOU IF I HAVE TO! BUT YOU'RE GOING TO MEMORIZE THOSE MAPS!

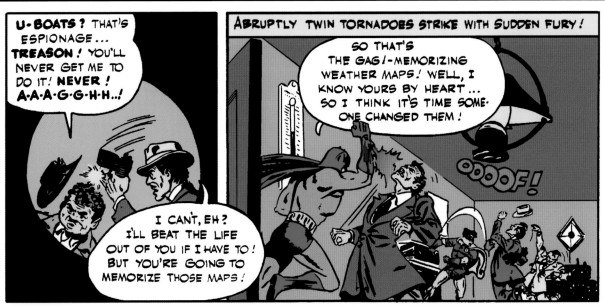

ABRUPTLY TWIN TORNADOES STRIKE WITH SUDDEN FURY!

SO THAT'S THE GAG!—MEMORIZING WEATHER MAPS! WELL, I KNOW YOURS BY HEART... SO I THINK IT'S TIME SOME-ONE CHANGED THEM!

OOOOF!

AMMUNITION IS SCARCE, BUT IT'S NO WASTE OF LEAD TO SHOOT DOWN THAT CONFOUNDED MEDDLER!

BUT THE BOY WONDER LASHES OUT WITH DAZ-ZLING SPEED!

PULL IN YOUR EARS, YOU'RE RUNNING INTO A BLOW!

MEANWHILE, IN THE FRINGES OF THE FRAY...

MURDER AND TREASON! I SHOULD HAVE KNOWN WHERE A CAREER OF CRIME WOULD LEAD ME! BUT IT'S NOT TOO LATE TO REDEEM MYSELF -- AT LEAST IN MY OWN EYES!

203

MINUTES LATER ... THE CRIMINALS FLEE TO THEIR PLANE!

THEY'RE ESCAPING!

WE'VE GOT TO STOP THEM BEFORE THE GET INTO THE AIR!

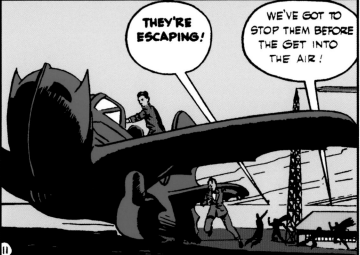

SOMEBODY ELSE HAS TAKEN CARE OF THAT, BATMAN!

HA, HA! I'VE BROKEN THE FEED LINE AND SET FIRE TO THE GAS! YOU'LL NEVER GET AWAY NOW, AND YOU WON'T HAVE THE BATPLANE TO USE AGAINST YOUR OWN COUNTRY! UGGH...

YOU DOUBLE-CROSSER!

BANG!

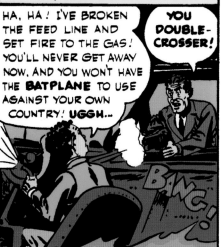

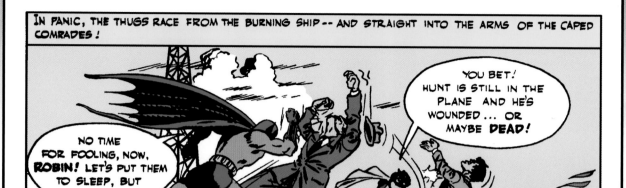

IN PANIC, THE THUGS RACE FROM THE BURNING SHIP -- AND STRAIGHT INTO THE ARMS OF THE CAPED COMRADES!

NO TIME FOR FOOLING, NOW, **ROBIN!** LET'S PUT THEM TO SLEEP, BUT FAST!

YOU BET! HUNT IS STILL IN THE PLANE AND HE'S WOUNDED ... OR MAYBE **DEAD!**

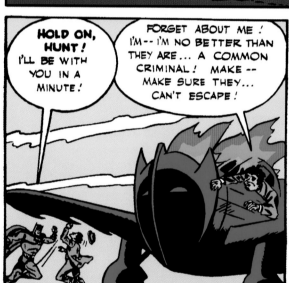

HOLD ON, HUNT! I'LL BE WITH YOU IN A MINUTE!

FORGET ABOUT ME! I'M -- I'M NO BETTER THAN THEY ARE ... A COMMON CRIMINAL! MAKE -- MAKE SURE THEY ... CAN'T ESCAPE!

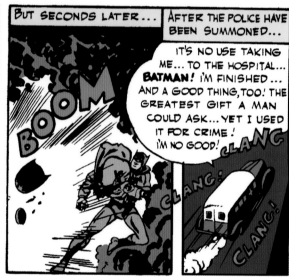

BUT SECONDS LATER...

AFTER THE POLICE HAVE BEEN SUMMONED...

IT'S NO USE TAKING ME ... TO THE HOSPITAL... **BATMAN!** I'M FINISHED ... AND A GOOD THING, TOO! THE GREATEST GIFT A MAN COULD ASK ... YET I USED IT FOR CRIME! I'M NO GOOD!

BOOM

CLANG! CLANG! CLANG!

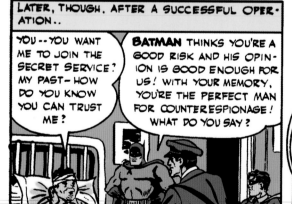

LATER, THOUGH. AFTER A SUCCESSFUL OPERATION..

YOU -- YOU WANT ME TO JOIN THE SECRET SERVICE? MY PAST- HOW DO YOU KNOW YOU CAN TRUST ME?

BATMAN THINKS YOU'RE A GOOD RISK AND HIS OPINION IS GOOD ENOUGH FOR US! WITH YOUR MEMORY, YOU'RE THE PERFECT MAN FOR COUNTERESPIONAGE! WHAT DO YOU SAY?

WHAT CAN I SAY? I WOULD GLADLY GIVE UP MY LIFE TO SERVE MY COUNTRY! **BATMAN,** I OWE YOU AN EVERLASTING DEBT OF GRATITUDE FOR THIS CHANCE!

NO, HUNT! YOU OWE IT TO YOURSELF! BY TURNING AGAINST DUDE FAY, YOU HELPED US CAPTURE HIM!

AS THE MONTHS FLY BY, A HYSTERICAL NOTE CREEPS INTO SHORT-WAVE AXIS BROADCASTS...

UND DER FUEHRER PROMISES DOT VE SHALL NAB DER PHANTOM AMERICAN WHO ISS STEALINK OUR VAR SECRETS MID-- OUDT TAKINK DEM! VHY DON'T DEY FIGHT HONEST, LIKE US...

LOOKS LIKE THE MAN WITH THE CAMERA EYES IS GIVING BERLIN THE JITTERS

YOU SAID IT!

The END

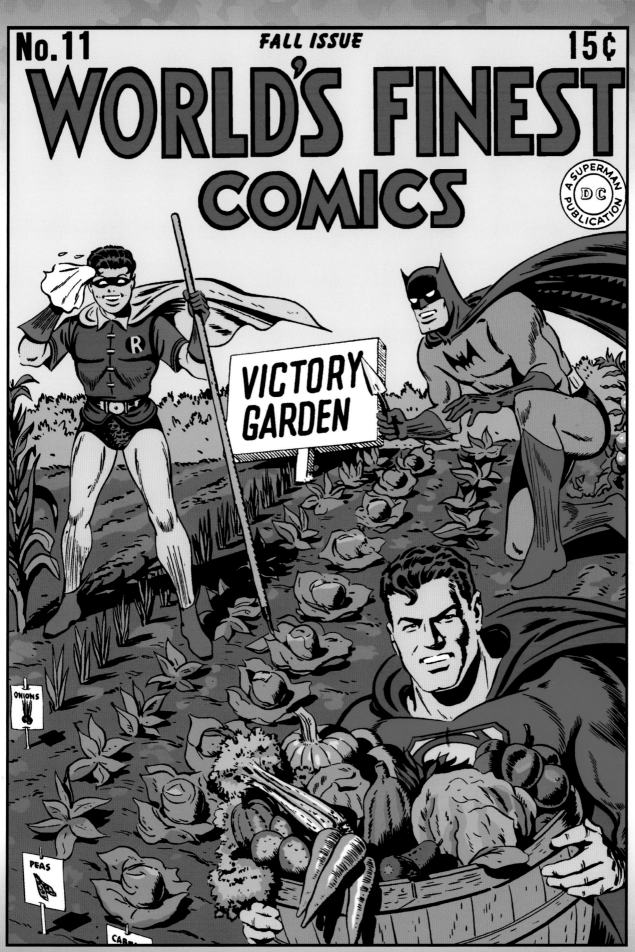

World's Finest Comics #11 (Fall 1943) - cover art: Jack Burnley

Part Four

Between mid-1943 and the latter days of 1944, the period during which the stories and covers in this section were published, the global situation slowly, remorselessly, changed.

CLOSING THE RING

The title below is borrowed (or perhaps just plain cribbed) from that of one of British Prime Minister Winston Churchill's postwar memoirs collectively titled The Second World War. It refers, of course, to slowly bringing maximum force to bear against first Nazi Germany and Fascist Italy in Europe, then against Imperial Japan in the Pacific theatre.

Between mid-1943 and the latter days of 1944, the period during which the stories and covers in this section were published, the global situation slowly, remorselessly changed . . . day by day—sometimes a step or two back for ones taken forward—yet, after the dark days of 1942, when there seemed to be little good news coming from the world's war fronts, there was rising confidence that the "good guys" (and we had no doubt about who they were) would win the war, even though it would be a long time in coming.

The Allies were finally beginning to pile up victories. Soviets were pushing back against the German army that had invaded their homeland in mid-1941, with the turning point coming at the city of Stalingrad in early 1943. U.S. Naval forces (including most definitely the Marines) had finally taken the strategic island of Guadalcanal in the Pacific by early 1943, beginning the long, slow, and bloody attempt to drive the Japanese out of the lands they had conquered and back toward their own islands. By late in the year 1943, the Western Allies were able to invade the Italian mainland, and only a fresh infusion of German troops prevented American and British troops from taking over the whole country by year's end.

On June 6, 1944, the Allies launched the historic Normandy landings of D-Day. American, British, Canadian, and Free French troops landed on the beaches of France, under withering gunfire, finally

establishing a foothold on the western edge of Europe, in spite of all that the Nazis could hurl against them. There were reverses—the disastrous failure of one attack in the Netherlands because Allied troops tried to capture "a bridge too far" being one of the worst—but slowly, if not always surely, the Germans were forced out of territory they had conquered four years earlier and had mightily fortified since.

Symbolically, the cover of *Batman* #18 (Aug.–Sept. 1943) sets the stage for the way America felt: firecrackers blowing up Hitler, Tojo, and Mussolini. By the time of the cover dates, one of those three—Benito Mussolini, for some two decades the fascist ruler of Italy—was no longer a factor in the war. Deposed by the Italians, rescued by Hitler and restored to some semblance of power in a single sector in Italy, he by then was really no more than a puppet of *Der Führer*. But everybody knew that the Germans and the Japanese still had plenty of fight left in them.

Batman and Robin continued the good fight on the Home Front. Their story in *Detective Comics* #77 (July 1943) climaxed with a battle against criminals atop an atom-smasher—at a time when, unknown to Batman in the tale or to his editors, writers, and artists in the real world, top-secret work was going on in New Mexico and elsewhere to develop a bomb that would make dramatic and fateful use of the cyclotron's atom-splitting abilities.

More typical, but still exciting, was the episode titled "Bond Wagon" in *Detective Comics* #78 (Aug. 1943). Yes, it's another war bond story. But so good were writers like Bill Finger, Don Cameron, and others

that they could find a seemingly infinite number of interesting varieties on that theme, and the artwork by Bob Kane and his various collaborators was always exciting.

One of the strangest of the Batman war stories—as strange in its own way as had been "Swastika over the White House!" and "Two Futures"—is "Atlantis Goes to War" in *Batman* #19. By Don Cameron and drawn by Dick Sprang, this story mixes Nazis and the concept of a lost sub-sea civilization—and is a particularly poignant adventure for young Robin. It is a real high point of the war years, and a rare excursion into far-out fantasy in the generally more realistic realm of Batman. Another fantasy starring Batman occurs in #26 (Dec. 1944–Jan. 1945), when the tale "Year 3000" echoes with overtones of a World War II that goes on seemingly forever!

The cover of *World's Finest Comics* #13 (Spring 1944) and the Batman story therein contrast a paper-collection drive by Superman, Batman, and Robin aimed at "the paper-hanger of Berlin" with a tale centered around merchant seamen and the very real fear of German U-boats that still

prowled the Atlantic, ready to sink any unwary ship. (The "paper-hanger of Berlin," of course, was Adolf Hitler—who reportedly once followed that profession, albeit briefly, to support himself in Austria after the end of World War I. It's not really known if those rumors are true or not—but somehow some folks managed to turn an honest occupation into a term of hatred. War does funny things to people's sense of perspective.)

Another intriguing twist on a war theme in this section comes in *Batman* #21 (Feb.–March 1943), when, in "Blitzkrieg Bandits," criminals adapt the rapid-attack tactics of the Nazis, which had served them so well back in 1939–40, at least, to the garnering of ill-gained loot.

By now, however, the Nazis' days of blitzkrieg were well behind them. When the final, sudden German assault in the West—the so-called "Battle of the Bulge" in December of 1944—failed, it seemed only a matter of time until first Germany fell, then Japan. But that didn't mean that many men, even women and children, would have to fight—and perhaps die—before the war ended.

207

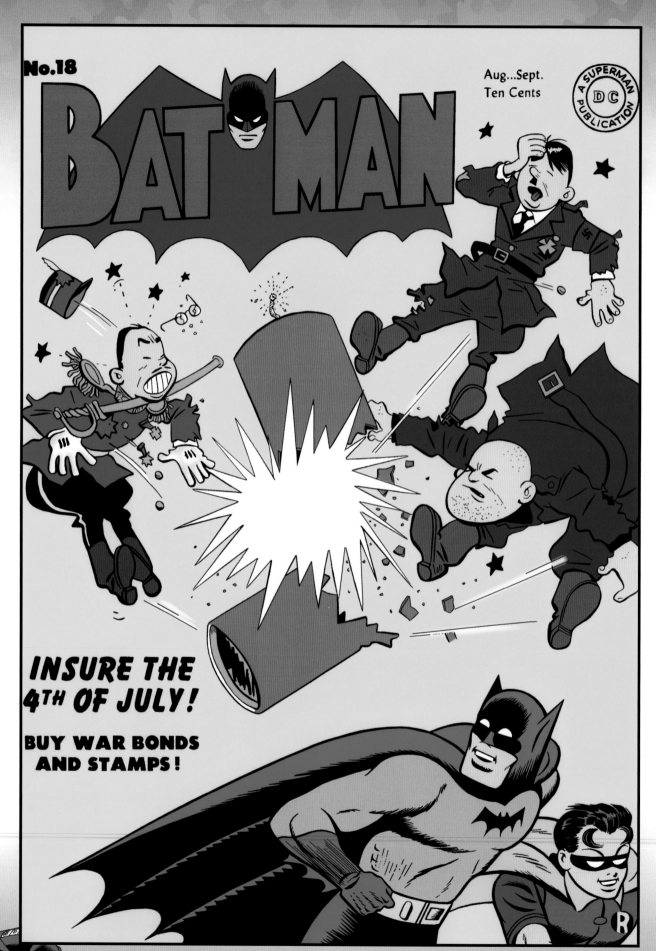

Batman #18 (Aug-Sept. 1943) - cover art: Ed Kressey, Dick Sprang, & Stan Kaye (pencils) & Sprang & Kaye (inks)

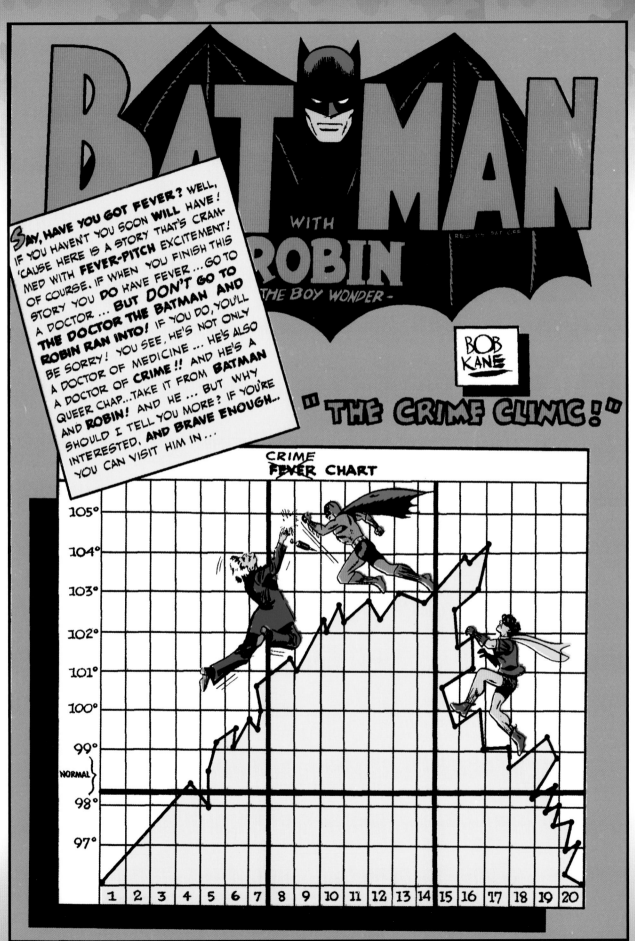

Detective Comics #77 (July 1943) - script: Bill Finger - art: Bob Kane (pencils) & George Roussos (inks)

WHEN A MAN BECOMES A DOCTOR HE BECOMES **MANY** MEN! -- A HEALER ...

NOW YOU MUST TAKE THESE PILLS REGULARLY TO GET WELL!

YOU'RE THE BOSS, DOCTOR!

-- A FRIEND AND CONFIDANT...

WELL, BILLY, IT WON'T BE LONG NOW BEFORE YOU'LL BE PLAYING BALL WITH YOUR GANG AGAIN!

GEE! GEE, WHILLIKERS!

-- A PUBLIC SERVANT...

DOCTOR, I KNOW IT'S FOUR IN THE MORNING ... BUT MY WIFE IS IN A BAD WAY AND ...

DON'T WORRY, MR. BROWN! I'LL BE RIGHT OVER!

-- MANY TIMES HE IS EVEN A GOOD SAMARITAN ...

GOLLY, DOC... I HAVEN'T ANY MONEY TO PAY YOU RIGHT NOW...

NEVER MIND! YOU CAN PAY ME WHEN YOU FIND A JOB AND GET BACK ON YOUR FEET!

-- AND THERE ARE TIMES WHEN HE IS A MAN WHO CAN WORK STRANGE MIRACLES!

INTERNES, LOOK CLOSELY! BRILLIANT SURGERY IS SAVING A MAN WHOSE LIFE WAS DESPAIRED OF!

BUT AMONG ALL MEN THERE IS ALWAYS A MAN OF EVIL... A RENEGADE! THIS STORY IS ABOUT SUCH A MAN!

②

THIS CASE ACTUALLY HAD ITS BEGINNING IN A GANGSTER HIDEOUT DEEP IN THE HEART OF THE UNDERWORLD...

HERE Y'ARE, GENTS! A LITTLE ADVERTISEMENT FROM THE **CRIME CLINIC!**

DE CRIME CLINIC? WELL CUT ME DOWN WIT' A TOMMY-GUN! LOOKA DIS!

WORRYING YOURSELF SICK OVER HOW TO OPERATE A CERTAIN CRIME? THEN COME TO THE CRIME CLINIC WHERE YOUR ILLS CAN BE CURED! I GUARANTEE TO DOCTOR YOUR TROUBLE WITH EXPERT TREATMENT! COME TO THE CRIME CLINIC FOR YOUR CRIME OPERATION!!

HEY, BUD, IF DIS IS ON DE LEVEL I COULD USE DOPE ON A SOITIN JOB I GOT IN MIND! I'M PIGGY PINTO!

OKAY, PINTO... BUT FIRST I'LL HAVE TO TAKE YOUR FINGERPRINTS!

ME FINGER-PRINTS! WHAT'S DE IDEA?

THE DOC DON'T TAKE NO CHANCES! YOU MIGHT BE A COPPER IN DISGUISE, TRYIN' TO COLLAR 'IM!

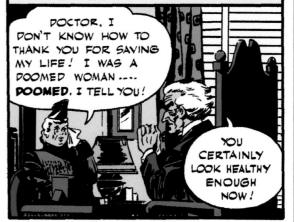

ON A CERTAIN FASHIONABLE AVENUE IN GOTHAM CITY IS THE RESIDENCE OF THE BRILLIANT SURGEON, DOCTOR MATTHEW THORNE...

DOCTOR, I DON'T KNOW HOW TO THANK YOU FOR SAVING MY LIFE! I WAS A DOOMED WOMAN---- DOOMED, I TELL YOU!

YOU CERTAINLY LOOK HEALTHY ENOUGH NOW!

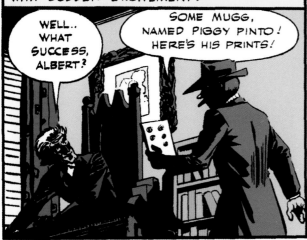

LATER... ANOTHER VISITOR... AND DOCTOR THORNE'S USUALLY MILD EYES NOW FLAME WITH SUDDEN EXCITEMENT!

WELL.. WHAT SUCCESS, ALBERT?

SOME MUGG, NAMED PIGGY PINTO! HERE'S HIS PRINTS!

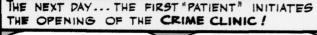

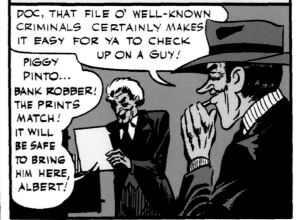

THE DOCTOR'S SLIM FINGERS TUG OPEN A FILE IN WHICH REPOSE HUNDREDS OF CARDS ... CARDS NOT CONTAINING CASE HISTORIES -- BUT FINGERPRINTS!

DOC, THAT FILE O' WELL-KNOWN CRIMINALS CERTAINLY MAKES IT EASY FOR YA TO CHECK UP ON A GUY!

PIGGY PINTO... BANK ROBBER! THE PRINTS MATCH! IT WILL BE SAFE TO BRING HIM HERE, ALBERT!

211

THE NEXT DAY... THE FIRST "PATIENT" INITIATES THE OPENING OF THE CRIME CLINIC!

...SO YOU SEE, DOC, WE CAN CRACK DAT BANK. BUT WE CAN'T FIGURE OUT DAT ONE ANGLE!

HMM-MM! MY DIAG-NOSIS INDICATES AN ACUTE SENSE OF OVERSIGHT! HMM-MM!

3

HERE IS MY PRESCRIPTION TO REMEDY YOUR TROUBLE! MY FEE IS 25% OF THE LOOT!

Rx SNIP VEIN OF BURGLAR ALARM WIRE NEAR RIGHT WALL FOR EXTRA PROTECTION

YES... THIS IS DOCTOR MATTHEW THORNE... DOCTOR OF MEDICINE... AND DOCTOR OF CRIME!!

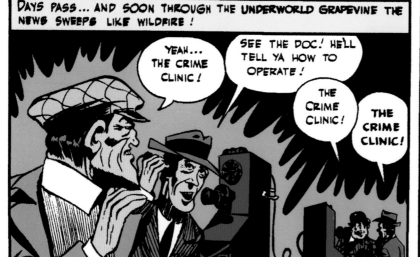
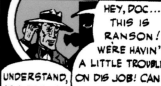
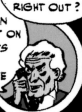
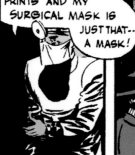

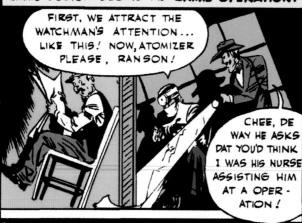

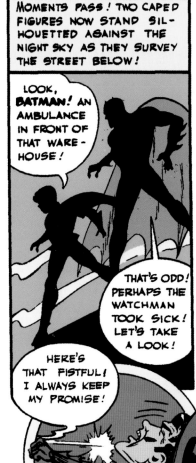

MOMENTS PASS! TWO CAPED FIGURES NOW STAND SILHOUETTED AGAINST THE NIGHT SKY AS THEY SURVEY THE STREET BELOW!

LOOK, **BATMAN!** AN AMBULANCE IN FRONT OF THAT WAREHOUSE!

THAT'S ODD! PERHAPS THE WATCHMAN TOOK SICK! LET'S TAKE A LOOK!

HERE'S THAT FISTFUL! I ALWAYS KEEP MY PROMISE!

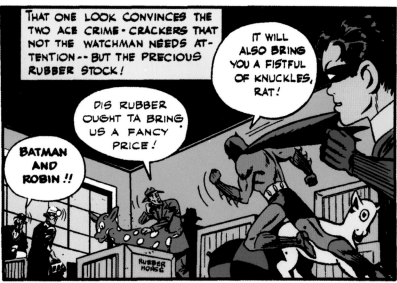

THAT ONE LOOK CONVINCES THE TWO ACE CRIME-CRACKERS THAT NOT THE WATCHMAN NEEDS ATTENTION -- BUT THE PRECIOUS RUBBER STOCK!

IT WILL ALSO BRING YOU A FISTFUL OF KNUCKLES, RAT!

DIS RUBBER OUGHT TA BRING US A FANCY PRICE!

BATMAN AND ROBIN!!

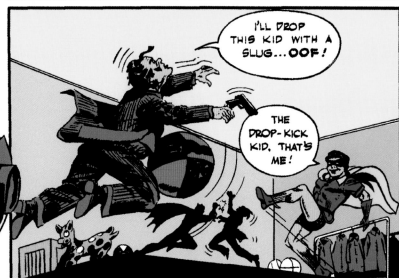

I'LL DROP THIS KID WITH A SLUG...OOF!

THE DROP-KICK KID, THAT'S ME!

213

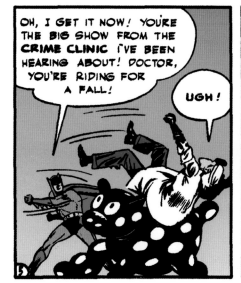

OH, I GET IT NOW! YOU'RE THE BIG SHOW FROM THE **CRIME CLINIC** I'VE BEEN HEARING ABOUT! DOCTOR, YOU'RE RIDING FOR A FALL!

UGH!

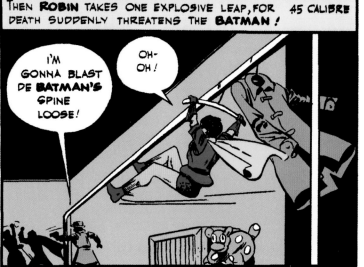

THEN **ROBIN** TAKES ONE EXPLOSIVE LEAP, FOR 45 CALIBRE DEATH SUDDENLY THREATENS THE **BATMAN!**

I'M GONNA BLAST DE **BATMAN'S** SPINE LOOSE!

OH-OH!

RIDING THE FULL LENGTH OF THE COAT RACK, **ROBIN** CANNONBALLS INTO THE KILL-CRAZY BANDIT!

BLAM

OOF!

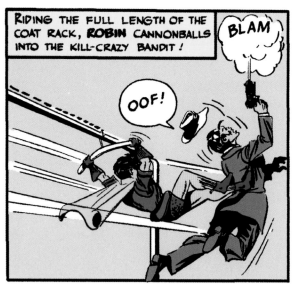

FOR ONE BREATHLESS INSTANT THE DUO STANDS. CAUGHT OFF GUARD, AND THAT'S WHEN THE CRIME-SPECIALIST BRINGS STRATEGY INTO PLAY!

THERE! A MORE **PRIMITIVE** ANESTHETIC SHOULD TAKE THE FIGHT OUT OF THEM!

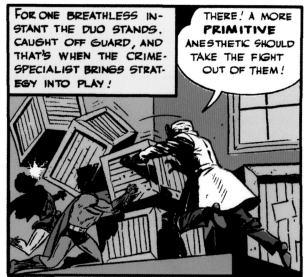

THE GREAT **BATMAN!** HA! DOC, I'M GONNA MAKE DIS TOUGH GUY **REAL** SICK WID A DOSE O' LEAD POISONING!

NO! I'LL TOLERATE NO KILLINGS! I'M A DOCTOR! A DOCTOR SAVES LIFE, DOESN'T TAKE IT! NOW WE'D BEST GET GOING BEFORE THE POLICE INVESTIGATE THAT SHOOTING!

AS THE CRIME DOCTOR BEGINS HIS GETAWAY, **BATMAN** AND **ROBIN** REVIVE! SWIFTLY ANALYSING THE SITUATION, **BATMAN** DIPS HIS HAND TO HIS UTILITY BELT...

NOVELTY RUBBER

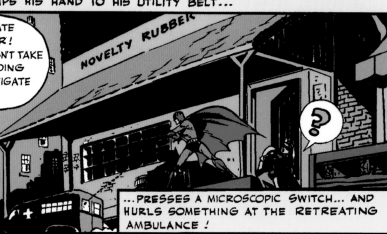

?

...PRESSES A MICROSCOPIC SWITCH... AND HURLS SOMETHING AT THE RETREATING AMBULANCE!

WHAT DID YOU THROW INTO THE AMBULANCE?

A TINY, LOW POWER **SHORT-WAVE TRANSMITTER** THAT WILL SEND OUT A CONTINUOUS SIGNAL FOR AN HOUR! NOW WE'LL SCOOT HOME AND FOLLOW THAT SIGNAL WITH THE **BATMOBILE'S** DIRECTION FINDER!

MINUTES LATER ...TWO HUMAN BLOODHOUNDS, **BATMAN** AND **ROBIN**, FOLLOW AN INVISIBLE RADIO TRAIL!

BATMAN, THE SIGNAL IS GROWING STRONGER NOW!

DA-DA-DI-DA

THAT MEANS WE'RE GETTING CLOSER TO THE AMBULANCE!

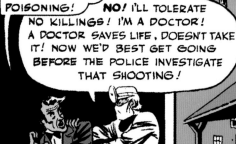

EXCITING MINUTES LATER ... THE DUO LOCATES THEIR QUARRY! **BATMAN** HAS MATCHED THE CRIME DOCTOR'S SCIENCE WITH CRIME-**FIGHTING** SCIENCE

THIS IS IT! MATTHEW THORNE! SO **HE'S** THE CRIME CLINIC!

THORNE? SAY, HE'S BIG TIME!

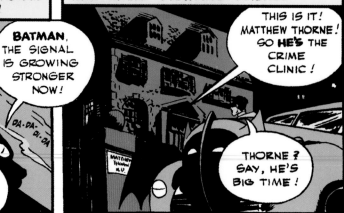

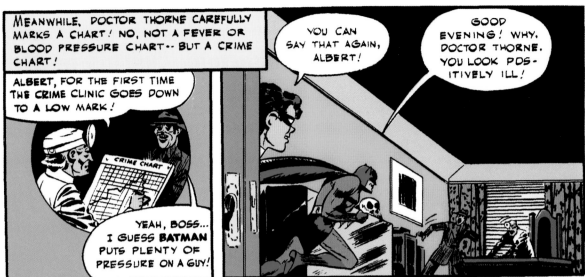

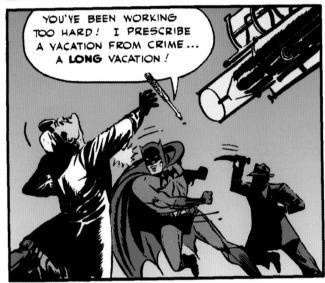

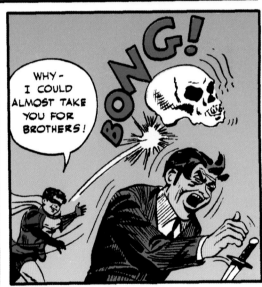

215

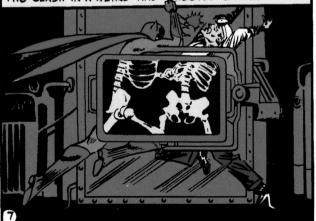

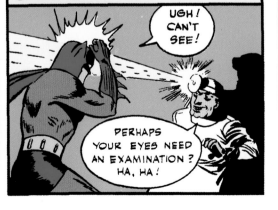

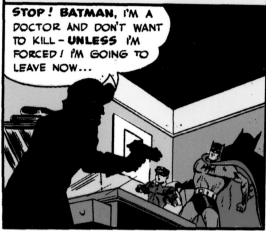

Swiftly, the doctor of crime snatches his advantage -- and a revolver from his drawer!

STOP! BATMAN, I'm a doctor and don't want to kill - **UNLESS I'M FORCED!** I'm going to leave now...

Abruptly, the door swings open! A man stumbles in...

Doctor Thorne... should have listened to you... ...I'm a sick man... I...Ohhhhh...

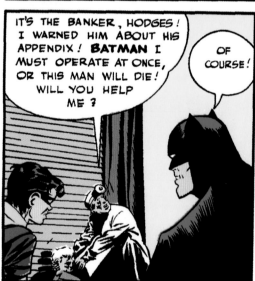

It's the banker, Hodges! I warned him about his appendix! **BATMAN** I must operate at once, or this man will die! Will you help me?

Of course!

Then begins the strangest of all operations! A man of crime and a man of the law call a truce... in order to save another's life!

Scissors, please!

Time ticks away slowly!... Instruments... Adrenalin... Oxygen!.The bellows expand and contract with normal rhythm! Medical science has performed another miracle!

THERE! DONE! HE'LL LIVE!

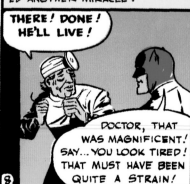

Doctor, that was magnificent! Say...you look tired! That must have been quite a strain!

Hmph! A brilliant surgeon like you, stooping to crime! You have a chance to save yourself, yet you stay to operate on a man! I can't figure you out!

It's quite simple really... I'm a doctor!

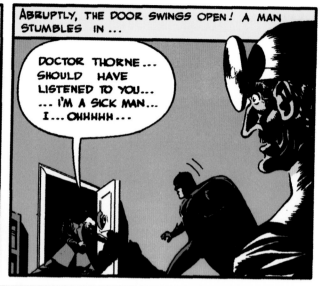

I love surgery... yet crime excites me! It's like a drug inside my body! I can't help it...but I **ENJOY** acting criminally!

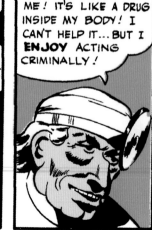

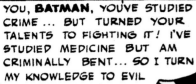

YOU, **BATMAN**, YOU'VE STUDIED CRIME ... BUT TURNED YOUR TALENTS TO FIGHTING IT! I'VE STUDIED MEDICINE BUT AM CRIMINALLY BENT... SO I TURN MY KNOWLEDGE TO EVIL PRACTICE!

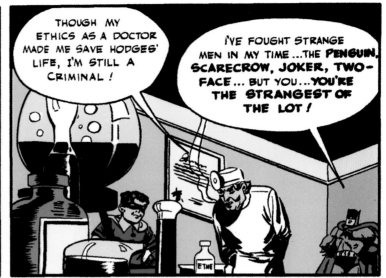

THOUGH MY ETHICS AS A DOCTOR MADE ME SAVE HODGES' LIFE, I'M STILL A CRIMINAL!

I'VE FOUGHT STRANGE MEN IN MY TIME...THE **PENGUIN**, **SCARECROW, JOKER, TWO-FACE**... BUT YOU...**YOU'RE THE STRANGEST OF THE LOT!**

YES.. BUT IT IS BECAUSE I'M A VILLAIN THAT I **DOUSE ROBIN WITH ETHER--** LIKE THIS! DON'T MOVE, **BATMAN**, OR THIS FLAME WILL TURN **ROBIN** INTO A FLAMING TORCH!

WITH THE AID OF THE REVIVING ALBERT, THE CRIME DOCTOR BINDS HIS CAPTIVES WITH RUBBER HOSE!

YOU SEE, I DON'T WANT YOUR LIFE ... BUT THIS WILL KEEP YOU STILL WHILE I CONTINUE MY WORK!

THORNE, DON'T! GIVE UP YOUR CRAZY CRIME IDEA BEFORE IT'S TOO LATE! I'LL EVEN GO TO BAT FOR YOU!

217

SORRY, **BATMAN** ... BUT I CAN'T HELP THE WAY I ACT! BESIDES, TONIGHT I'M GOING TO FIND ANOTHER PHILOSO-PHER'S STONE, AND THAT IDEA TEMPTS ME VERY MUCH!

OKAY, THORNE... BUT THIS MEANS WE'RE ON OPPOSITE SIDES! IT'S A FIGHT TO THE FINISH NEXT TIME WE MEET!

THE DOOR SLAMS SHUT, AND **BATMAN** PITS HIS MUSCULAR STRENGTH IN VAIN AGAINST THE TENTACLE-LIKE RUBBER HOSE!

NO USE! THE RUBBER STRETCHES BUT SNAPS RIGHT BACK AGAIN!

SNAP!

THEN HIS EYES SPY THE ALMOST EMPTY ETHER BOTTLE...AND THE DOCTOR'S DISCARDED CIGARETTE!

WAIT A MINUTE! THAT ETHER BOTTLE! I THINK I'M GETTING A BRAINSTORM!

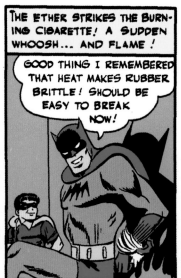

ROBIN, I THINK THIS IS GOING TO WORK!

THE ETHER STRIKES THE BURNING CIGARETTE! A SUDDEN WHOOSH... AND FLAME!

GOOD THING I REMEMBERED THAT HEAT MAKES RUBBER BRITTLE! SHOULD BE EASY TO BREAK NOW!

IN LESS TIME THAN IT TAKES TO TELL, BATMAN FREES HIMSELF, AND THEN ROBIN!

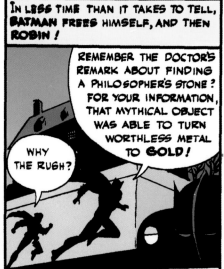

WHY THE RUSH?

REMEMBER THE DOCTOR'S REMARK ABOUT FINDING A PHILOSOPHER'S STONE? FOR YOUR INFORMATION, THAT MYTHICAL OBJECT WAS ABLE TO TURN WORTHLESS METAL TO GOLD!

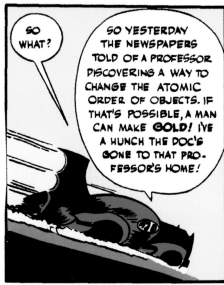

SO WHAT?

SO YESTERDAY THE NEWSPAPERS TOLD OF A PROFESSOR DISCOVERING A WAY TO CHANGE THE ATOMIC ORDER OF OBJECTS. IF THAT'S POSSIBLE, A MAN CAN MAKE GOLD! I'VE A HUNCH THE DOC'S GONE TO THAT PROFESSOR'S HOME!

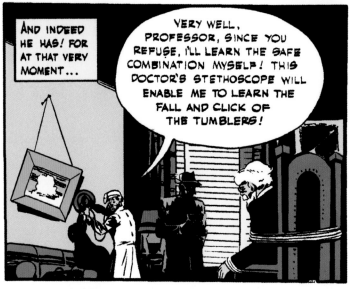

AND INDEED HE HAS! FOR AT THAT VERY MOMENT...

VERY WELL, PROFESSOR, SINCE YOU REFUSE, I'LL LEARN THE SAFE COMBINATION MYSELF! THIS DOCTOR'S STETHOSCOPE WILL ENABLE ME TO LEARN THE FALL AND CLICK OF THE TUMBLERS!

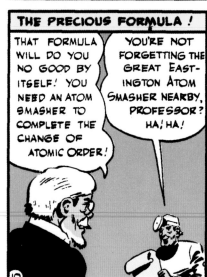

THE PRECIOUS FORMULA!

THAT FORMULA WILL DO YOU NO GOOD BY ITSELF! YOU NEED AN ATOM SMASHER TO COMPLETE THE CHANGE OF ATOMIC ORDER!

YOU'RE NOT FORGETTING THE GREAT EASTINGTON ATOM SMASHER NEARBY, PROFESSOR? HA! HA!

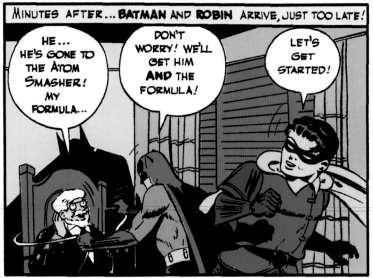

MINUTES AFTER... BATMAN AND ROBIN ARRIVE, JUST TOO LATE!

HE... HE'S GONE TO THE ATOM SMASHER! MY FORMULA...

DON'T WORRY! WE'LL GET HIM **AND** THE FORMULA!

LET'S GET STARTED!

10

① THE MAMMOTH **ATOM SMASHER VACUUM TUBE**... WHERE SCIENCE HOPES TO RELEASE THE ATOM'S VAST ENERGIES IN A FORM THAT MAY BE HARNESSED AND PUT TO WORK FOR MANKIND!

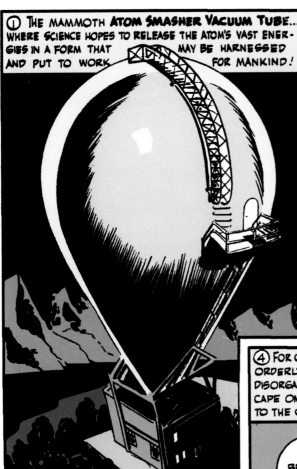

② INSIDE... UNDER THE HUGE ELECTRODE TOWERS, COME TWO UNWELCOME VISITORS!

HOLD IT, PUNKS!

WHA... WHAT'S THE REASON FOR THIS INTRUSION?

SIMPLE, GENTLEMEN! I INTEND TO HAVE THE ATOM SMASHER MAKE ME GOLD FOR MY OWN PERSONAL USE!

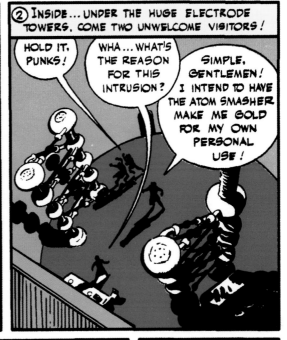

③ SORRY, DOCTOR, BUT I THINK THERE IS GOING TO BE A CHANGE IN YOUR PLANS!

BATMAN! BUT HOW..??

BE GOOD, ALBERT, AND I'LL ONLY HAVE TO HIT YOU ONCE!

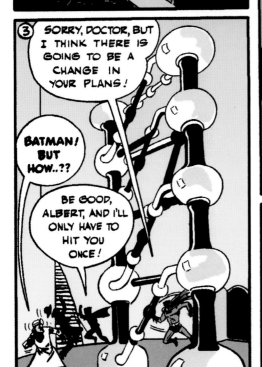

④ FOR ONCE THE CRIME DOCTOR'S ORDERLY, SCIENTIFIC MIND IS DISORGANIZED! HIS HASTE TO ESCAPE ONLY LEADS TO THE DOOR TO THE OUTSIDE TUBE-STAIRS!

RIGHT BEHIND YOU, DOCTOR!

⑤ GAINING THE BALCONY FIRST, THORNE GRIMLY DRIVES HIS FOOT STRAIGHT DOWN AT **BATMAN'S** FACE...

⑥ BUT ANTICIPATING SUCH A MOVE, **BATMAN** SEIZES THE FOOT -- AND PUSHES BACK, **HARD!**

UH - UH! WATCH YOURSELF, THORNE! THAT'S A FIFTY FOOT DROP BELOW!

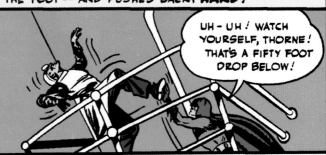

219

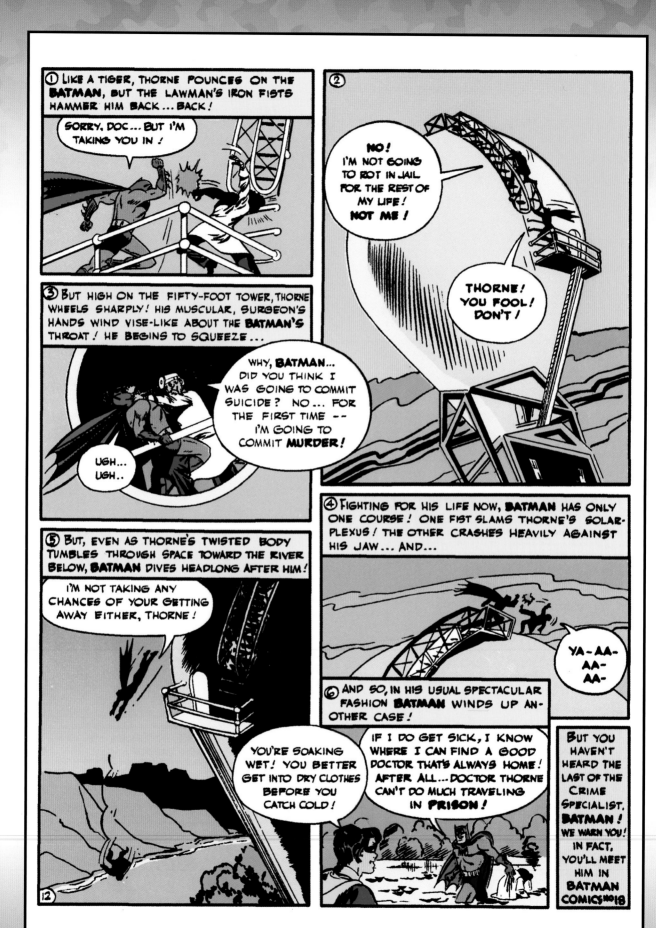

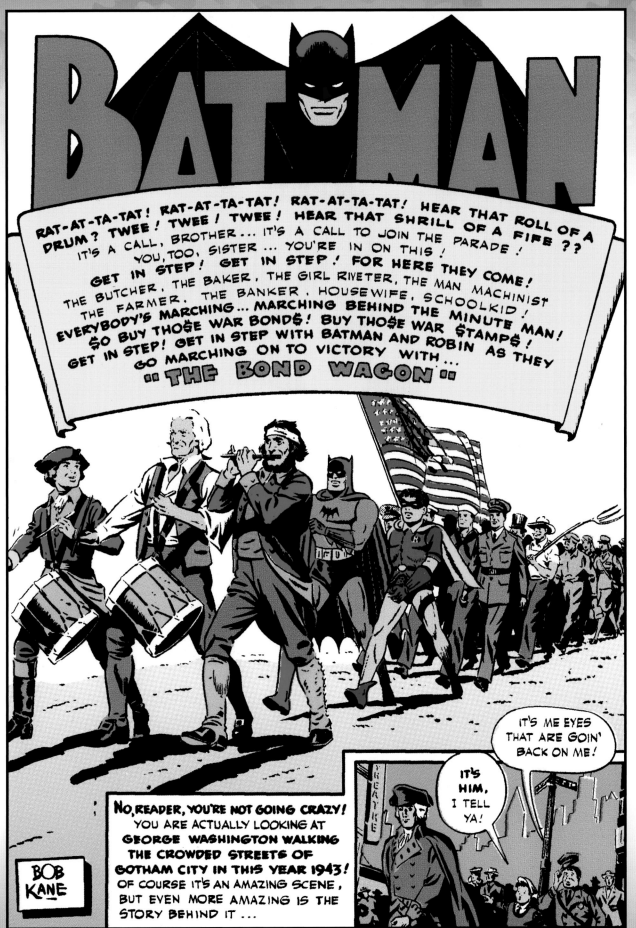

Detective Comics # 78 (Aug. 1943) - script: Joe Greene - art: Jack Burnley (pencils) & George Roussos (inks)

IT BEGAN WHEN DICK GRAYSON, WARD OF BRUCE WAYNE, WAS DOING HIS HISTORY HOMEWORK...

BRUCE, I'LL BET MOST AMERICANS DON'T REALIZE WE'RE FIGHTING A REVOLUTIONARY WAR LIKE THE ONE IN 1776!

YOU'RE RIGHT! IN '76 WE FOUGHT FOR FREEDOM FROM TYRANNY AND WE'RE DOING IT AGAIN TODAY!

SILENCE FOR A MOMENT... THEN...

HUMPH! PEOPLE COMPLAIN ABOUT RATIONING, BUT HOW ABOUT THE PEOPLE OF '76? HOW ABOUT WASHINGTON'S STARVING, RAGGED, BAREFOOTED MEN AT VALLEY FORGE?

WASHINGTON!! GOLLY, WE HAD SOME GREAT HEROES THEN! PATRICK HENRY, THOMAS JEFFERSON, TOM PAINE, SAM ADAMS...

AND BETSY ROSS... AND MOLLY PITCHER! WOMEN SERVED THEN JUST AS TODAY!

MORE SILENCE... THEN...

I'LL BET IF A LOT OF THOSE AMERICANS COULD SEE THOSE DAYS AGAIN THEY'D REMEMBER AND BUY MORE WAR BONDS!

EH?? WHY NOT? WHY NOT?!! DICK, HOP INTO YOUR DUDS! WE'RE GOING OUT AND PUT AN AD IN THE PAPERS!

YOU GOING TO ADVERTISE FOR SOMETHING?

YES... FOR AMERICANS!!

THE NEXT MORNING IN THE "HELP WANTED" COLUMNS, THIS APPEARED...

WANTED! GEORGE WASHINGTON, PATRICK HENRY, NATHAN HALE... AMERICANS! If you resemble any great American patriot of '76, call on the BATMAN, Room 76, Constitution Ave.

FIRST CAME THE REPORTERS...

WHAT'S UP, BATMAN? GIVE OUT!

BOYS, I'M ORGANIZING A BOND WAGON! I HOPE TO SELL WAR BONDS BY RESTAGING STIRRING PAGES OF '76 AND SO WAKE UP THE PUBLIC!

THEN CAME THE MOB!

I'M A DOUBLE FOR BETSY ROSS!

I MAKE A PERFECT WASHINGTON!

I'M YOUR PATRICK HENRY!

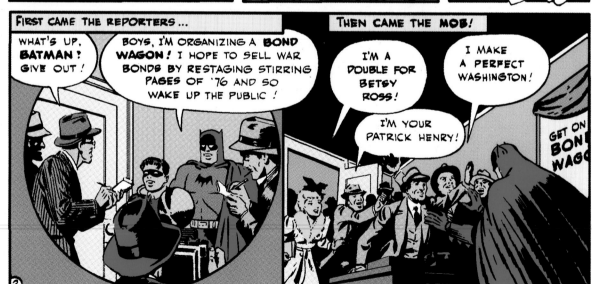

LATER **BATMAN** INTERVIEWED APPLICANTS IN PRIVATE...

HMM-MM! AN EX-SEA CAPTAIN... AND YOU'RE NOT WITH THE MERCHANT MARINE?

I WAS! A GERMAN DESTROYER SANK MY SHIP! GUNS, CANNON WENT OFF ALL ABOUT ME! I WAS WOUNDED... DRIFTED ON A RAFT FOR DAYS...

...A FREIGHTER FINALLY PICKED ME UP! MY BODY RECOVERED...BUT NOT MY MIND! GUNSHOCK, THE DOCTOR CALLED IT! ALL I KNOW IS, WHEN A BIG GUN GOES OFF, I GET SICK... SICK WITH FEAR!

THEY WON'T HAVE ME ANYWHERE! NOW I'M MATT WILKINS, THE COWARD... THE CAPTAIN WITHOUT A SHIP!

IT TOOK COURAGE TO TELL ME WHAT YOU DID! I'LL GIVE YOU A SHIP! THE **BONHOMME RICHARD** OF CAPTAIN JOHN PAUL JONES!

LATER, ANOTHER APPLICANT...

SAY, YOU'RE "PASSIN' PETE" ARNOLD, THE FOOTBALL BACK WHO...

...WHO DOUBLE-CROSSED HIS TEAM BY THROWING THE ROSE BOWL GAME SO HE'D WIN MONEY BY BETTING ON THE OTHER TEAM! THAT'S WHAT THEY SAY... **BUT IT ISN'T TRUE!!**

ARNOLD, IT **IS** TRUE YOU NEEDED MONEY TO PAY OFF YOUR GAMBLING DEBTS!

SURE, BUT I'M NO RAT! MY PASSES WERE ALL OFF BECAUSE I WAS **SICK**! BUT I HAD TO PLAY! I WANTED TO WIN FOR MY SCHOOL... INSTEAD I LOST... AND NOW THEY CALL ME "BENEDICT" ARNOLD!

HMM...YOU RESEMBLE A CERTAIN AMERICAN... A MAN WHO GAVE HIS LIFE SO AS NOT TO DOUBLE-CROSS **HIS** TEAM! YOU CAN BE **NATHAN HALE!!**

223

SOON THE CAST WAS COMPLETE... AND AFTER MANY REHEARSALS, THE **BOND WAGON** WAS READY TO ROLL!

C'MON, GEORGE WASHINGTON! WE'VE BEEN WAITING FOR YOU! YOU'RE LATE!

SORRY, I LIVE WAY OUT IN BROOKLYN AND HAD TO CHANGE FROM THE BUS TO THE SUBWAY!

AND NOW, READERS, YOU'VE SEEN EVERYTHING... EVERYTHING EXCEPT THE ADVENTURES THE BOND WAGON MET ON ITS TRAVELS... BUT YOU CAN READ ALL ABOUT THEM BY SIMPLY TURNING THE PAGES!

The BOND Wagon

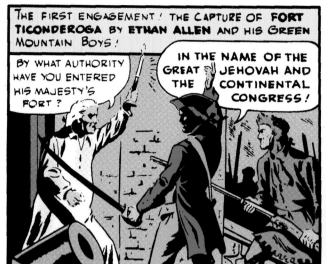

THE FIRST ENGAGEMENT! THE CAPTURE OF **FORT TICONDEROGA** BY **ETHAN ALLEN** AND HIS **GREEN MOUNTAIN BOYS!**

BY WHAT AUTHORITY HAVE YOU ENTERED HIS MAJESTY'S FORT?

IN THE NAME OF THE GREAT JEHOVAH AND THE CONTINENTAL CONGRESS!

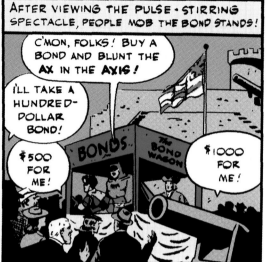

AFTER VIEWING THE PULSE-STIRRING SPECTACLE, PEOPLE MOB THE BOND STANDS!

C'MON, FOLKS! BUY A BOND AND BLUNT THE **AX** IN THE **AXIS!**

I'LL TAKE A HUNDRED-DOLLAR BOND!

$500 FOR ME!

$1000 FOR ME!

BUT NOT EVERYONE VIEWS THE **BOND WAGON** WITH FAVOR! IN A ROOM SOMEWHERE IN AMERICA...

BARON VON LUGER, DIS BOND VAGON ISS SELLING BONDS: BONDS MEAN MORE PLANES, TANKS SHIPS FIGHTING DER NEW ORDER!

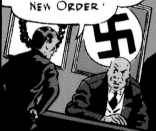

IF ONLY VE CAN SABOTAGE DIS BONDVAGON VE ALSO STRIKE A BLOW AT AMERIKANER MORALE! TOMORROW DER BOND VAGON ENACTS DER CAPTURE OF DER HESSIANS AT TRENTON! DER HESSIANS VERE HIRED **CHERMAN** SOLDIERS...

AH! YOU HAF A PLAN! GOOT...

NEXT DAY, AFTER RECRUITING EXTRAS FOR THE BIG SCENE. **BATMAN** AND **ROBIN** STAND ON THE BANKS OF THE DELEWARE...

RIGHT! I WANT YOU THERE WITH THEM IN CASE THEY FORGET THEIR LINES! I'LL COACH WASHINGTON'S "ARMY!"

GOSH, THIS ICE IS A BREAK FOR US! IS THAT OLD, DESERTED TAVERN WHERE THE "HESSIANS" STAY?

THAT NIGHT... AS **ROBIN** GIVES LAST-MINUTE INSTRUCTIONS...

OKAY, NOW REMEMBER YOU'RE SUPPOSED TO BE GERMANS, SO HOP INTO THOSE HESSIAN UNIFORMS AND...

NEIN! VE TAKE DER UNIFORMS! VE DO NOT **HAF** TO PRETEND!

QUICK! YOU ALL GO DOWN DER CELLAR! BOY, YOU STAY HERE TO STOP SUSPICION SHOULD SOMEVONE ENTER! VE LEAF YOUR HANDS UNTIED... BUT VON FALSE MOVE... UND I SHOOT!

I CAN'T HELP ANY BY BEING DEAD! BETTER PRETEND TO BE SCARED! PLEASE.. PLEASE DON'T SHOOT ME!

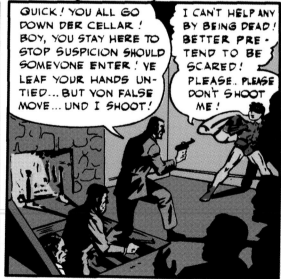

4

AFTER THE ACTORS ARE HERDED TO THE CELLAR...

UH .. WH-WHAT ARE YOU GOING TO DO ?

"WASHINGTON'S ARMY" CARRIES RIFLES MIT ONLY **BLANK** CARTRIDGES ... BUT NOT **OUR** LUGERS! YEN DEY LAND --**VE SLAUGHTER DEM!** HA! HA! GOOT, EH ?

MINUTES TICK BY... **THEN... A PAGE OF HISTORY DRAMATICALLY COMES TO LIFE !** AS DID THOSE HEROIC MEN ON CHRISTMAS EVE IN 1776, ANOTHER ARMY CROSSES THE ICE-CHOKED DELAWARE !

..BUT... ON THAT PAGE OF HISTORY OF 1776, THERE WAS NO **DEATH-TRAP** AMBUSHING WASHINGTON AND **HIS** MEN !

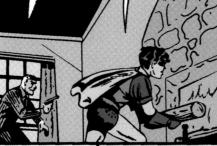

HA! DEY HAF STARTED! NOW VE... BOY, VOT ARE YOU DOING ?

JUST PUTTING ANOTHER LOG ON THE FIRE! **I'M COLD!!**

I...I BETTER USE THE BELLOWS TO MAKE A GOOD BLAZE! IM FREEZING !

UND YOU ARE THE "DARE DEVIL" ROBIN I HAF HEARD SO MUCH ABOUT ! "COLD"! BAH! LIKE ALL AMERICAN YOUTH YOU ARE SOFT... A PHYSICAL COWARD !

ON THE OPPOSITE SHORE, BATMAN SUDDENLY STIFFENS... HIS EYES SNAP WIDE OPEN...

WHAT'S THIS ? IS **ROBIN** REALLY GOING SOFT? OR IS HE USING THOSE BELLOWS FOR ANOTHER PURPOSE ?!!

THAT SMOKE FROM THE CHIMNEY! IT... **HOLY CATS !** SOMETHING'S UP! I'VE GOT TO BEAT THE "ARMY" ACROSS!

THE NEXT INSTANT **BATMAN** IS DOWN ON THE RIVER. HOPPING FROM ONE FLOATING ICE CAKE TO ANOTHER LIKE A MAN GONE WILD !

ALL **BATMAN** HAS SPOTTED IS SOME SMOKE FROM A CHIMNEY, YET HE'S WISE SOMETHING'S WRONG! **HOW COME ?**

BUT ALREADY WASHINGTON'S MEN HAVE LANDED... AND ARE MARKED MEN ! - MARKED BY LUGER SIGHTS !!

READY... AIM...

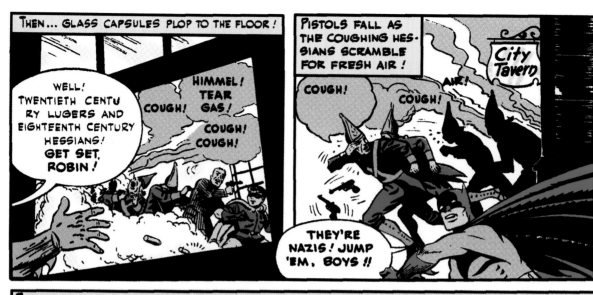

THEN... GLASS CAPSULES PLOP TO THE FLOOR!

WELL! TWENTIETH CENTURY LUGERS AND EIGHTEENTH CENTURY HESSIANS! GET SET, ROBIN!

HIMMEL! TEAR GAS!

COUGH!

COUGH! COUGH!

PISTOLS FALL AS THE COUGHING HESSIANS SCRAMBLE FOR FRESH AIR!

City Tavern

COUGH!

COUGH!

AIR!

THEY'RE NAZIS! JUMP 'EM, BOYS!!

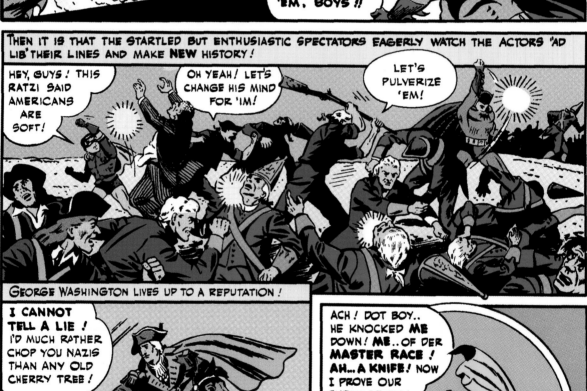

THEN IT IS THAT THE STARTLED BUT ENTHUSIASTIC SPECTATORS EAGERLY WATCH THE ACTORS 'AD LIB' THEIR LINES AND MAKE NEW HISTORY!

HEY, GUYS! THIS RATZI SAID AMERICANS ARE SOFT!

OH YEAH! LET'S CHANGE HIS MIND FOR 'IM!

LET'S PULVERIZE 'EM!

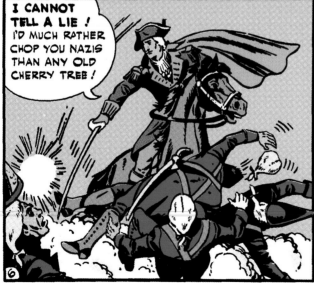

GEORGE WASHINGTON LIVES UP TO A REPUTATION!

I CANNOT TELL A LIE! I'D MUCH RATHER CHOP YOU NAZIS THAN ANY OLD CHERRY TREE!

6

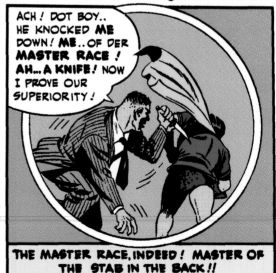

ACH! DOT BOY.. HE KNOCKED ME DOWN! ME..OF DER MASTER RACE! AH...A KNIFE! NOW I PROVE OUR SUPERIORITY!

THE MASTER RACE, INDEED! MASTER OF THE STAB IN THE BACK!!

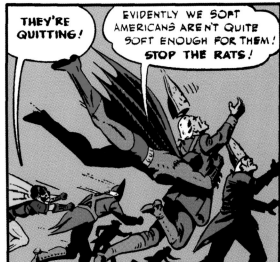

AH!

OOOHM!

OOOH!

THEY'RE QUITTING!

EVIDENTLY WE SOFT AMERICANS AREN'T QUITE SOFT ENOUGH FOR THEM! STOP THE RATS!

AND SO THE BATTLE IS WON!

JUST LIKE HISTORY, EH?

NOT EXACTLY! IN 1776 WASHINGTON CAUGHT THE COCKSURE HESSIANS NAPPING BECAUSE THEY WERE HALF-TIPSY WITH DRINK!

THESE GERMANS WERE DRUNK, TOO--DRUNK WITH THEIR OWN BLOATED SUPERIORITY! HISTORY **DID** REPEAT ITSELF AFTER ALL!

YOU DEVIL! HOW DID YOU KNOW ABOUT US?

BY SMOKE SIGNALS! **ROBIN** WORKED THE BELLOWS AND SENT UP SMOKE IN THREE **SHORT** PUFFS AND **ONE** LONG... OR **THREE DOTS** AND **ONE DASH**-- THE V FOR VICTORY SIGNAL!

THAT MEANT SOME-THING WITH A **MOD-ERN NAZI** ANGLE, SO I INVES-TIGATED! SIMPLE?

SOME TIME LATER, AFTER QUESTIONING THE NAZI PRISONERS..

WELL?

SO FAR, NO GOOD! NOT ONE OF THE RATS KNOWS WHO THE **BIG RATS** ARE! THEY RE-CEIVED INSTRUCTIONS BY TELEPHONE OR TELEGRAM!

POLICE HEAD-QUARTERS

227

BUT THE BATMAN IS NOT THE ONLY DISGUSTED ONE ...

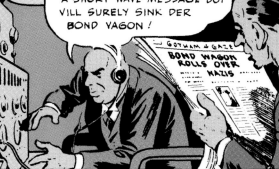

DER FUEHRER VILL NOT LIKE DIS!

TCH! A TEMPORARY DEFEAT! BUT NOW I SEND A SHORT WAVE MESSAGE DOT VILL SURELY SINK DER BOND VAGON!

— GOTHAM GAZE —
BOND WAGON ROLLS OVER NAZIS

AND THE BOND WAGON ROLLS ON!

THIS OLD SCHOONER MAKES A GOOD BONHOMME RICHARD NOW, BUT I HAD TO STUFF THE HOLD WITH CORK TO KEEP 'ER AFLOAT!

WHY THE BALL AND POWDER?

GOING TO FIRE A FEW BROADSIDES TO DEMONSTRATE HOW THESE OLD CANNON WORKED!

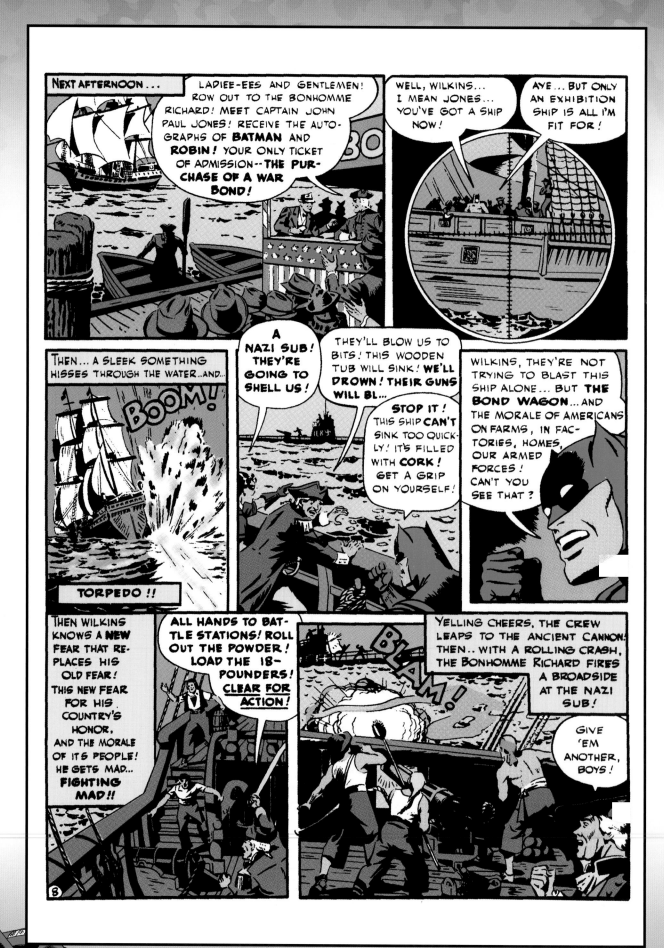

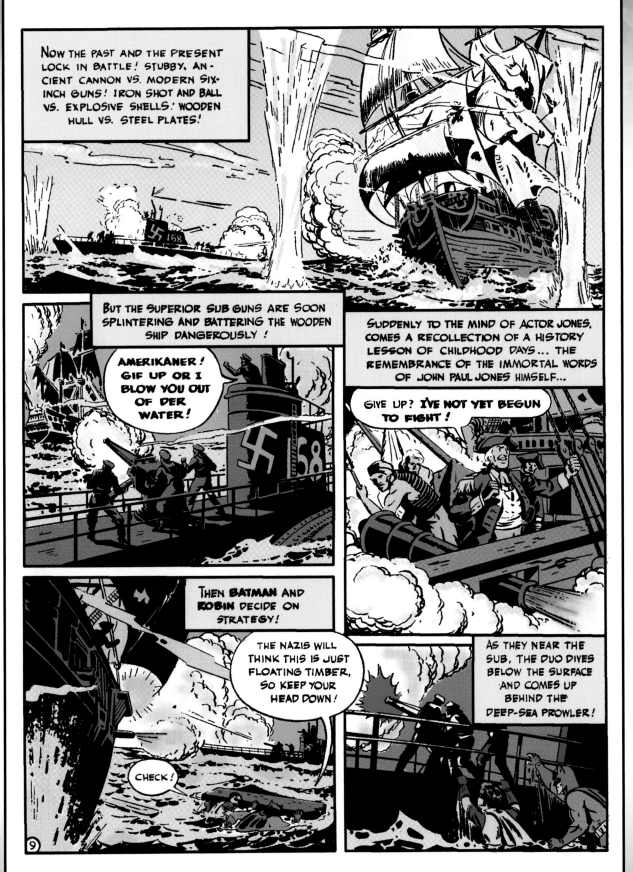

NOW THE PAST AND THE PRESENT LOCK IN BATTLE! STUBBY, ANCIENT CANNON VS. MODERN SIX-INCH GUNS! IRON SHOT AND BALL VS. EXPLOSIVE SHELLS! WOODEN HULL VS. STEEL PLATES!

BUT THE SUPERIOR SUB GUNS ARE SOON SPLINTERING AND BATTERING THE WOODEN SHIP DANGEROUSLY!

AMERIKANER! GIF UP OR I BLOW YOU OUT OF DER WATER!

SUDDENLY TO THE MIND OF ACTOR JONES, COMES A RECOLLECTION OF A HISTORY LESSON OF CHILDHOOD DAYS... THE REMEMBRANCE OF THE IMMORTAL WORDS OF JOHN PAUL JONES HIMSELF...

GIVE UP? I'VE NOT YET BEGUN TO FIGHT!

THEN BATMAN AND ROBIN DECIDE ON STRATEGY!

THE NAZIS WILL THINK THIS IS JUST FLOATING TIMBER, SO KEEP YOUR HEAD DOWN!

CHECK!

AS THEY NEAR THE SUB, THE DUO DIVES BELOW THE SURFACE AND COMES UP BEHIND THE DEEP-SEA PROWLER!

229

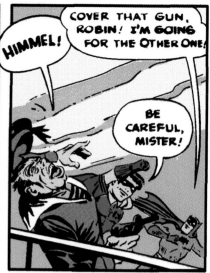

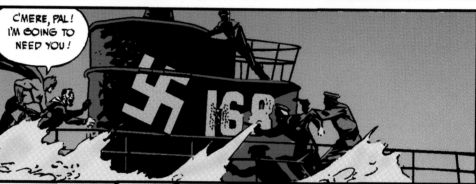

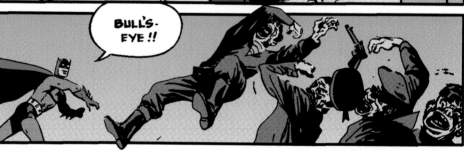

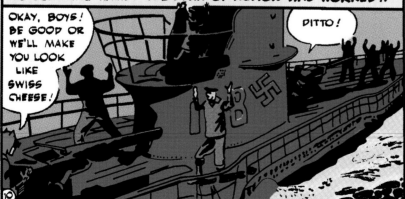

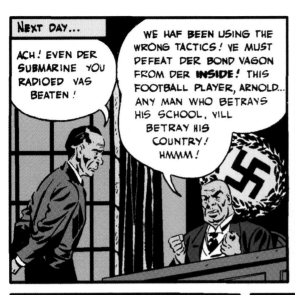

NEXT DAY...

ACH! EVEN DER SUBMARINE YOU RADIOED VAS BEATEN!

WE HAF BEEN USING THE WRONG TACTICS! VE MUST DEFEAT DER BOND VAGON FROM DER **INSIDE**! THIS FOOTBALL PLAYER, ARNOLD... ANY MAN WHO BETRAYS HIS SCHOOL, VILL BETRAY HIS COUNTRY! HMMM!

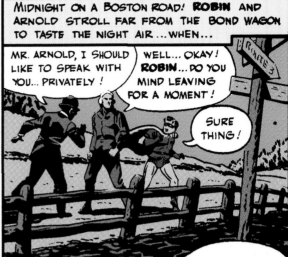

MIDNIGHT ON A BOSTON ROAD! **ROBIN** AND ARNOLD STROLL FAR FROM THE BOND WAGON TO TASTE THE NIGHT AIR...WHEN...

MR. ARNOLD, I SHOULD LIKE TO SPEAK WITH YOU... PRIVATELY!

WELL... OKAY! **ROBIN**...DO YOU MIND LEAVING FOR A MOMENT!

SURE THING!

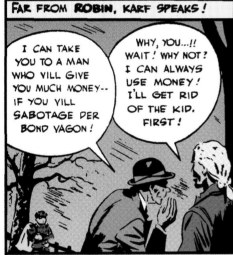

FAR FROM **ROBIN**, KARF SPEAKS!

I CAN TAKE YOU TO A MAN WHO VILL GIVE YOU MUCH MONEY-- IF YOU VILL SABOTAGE DER BOND VAGON!

WHY, YOU...!! WAIT! WHY NOT? I CAN ALWAYS USE MONEY! I'LL GET RID OF THE KID. FIRST!

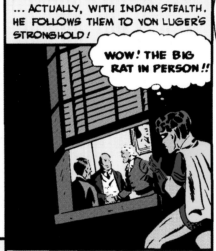

AND THOUGH HE PRETENDS TO LEAVE ... ACTUALLY, WITH INDIAN STEALTH, HE FOLLOWS THEM TO VON LUGER'S STRONGHOLD!

WOW! THE BIG RAT IN PERSON!!

GOT TO GET TO THE **BATMAN**! NO CARS AROUND BECAUSE OF GAS RATIONING... SO I'VE GOT TO USE THE NEXT BEST THING!

BUT **ROBIN** KNOWS-- FOR ONE OF HIS CRIME-FIGHTING WEAPONS IS THE READ-ING OF LIPS!

THE MID-NIGHT RIDE OF BOY ROBIN!

LOOKS LIKE I'M PULLING A PAUL REVERE BUT I'VE **GOT** TO GET TO THE **BATMAN**!

THEN THE CLATTER OF HOOFS AWAKENS **BATMAN**...

WHAT? I'LL BE RIGHT DOWN!

C'MON! I KNOW WHERE THE BIG RAT LIVES! THAT ARNOLD GUY DOUBLE-CROSSED US!

11

231

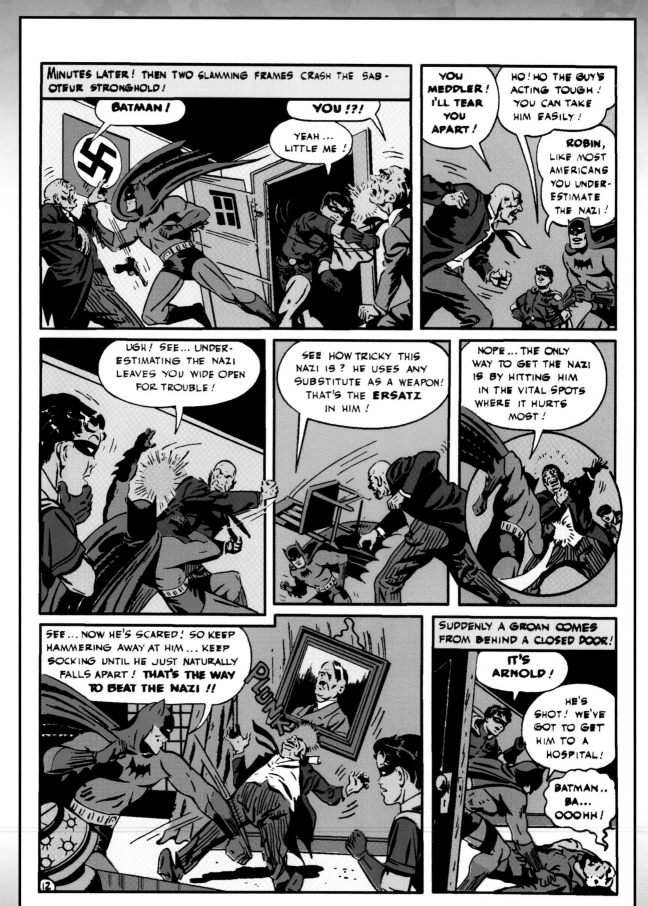

THE NEXT DAY,.. ARNOLD EXPLAINS!

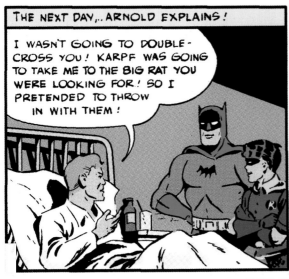

I WASN'T GOING TO DOUBLE-CROSS YOU! KARPF WAS GOING TO TAKE ME TO THE BIG RAT YOU WERE LOOKING FOR! SO I PRETENDED TO THROW IN WITH THEM!

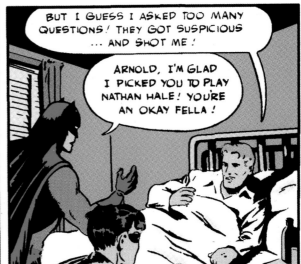

BUT I GUESS I ASKED TOO MANY QUESTIONS! THEY GOT SUSPICIOUS ... AND SHOT ME!

ARNOLD, I'M GLAD I PICKED YOU TO PLAY NATHAN HALE! YOU'RE AN OKAY FELLA!

AND WHEN THE PRESS LEARNS, AND ARNOLD'S SCHOOLMATES LEARN THE TRUTH, A SPECIAL COMMITTEE INVADES THE HOSPITAL!

I GUESS YOU OUGHT TO HAVE THIS! THE SPORTS WRITERS OF ALL PAPERS HAVE VOTED YOU AS HALF-BACK ON THE ALL-AMERICAN TEAM!

ALL AMERICAN! GEE... GEE...

AND SO THE **BOND WAGON** ROLLS ON... TO INDEPENDENCE HALL IN PHILADELPHIA... WHERE EAGER SPECTATORS WATCH –

THE SIGNING OF THE DECLARATION OF INDEPENDENCE!!

233

AFTER THE STIRRING SPECTACLE, **BATMAN** ADDRESSES THE PEOPLE CROWDING THE HALL...

FELLOW AMERICANS, YOU, TOO, CAN SIGN A DECLARATION OF INDEPENDENCE... INDEPENDENCE FROM SLAVERY TO SCHICKELGRUBER... FOR SHOULD THE AXIS WIN, AMERICANS **WILL BE** SLAVES IN BONDAGE!

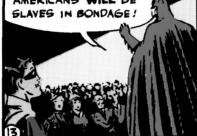

13

FELLOW AMERICANS! WHICH IS IT TO BE -- BONDAGE OR WAR BONDS?

AND SO A NEW DECLARATION OF INDE-PENDENCE IS SIGNED... ANOTHER DE-CLARATION OF INDEPENDENCE FROM SLAVERY... A DECLARATION TO BUY WAR BONDS AND STAMPS!

FELLOW AMERICANS, WE SALUTE YOU!!

SIGN HERE FOR WAR BONDS

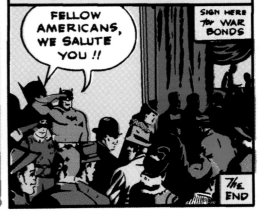

THE END

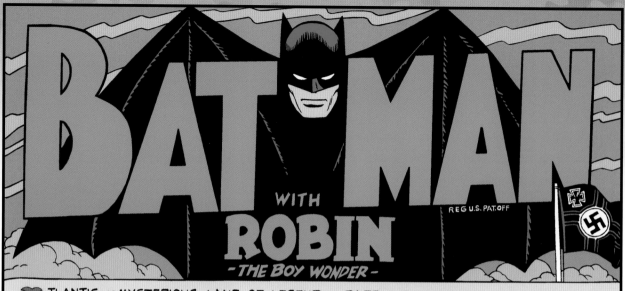

BAT MAN
WITH
ROBIN
—THE BOY WONDER—

REG U.S. PAT.OFF

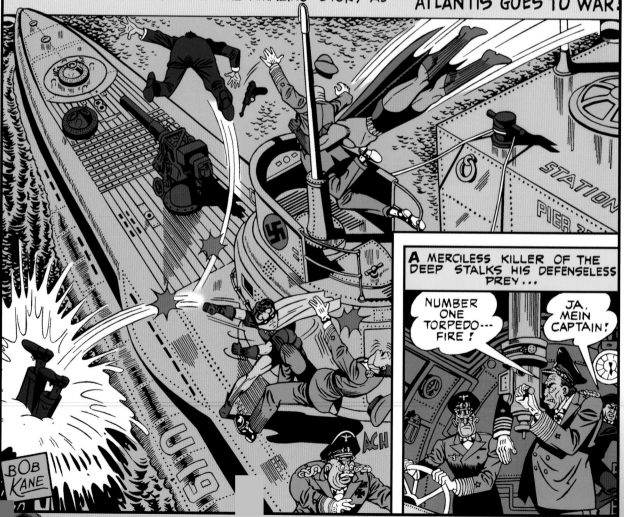

ATLANTIS---MYSTERIOUS LAND OF LEGEND--- BAFFLING ENIGMA WHICH HAS ENTHRALLED THE FANCY OF SCIENTISTS AND HISTORIANS, ANCIENT AND MODERN! WHAT BECAME OF ITS PEOPLE, ITS CULTURE, ITS IDEALS, WHEN EARTHQUAKE AND TIDAL WAVE BURIED IT DEEP IN THE OCEAN THOUSANDS OF YEARS AGO?

NO ONE REALLY KNOWS, SAY THE SCHOLARS---
BUT THE MIGHTY **BATMAN** AND HIS DAREDEVIL COMRADE **ROBIN** KNOW--- FOR THE TRAIL OF SKULKING NAZI U-BOATS LEADS THEM INTO THEIR MOST FANTASTIC ADVENTURE OF ALL, DEEP IN THE ROLLING SEA! TREACHERY AND PERIL ... BATTLES AND HAIRSBREADTH ESCAPES ... GLAMOR AND ROMANCE ... ALL THESE HAVE THEIR PART IN THE AMAZING STORY AS---"ATLANTIS GOES TO WAR!"

A MERCILESS KILLER OF THE DEEP STALKS HIS DEFENSELESS PREY...

NUMBER ONE TORPEDO--- FIRE!

JA, MEIN CAPTAIN!

BOB KANE

Batman #19 (Oct.-Nov. 1943) - script: Don Cameron - art: Dick Sprang

AND THE CALM OF THE NIGHT IS SHATTERED BY THE FLAME AND THUNDER OF A TERRIFIC EXPLOSION...

ABOARD THE STRICKEN AMERICAN TANKER, A WOUNDED HERO STICKS GRIMLY AT HIS POST...

CALLING U.S. COAST GUARD! TANKER CRYSTAL BELLE TORPEDOED EIGHTY MILES EAST OF SAVANNAH! WE'RE SINKING FAST...

CRACKLING THROUGH THE ETHER, THE RADIO CALL IS AT ONCE A WARNING AND A FAREWELL...

ALL LIFEBOATS SMASHED... SUB STANDING BY... THIS LOOKS LIKE THE FINISH FOR ALL OF US!

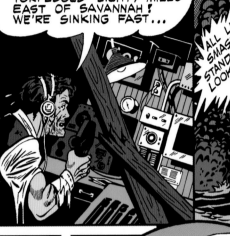

LANDBASED PLANES ROAR INTO THE BLACKNESS ON THE SLIM CHANCE OF SIGHTING THE DEADLY U-BOAT IN THE VAST EXPANSE OF OCEAN...

IF YOU SIGHT THE SHIP BEFORE SHE SINKS, DROP YOUR RUBBER LIFEBOAT... IT MIGHT SAVE SOME OF THOSE POOR DEVILS!

RIGHT, MAJOR!!

OUR RADIO OPERATOR REPORTS THAT THE SHIP IS CALLING FOR HELP, SIR!

LET THEM CALL! NO ONE WILL EVER FIND THEM--- OR US!

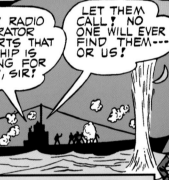

MEANWHILE, CAPTAIN KURT FRITZL, IN THE FINEST TRADITION OF NAZI WARFARE, AMUSES HIMSELF BY SHELLING HIS HELPLESS VICTIM...

NOT IN TEN MILLION YEARS COULD AMERICAN PLANES OR SHIPS FIND THE SECRET BASE OF OUR UNDERSEA FLEET! SOMETIMES I MYSELF WONDER IF IT IS NOT ALL A DREAM!

LATER, AS THE KILLER CRAFT GLIDES THROUGH THE INKY DEPTHS THAT ARE THE COMMON GRAVE OF BRAVE MERCHANT SEA MEN...

WHAT COURSE, HERR CAPTAIN?

WE HAVE DONE A GOOD NIGHT'S WORK FOR DER FUEHRER--- LET US RETURN TO OUR HOME PORT--- TO ATLANTIS!

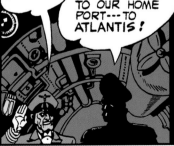

WHAT'S THIS? ATLANTIS-- THE FABULOUS LAND WHERE THE ANCIENTS BELIEVED A GREAT CIVILIZATION FLOURISHED BETWEEN THE CONTINENTS OF EUROPE AND AMERICA, UNTIL THE SEA SWALLOWED IT!
DID SUCH A LAND EVER EXIST? CAN IT POSSIBLY STILL EXIST, SOMEWHERE BENEATH THE RESTLESS WAVES?

OH, WELL--- PERHAPS THE NAZI U-BOAT COMMANDER WAS SPEAKING IN JEST...

... PERHAPS.

235

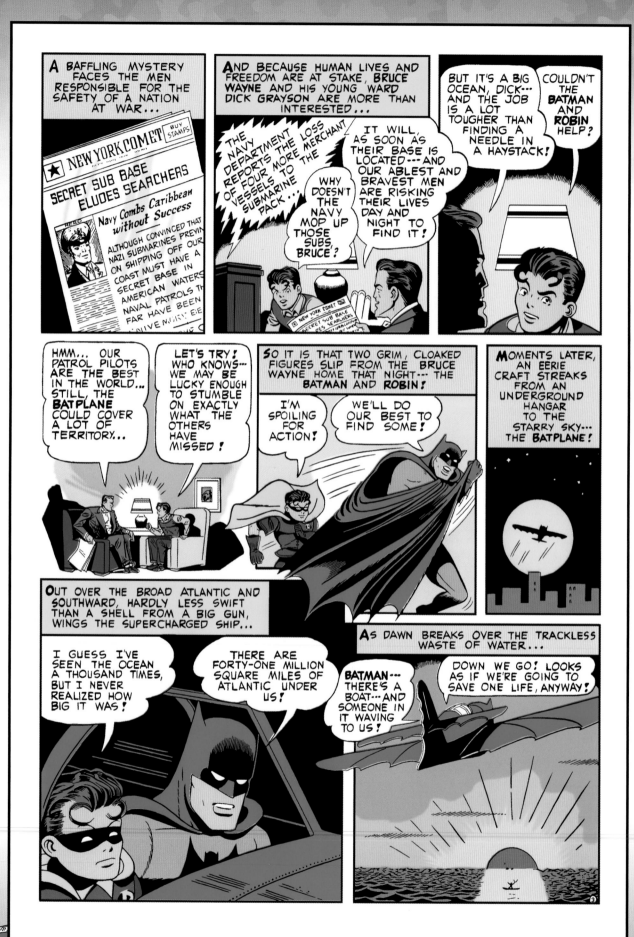

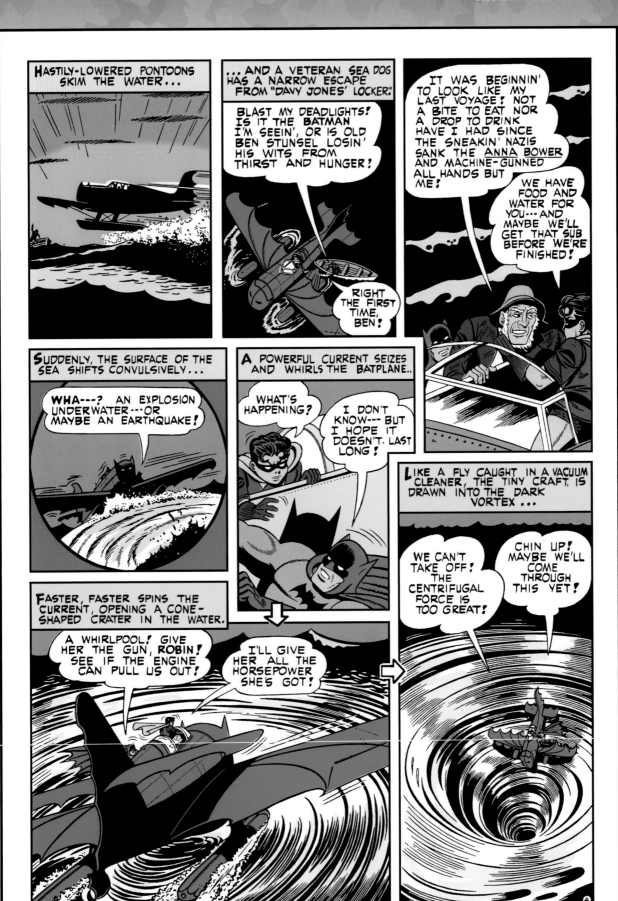

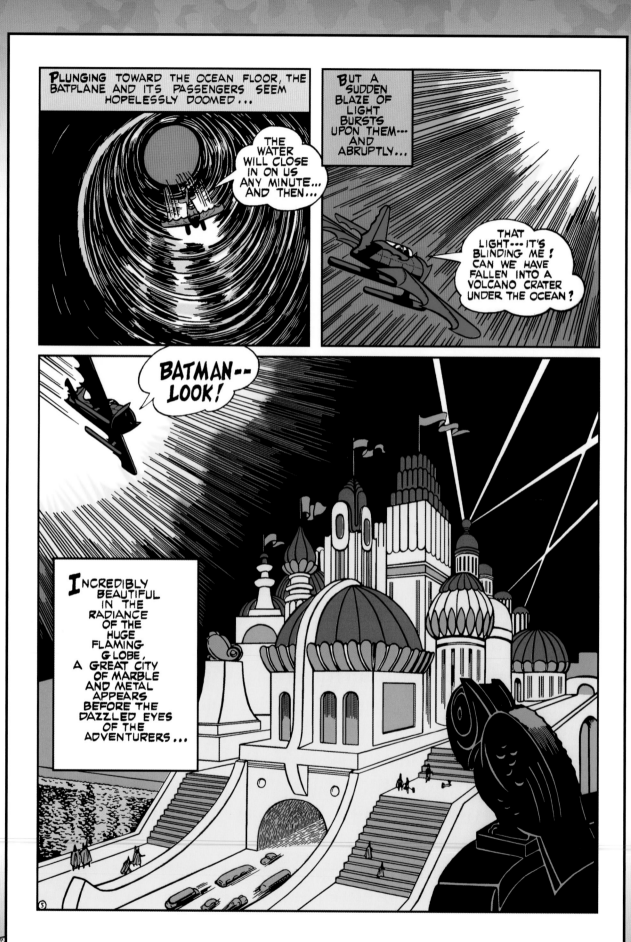

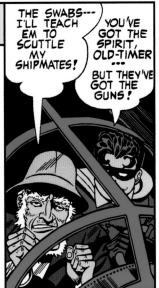

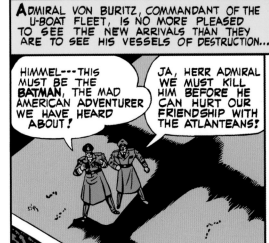

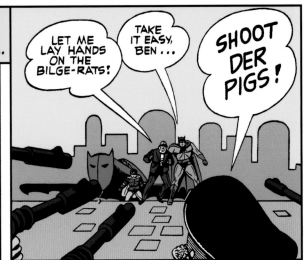

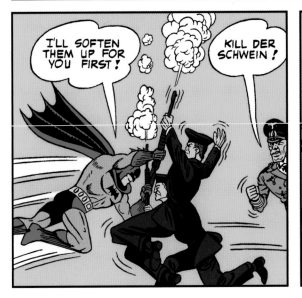

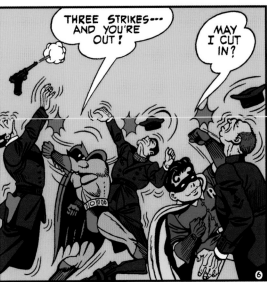

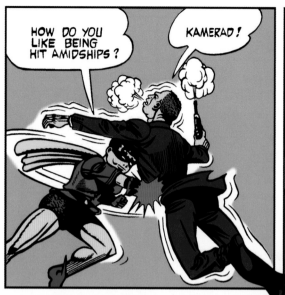

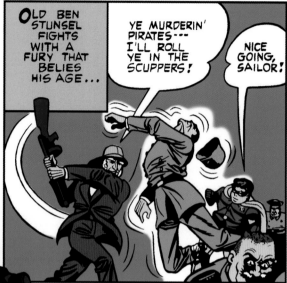

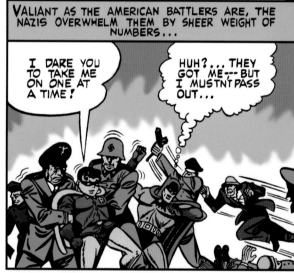

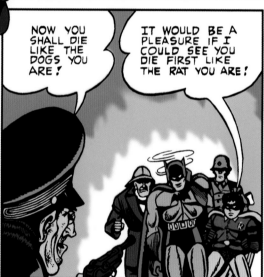

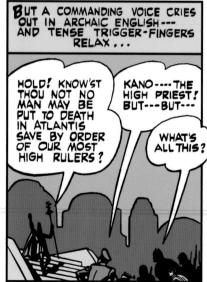

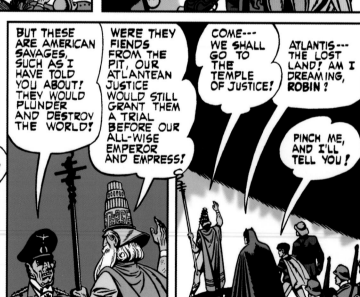

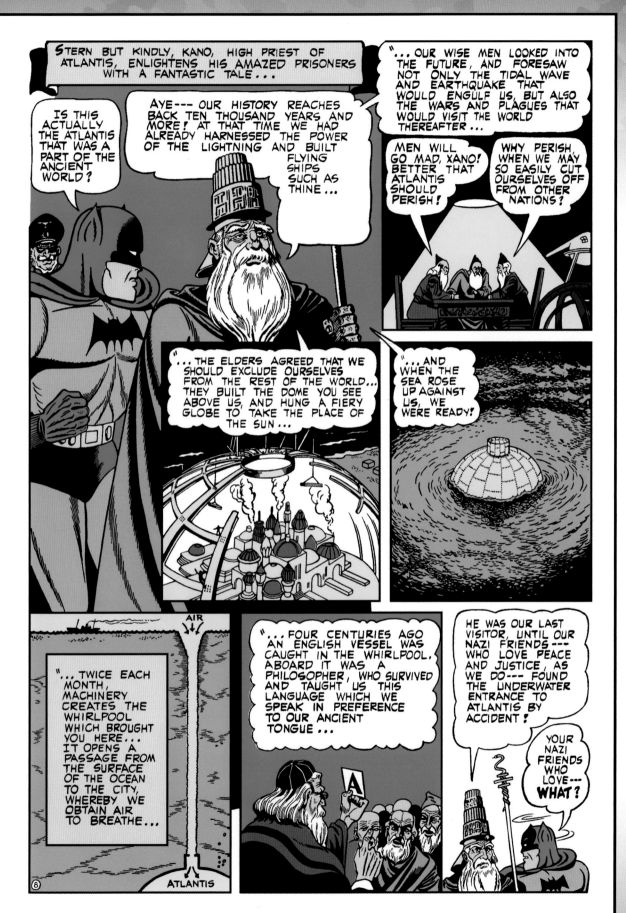

STERN BUT KINDLY, KANO, HIGH PRIEST OF ATLANTIS, ENLIGHTENS HIS AMAZED PRISONERS WITH A FANTASTIC TALE...

IS THIS ACTUALLY THE ATLANTIS THAT WAS A PART OF THE ANCIENT WORLD?

AYE--- OUR HISTORY REACHES BACK TEN THOUSAND YEARS AND MORE! AT THAT TIME WE HAD ALREADY HARNESSED THE POWER OF THE LIGHTNING AND BUILT FLYING SHIPS SUCH AS THINE...

"...OUR WISE MEN LOOKED INTO THE FUTURE, AND FORESAW NOT ONLY THE TIDAL WAVE AND EARTHQUAKE THAT WOULD ENGULF US, BUT ALSO THE WARS AND PLAGUES THAT WOULD VISIT THE WORLD THEREAFTER...

MEN WILL GO MAD, XANO! BETTER THAT ATLANTIS SHOULD PERISH!

WHY PERISH, WHEN WE MAY SO EASILY CUT OURSELVES OFF FROM OTHER NATIONS?

"...THE ELDERS AGREED THAT WE SHOULD EXCLUDE OURSELVES FROM THE REST OF THE WORLD... THEY BUILT THE DOME YOU SEE ABOVE US, AND HUNG A FIERY GLOBE TO TAKE THE PLACE OF THE SUN...

"...AND WHEN THE SEA ROSE UP AGAINST US, WE WERE READY!

AIR

"...TWICE EACH MONTH, MACHINERY CREATES THE WHIRLPOOL WHICH BROUGHT YOU HERE... IT OPENS A PASSAGE FROM THE SURFACE OF THE OCEAN TO THE CITY, WHEREBY WE OBTAIN AIR TO BREATHE...

ATLANTIS

"...FOUR CENTURIES AGO AN ENGLISH VESSEL WAS CAUGHT IN THE WHIRLPOOL. ABOARD IT WAS A PHILOSOPHER, WHO SURVIVED AND TAUGHT US THIS LANGUAGE WHICH WE SPEAK IN PREFERENCE TO OUR ANCIENT TONGUE...

HE WAS OUR LAST VISITOR, UNTIL OUR NAZI FRIENDS --- WHO LOVE PEACE AND JUSTICE, AS WE DO--- FOUND THE UNDERWATER ENTRANCE TO ATLANTIS BY ACCIDENT!

YOUR NAZI FRIENDS WHO LOVE--- WHAT?

A

241

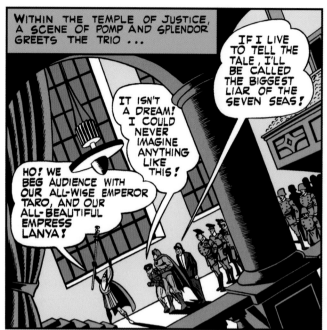

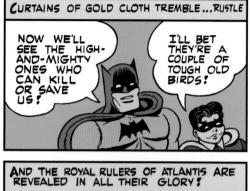

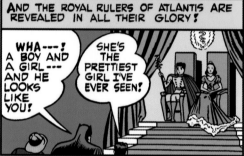

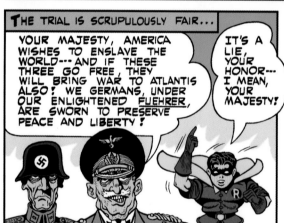

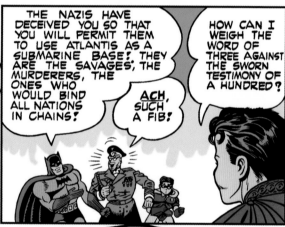

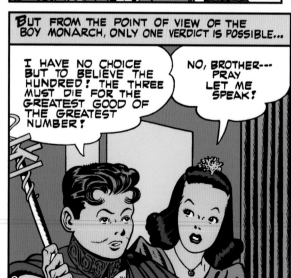

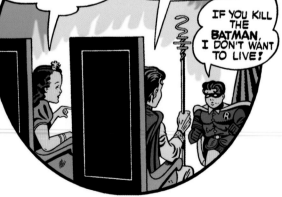

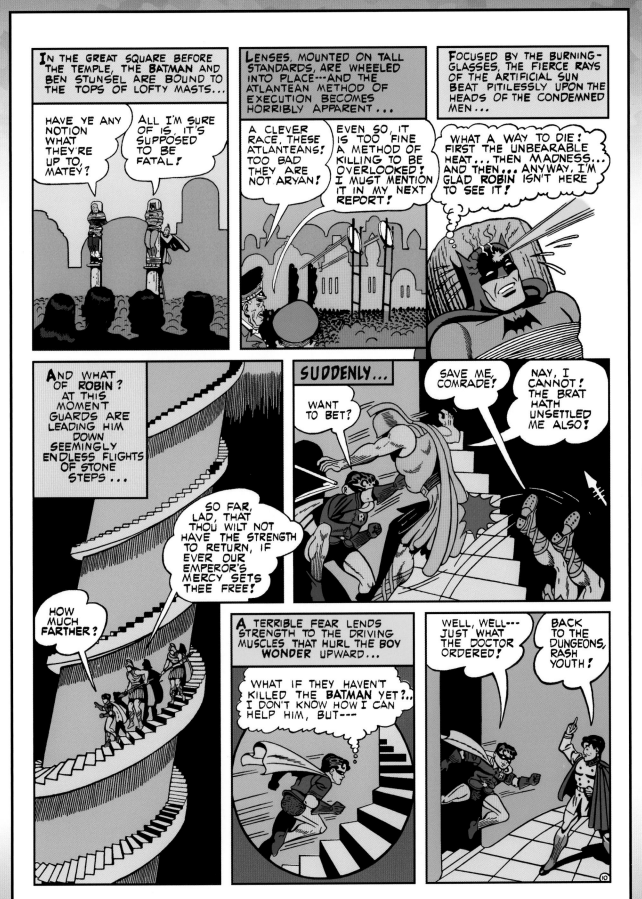

I HATE TO DO THIS, YOUR MAJESTY--- BUT YOU'VE GOT IT COMING FOR BELIEVING THOSE NAZI LIES!

OHHH!!

A LIGHTNING CHANGE OF GARMENT, AND...

WE LOOK ENOUGH ALIKE SO THAT I OUGHT TO GET AWAY WITH IT... BUT I MUSTN'T FORGET TO SPEAK OLD-STYLE ENGLISH!

A DRAMATIC SCENE IS ENACTED ON THE BALCONY OF THE TEMPLE OF JUSTICE...

HO, MEN OF ATLANTIS--- YOUR EMPEROR HATH BEEN BLIND! RELEASE THE PRISONERS AT ONCE!

TARO, MY BROTHER- I AM SO GLAD!... WHY---WHY YOU ARE NOT TARO! YOU ARE---

PLEASE, EMPRESS--- YOU SAVED MY LIFE--- NOW LET ME SAVE MY FRIEND! WE TOLD THE TRUTH, EVEN IF TARO WOULDN'T BELIEVE US!

FAITH, LAD, I BELIEVE THEE! MY BROTHER WILL BE ANGRY, BUT DO AS THOU THINKEST RIGHT!

WE STILL HAVE ONE CHANCE... WE SHALL SEIZE THE EMPEROR!

JA---WE WERE FOOLS NOT TO HAVE DONE SO IN THE FIRST PLACE!

IT'S ROBIN! BUT HOW DID HE MANAGE IT?

AT LAST THE NAZIS REVEAL THEMSELVES IN THEIR TRUE COLORS...

PROCEED WITH THE EXECUTION, OR I SHALL KILL YOUR PIG-HEADED EMPEROR!

WHAT---? WHERE---?

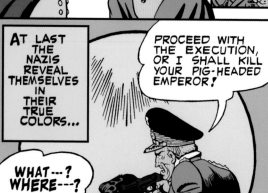

AS THE BATMAN STRUGGLES FRANTICALLY TO BURST HIS HALF-LOOSENED THONGS, BEN STUNSEL SNATCHES A BRONZE HELMET FROM AN ATLANTEAN GUARD AND HURLS IT WITH PERFECT AIM...

SO NOW YE'D MURDER BOYS AS WELL AS HONEST SEAMEN, WOULD YE?

KILL HIM, SOLDIERS OF THE REICH!

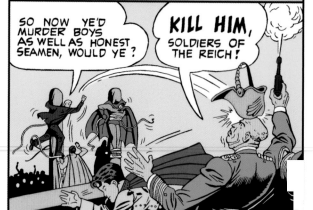

THE NEXT INSTANT...

A-A-A-H-H-H...

BUT THE HEROIC ACT HAS GIVEN ROBIN ALL THE OPPORTUNITY HE NEEDS...

WHY DON'T YOU FIGHT LIKE A MAN FOR A CHANGE?

SMITE HIM, ROBIN! IN TRUTH HE HATH DECEIVED US GRAVELY!

ONE BULLET WILL PUT AN END TO ALL THIS!

AND A SPLIT SECOND LATER, A MIGHTY LUNGE SETS THE BATMAN FREE...

SAVE THAT BULLET, ADMIRAL!

HEIN? JA---I SHALL SAVE IT FOR YOU!

A LITTLE SLOW ON THE TRIGGER, AREN'T YOU?

ACH--- I AM RUINED!

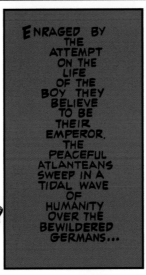

ENRAGED BY THE ATTEMPT ON THE LIFE OF THE BOY THEY BELIEVE TO BE THEIR EMPEROR, THE PEACEFUL ATLANTEANS SWEEP IN A TIDAL WAVE OF HUMANITY OVER THE BEWILDERED GERMANS...

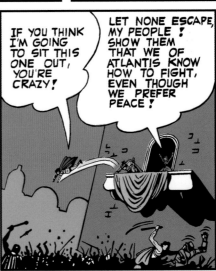

IF YOU THINK I'M GOING TO SIT THIS ONE OUT, YOU'RE CRAZY!

LET NONE ESCAPE, MY PEOPLE! SHOW THEM THAT WE OF ATLANTIS KNOW HOW TO FIGHT, EVEN THOUGH WE PREFER PEACE!

245

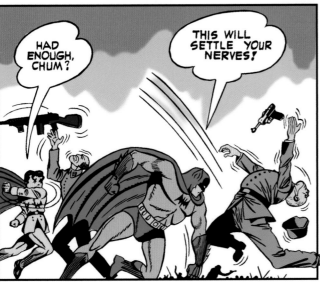

HAD ENOUGH, CHUM?

THIS WILL SETTLE YOUR NERVES!

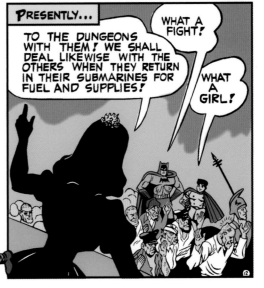

PRESENTLY...

TO THE DUNGEONS WITH THEM! WE SHALL DEAL LIKEWISE WITH THE OTHERS WHEN THEY RETURN IN THEIR SUBMARINES FOR FUEL AND SUPPLIES!

WHAT A FIGHT!

WHAT A GIRL!

AN AMERICAN HERO SAYS GOODBYE...

SO THEY GOT OLD BEN AT LAST!... BUT I'M MAKIN' MY LAST VOYAGE WITHOUT REGRETS... KNOWIN' I HELPED WIPE 'EM OFF THE FACE O' THE EARTH!... SO LONG, BATMAN... ROBIN...

SO LONG, BEN STUNSEL...

ALL ATLANTIS SHALL DO HIM HONOR!

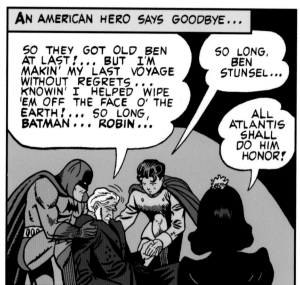

WHEN EXPLANATIONS HAVE BEEN MADE AND MISUNDERSTANDINGS STRAIGHTENED OUT..

THY BLOW IS FORGIVEN, ROBIN,--- FOR IT OPENED MINE EYES TO THE TRUTH! THOU AND THE BATMAN MAY GO IN PEACE--- LEAVING ONLY THY PROMISE TO TELL NO MAN WHERE ATLANTIS LIES!

YOUR SECRET IS SAFE WITH US!

I GUESS--- I GUESS--- THIS IS GOODBYE, LANYA--- YOUR MAJESTY!

READY, ROBIN?

GOODBYE--- ROBIN--- AND GOOD FORTUNE GO WITH THEE!

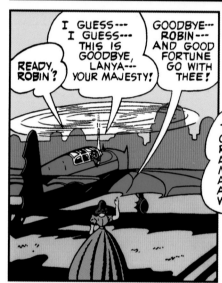

AUTOGYRO BLADES LIFT THE BATPLANE INTO A GRIMMER, LESS ROMANTIC, GLAMOROUS WORLD, AS THE VAST WHIRLPOOL AGAIN DRILLS A PASSAGE FROM THE TOP TO THE BOTTOM OF THE SEA...

THAT'S THE END OF THOSE U-BOATS, ROBIN--- AND OF ALL OTHERS THAT MAKE ATLANTIS A PORT OF CALL! A GRAND ADVENTURE, WASN'T IT?

I'LL NEVER FORGET HER---I MEAN IT!

AS SWIRLING WATERS CLOSE OVER THE SHINING CITY OF THE AGES...

YOU MEAN HER, YOU ROMANTIC YOUNG RASCAL! AND HERE'S A LETTER SHE ASKED ME TO GIVE YOU, ONCE ON OUR WAY!

FOR ME?-- QUICK--- LET ME SEE!

Dear Robin:

Fate hath decreed that we shall not meet again, but I would have thee know that my nation shall fight the fight beside thine for the human dignity of the human race --- yet, having foresworn the world, we must fight alone, in our own way...

Keep well our secret and think of me sometimes, not as the ruler of a people, but simply as,

Thy friend,
Lanya

SOME DAYS LATER...

HERE'S SOMETHING, DICK... AN AMERICAN SUBMARINE IN THE CARIBBEAN, NEAR WHERE WE WERE, FOUND THREE NAZI U-BOATS TRAPPED IN A METAL NET FAR BELOW THE SURFACE--- AND NO ONE SEEMS TO KNOW HOW THE NET GOT THERE!

AND TO THINK I'LL PROBABLY NEVER SEE HER AGAIN!

The End

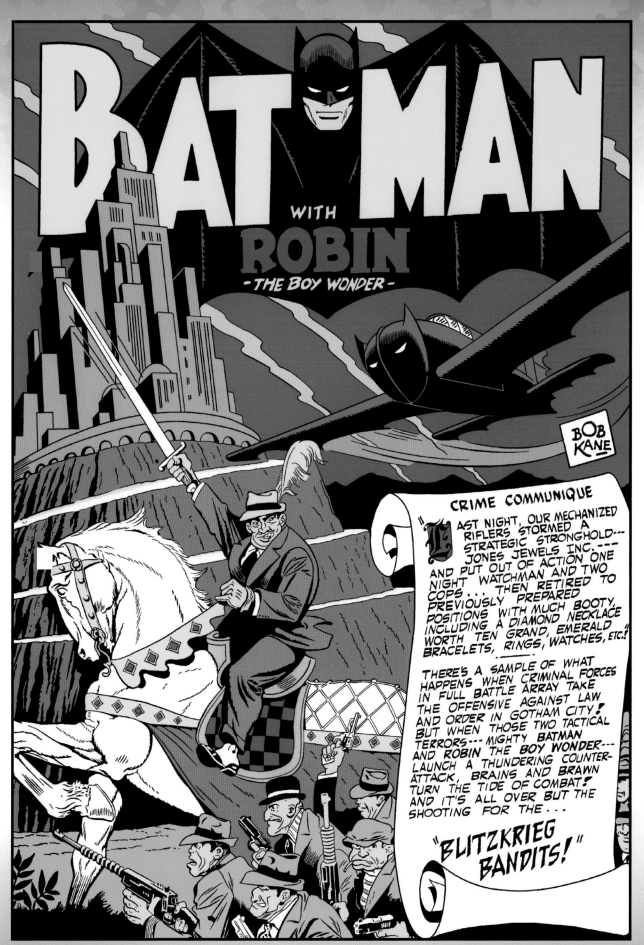

Batman #21 (Feb.-March 1943) - script: Don Cameron - art: Dick Sprang

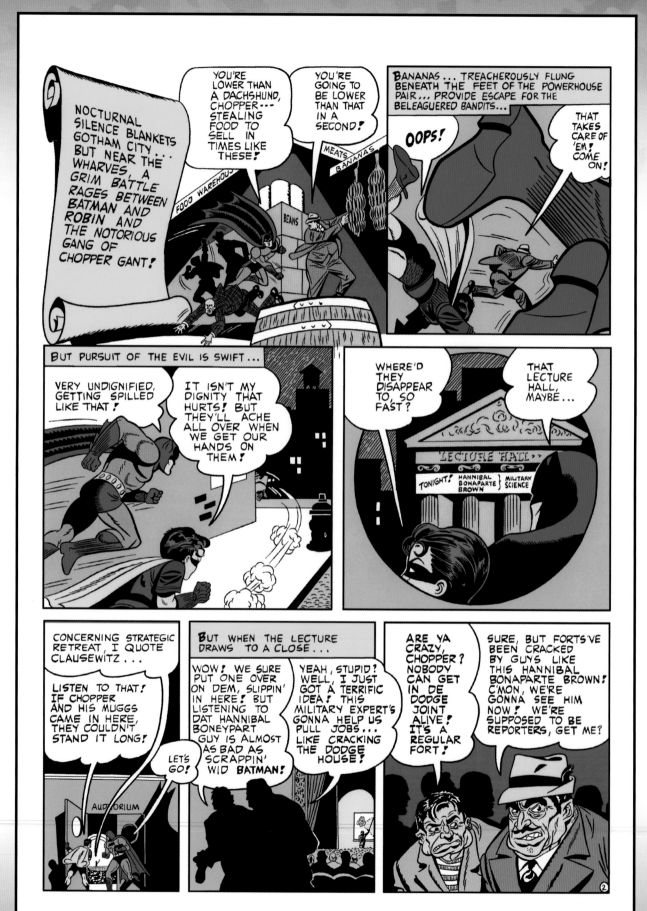

BACKSTAGE...

REAL REPORTERS? MY GOODNESS, ARE YOU SURE IT'S ME YOU WANT? I'VE NEVER BEEN INTERVIEWED IN MY LIFE!

YOU WORK WITH US, BROWNIE, AND YOU'LL BE INTERVIEWED PLENTY! WE'RE GONNA MAKE YOU FAMOUS AND PUT A LOAD OF DOUGH IN YOUR POCKET, SEE!

FAME AND FORTUNE--- TANTALIZING BAIT TO DANGLE BEFORE AN OPSCURE LITTLE DREAMER.

WE'LL FIX YOU UP A REGULAR HQ, WITH MAPS AND ALL THE OTHER STUFF YOU NEED...AND A SWELL SALARY... AND YOU GIVE US THE ANSWERS TO WHAT WE HAVE TO WRITE ABOUT! HOW DOES THAT SOUND TO YOU?

MY WORD! WONDERFUL!

LATER, AT THE GANG'S HIDEOUT...

WELL, WHAT DO YOU THINK OF IT, BROWNIE?

IT'S---IT'S THE ANSWER TO ALL MY PRAYERS! MY WHOLE LIFE SPENT STUDYING THE INTRICACIES OF MILITARY SCIENCE... AND NOW AT LAST I'M TO BE A RECOGNIZED AUTHORITY! I'M--- I'M--- DEAR ME, I'M ALL CHOKED UP!

HIS UNWITTING VICTIM SECURELY SNARED, THE WILY CRIME LEADER GETS DOWN TO BUSINESS...

NOW, US REPORTERS GOT A PROBLEM TO WRITE ABOUT FOR TOMORROW! WE GOTTA FIGURE OUT HOW TO CAPTURE AN ENEMY FORT UP ON A MOUNTAIN TOP! OUR MOB--- UH---SOLDIERS CAN'T JUST WALK UP AND TAKE IT BECAUSE THEY'D BE CUT DOWN BY MACHINE GUNS! SO HOW CAN IT BE DONE?

A FASCINATING PROBLEM, MR. GANT! FRONTAL ASSAULT WOULD BE INEFFECTIVE, AS YOU SUGGEST! I WOULD ADVISE THE MOST MODERN METHODS DEVISED!

A "FASCINATING PROBLEM" IN PURE STRATEGY TO UNWORLDLY HANNIBAL BONAPARTE BROWN... BUT A SHREWD CRIMINAL PLAN TO CHOPPER GANT! FOR THAT NIGHT...

BOY, YER A GENIUS, CHOPPER...GETTING DAT EXPERT TO TELL US HOW TO CRACK DE DODGE JOINT! OLD MAN DODGE T'INKS IT'S BURGLAR PROOF! IS HE GONNA BE SURPRISED!

YEAH! AFTER WE LOOT THE PLACE, WE'LL MEET THE PLANE IN THE VALLEY AT THE BOTTOM OF THE MOUNTAIN!

249

PARACHUTES SUDDENLY BLOSSOM IN THE MURKY SKY, AND THEN FLOAT TOWARD THE MASSIVE STRONGHOLD OF THE MILLIONAIRE RECLUSE... A PARATROOP ATTACK!

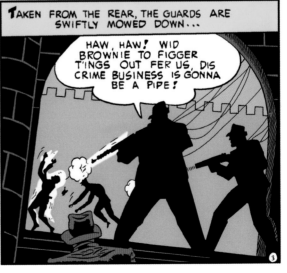

TAKEN FROM THE REAR, THE GUARDS ARE SWIFTLY MOWED DOWN...

HAW, HAW! WID BROWNIE TO FIGGER T'INGS OUT FER US, DIS CRIME BUSINESS IS GONNA BE A PIPE!

3

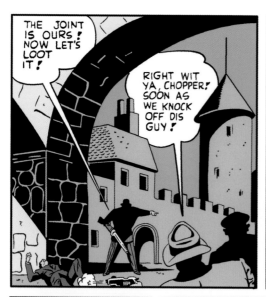

THE JOINT IS OURS! NOW LET'S LOOT IT!

RIGHT WIT YA, CHOPPER! SOON AS WE KNOCK OFF DIS GUY!

BUT AS THE KILLER HORDE RACES AWAY, A WOUNDED GUARD...LEFT FOR DEAD IN THE CRIMSON SHAMBLES... STRUGGLES TO A CALL-BOX AND...

PO-POLICE HEADQUARTERS? P-PARACHUTE CROOKS H-HAVE INVADED TH-THE DODGE HOME ON THE MOUNTAIN TOP! H-HURRY!

A BLINDING BEAM SLASHES THROUGH THE DARKNESS---A NIGHTMARE SIGNAL TO THE WICKED--- CALLING THE BATMAN!

AND A WEIRD BAT SHAPE WHIZZES ON SILENCED, SUPER-SWIFT PROPELLERS TO THE FRAY---THE BAT- PLANE, DREAD SCOURGE OF THE SKIES!

THE DODGE HOME! GOSH, BATMAN, THAT'S ONE PLACE I NEVER THOUGHT COULD BE ROBBED!

SO DID OLD MR. DODGE! BUT PARACHUTE TROOPS HAVE OFTEN TAKEN SUCH PLACES... THOUGH THIS IS THE FIRST TIME I'VE HEARD OF PARACROOKS! GET READY--- WE'RE GOING TO LAND IN THE COURT YARD!

MEANWHILE, IN THE ANCIENT WEAPONS ROOM OF THE MOUNTAIN STRONGHOLD...

I WAS A FOOL NOT TO TRUST MY MONEY AND JEWELS TO A BANK! THAT'S WHERE I'LL KEEP THEM FROM NOW ON!

IF THERE'S ANYTHING LEFT WHEN WE GET THROUGH, DODGE! TAKE YOUR TIME BLOWING THAT VAULT, BOYS! NOBODY'S GONNA BOTHER US HERE!

BUT SUDDENLY---

NOBODY BUT THE TWO OF US, CHOPPER! BUT DON'T LET US STOP YOU--- IF YOU CAN!

HEY, WE'RE OUTFLANKED OR WHATEVER DEY CALL IT!

SWIFTLY, THOUGH, THE BANDIT COMMANDER MARSHALS HIS SHAKEN FORCES!

RUSH 'EM! THEY CAN'T LICK ALL OF US AT ONCE!

OH-OH! CHOPPER AND HIS BOYS WANT TO PLAY FOR KEEPS!

WELL, WE'RE PRETTY GOOD AT HITTING THE JACKPOT OURSELVES!

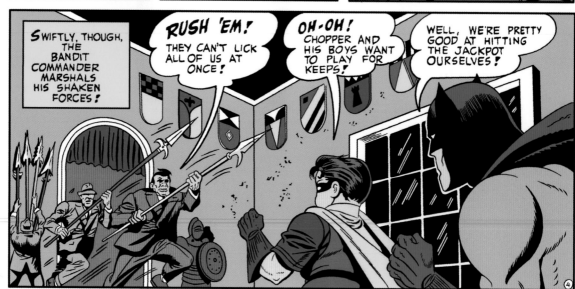

4

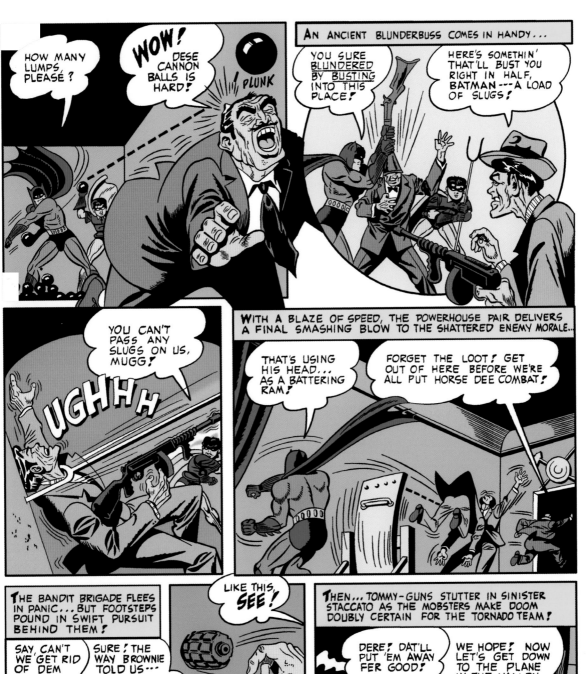

251

BUT LONG MINUTES LATER..

WHEW! THAT LONG SWIM UNDER WATER IS TOUGH ON THE LUNGS! BUT AT LEAST WE ESCAPED THOSE BULLETS!

YEAH! BUT HOW ARE WE GOING TO GET OUT OF THIS MOAT?

THIS OUGHT TO DO THE JOB!

NICE THROW!

SCRAMBLING SWIFTLY UP THE STEEL-STRONG SILKEN ROPE, THE CAPED COMRADES RACE TO THE BATPLANE PARKED IN THE COURTYARD...

I CAN'T FIGURE IT OUT, BATMAN! CHOPPER ALWAYS WAS A SMART GANG LEADER... BUT NOTHING LIKE NOW! YOU'D THINK HE WAS A GENERAL THE WAY HE PLANNED THIS CRIME!

RIGHT! ONLY CHOPPER ISN'T ANY MILITARY STRATEGIST---HE PROVED THAT ALL THROUGH HIS CRIMINAL CAREER! SO SOMEBODY ELSE MUST BE DOING HIS PLANNING FOR HIM! BUT WHO?

SUPER-CHARGED MOTORS WHISPER TO POWERFUL LIFE... AND THE SPEEDY BATPLANE STREAKS OFF ON THE TRAIL! BUT...

GUESS WE'D BETTER GIVE UP! THERE ISN'T A TRACE OF 'EM!

NOW I REMEMBER! THAT LECTURE HALL WE THOUGHT THE GANG WOULDN'T GO INTO! A MILITARY EXPERT WAS GIVING A TALK THERE! COME ON, WE'RE GOING TO DO SOME CHECKING ON HIM!

AT THAT MOMENT, MANY MILES AWAY...

WELL, WE'RE BACK AT DE HIDEOUT WIDOUT DE SWAG! BUT BATMAN AN' DAT BRAT'RE OUTA DA WAY FOR GOOD, HUH, CHOPPER?

I AIN'T SO SURE! THEY GOT MORE LIVES THAN A FAMILY OF CATS! BUT IF THEY'RE STILL ALIVE, WE'RE GONNA GET RID OF 'EM... AND BROWNIE'S GONNA FIGURE OUT HOW!

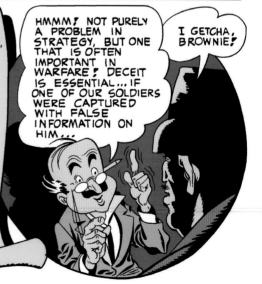

WHEN AM I GOING TO SEE THE ARTICLES YOU AND YOUR COLLEAGUES ARE WRITING ABOUT ME, MR. GANT? I CAN HARDLY WAIT!

LATER! RIGHT NOW WE GOT A BIG PROBLEM! LET'S SAY WE GOTTA CAPTURE A COUPLA TOUGH ENEMY SPIES AND BUMP--- UH--- BRING 'EM TO JUSTICE! HOW COULD WE GO ABOUT IT?

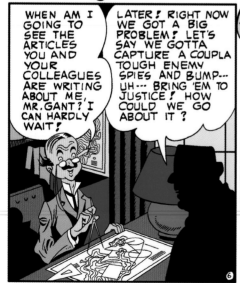

UNSUSPECTING, THE MILITARY EXPERT'S BRILLIANT TACTICAL MIND CONCEIVES A DEADLY PLAN OF AMBUSH FOR THOSE CHAMPIONS OF JUSTICE--- THE BATMAN AND ROBIN!

HMMM! NOT PURELY A PROBLEM IN STRATEGY, BUT ONE THAT IS OFTEN IMPORTANT IN WARFARE! DECEIT IS ESSENTIAL... IF ONE OF OUR SOLDIERS WERE CAPTURED WITH FALSE INFORMATION ON HIM...

I GETCHA, BROWNIE!

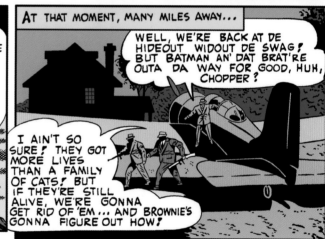

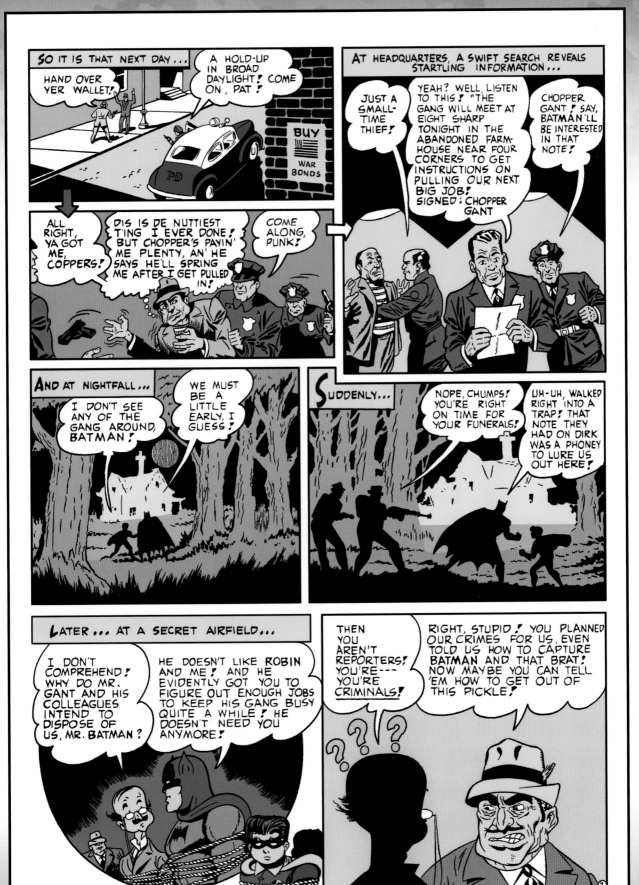

253

OKAY, CHOPPER! DE BOMB IS TIED UNDER DE NOSE OF DE GLIDER! DEY WON'T SHAKE IT OFF EVEN WIT STUNTIN'!

HOW'S THIS FOR A MILITARY PROBLEM, BROWNIE? EVEN IF YOU UNTIE YOURSELVES UP THERE YOU'LL BE BLOWN APART IF YOU TRY TO LAND! HAW, HAW! LETS SEE YO'U FIGURE YOUR WAY OUT OF THAT ONE!

THEN, MOTOR ROARING, THE GANGSTERS' PLANE ZOOMS INTO THE SKY, DRAWING THE DEATH GLIDER WITH ITS HELPLESS CARGO! AND MINUTES LATER...

DE TOW ROPE'S CUT! CLEAR OUTA HERE BEFORE DEY BLOW US UP WID DEM!

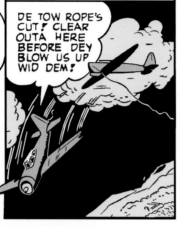

WHAT A MESS WE'RE IN! WE CAN'T STAY UP HERE BECAUSE GLIDERS HAVE TO COME DOWN SOME TIME! AND IF WE LAND, THAT BOMB WILL GO OFF!

DEAR ME! THIS IS A PROBLEM! I'M AFRAID I MUST CONCEDE DEFEAT!

BUT NOT THE BATTLING BATMAN! EYES ROVING RESTLESSLY, HE SEARCHES FOR A WAY TO CHEAT DEATH..

WE'RE NOT LICKED YET! THAT'S A COMPASS IN YOUR POCKET, ISN'T IT? ROLL OVER HERE --- BUT IMMEDIATELY!

MY GOODNESS, IT IS MY COMPASS! I MUST HAVE ABSENT-MINDEDLY SLIPPED IT INTO MY POCKET WHEN I WAS TAKEN FOR A DRIVE! I--I HOPE THAT ISN'T STEALING!

AFTER TENSE MINUTES OF STRUGGLING AND STRAINING...

VERY CLEVER, PICKING THE KNOTS WITH THE POINTS OF THE COMPASS! I'D NEVER HAVE THOUGHT OF IT!

JUST A TRICK OF THE TRADE! BUT WE'RE NOT EXACTLY SITTING PRETTY YET! I'VE GOT TO GO OVER THE SIDE AND CUT THAT BOMB LOOSE... OTHERWISE, WE WON'T BE ABLE TO LAND! AND AS ROBIN SAYS, GLIDERS HAVE TO COME DOWN SOME TIME!

THE THREE ARE TYING THEIR ROPES TOGETHER...

IF I MAY MAKE A SUGGESTION, MR. BATMAN! I'VE MADE A QUITE EXTENSIVE SURVEY OF AERONAUTICS... YOUR JUNIOR COLLEAGUE WOULD BE BETTER SUITED FOR THE PURPOSE! YOUR WEIGHT, ADDED TO THE BOMB'S, WOULD TIP THE SHIP BADLY!

HE'S RIGHT! I'D BETTER DO THE JOB!

NIMBLY, THE BOY WONDER CLAMBERS OVER THE FRAIL GLIDER'S SIDE... A SLIM ROPE BETWEEN HIM AND CRASHING DOOM ON THE GROUND FAR BELOW!

CAREFUL, ROBIN!

GOLLY, I HOPE I DON'T SUDDENLY HAVE TO SNEEZE!

BUT TROUBLE LOOMS LARGE FOR THE TRAPPED TRIO! FOR ...

WE'RE LOSING ALTITUDE! EVEN ROBIN'S WEIGHT WAS ENOUGH TO BRING DOWN THE BOW! GRAB THE WHEEL... I'LL TRY TO BALANCE THE SHIP AT THE OTHER END!

GOODNESS ME! I HOPE I CAN DO IT! YOU SEE, I'VE NEVER EVEN GONE UP IN A GLIDER OR PLANE, LET ALONE FLY ONE!

MOMENTS LATER...

THERE! THE TAIL IS GOING DOWN A LITTLE!

IT'S FORTUNATE I REMEMBER ALL I READ ON THE SUBJECT LET ME SEE... THE FIRST PRINCIPLE IS TO EMPLOY THE THERMAL CURRENTS, OR RISING COLUMNS OF AIR---

CLINGING PERILOUSLY TO THE SWAYING CRAFT, ROBIN FINALLY LOOSENS THE BOMB'S LASHINGS AND...

WHEW! THAT JOB IS DONE! AND JUST IN TIME, TOO!

THEN...

THANK HEAVEN THAT'S OVER! BUT I'M WORRIED ABOUT WHAT THE GANG IS GOING TO DO! THEY HAD ME OUTLINE A PLAN TO CAPTURE AN ENEMY TANK PLANT---BUT I'M SURE IT'S AN AMERICAN ONE THEY INTEND TO ATTACK! WHAT SHALL WE DO?

GET TO THE TANK FACTORY OUTSIDE GOTHAM CITY AS FAST AS WE CAN! THIS GLIDER'S THE ONLY TRANS-PORTATION HANDY! SO YOU'LL HAVE TO FLY US THERE...

MEANWHILE, AT A FASHIONABLE HOTEL IN GOTHAM CITY...

THEES EES AN OUTRAGE! WE ARE VISITING DEEPLOMATS FROM AN ALLIED COUNTREE! WE SHALL PROTEST TO THE PRESIDENTE HIMSELF!

WE KNOW WHO YOU ARE--- THAT'S WHY WE'RE HERE! HAND OVER YOUR CREDENTIALS AND FANCY DUDS!

255

BONAS NOTCHES, SEENOR! WE ARE VISITING DEEPLOMATS FROM AN ALLIED COUNTREE! HOW'S DAT SOUND, CHOPPER?

ELEGANT! THEY'LL NEVER SUSPECT YOU— AS LONG AS YOU KEEP YER TRAP SHUT! NOW HURRY UP! WE AIN'T GOT MUCH TIME!

SPEEDING THROUGH CROWDED STREETS, THE DISGUISED GANGSTERS SOON REACH THE GIANT WAR FACTORY ON THE OUTSKIRTS OF TOWN...

WE HAVE BEEN COMMEESSIONED BY OUR COUNTREE TO EENSPECT THEES SO-GREAT TANK PLANT, WHEECH EES MAKEENG TANKS FOR OUR COUNTREE! EET EES ---HOW DO YOU SAY?--- OKAY WEETH YOU?

CERTAINLY, SENOR! YOUR CREDENTIALS ARE IN ORDER! PLEASE FOLLOW ME AND I'LL SHOW YOU AROUND PERSONALLY!

HERCULES TANK FACTORY

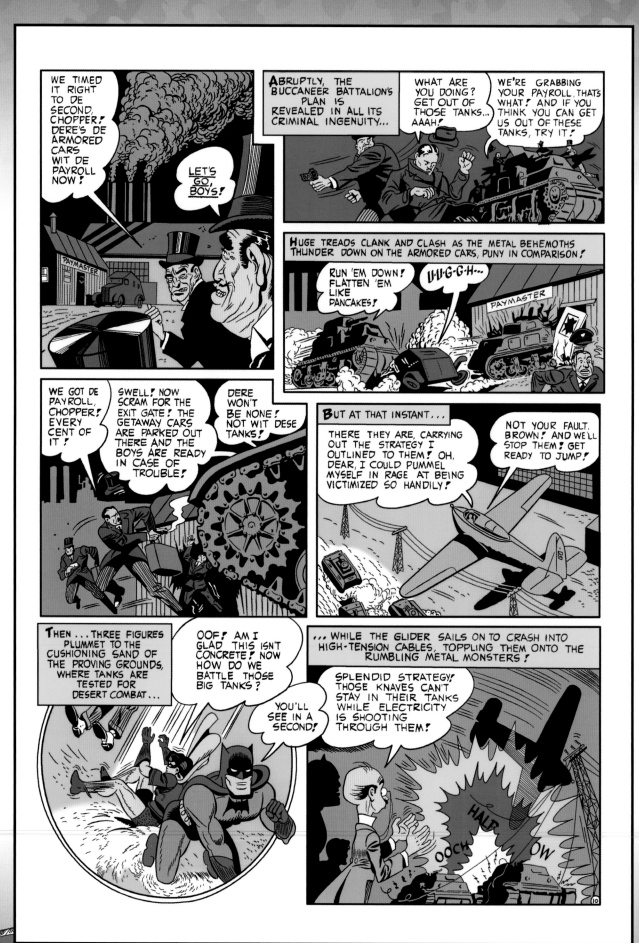

YOU TWO GENTLEMEN ATTEND TO THESE DESPERADOES! I BELIEVE A PLAN OF TACTICS I'VE WORKED OUT WILL ENABLE ME TO TAKE CARE OF THEIR ASSOCIATES OUTSIDE BY MYSELF!

GO TO IT! GOOD HUNTING!

AND AS THE POWER-HOUSE PAIR RACES OFF AFTER THE ROUTED MILITARY MARAUDERS...

HEAVENS, I'M SO NERVOUS! I'VE NEVER BEEN THIS CLOSE TO A TANK BEFORE! I HOPE MY EXCITEMENT DOESN'T MAKE ME FORGET ALL I READ ABOUT OPERATING ONE...

OUTSIDE THE TANK FACTORY...

HEY! HERE COME SOME OF DE FELLERS!

GET A LOAD OF DAT ROTTEN DRIVIN'! DEY MUSTA BEEN WOUNDED, OR MAYBE DEY'RE DRUNK!

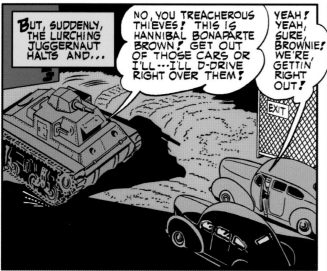

BUT, SUDDENLY, THE LURCHING JUGGERNAUT HALTS AND...

NO, YOU TREACHEROUS THIEVES! THIS IS HANNIBAL BONAPARTE BROWN! GET OUT OF THOSE CARS OR I'LL...I'LL D-DRIVE RIGHT OVER THEM!

YEAH! YEAH, SURE, BROWNIE! WE'RE GETTIN' RIGHT OUT!

EXIT

MARCH RIGHT INTO THE FACTORY AND DON'T ATTEMPT ANYTHING RASH! THIS GUN IS LOADED! (GOODNESS ME! I HOPE I DON'T HAVE TO USE IT! I COULDN'T SHOOT ANYTHING, NOT EVEN THESE CALLOUS CRIMINALS!)

257

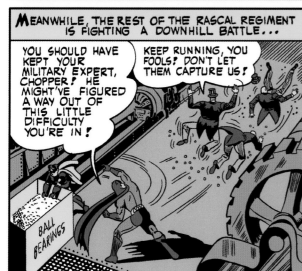

MEANWHILE, THE REST OF THE RASCAL REGIMENT IS FIGHTING A DOWNHILL BATTLE...

YOU SHOULD HAVE KEPT YOUR MILITARY EXPERT, CHOPPER! HE MIGHT'VE FIGURED A WAY OUT OF THIS LITTLE DIFFICULTY YOU'RE IN!

KEEP RUNNING, YOU FOOLS! DON'T LET THEM CAPTURE US!

BALL BEARINGS

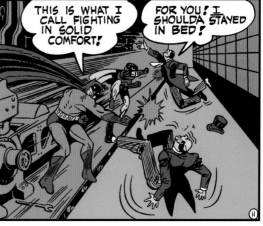

THROUGH THE HUGE FACTORY RACE THE SQUADRON OF SCOUNDRELS...A TWO-MAN OFFENSIVE AT THEIR HEELS! IN THE ENGINE ASSEMBLY DEPARTMENT...

THIS IS WHAT I CALL FIGHTING IN SOLID COMFORT!

FOR YOU! I SHOULDA STAYED IN BED!

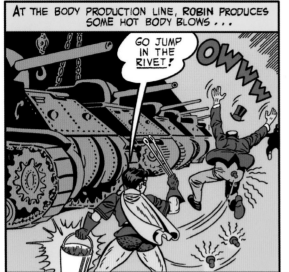

AT THE BODY PRODUCTION LINE, ROBIN PRODUCES SOME HOT BODY BLOWS...

GO JUMP IN THE RIVET!

OWWW

WHERE TURRETS ARE MOUNTED, BATMAN SURMOUNTS A SUDDEN DANGER!

HERE'S WHERE YOU GET YOURS, BATMAN! UGH!

A REVOLVING TURRET'S ONE WAY TO PUT A REVOLVER OUT OF ACTION!

THE TREAD DEPARTMENT...

WE'RE GETTING TO THE BOTTOM OF THINGS NOW, RATS!

SNAP

YOW

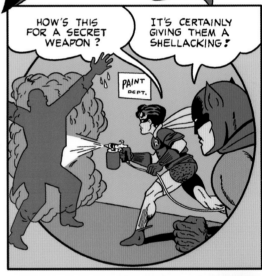

HOW'S THIS FOR A SECRET WEAPON?

IT'S CERTAINLY GIVING THEM A SHELLACKING!

PAINT DEPT.

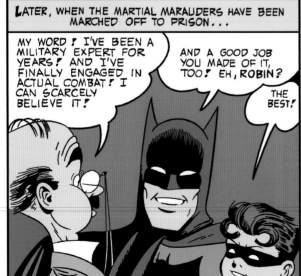

LATER, WHEN THE MARTIAL MARAUDERS HAVE BEEN MARCHED OFF TO PRISON...

MY WORD! I'VE BEEN A MILITARY EXPERT FOR YEARS! AND I'VE FINALLY ENGAGED IN ACTUAL COMBAT! I CAN SCARCELY BELIEVE IT!

AND A GOOD JOB YOU MADE OF IT, TOO! EH, ROBIN?

THE BEST!

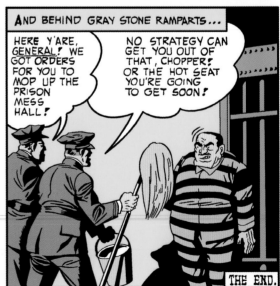

AND BEHIND GRAY STONE RAMPARTS...

HERE Y'ARE, GENERAL! WE GOT ORDERS FOR YOU TO MOP UP THE PRISON MESS HALL!

NO STRATEGY CAN GET YOU OUT OF THAT, CHOPPER! OR THE HOT SEAT YOU'RE GOING TO GET SOON!

THE END.

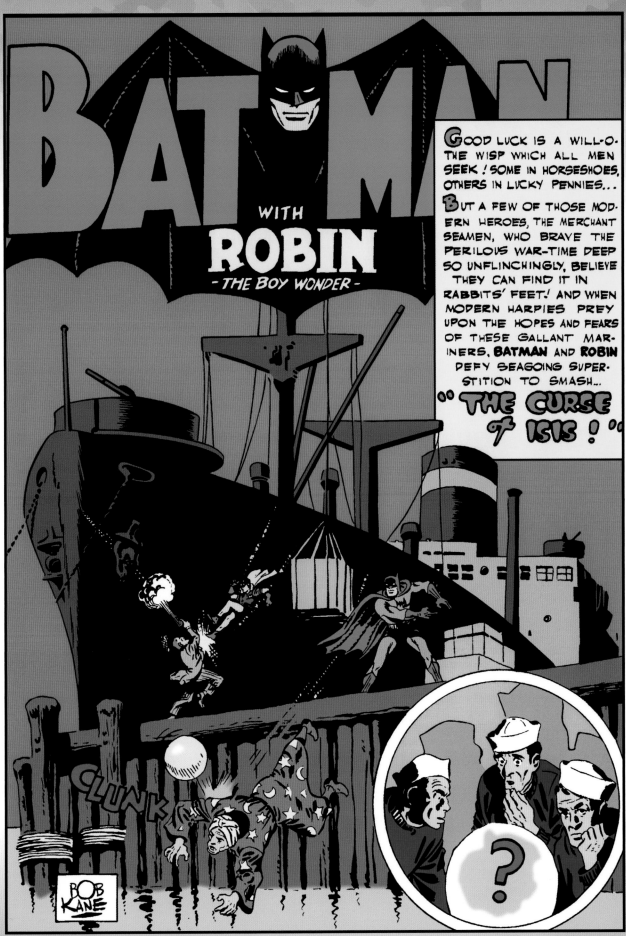

World's Finest Comics #13 (Spring 1944) - script: Bill Finger - art: Jack Burnley (pencils) & George Roussos & Ray Burnley (inks)

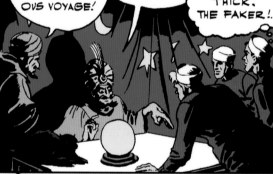

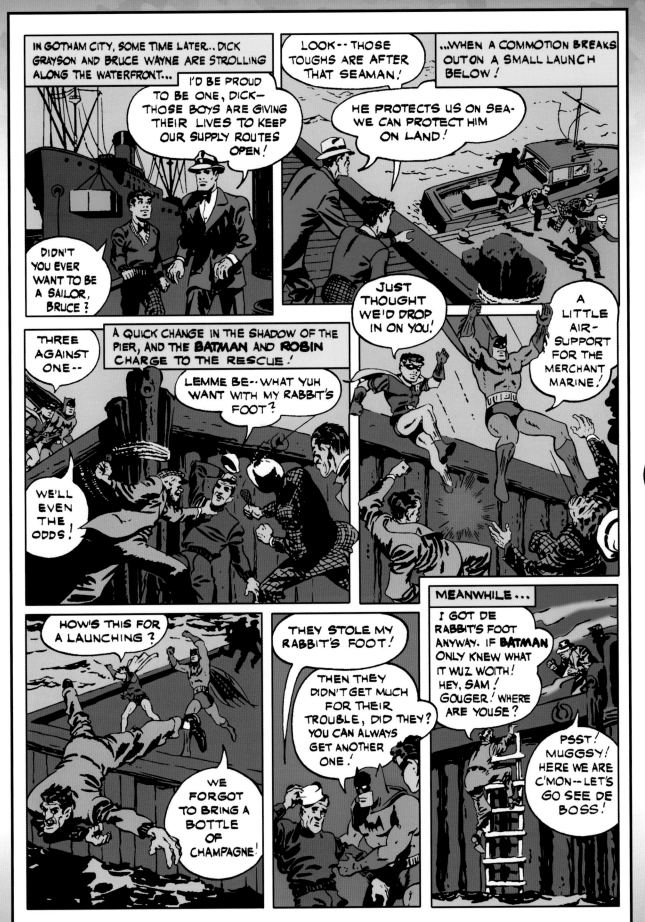

261

PRESENTLY...

SWAMI PRAVHO
THE WISE MAN OF INDIA!
FORTUNES TOLD

WE HAD TO USE A LITTLE PRESSURE, BOSS -- BUT HERE IT IS! WE HAD A RUN-IN WITH BATMAN, TOO!

BATMAN, EH? NO MATTER, WE HAVE WHAT WE WANT! I'M EXPECTING SOME MORE SEAMEN FROM THE CONVOY THAT'S JUST ARRIVING!

SURE ENOUGH, INTO THE HAVEN OF GOTHAM HARBOR AT THAT VERY MOMENT, IS STEAMING THE CONVOY BEARING OUR THREE SAILOR FRIENDS. WAS IT REALLY THE CHARM OF THE SWAMI THAT BROUGHT THEM THROUGH? LET'S SEE WHAT THEY THINK

WELL, WE GOT THROUGH, THANKS TO THE RABBITS' FEET!

RABBITS' FEET, MY EYE! THANKS TO THE U.S. NAVY!

JUST THE SAME, I'M GONNA SEE THAT OTHER SWAMI WHEN WE LAND! WE'RE GONNA NEED GOOD LUCK ON THE NEXT TRIP OUT!

AW, COME ON WITH US, JACK! THE SWAMI'S RIGHT NEAR HERE!

NO SIREE! I'M NOT GOING FOR THAT MALARKEY AGAIN!

PIER 8

BLIND

AND A FEW MINUTES LATER -- AT THE SHACK OF THE SWAMI...

LOOKA THAT! HE'S GIVIN IT AWAY!

HERE, BUD... IF THIS RABBITS' FOOT IS LUCKY, YOU'RE WELCOME TO IT!

LET HIM! HE'LL BE SORRY LATER! LET'S GO SEE THAT SWAMI!

FRIENDS, THE CRYSTAL TELLS ME THAT THE CHARM OF ISIS HAS BROUGHT YOU SAFELY FROM A FAR PLACE! PASS ME THE RABBITS' FEET THAT I MAY RENEW THEIR MYSTIC POWER!

WE TRIED TO BRING OUR PAL BUT HE THINKS THIS STUFF IS THE BUNK! HE GAVE HIS RABBIT'S FOOT TO A BLIND BEGGAR!

WHAT! HE GAVE HIS RABBIT'S FOOT AWAY? HE HAS SPURNED THE FRIENDSHIP OF THE STARS! ALAS YOUR FATE IS LINKED WITH HIS--

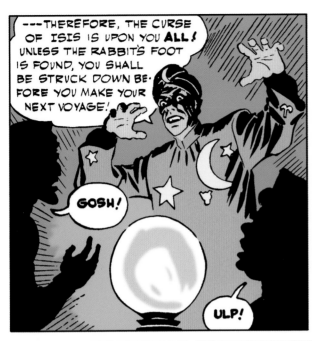

---THEREFORE, THE CURSE OF ISIS IS UPON YOU **ALL!** UNLESS THE RABBIT'S FOOT IS FOUND, YOU SHALL BE STRUCK DOWN BEFORE YOU MAKE YOUR NEXT VOYAGE!

GOSH!

ULP!

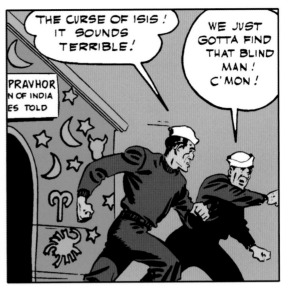

THE CURSE OF ISIS! IT SOUNDS TERRIBLE!

WE JUST GOTTA FIND THAT BLIND MAN! C'MON!

PRAVHOR N OF INDIA ES TOLD

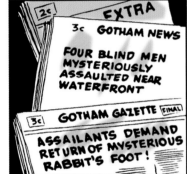

THE FOLLOWING MORNING, GOTHAM CITY IS OUTRAGED BY SHOCKING NEWS!

EXTRA
GOTHAM NEWS
FOUR BLIND MEN MYSTERIOUSLY ASSAULTED NEAR WATERFRONT

GOTHAM GAZETTE FINAL
ASSAILANTS DEMAND RETURN OF MYSTERIOUS RABBIT'S FOOT!

IMAGINE STRIKING A BLIND MAN! WHAT'S ALL THIS STUFF ABOUT A RABBIT'S FOOT?

DICK-- DO YOU REMEMBER THOSE THUGS WHO STOLE A RABBIT'S FOOT FROM THAT SEAMAN?

AND AT BRUCE WAYNE'S HOME--

YES! DO YOU THINK THERE'S A CONNECTION?

I DO AND WE'RE GOING TO FIND OUT WHAT IT IS!

263

WE LET THOSE BRUISERS GET AWAY YESTERDAY BECAUSE THERE DIDN'T SEEM TO BE ANY PARTICULAR REASON TO HOLD THEM! THIS TIME WE'LL HANG ON TO THEM!

MAYBE WE'LL FIND THEM AT THAT LAUNCH WHERE THEY WERE YESTERDAY!

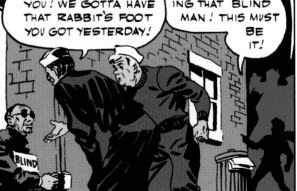

BUT WHAT'S THIS? OUR TWO SAILORS AGAIN - AND UNDER VERY INCRIMINATING CIRCUMSTANCES

LISTEN, MISTER-- WE'VE BEEN LOOKING ALL OVER FOR YOU! WE GOTTA HAVE THAT RABBIT'S FOOT YOU GOT YESTERDAY!

BATMAN, LOOK!

THEY'RE ANNOYING THAT BLIND MAN! THIS MUST BE IT!

5

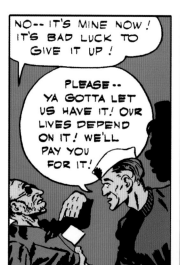

NO-- IT'S MINE NOW! IT'S BAD LUCK TO GIVE IT UP!

PLEASE-- YA GOTTA LET US HAVE IT! OUR LIVES DEPEND ON IT! WE'LL PAY YOU FOR IT!

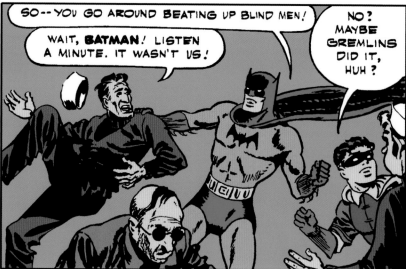

SO-- YOU GO AROUND BEATING UP BLIND MEN!

WAIT, **BATMAN**! LISTEN A MINUTE. IT WASN'T US!

NO? MAYBE GREMLINS DID IT, HUH?

HASTILY, THE SEAMEN RELATE THE STORY OF THE RABBIT'S FEET AND THE SWAMI'S GRIM IN-JUNCTION TO OBTAIN THE MISSING ONE

...SO WE'VE BEEN SEARCHING EVERYWHERE FOR THE BLIND MAN...

BUT WE DIDN'T HURT NOBODY! I SWEAR WE DIDN'T!

WHAT A CRAZY STORY!

CRAZY ENOUGH TO BE TRUE, **ROBIN**! THESE AREN'T THE MUGGS WE RAN INTO YESTERDAY. AND-- SAY-- THE BLIND MAN! HE'S GONE!

WE GOTTA FIND HIM! HE MUSTA RUN THIS WAY!

RIGHT! THAT RABBIT'S FOOT MAY BE THE KEY TO THE WHOLE MYS-TERY! I WANT TO GET A LOOK AT IT!

SUDDENLY-- THE PUR-SUERS ARE FROZEN BY A GHASTLY SIGHT!

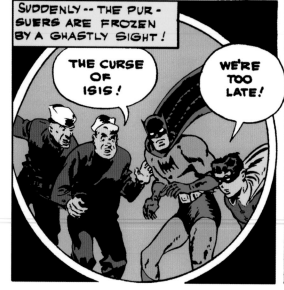

THE CURSE OF ISIS!

WE'RE TOO LATE!

THE FIENDS!

STABBED THROUGH THE HEART!

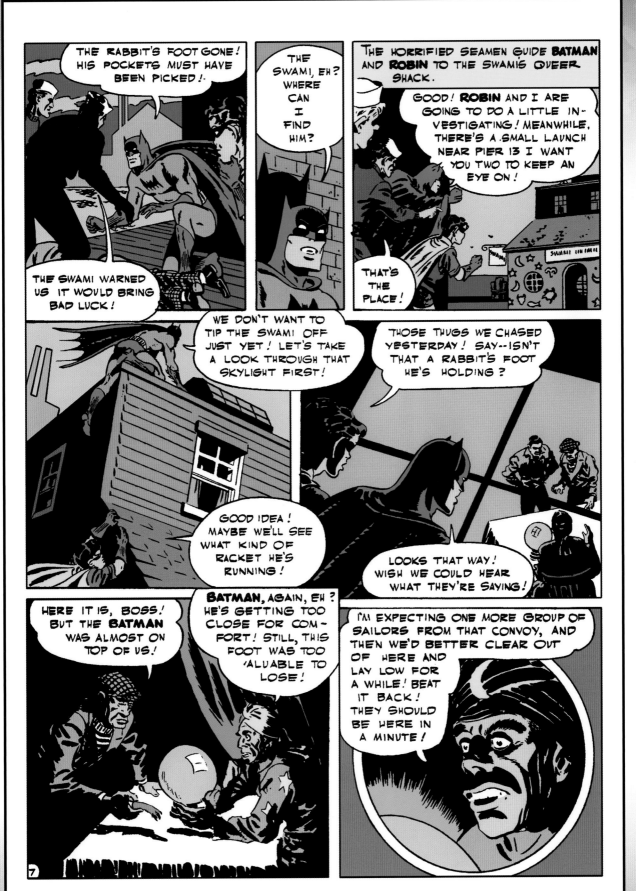

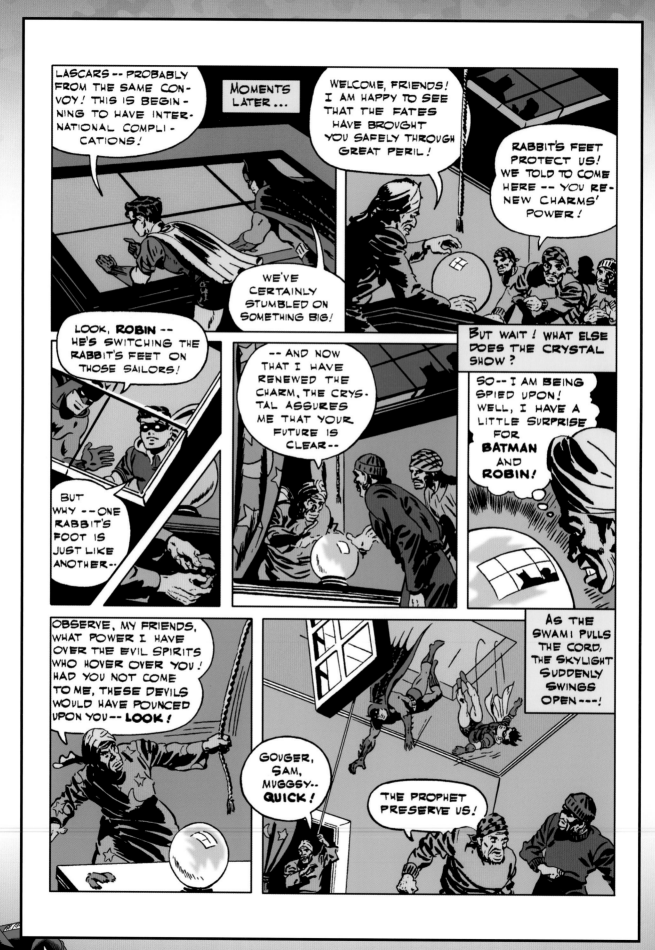

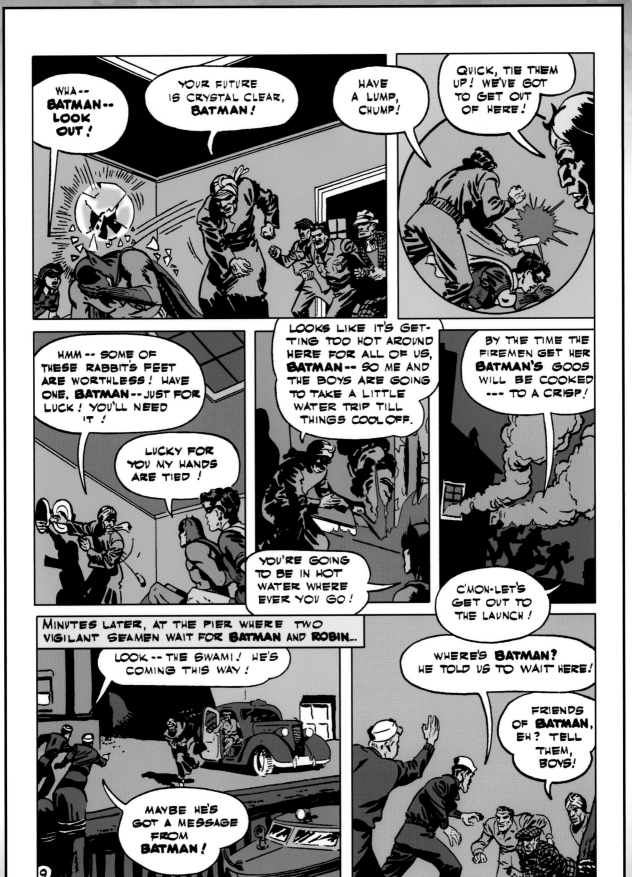

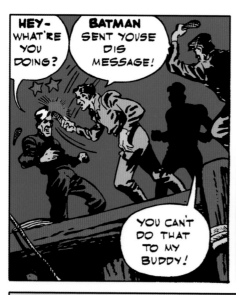

HEY-- WHAT'RE YOU DOING?

BATMAN SENT YOUSE DIS MESSAGE!

YOU CAN'T DO THAT TO MY BUDDY!

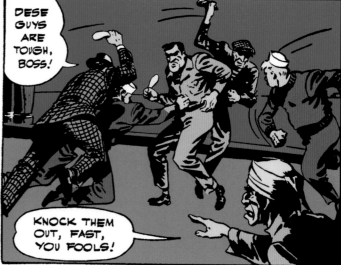

DESE GUYS ARE TOUGH, BOSS!

KNOCK THEM OUT, FAST, YOU FOOLS!

MEANWHILE, BACK AT THE SHACK, THE HUNGRY FLAMES LICK GREEDILY AROUND THE HELPLESS CRIME-CRUSHERS ---

ROBIN... THAT RABBIT'S FOOT ON THE FLOOR!.. IT MAY STILL BRING US LUCK!

(COUGH-COUGH) THIS IS A FINE TIME TO BE GET-TING SUPER-STITIOUS!

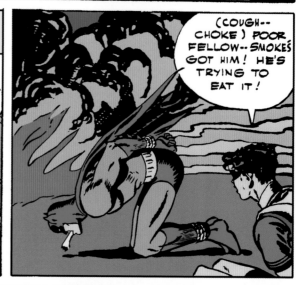

(COUGH-- CHOKE) POOR FELLOW-- SMOKE'S GOT HIM! HE'S TRYING TO EAT IT!

AS THE BATMAN BRINGS HIS FACE CLOSE TO THE SEARING FLAME ...

OH - OH, I BEGIN TO SEE WHAT YOU'RE UP TO, BATMAN!

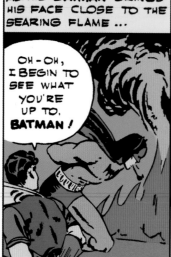

AND THEN--THE FLAM-ING BRAND QUICKLY SEVERS ROBIN'S BONDS!

(COUGH) JUST ANOTHER (COUGH) SECOND! I-- (COUGH) CAN FEEL THEM LOOSENING!

IN THE NICK OF TIME !! THERE GOES THE ROOF!

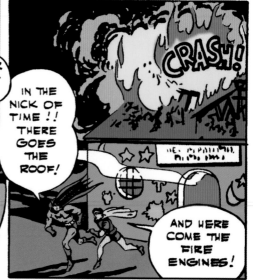

CRASH!

AND HERE COME THE FIRE ENGINES!

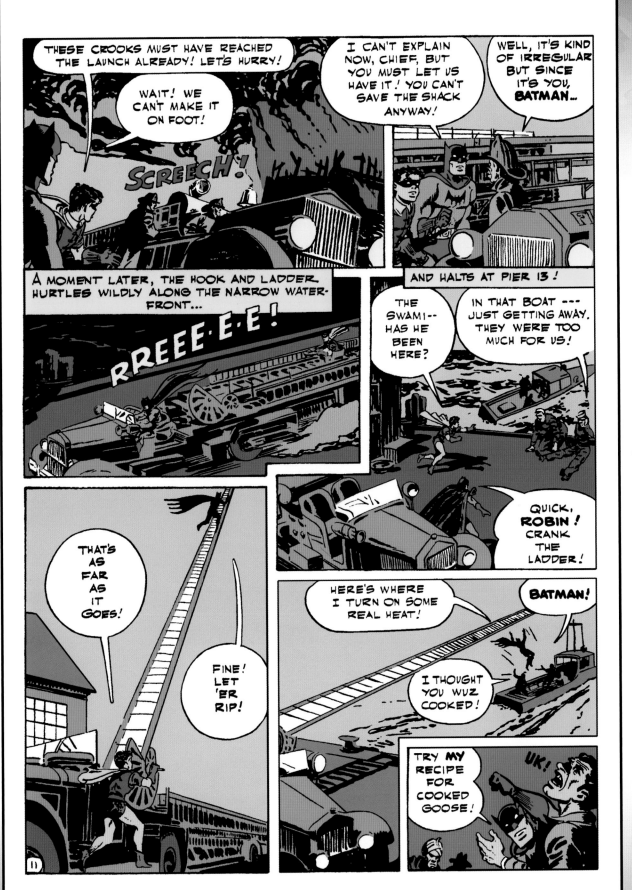

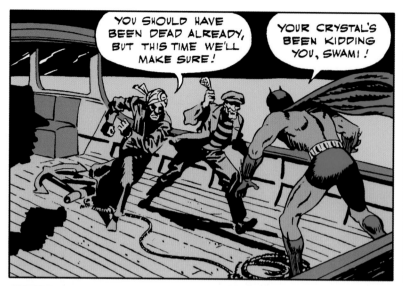

POWERFUL YANK ON THE ANCHOR ROPE, AND...

THE END

BAT MAN
WITH
ROBIN

THIS STORY CONCERNS **BATMAN** AND **ROBIN**... *YET BATMAN AND ROBIN DO NOT APPEAR IN IT!*

FOR IT IS NOT A STORY ABOUT **BATMAN** AND **ROBIN**. RATHER IS IT A STORY OF PEOPLE... ORDINARY PEOPLE LIKE YOU AND ME... PEOPLE WHO LIKE OUR GOVERNMENT THAT GIVES US LIFE, LIBERTY AND THE PURSUIT OF HAPPINESS — AND ARE WILLING TO **FIGHT FOR IT!**

THESE ARE THE PEOPLE YOU SHALL READ ABOUT... A PEOPLE OF TOMORROW... FOR, IT IS A STORY OF...

"THE YEAR 3000!"

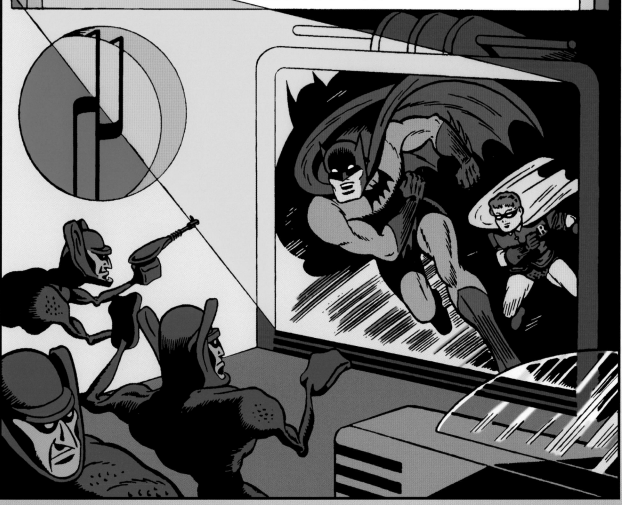

271

Batman #26 (Dec. 1944-Jan. 1945) - script: Joe Greene - art: Dick Sprang

AT THE TURN OF THE CENTURY, THE YEAR 3000 SAW THE EARTH REACH THE PEAK OF ITS DEVELOPMENT! SWIFTLY, GLORIOUSLY IT ROSE TOWARD THE CLOUDS!

INTERPLANETARY TRADE AND TRAVEL, AS FORESEEN BY H.G. WELLS AND JULES VERNE, HAD BECOME A REALITY!

...FOR IT WAS A WORLD AT PEACE, WHERE ONLY SCIENTISTS AND TEACHERS MADE WAR — ON DISEASE AND IGNORANCE!

AND CHILDREN PLAYED UNDER THE WARM SUN, INSTEAD OF COWERING IN UNDER GROUND AIR-RAID SHELTERS...

CAUGHT UNPREPARED AFTER MORE THAN A CENTURY OF PEACE, EARTH'S PROUD CITIES CRUMPLED BEFORE THE ONSLAUGHT OF THE GROTESQUE SPACE INVADERS!

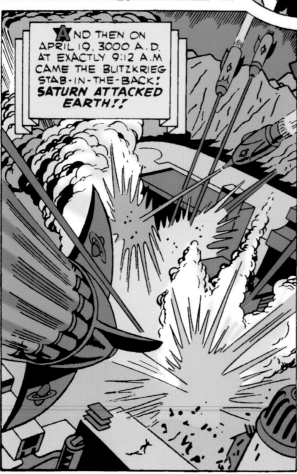

AND THEN ON APRIL 19, 3000 A.D. AT EXACTLY 9:12 A.M CAME THE BLITZKRIEG STAB-IN-THE-BACK! *SATURN ATTACKED EARTH!!*

FROM HIS STRONGHOLD ON THE PLANET SATURN, *FURA*, THE WARLORD, RULED THE EARTH!

FIRST EARTH, THEN MARS, THEN MERCURY ...AND TOMORROW THE REST OF THE SOLAR SYSTEM! SATURN SHALL BE THE MASTER WORLD!

2

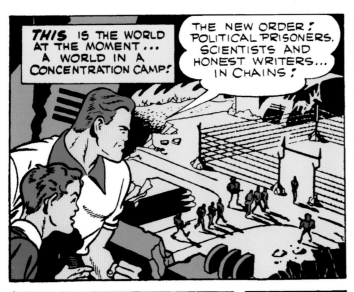

THIS IS THE WORLD AT THE MOMENT... A WORLD IN A CONCENTRATION CAMP!

THE NEW ORDER! POLITICAL PRISONERS, SCIENTISTS AND HONEST WRITERS... IN CHAINS!

SATURNIANS! BARBARIANS! THEY'VE SMASHED OUR CITIES AND OUR LIVES! RICKY, I...

BRANE, SEE DOWN THERE ... AT THE BOTTOM OF THE ATOMIC BOMB CRATER! A LONG TUBE!

CURIOUS, THE TWO INVESTIGATE...

LOOKS LIKE A TWENTIETH CENTURY UNDERSEA TORPEDO!

HAS SOME ENGRAVING ON IT...

NEW YORK WORLD'S FAIR 1939 TIME CAPSULE

1939! WOW! THAT'S WAY BACK!

I FAINTLY REMEMBER MY GREAT GRAND-FATHER TALKING ABOUT THIS! RICKY, THIS IS A FIND!

273

EMPLOYING AN ANTI-GRAVITY BELT TO LIFT THE TON-HEAVY CAPSULE, THE TWO SNEAK IT HOME! A HAND-SAW OPENS THE CYLINDER TO REVEAL ITS CONTENTS— SAMPLES OF A CENTURY PAST!

AN ANCIENT WATCH, CAN OPENER, RAZOR, COINS, BILLS... GOLLY, THIS STUFF HAS WHISKERS ON IT!

AND HERE IS MICROFILM, AND DIRECTIONS FOR BUILDING AN OLD-FASHIONED MOTION PICTURE PROJECTION MACHINE TO SHOW THE FILM!

LATER, WITH MOUNTING EXCITEMENT, THE TWO READ THE THRILLING TEXT OF A HISTORY ALMOST FORGOTTEN IN THEIR TIME!

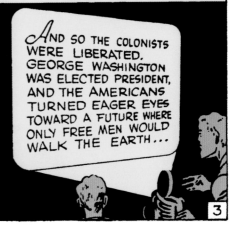

AND SO THE COLONISTS WERE LIBERATED. GEORGE WASHINGTON WAS ELECTED PRESIDENT, AND THE AMERICANS TURNED EAGER EYES TOWARD A FUTURE WHERE ONLY FREE MEN WOULD WALK THE EARTH...

3

"... TURNED EAGER EYES TOWARD A FUTURE WHERE ONLY FREE MEN WOULD WALK THE EARTH!" **WE'RE** THE FUTURE! AND LOOK AT US — SLAVES!

NOT FOR LONG, RICKY! **THEY** WON THEIR FREEDOM, AND WE'LL WIN OURS! **THEY** FOUGHT FOR IT... AND **WE'LL** FIGHT FOR IT!

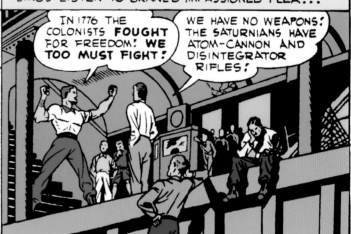

LATER... IN AN ANCIENT SUBWAY TUNNEL, EARTHLINGS LISTEN TO BRANE'S IMPASSIONED PLEA...

IN 1776 THE COLONISTS **FOUGHT** FOR FREEDOM! **WE TOO MUST FIGHT!**

WE HAVE NO WEAPONS! THE SATURNIANS HAVE ATOM-CANNON AND DISINTEGRATOR RIFLES!

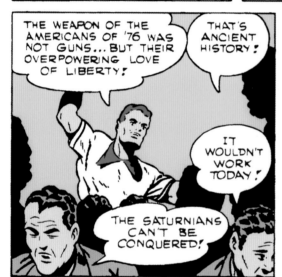

THE WEAPON OF THE AMERICANS OF '76 WAS NOT GUNS... BUT THEIR OVERPOWERING LOVE OF LIBERTY!

THAT'S ANCIENT HISTORY!

IT WOULDN'T WORK TODAY!

THE SATURNIANS CAN'T BE CONQUERED!

SOON THE TUNNEL IS EMPTY BUT FOR BRANE... AND A GIRL!

BRANE, I'M GLAD IT'S YOU I'M GOING TO MARRY, INSTEAD OF ONE OF THOSE SPINELESS COWARDS!

LORAL, DEAR... THEY'RE NOT COWARDS! THEY'VE TAKEN FREEDOM FOR GRANTED SO LONG THEY'VE FORGOTTEN HOW TO FIGHT FOR IT!

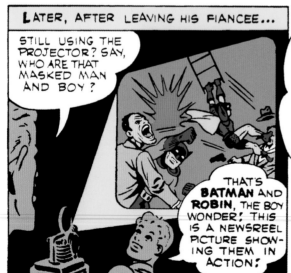

LATER, AFTER LEAVING HIS FIANCEE...

STILL USING THE PROJECTOR? SAY, WHO ARE THAT MASKED MAN AND BOY?

THAT'S **BATMAN** AND **ROBIN**, THE BOY WONDER! THIS IS A NEWSREEL PICTURE SHOWING THEM IN ACTION!

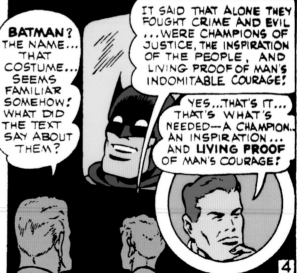

BATMAN? THE NAME... THAT COSTUME... SEEMS FAMILIAR SOMEHOW! WHAT DID THE TEXT SAY ABOUT THEM?

IT SAID THAT ALONE THEY FOUGHT CRIME AND EVIL ...WERE CHAMPIONS OF JUSTICE, THE INSPIRATION OF THE PEOPLE, AND LIVING PROOF OF MAN'S INDOMITABLE COURAGE!

YES...THAT'S IT... THAT'S WHAT'S NEEDED—A CHAMPION... AN INSPIRATION... AND **LIVING PROOF** OF MAN'S COURAGE!

4

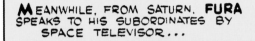

MEANWHILE, FROM SATURN, **FURA** SPEAKS TO HIS SUBORDINATES BY SPACE TELEVISOR...

FROM THIS DAY ON, ALL EARTHLINGS FOUND ON THE STREETS AFTER NINE O'CLOCK WILL BE DISINTEGRATED!

YES, MY LEADER! **FEALTY TO FURA!**

HUMANS! BAH! YOU DEPRIVE THEM OF FOOD AND LIBERTY, THEN GIVE THEM JUST A LITTLE OF BOTH... LIKE THROWING SCRAPS OF FOOD TO A DOG...

...AND THEY FAWN ON YOU AND ARE YOUR SLAVES! CONTROLLING THEM IS A SCIENCE! THEY ALL REACT THE SAME! THEY ARE LIKE ROBOTS! ROBOTS! HA! HA! A GOOD JOKE! ROBOTS! HA! HA!

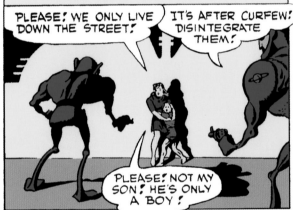

NINE O'CLOCK! DEATH'S CURFEW! WITH ALMOST MECHANICAL DELIBERATION, THE EMOTIONLESS SATURNIANS OBEY THEIR LEADER'S ORDER!

PLEASE! WE ONLY LIVE DOWN THE STREET!

IT'S AFTER CURFEW! DISINTEGRATE THEM!

PLEASE! NOT MY SON! HE'S ONLY A BOY!

SUDDENLY, TWO GRIM FIGURES LEAP FROM THE SHADOWS!!

LET 'EM HAVE IT!

CHECK!

275

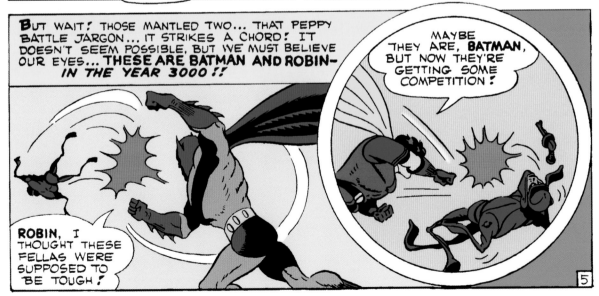

BUT WAIT! THOSE MANTLED TWO... THAT PEPPY BATTLE JARGON... IT STRIKES A CHORD! IT DOESN'T SEEM POSSIBLE, BUT WE MUST BELIEVE OUR EYES... **THESE ARE BATMAN AND ROBIN— IN THE YEAR 3000!!**

MAYBE THEY ARE, **BATMAN,** BUT NOW THEY'RE GETTING SOME COMPETITION!

ROBIN, I THOUGHT THESE FELLAS WERE SUPPOSED TO BE TOUGH!

5

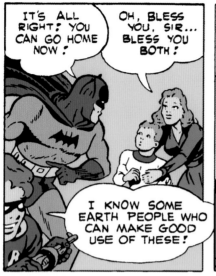

IT'S ALL RIGHT! YOU CAN GO HOME NOW!

OH, BLESS YOU, SIR... BLESS YOU BOTH!

I KNOW SOME EARTH PEOPLE WHO CAN MAKE GOOD USE OF THESE!

BUT THIS IS ONLY THE BEGINNING OF A SERIES OF DARING GUERRILLA RAIDS AND SABOTAGE BY A TWO-MAN ARMY!

THAT'S ONE MORE FACTORY LESS TO PRODUCE WEAPONS FOR THE ENEMY!

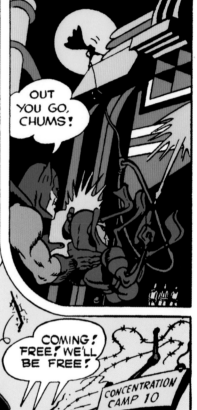

A MAN AND A BOY... AGAINST THE WHOLE SATURNIAN ARMY! INCREDIBLE? NO.... FOR THIS IS HISTORY!

OUT YOU GO, CHUMS!

NIGHT AFTER NIGHT, THEY STRIKE ... AND THEN STEAL AWAY TO MERGE WITH THE SHADOWS OF WHICH THEY SEEM A PART!

TAKE FOOD FROM STARVING EARTH PEOPLE, WILL YOU? RATS... THIEVING RATS!

FOOD MARKET

A MAN AND A BOY! THEY ARE THE STUFF OF WHICH HEROES ARE MADE! HEROES AND LIBERATORS OF ENSLAVED PEOPLE!

C'MON, FOLKS! DO YOU WANT TO STAY HERE FOREVER?!!

COMING! FREE! WE'LL BE FREE!

CONCENTRATION CAMP 10

SOON THEIR NAMES BECOME FAMILIAR TO THE EARTH PEOPLE...

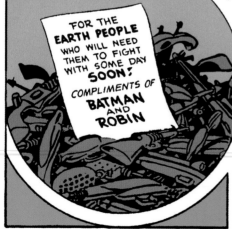

FOR THE **EARTH PEOPLE** WHO WILL NEED THEM TO FIGHT WITH SOME DAY **SOON!** COMPLIMENTS OF **BATMAN** AND **ROBIN**

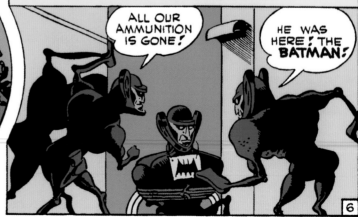

...AND THEIR NAMES ARE ALSO FAMILIAR... SO VERY FAMILIAR, TO THE SATURNIANS!

ALL OUR AMMUNITION IS GONE!

HE WAS HERE! THE BATMAN!

6

BATMAN! THE WORD SPREADS LIKE WILDFIRE, AND THERE IS MANY A THOUGHT ABOUT HIM...

THE RECORDS SHOW HE LIVED IN THE TWENTIETH CENTURY!

BUT THAT WOULD MAKE HIM OVER A THOUSAND YEARS OLD!

PERHAPS HE USED A TIME-MACHINE TO TRAVEL TO OUR TIME!

AT THAT MOMENT...

IT'S THE BED FOR ME TONIGHT! I'M TIRED!

ME TOO! WE DID A GOOD NIGHT'S WORK!

BRANE, I THINK YOUR "BATMAN" PLAN IS WORKING! YOU'VE GOT THE PEOPLE ALL EXCITED!

...AND INSPIRED, I HOPE! THEY'VE ALL THOUGHT NO MEN COULD BEAT THE SATURNIANS... BUT NOW I THINK THEY'RE CHANGING THEIR MINDS!

AND SO THEY ARE! FOR THE FIRST TIME SINCE THE INVASION, EARTH PEOPLE STARE AT THE SATURNIANS WITH BOLD AND SCORNFUL EYES!

INVINCIBLE, EH? THE BATMAN CERTAINLY SCOTCHED THAT RUMOR!

MAYBE SOON WE'LL DO SOMETHING ABOUT THAT, TOO!

AND FURA SUDDENLY REALIZES THAT ALL MEN ARE NOT ROBOTS, AND THAT THEY CAN BE EXPECTED TO DO THE UNEXPECTED!

YOU MUST FIND AND DISINTEGRATE THIS BATMAN AND ROBIN!

YES, MY LEADER! FEALTY TO FURA!

277

EVEN AS HE SPEAKS... IN THE WAR WING OF THE MUSEUM OF ANCIENT HISTORY...

THE PEOPLE CAN USE ANY WEAPONS, EVEN IF THEY ARE ARCHAIC TWENTIETH CENTURY MACHINE GUNS AND GRENADES!

THIS BOOK, HERE... I THINK IT'S GOING TO HELP US!

COMMANDO Battle Tactics

WHEN MORNING COMES...

HI! SAY... DON'T TELL ME YOU'VE BEEN UP ALL NIGHT READING THAT BOOK!

I HAVE... AND THIS BOOK HAS GIVEN ME THE BEST IDEA I'VE HAD YET! I'VE GOT TO SPEAK TO THE PEOPLE!

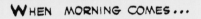

7

ONCE AGAIN, BRANE SPEAKS TO THE PEOPLE... AND THIS TIME THEY LISTEN... FOR HE SPEAKS IN THE GARB OF **BATMAN**!

WELL... ARE WE GOING TO CRAWL— **OR FIGHT LIKE MEN**!!

FIGHT!

FIGHT!

SO IT BEGINS! THE TOUGHENING-UP PROCESS! JUDO... OBSTACLE CHARGES...

BUT BRANE FINDS BEING **BATMAN** HAS ITS DRAWBACKS...

WHY IS IT YOU HAVEN'T JOINED THE **BATMAN'S** COMMANDO CLASSES?

I...I...ER... I'VE CHANGED MY MIND! I THINK WE'D BE FOOLS TO FIGHT THE SATURNIANS!

AND I THOUGHT YOU WERE A MAN! WELL, I CAN CHANGE MY MIND, TOO! YOU CAN KEEP YOUR OLD ENGAGEMENT RING!

GOSH, RICKY, HOW CAN I EXPLAIN? I CAN'T VERY WELL BE BOTH BRANE _AND_ **BATMAN** AT CLASSES!

YOU CAN EXPLAIN AFTER THIS IS ALL OVER! MEAN- WHILE, WE'VE GOT A JOB TO DO!

"A JOB TO DO!" AND ON THE NIGHT THAT WILL LIVE FOREVER IN THE ANNALS OF HISTORY, **THE COMMANDOS OF 3000 ATTACKED THE INVADER!**

LET 'EM HAVE IT!

YAHOO!

THEN FROM OUT OF THE SKY POURS THE NEW SECRET WEAPON CONSTRUCTED BY THE EARTH PEOPLE IN PRIVATE— **THE SKY-SLED!**

SURPRISE, SURPRISE!

8

SATURNIAN FIGHTER-SHIPS ATTEMPT A COUNTER-ATTACK, BUT THE TINY, SPEEDY, EASILY MANEUVERABLE **SKY-SLEDS** PROVE TOO MUCH FOR THE CLUMSIER, HEAVIER SHIPS!

COMMANDO TACTICS! PRECISE, CLOCK-WORK WARFARE! EVERY MAN TO HIS JOB! EVERY TRICK BROUGHT INTO PLAY!

EARTHMAN COURAGE, COUPLED WITH COMMANDO TACTICS, PROVE TOO MUCH FOR STOLID SATURNIAN STRATEGY!

WE'VE WON!

WE'VE BEATEN THEM!!

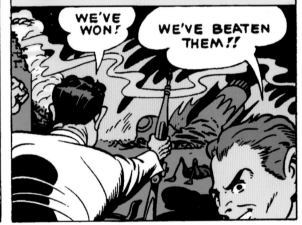

279

WAIT! WE'RE NOT FINISHED YET! WE'VE GOT TO ATTACK SATURN... **NOW**... BEFORE **FURA** CAN ATTACK EARTH AGAIN!

ATTACK...SATURN! THAT'S SUICIDE!

I SAY WE STAY HERE AND MAKE A STAND!

WE WERE JUST LUCKY BEFORE, **BATMAN!** WE'RE NOT PROFESSIONAL FIGHTING MEN!

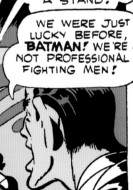

IN ANSWER, BRANE WHIPS AWAY HIS COWL AND STANDS REVEALED!

YES...ME! AM I A PROFESSIONAL FIGHTING MAN... OR AM I JUST A MAN LIKE YOU? I ONLY ADOPTED THIS **BATMAN** DISGUISE BECAUSE I KNEW YOU'D NEVER BELIEVE IN JUST BRANE HIMSELF!

BRANE!

9

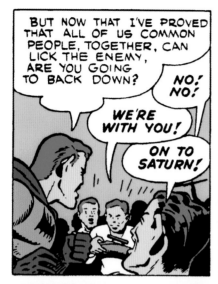

BUT NOW THAT I'VE PROVED THAT ALL OF US COMMON PEOPLE, TOGETHER, CAN LICK THE ENEMY, ARE YOU GOING TO BACK DOWN?

NO! NO!

WE'RE WITH YOU!

ON TO SATURN!

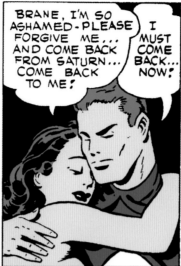

BRANE, I'M SO ASHAMED-PLEASE FORGIVE ME... AND COME BACK FROM SATURN... COME BACK TO ME!

I MUST COME BACK... NOW!

THAT VERY NIGHT, A VAST FLEET OF SPACE-FIGHTERS ROCKETS FROM EARTH, AND HEADS TOWARD THE RINGED PLANET—SATURN!

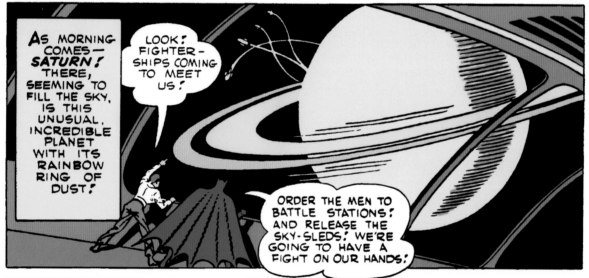

AS MORNING COMES— SATURN! THERE, SEEMING TO FILL THE SKY, IS THIS UNUSUAL, INCREDIBLE PLANET WITH ITS RAINBOW RING OF DUST!

LOOK! FIGHTER-SHIPS COMING TO MEET US!

ORDER THE MEN TO BATTLE STATIONS! AND RELEASE THE SKY-SLEDS! WE'RE GOING TO HAVE A FIGHT ON OUR HANDS!

EARTH VS. SATURN! THE WAR OF THE WORLDS!

BUT THE EARTH FORCE IS TOO POWERFUL, FOR IT CONSISTS OF RECOVERED EARTH SHIPS, THE COMMANDEERED SATURNIAN SHIPS... AND THE SKY-SLEDS! AND SO... THE EARTH FORCE LANDS ON SATURN...

HERE THEY COME! POUR IT INTO THEM!

10

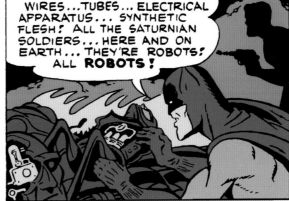

281

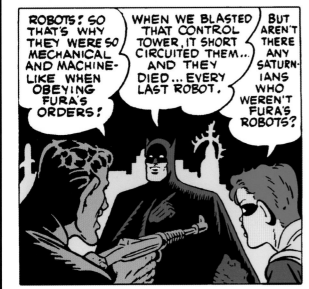

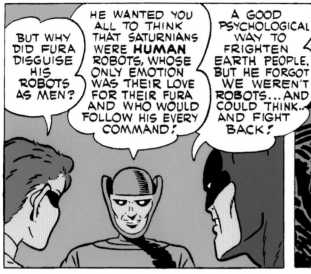

BUT WHY DID FURA DISGUISE HIS ROBOTS AS MEN?

HE WANTED YOU ALL TO THINK THAT SATURNIANS WERE **HUMAN** ROBOTS, WHOSE ONLY EMOTION WAS THEIR LOVE FOR THEIR FURA AND WHO WOULD FOLLOW HIS EVERY COMMAND!

A GOOD PSYCHOLOGICAL WAY TO FRIGHTEN EARTH PEOPLE, BUT HE FORGOT WE WEREN'T ROBOTS...AND COULD THINK.. AND FIGHT BACK!

LOOK! IT MUST BE FURA IN A STRATO-ROCKET SUIT! HE'S TRYING TO ESCAPE TO OUR MOON, TITAN!

QUICK! GET ME A STRATO-SUIT! HURRY!

S WIFT AS A METEOR, "BATMAN" HURTLES THROUGH SPACE... AS FURA WHEELS IN FLIGHT AND DRAWS A DISINTEGRATOR-PISTOL!

A ND THERE, 2000 MILES IN THE STRATOSPHERE, EARTHMAN AND SATURNIAN LOCK IN A DEATH BATTLE!

S UDDENLY, FURA TRIES TO PULL FREE! THE GUN BLASTS LURID FLAME... AND THEN...

AGH! I'M FREEZING... FREEZING TO DEATH *

* EDITOR'S NOTE: FURA WAS FREEZING TO DEATH BECAUSE THE AIR WAS RUSHING INTO THE HOLE IN HIS SUIT! AND IN THE STRATOSPHERE, SPACE NIGHT IS TWO HUNDRED DEGREES BELOW ZERO!

A ND SO, TUMBLING AND TWISTING, FURA DRIFTS AWAY IN SPACE... AND HE AND HIS GREAT SCHEMES ARE AS MERE DUST IN THE INFINITE, IMMEASURABLE MAJESTY OF THE VAST UNIVERSE!

12

NEXT DAY, GRATEFUL SATURNIANS WATCH THE EARTHMEN HEAD FOR HOME...

ON EARTH, A TREMENDOUS OVATION AWAITS THE RETURNING HEROES! AND IN A TELEVISOR CONTROL BOOTH...

BATMAN... I MEAN, BRANE... THE PEOPLE ARE ASKING FOR YOU! WILL YOU SPEAK INTO THIS TELEVISOR HERE?

YES... I'LL SPEAK TO THEM!

WE HAVE WON OUR PEACE AND FREEDOM, BUT WE MUST NEVER AGAIN RELAX OUR VIGILANCE... FOR PEACE AND FREEDOM ARE FAR TOO PRECIOUS EVER TO BE LEFT UNGUARDED AGAIN!

283

NOW WE CAN LOOK FORWARD TO THE FUTURE AND FORGET THE PAST!

NO, LORAL! WE MUST NEVER FORGET THAT THE PAST REVEALS OUR PAST MISTAKES AND GLORIES BOTH! REMEMBER, WE WON NOW BECAUSE OF A TEXT ON AMERICAN HISTORY... AND A BOOK ON COMMANDO WARFARE...

AND DON'T FORGET THE BATMAN AND ROBIN GAVE US A FEW POINTERS, TOO!

13.

BRANE, I'M CURIOUS ABOUT YOUR REAL NAME! WE STREAM-LINE EVERYTHING IN THIS MODERN AGE SO THAT WE EVEN RUN OUR FIRST AND LAST NAMES TOGETHER! MINE, YOU KNOW, IS LORA HALL, BUT YOU NEVER TOLD ME YOURS!

I'M THE TWENTIETH DIRECT DESCENDANT OF MY FAMILY TO BEAR MY FIRST NAME AND LAST NAME!

BUT, I THOUGHT YOU KNEW IT WAS WAYNE... BRUCE WAYNE!

the END.

Part Five

1945 was the year it would all end, everybody knew—at least they knew it would be over in Europe.

VICTORY

Defeating Japan, island by island, across vast stretches of the Pacific Ocean, followed by an invasion of the Home Islands, was likely to take a year or two longer, experts calculated.

And because "everybody knew" that the war was nearly over, lots of people did what people tend to do. They slacked off. Absenteeism in factories and other essential war industries went up . . . and thus, production went down. From the government down to the local level, responsible leaders had to keep reminding people: this war isn't over yet; we've got to keep turning out bombers and bullets, tanks and trucks, until Hitler and Tojo are done.

Well, actually, General Tojo *was* finished. As the events of war went ever more solidly against Japanese forces, he was forced to resign his position as virtual military dictator in July of 1944. It is possible to say that no one person ever held so much power in the nation again, with the possible exception of Emperor Hirohito, who was officially worshipped and revered by the Japanese, and duly hated and reviled by Americans for the attack on Pearl Harbor.

But Hitler fought on, even as the Americans and British pressed him from the west and Soviet troops attacked from the east. It was, as the governments constantly reminded their populations, no time to let down their guard.

The editors of the Batman series, however, had decided that no good purpose was to be served by having any more war-oriented stories in his various series, so he and Robin were relegated to simply appearing on a few patriotic covers: plugging the "7th War Loan" (basically another national war bond drive, a big push to finance the last days of the hostilities) on that of *Detective Comics* #101 (July 1945), and showing Batman and Robin personally delivering a gun to a soldier at war in a jungle (and thus certainly in the Pacific theatre). Probably, few young readers really expected to see them repeat that action in a story inside, unless that reader was perusing his or her first ever Batman comic. Such covers were the comic book equivalent of the patriotic posters kids saw when they accompanied their parents to the post office, or perhaps glimpsed in some other public place, perhaps even along the roadside.

Behind those covers, there were still a few patriotic flourishes which obliquely aided the war effort. The most notable of these was "Batman Goes to Washington" in *Batman* #28 (April–May 1945), in which Batman and Robin travel from Gotham City (which seems to be located just next door to New York City—and to Superman's hometown of Metropolis) and address the United States Senate in order to give crooks and other shady characters a chance to contribute to war production. In retrospect, it seems a somewhat dubious proposition, echoing the Joker vowing to return a stolen bomber or movies like *Lucky Jordan* (as in Part II: The Home Front War). But assuming that Batman and U.S. Senators know more than we do,

the story itself is an interesting one, a sort of Bob-Kane-Meets-Damon-Runyon slugfest.

The inspiration for the title, if not the precise theme, was of course the popular 1939 film *Mr. Smith Goes to Washington*, starring James Stewart and directed by that filmic populist, Frank Capra. In the movie, a political innocent named Jefferson Smith (Stewart) is selected by a corrupt political boss to fill a Senate seat vacated by a legislator's death—with the idea that the boss can easily control said Senator. The boss finds, of course, that Smith eventually wises up and makes a stand against his "benefactor." (Oddly, there were at least partial foundations for such a story, since it was fairly well-known, and would become even more so a few years hence, that Harry S. Truman had entered Congress as the candidate of the corrupt Pendergast machine in Missouri, yet pursued a fairly independent course with never a touch of personal scandal. Of course, whatever his other virtues, Truman never publicly turned on Pendergast and denounced him, but that's about as close as you can expect true life to get to *Mr. Smith Goes to Washington*.)

And then, a couple of months later, when the actual calendar caught up to the April–May cover date on the cover of *Batman* #28, it was indeed all over in Europe. On April 30, 1945, Hitler committed suicide in his bunker beneath embattled Berlin, as the Russians closed in and the Americans and British held back to let them do so. (Only a couple of weeks earlier, President Roosevelt had died, as well, and Truman succeeded him as President.) Germany's government submitted its unconditional surrender on May 7, to be effective the next day.

In the Pacific, American forces pressed on, recapturing the Philippines and carrying out increasing bombings of Tokyo and other cities in an effort to force Japan to unconditionally surrender. The fall of the Japanese islands of Iwo Jima and Okinawa by the early summer, plus American submarines and incessant bombing, made Japanese defeat inevitable. Two atomic bombs dropped on the cities of Hiroshima and Nagasaki in early August hastened the process and spared both sides the catastrophe of a D-Day-style invasion, which would probably have resulted in the deaths of far more people on both sides. When the Allies agreed that Japan could keep its emperor, Japan surrendered on August 15. The official documents were signed aboard the deck of the battleship *U.S.S. Missouri* on September 2, 1945.

World War II was finally over.

By then, the comic books—and few more so than those starring Batman and Robin—had already "converted to peacetime," with the Dynamic Duo back to fighting the Joker, the Penguin, and Catwoman, villains who had no cause save their own.

285

Even so, with their patriotic covers and the more than occasional story, Batman and Robin had done their bit for the war effort—and they could hold their masked heads up high.

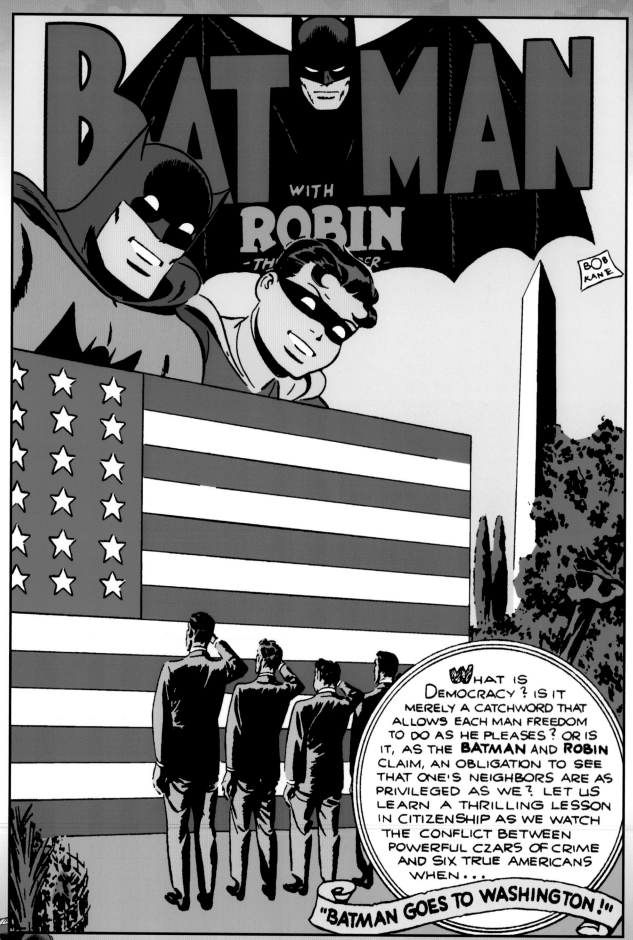

Batman #28 (April-May 1945) - script: Alvin Schwartz - art: Jerry Robinson

TWILIGHT— AND THE **BATMOBILE** WINDS THROUGH A SECTION IN WHOSE SHADOWED ALLEY- WAYS LINGER THE OUTCASTS AND DERELICTS OF A GREAT CITY...

THEY CALL THIS "THE STREET OF SORROW." IT LOOKS IT!

FORTUNATELY, THE CITY IS PLAN- NING TO IMPROVE THIS WHOLE SECTION!

SUDDENLY...! — ROBIN! UP THERE! A MAN ABOUT TO JUMP!

WE'VE GOT TO STOP HIM!

I SHOULDA DONE DIS LONG AGO! NOW IT'LL SOON BE OVER!

SAVED BY THE CAPE!

WHAT A NARROW ESCAPE!

287

HUH! IT'S DANNY THE DIP! HOW COME SO TIRED OF LIVING, DANNY?

A YEAR AGO, YA SENT ME TO DA PEN! WHEN I GOT OUT, I TRIED TO GO STRAIGHT! BUT AN EX-CON CAN'T EVEN GET A JOB! I WUZ DESPERATE!

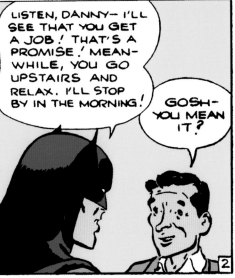

LISTEN, DANNY— I'LL SEE THAT YOU GET A JOB! THAT'S A PROMISE! MEAN- WHILE, YOU GO UPSTAIRS AND RELAX. I'LL STOP BY IN THE MORNING!

GOSH— YOU MEAN IT?

2

LATER THAT EVENING, AT BRUCE WAYNE'S HOME...

DANNY IS REALLY A SKILLED WORKER... BECAUSE HE'S AN EX-CON, HE CAN'T GET A JOB. THERE ARE LOTS LIKE HIM, BUT NOBODY'LL GIVE THEM A CHANCE TO GO STRAIGHT!

AND THERE'S SUPPOSED TO BE A MANPOWER SHORTAGE!

DICK, SOMETHING OUGHT TO BE DONE TO HELP THOSE MEN WHO'VE PAID THEIR DEBT TO SOCIETY AND WANT TO GO STRAIGHT.' AND THE **BATMAN** IS GOING TO START THE BALL ROLL-ING BY PRESENTING THE MATTER TO THE PUBLIC OVER THE RADIO.'

AND THE FOLLOWING DAY...

THE GREAT LESSON OF DEMOCRACY IS THAT ALL MEN ARE CREATED EQUAL. WHY THEN SHOULD ANYONE CON-TINUE TO SUFFER FOR A MISTAKE AFTER THIS DEBT HAS BEEN PAID?...

AND IN A CERTAIN DIVE OF SHADY REPU-TATION...

...TODAY, THERE IS NO REASON WHY ANY MAN SHOULD BE FORCED INTO CRIME. OUR FACTORIES NEED WORKERS BADLY...

THE **BATMAN'S** RIGHT.' IF I COULD GET A JOB, I'D FORGET ABOUT THE RACKETS FOR GOOD.'

I'D LIKE TO HELP MY COUNTRY, BUT THEY WON'T LET ME.

AND IN WASHINGTON, D.C., A DISTIN-GUISHED SENATOR, HENRY K. VANDER-COOK, ALSO LISTENS...

...FOR THIS GREAT NATION CANNOT ALLOW PREJUDICE TO DEPRIVE IT OF THE BADLY NEEDED SKILLS OF THESE MEN.'

REMARKABLE!

I'M JUST ABOUT TO INTRODUCE A BILL TO APPROPRIATE FUNDS TO BUILD A SMALL PLANT AT WHICH THESE UNWANTED MEN CAN PROVE THEIR WORTH TO EMPLOYERS...

... AND **BATMAN** HAS SUBSTAN-TIALLY THE SAME IDEA. WHY, IF I COULD INDUCE HIM TO ADDRESS THE SENATE WHEN THE MEASURE REACHES THE FLOOR, HIS PRES-TIGE IS BOUND TO INFLUENCE ITS APPROVAL. I'LL WRITE HIM AT ONCE.'

THE NEXT MORNING...

HUNDREDS OF LETTERS, MOSTLY FROM EX-CROOKS WHO WANT TO GO STRAIGHT.' THEY ALL THINK YOU'RE A GREAT GUY, **BATMAN**!

WHY, HERE'S A LETTER FROM SENATOR VANDERCOOK! HE WANTS ME TO GO TO WASHINGTON!

3

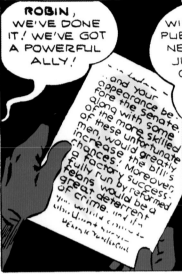

ROBIN, WE'VE DONE IT! WE'VE GOT A POWERFUL ALLY!

...and your appearance before the Senate along with some of the more skilled of these unfortunate men, would greatly increase the bill's chances. Moreover, a factory fully run by reformed felons would be a great deterrent of crime, and if...

THE FACTORY WILL CONVINCE THE PUBLIC A MAN ISN'T NECESSARILY BAD JUST BECAUSE HE ONCE WENT WRONG. AND I KNOW JUST THE MEN TO TAKE WITH US!

WOW! WASH-INGTON IS ONE PLACE I'VE ALWAYS WANTED TO SEE!

A COUPLE OF DAYS LATER...

SOME CARAVAN! BESIDES US, THERE'S AN EX-PICKPOCKET, AN EX-FORGER, AN EX-TORPEDO, AND AN EX-SAFECRACKER!

I GUESS EX MARKS THE SPOT-LIGHT ON US! THE PAPERS GAVE US QUITE A SPREAD THIS MORNING!

LOOK AT ALL DA SCENERY! I'M JUST REALIZIN' WHAT A BIG BEEOOTIFUL COUNTRY WE LIVE IN!

YEAH — AN' SOON WE'RE GONNA HAVE OUR CHANCE TO DO SOMETHIN' FOR IT!

ROBIN! LOOK! A MAN LYING IN THE ROAD!

289

HE MUST HAVE STUMBLED AND FALLEN DOWN THE MOUNTAINSIDE!

BATMAN! WATCH OUT!

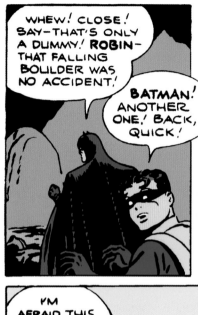

WHEW! CLOSE! SAY—THAT'S ONLY A DUMMY! ROBIN— THAT FALLING BOULDER WAS NO ACCIDENT!

BATMAN! ANOTHER ONE! BACK, QUICK!

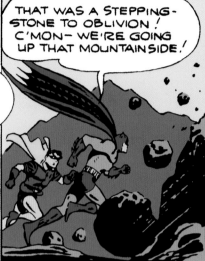

THAT WAS A STEPPING-STONE TO OBLIVION! C'MON—WE'RE GOING UP THAT MOUNTAINSIDE!

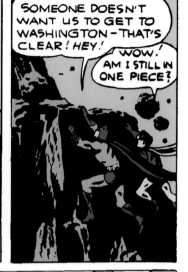

SOMEONE DOESN'T WANT US TO GET TO WASHINGTON—THAT'S CLEAR! HEY!

WOW! AM I STILL IN ONE PIECE?

I'M AFRAID THIS ONE'S GOT OUR NAMES ON IT!

NOW I KNOW WHAT A BOWLING PIN FEELS LIKE!

THERE THEY GO!

QUICK—BEFORE WE LOSE THEM IN THE WOODS!

GOO OLD GUARDIAN ANGEL! ALWAYS AROUND AT THE RIGHT TIME!

THE ROTTEN MURDERERS! WHEN WE CATCH UP WITH THEM—!

BUT THE TREE-COVERED TERRAIN AMPLY CONCEALS THE MYSTERIOUS CULPRITS. EMPTY-HANDED, THE CRIME-FIGHTERS RETURN TO THE ROAD...

WHO DONE IT, BATMAN? JUS' TELL ME THAT!

DAT AIN'T HARD! A LOTTA SMALL FRY IN DA RACKETS MAYBE LIKE DIS FACTORY IDEA, BUT DA BIG SHOTS—DEY DON'T!

THAT'S PROBABLY THE ANSWER, DANNY!

THE RACKET BOSSES STAND TO LOSE IF YOU LITTLE GUYS WON'T DO THEIR DIRTY WORK ANYMORE. THEY DON'T WANT YOU TO GO STRAIGHT, SO THEY'LL TRY ANYTHING TO KEEP ME FROM BACKING THAT BILL!

DA RATS!

AND IN A CERTAIN RAT-HOLE JUST BEYOND THE HIGHWAY...

DON'T TELL ME! YOUR FACES SHOW THAT YOU'VE FAILED!

SURE, WE FAILED! MURDER ISN'T OUR LINE, SKYE. WE'VE ALWAYS HIRED MUGGS FOR THE DIRTY STUFF. I TELL YOU, WE'VE GOT TO DIG UP SOME HOODS FOR THIS JOB!

AND I TELL YOU WE CAN'T STICK OUR NECKS OUT. THERE ISN'T A HOOD WE CAN TRUST TO BUMP OFF **THE BATMAN** AFTER THAT SPEECH. THEY SAY THEY'RE TIRED OF DICTATORS!

OUR ONE CHANCE IS TO KEEP **BATMAN** FROM INFLUENCING THE SENATE IN FAVOR OF THAT FACTORY BILL!

SKYE'S RIGHT! IF WE KILL THAT BILL, WE CAN BUILD UP OUR ORGANIZATION AGAIN. UNTIL THEN, WE DO OUR OWN DIRTY WORK. GENTLEMEN, I SAY—ON TO WASHINGTON!

WASHINGTON— THE LEGISLATIVE HEART OF A SOVEREIGN DEMOCRACY, UPON WHOSE MAGNIFICENT MONUMENTS HISTORY HAS GRAVEN HER GRANDEST ACHIEVEMENTS. TO THIS CITY COME **BATMAN** AND **ROBIN** TO ADD ANOTHER STONE TO THE STRUCTURE OF LIBERTY EVEN AS MOBSTER MOGULS SEEK TO DETER THEM...

291

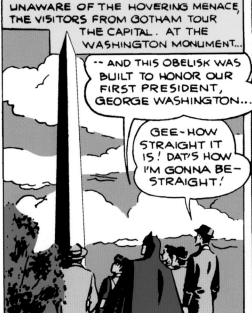

UNAWARE OF THE HOVERING MENACE, THE VISITORS FROM GOTHAM TOUR THE CAPITAL. AT THE WASHINGTON MONUMENT...

-- AND THIS OBELISK WAS BUILT TO HONOR OUR FIRST PRESIDENT, GEORGE WASHINGTON...

GEE-HOW STRAIGHT IT IS! DAT'S HOW I'M GONNA BE- STRAIGHT!

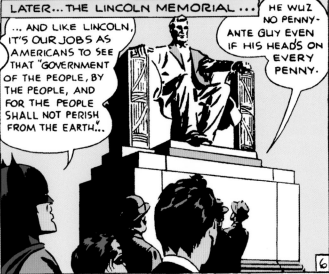

LATER...THE LINCOLN MEMORIAL...

... AND LIKE LINCOLN, IT'S OUR JOBS AS AMERICANS TO SEE THAT "GOVERNMENT OF THE PEOPLE, BY THE PEOPLE, AND FOR THE PEOPLE SHALL NOT PERISH FROM THE EARTH."

HE WUZ NO PENNY-ANTE GUY EVEN IF HIS HEAD'S ON EVERY PENNY.

6

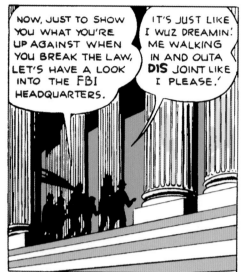

NOW, JUST TO SHOW YOU WHAT YOU'RE UP AGAINST WHEN YOU BREAK THE LAW, LET'S HAVE A LOOK INTO THE FBI HEADQUARTERS.

IT'S JUST LIKE I WUZ DREAMIN'! ME WALKING IN AND OUTA *DIS* JOINT LIKE I PLEASE.'

EACH OF THOSE MILLIONS OF CARDS CONTAINS A MAN'S COMPLETE RECORD. YET THOSE MACHINES CAN PICK OUT A SINGLE CARD IN A FEW SECONDS.

DEY SURE GOT DA CARDS STACKED AGAINST CRIME!

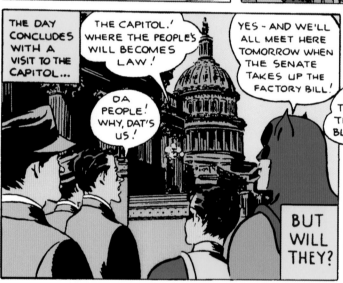

THE DAY CONCLUDES WITH A VISIT TO THE CAPITOL...

THE CAPITOL! WHERE THE PEOPLE'S WILL BECOMES LAW!

DA PEOPLE! WHY, DAT'S US!

YES - AND WE'LL ALL MEET HERE TOMORROW WHEN THE SENATE TAKES UP THE FACTORY BILL!

BUT WILL THEY?

THE NEXT DAY — IS IT CHANCE OR CHOICE THAT PARKS A CERTAIN LONE CAB NEAR THE **BATMAN'S** HOTEL? LET US SEE ...'

THE SENATE CONVENES IN TWENTY MINUTES. THERE'S A CAB — BUT NO — IT'S TAKEN!

IN CROWDED WASH-INGTON, A CAB NEVER LEAVES FOR DOWNTOWN WITHOUT A FULL LOAD. I ONLY SEE THREE PASSEN-GERS — THERE'S ROOM FOR TWO MORE—

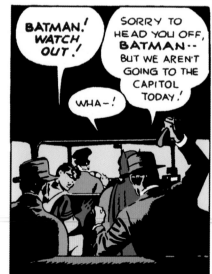

BATMAN! WATCH OUT!

WHA-!

SORRY TO HEAD YOU OFF, **BATMAN** -- BUT WE AREN'T GOING TO THE CAPITOL TODAY!

WHY, YOU SNEAKING RAT!

A BOP ON THE KNOB SHOULD SETTLE YOUR HASH!

ALL RIGHT, BENDER — *TO THE WARE-HOUSE!*

7

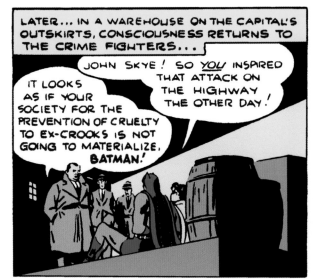

LATER... IN A WAREHOUSE ON THE CAPITAL'S OUTSKIRTS, CONSCIOUSNESS RETURNS TO THE CRIME FIGHTERS...

JOHN SKYE! SO *YOU* INSPIRED THAT ATTACK ON THE HIGHWAY THE OTHER DAY!

IT LOOKS AS IF YOUR SOCIETY FOR THE PREVENTION OF CRUELTY TO EX-CROOKS IS NOT GOING TO MATERIALIZE, BATMAN!

THIS VAULT WAS ONCE USED TO STORE VALUABLE MATERIALS. ONCE THE STEEL DOOR IS CLOSED, IT BECOMES AIR-TIGHT. AND IN A FEW HOURS... YOU SEE WHAT I MEAN? AND WE'LL BE IN THE SENATE GALLERY WHILE A CERTAIN BILL IS **DEFEATED**!

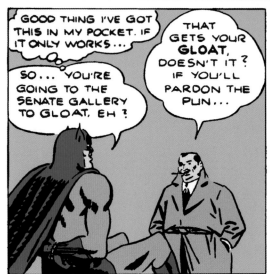

GOOD THING I'VE GOT THIS IN MY POCKET. IF IT ONLY WORKS...

THAT GETS YOUR **GLOAT**, DOESN'T IT? IF YOU'LL PARDON THE PUN...

SO... YOU'RE GOING TO THE SENATE GALLERY TO GLOAT, EH?

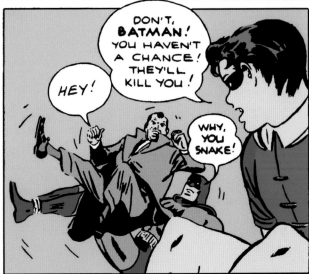

DON'T, BATMAN! YOU HAVEN'T A CHANCE! THEY'LL KILL YOU!

HEY!

WHY, YOU SNAKE!

293

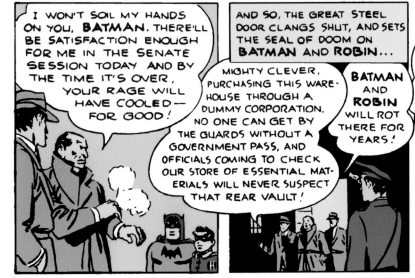

I WON'T SOIL MY HANDS ON YOU, BATMAN. THERE'LL BE SATISFACTION ENOUGH FOR ME IN THE SENATE SESSION TODAY AND BY THE TIME IT'S OVER, YOUR RAGE WILL HAVE COOLED— FOR GOOD!

AND SO, THE GREAT STEEL DOOR CLANGS SHUT, AND SETS THE SEAL OF DOOM ON BATMAN AND ROBIN...

MIGHTY CLEVER, PURCHASING THIS WARE-HOUSE THROUGH A DUMMY CORPORATION, NO ONE CAN GET BY THE GUARDS WITHOUT A GOVERNMENT PASS, AND OFFICIALS COMING TO CHECK OUR STORE OF ESSENTIAL MATERIALS WILL NEVER SUSPECT THAT REAR VAULT!

BATMAN AND ROBIN WILL ROT THERE FOR YEARS!

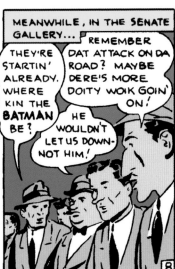

MEANWHILE, IN THE SENATE GALLERY...

REMEMBER DAT ATTACK ON DA ROAD? MAYBE DERE'S MORE DOITY WOIK GOIN' ON!

THEY'RE STARTIN' ALREADY. WHERE KIN THE BATMAN BE?

HE WOULDN'T LET US DOWN— NOT HIM!

8

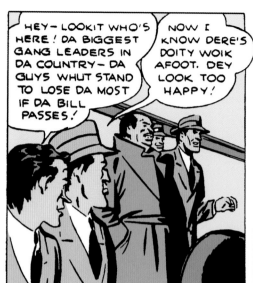

DAT VAULT! IT'S DE ONLY PLACE WE AIN'T LOOKED. WE GOTTA SOICH IT!

BUT GENTLEMEN, IT'S LOCKED! AND AS FAR AS I KNOW, IT'S NEVER BEEN USED! WHATEVER YOU'RE LOOKING FOR, YOU'RE WASTING YOUR TIME!

IT'S LOCKED, HUH? WELL, JUST LET ME AT IT!

ER...THIS SEEMS HIGHLY IRREGULAR, BUT I SUPPOSE IT'S ALL RIGHT AS LONG AS YOUR PASSES ARE IN ORDER...

THE TUMBLERS OF THE GREAT LOCK SOON RESPOND TO THE SKILLED MANIPULATIONS OF THE EX-SAFE-CRACKER, AND...

LOOK! DA BATMAN AND ROBIN!

YOU GOT HERE! ANOTHER HALF HOUR AND WE'D HAVE SUFFOCATED! LUCKY I WAS ABLE TO PLANT THAT BAT-STICKER ON SKYE WHEN I TRIPPED HIM!

SO THAT'S WHAT YOU WERE UP TO!

FREED FROM THEIR BONDS, THE BATMAN AND ROBIN PREPARE TO RETURN TO THE CAPITOL, WHEN SUDDENLY...

WELL—JUST MADE IT! LUCKY I DISCOVERED MY WALLET MISSING AND REALIZED WHAT MUST HAVE HAPPENED! BUT NOW, WE'LL SETTLE THIS LITTLE MATTER WITH BULLETS! READY, BOYS?—

IT'S SKYE AND HIS MEN!

LOOK! G-MEN!

HUH! WHERE?

295

JUST BE PATIENT! YOU'LL MEET HIM SOON ENOUGH!

SOMETIMES AN OLD TRICK WORKS BETTER THAN A NEW ONE!

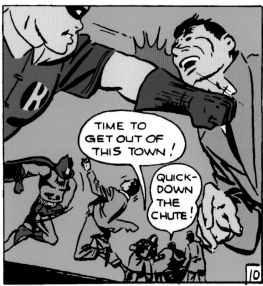

TIME TO GET OUT OF THIS TOWN!

QUICK—DOWN THE CHUTE!

10

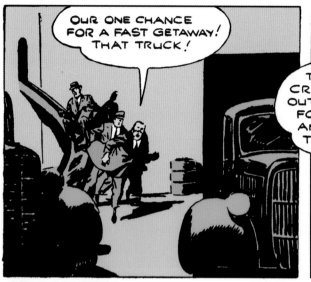

OUR ONE CHANCE FOR A FAST GETAWAY! THAT TRUCK!

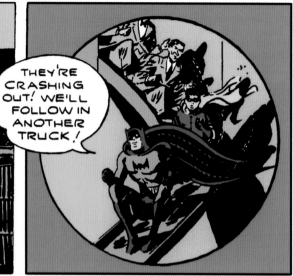

THEY'RE CRASHING OUT! WE'LL FOLLOW IN ANOTHER TRUCK!

STEP ON IT, SKYE – THEY'RE GAINING! CRACK THE HEAD OF THE FIRST MAN THAT TRIES TO HOP ON!

HEY, ROBIN– WE'RE PASSIN' DA WASHINGTON MONUMENT AGAIN! TOO BAD WE'RE SO BUSY!

YES – THIS MIGHT'VE BEEN A NICE SIGHTSEEING TOUR!

WITH SUPERIOR SKILL, THE BATMAN MANEUVERS SKYE'S TRUCK TO A STOP, AND...

MAY I POINT OUT THE FBI OFFICES ON YOUR LEFT– WITH MY RIGHT?

FER TWO YEARS I TOOK ORDERS FROM GUYS LIKE YOU, BUT NOW I'M STRIKIN' OUT FER MESELF – WIT' DIS!

AND SO, THE BATTLE CONCLUDES CONVENIENTLY BUT DECISIVELY ON THE VERY DOORSTEP OF THE FBI...

OUR OFFICE DIDN'T HAVE ANY EVIDENCE ON THESE BIRDS, **BATMAN**—BUT THANKS TO YOU, WE CAN TAKE CARE OF THEM NOW FOR A GOOD LONG TIME!

I'LL LEAVE THEM IN YOUR CARE. WE'VE A DATE AT THE CAPITOL—IF IT ISN'T TOO LATE!

IS IT TOO LATE? IN THE SENATE CHAMBER...

--AND I MIGHT REMIND THE SENATOR THAT THE **BATMAN** HAS FAILED TO APPEAR TO SUPPORT THIS ABSURD MEASURE...

ORDER! SENATOR VANDERCOOK HAS THE FLOOR...

GENTLEMEN, I ASSURE YOU, THE **BATMAN** WILL APPEAR! I HAVE HIS PROMISE...

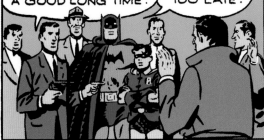

GENTLEMEN— THE **BATMAN** IS HERE!

AS HONORED GUESTS, THE FABULOUS CRIME FIGHTER AND HIS COMPANY ARE INVITED TO ADDRESS THE SENATE FROM THE PLATFORM...

... AND THESE FOUR, JUST A FEW MINUTES AGO, HELPED ARREST SOME OF THE NATION'S LEADING CROOKS! MEN LIKE THESE— AND THERE ARE MANY— EXEMPLIFY THE HUNDREDS OF OTHERS WHO WISH TO AID THEIR NATION IN ITS FACTORIES...

297

IN CONCLUSION, GENTLEMEN, I CAN ONLY URGE YOU TO FAVORABLE CONSIDERATION OF THE VANDERCOOK MEASURE. THESE MEN WILL NOT FAIL AMERICA! AMERICA SURELY WILL NOT FAIL THEM!

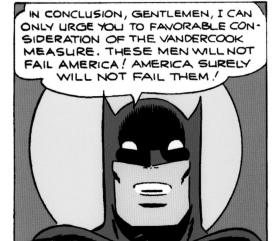

AND AMERICA DOES NOT FAIL THEM!

YEP...SEEMS LIKE ONLY YESTERDAY WE WUZ WEARIN' STRIPES... AN' TODAY WE KIN REACH FER DA STARS!

YEAH... DA STARS AN' STRIPES FOREVER!

GEE... DAT'S POETRY!

POETRY NUTHIN'! DAT'S AMERICA!

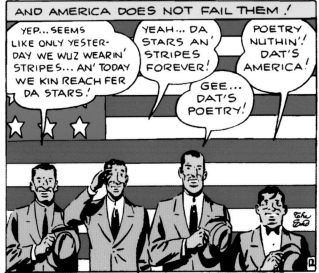

The End

Detective Comics #101 (July 1945) - cover art: Dick Sprang

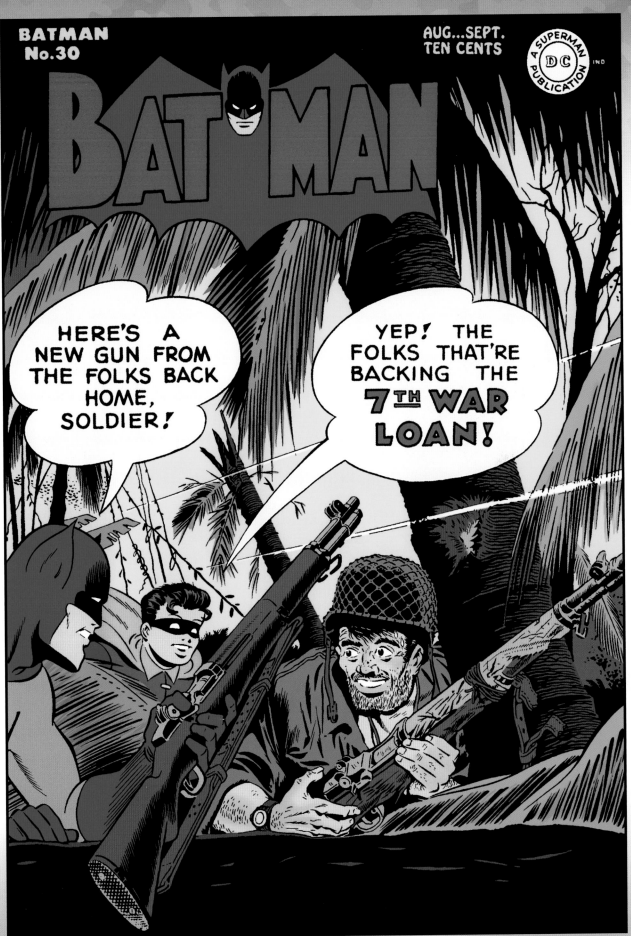

Batman #30 (Aug.-Sept. 1945) - cover art: Dick Sprang